Expressionism
A GERMAN INTUITION 1905-1920

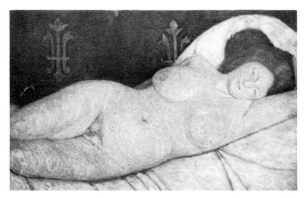

1 a.

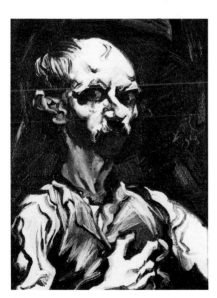

301 a.

ADDENDA

The following works are included in the exhibition but are not in the catalogue:

Paula Mondersohn-Becker
1 a. *Reclining Nude (Liegender Akt)*. 1905
Oil on canvas, 27½ x 44¼" (69.9 x 112.4 cm.)
Signed l.l.: *P.M.B.* Not dated.
Albert and Mildred Otten Collection

Ludwig Meidner
301 a. *My Night Visage (Self-Portrait) (Mein Nacht Gesicht)*.
1913
Oil on canvas, 26½ x 19½" (67.3 x 49.5 cm.)
Signed and dated r.c.: *L.M. 1913.*
Collection Mr. and Mrs. Marvin L. Fishman, Milwaukee

Max Pechstein
212 d. *Farm with Chestnuts (Goppeln) (Gehöft mit Kastanie [Goppeln])*. 1907
Woodcut, 12³⁄₁₆ x 18½" (31 x 47 cm.)
Private Collection

Max Pechstein
214 a. *Carnival (Karneval)*. 1910
Lithograph, 11 x 14¹⁵⁄₁₆" (28 x 38 cm.)
Private Collection

Max Pechstein
214 b. *Bather III (Badende III)*. 1911
Woodcut, 13 x 15¾" (33 x 40 cm.)
Private Collection

Max Pechstein
214 c. *Russian Ballet (Russisches Ballett)*. 1912
Etching, 11¹³⁄₁₆ x 9⅞" (30 x 25 cm.)
Private Collection

Max Pechstein
214 d. *The Canal in La Bassée (La Bassée Kanal)*. 1917
Lithograph, 18⅞ x 15⁹⁄₁₆" (48 x 39.5 cm.)
Private Collection

Max Pechstein
214 e. *Roman Dance Hall (Römische Tanzbude)*. 1917
Lithograph, 13⅜ x 21¹¹⁄₁₆" (34 x 55 cm.)
Private Collection

Max Pechstein
215 a. *Cello Player (Cellospieler)*. 1919
Etching, 6¹¹⁄₁₆ x 5⅛" (17 x 13 cm.)
Private Collection

Max Pechstein
216 a. *To the Baths (Nach dem Bade)*. 1920
Etching, 10⁷⁄₁₆ x 8¹⁄₁₆" (26.5 x 20.5 cm.)
Private Collection

Vasily Kandinsky

265 a. *Oriental (Orientalisches)*. 1911
Color woodcut, 4⅞ x 7½″ (12.4 x 19 cm.)
Print Collection, Arts, Prints and Photographs Department,
The New York Public Library, Astor, Lenox and Tilden
Foundations

Vasily Kandinsky

265 b. *Lyrical (Lyrisches)*. 1911
Color woodcut, 5⅝ x 8½″ (14.9 x 21.8 cm.)
Collection Städtische Galerie im Lenbachhaus, Munich

Vasily Kandinsky

265 c. *Woodcut for the Blaue Reiter Almanac (Holzschnitt für
Almanach Der Blaue Reiter)*. 1911
Color woodcut, 12⅝ x 8¾″ (32 x 22.2 cm.)
Collection Städtische Galerie im Lenbachhaus, Munich

Oskar Kokoschka

287 a. *Woman Leading the Man, from Bach Cantata: O Eternity,
Word of Thunder (Das Weib den Mann führend, Bach-
kantate: O Ewigkeit—Du Donnerwort)*. 1914
Lithograph, 15½ x 12¼″ (39.5 x 31.1 cm.)
Collection The Museum of Modern Art, New York.
Purchase Fund

Oskar Kokoschka

287 b. *The Man Raises His Head from the Grave on Which the
Woman Sits, from Bach Cantata: O Eternity, Word of
Thunder (Der Mann erhebt seinen Kopf aus dem Grabe,
auf dem das Weib sitzt, Bachkantate: O Ewigkeit—Du
Donnerwort)*. 1914
Lithograph, 17⅞ x 13⅜″ (44.8 x 34.1 cm.)
Collection The Museum of Modern Art, New York.
Purchase Fund

Ludwig Meidner

303 a. *Self-Portrait (Selbstbildnis)*. ca. 1920
Drypoint, 7¹³⁄₁₆ x 6¼″ (19.9 x 15.9 cm.)
Collection The Museum of Modern Art, New York. Given
anonymously

George Grosz

311 a. *Attack*. ca. 1915
Lithograph, 7⅝ x 9¾″ (19.4 x 24.8 cm.)
Collection The Museum of Modern Art, New York. Gift of
Mr. and Mrs. Eugene Victor Thaw

George Grosz

311 b. *Moonlit Night (Mondnacht)*. 1916
Lithograph, 14⅝ x 11¾″ (37.2 x 29.9 cm.)
Collection The Museum of Modern Art, New York.
Purchase Fund

George Grosz

311 c. *Blood is the Best Sauce*. 1920
Lithograph, 12 x 17¾″ (30.5 x 45.1 cm.)
Collection The Museum of Modern Art, New York.
Purchase Fund

Otto Dix

317 a. *Apotheosis (Apotheose)*. 1919
Woodcut, 11 x 7¾″ (28 x 19.7 cm.)
Collection The Museum of Modern Art, New York.
Given anonymously

Otto Dix

317 b. *Man and Wife (Mann und Weib)*. 1919
Woodcut, 9¾ x 6¼″ (24.8 x 15.8 cm.)
Collection The Museum of Modern Art, New York.
Given anonymously

Otto Dix

317 c. *War Cripples (Kriegskrüppel)*. 1920
Drypoint, 10⅛ x 15½″ (25.7 x 39.4 cm.)
Collection The Museum of Modern Art, New York.
Purchase Fund

Max Beckmann

326 a. *Crying Woman. The Widow (Weinende. Frau [Die Witwe])*.
1914
Drypoint, 9¹³⁄₁₆ x 7⁷⁄₁₆″ (24.3 x 19 cm.)
Collection The Museum of Modern Art, New York.
Gift of Abby Aldrich Rockefeller

Max Beckmann

326 b. *Evening (Abend—drei Figuren)*. 1916
Drypoint, 9⁷⁄₁₆ x 7″ (23.9 x 17.8 cm.)
Collection The Museum of Modern Art, New York.
Purchase Fund

The following works listed in the catalogue are not included
in the exhibition:

cat. nos. 20, 22, 25, 26, 84, 105, 107, 111, 112, 125, 152,
153, 154, 171, 173, 174, 273, 284, 285, 293

The date for cat. no. 34 should read 1913

Expressionism A GERMAN INTUITION, 1905-1920

The exhibition is sponsored by The Federal Republic of Germany, Philip Morris Incorporated, and the National Endowment for the Arts. An indemnity for the exhibition has been provided by the Federal Council on the Arts and Humanities. Additional support has been contributed by Lufthansa German Airlines.

Expressionism

A GERMAN INTUITION 1905-1920

THE SOLOMON R. GUGGENHEIM MUSEUM, NEW YORK

SAN FRANCISCO MUSEUM OF MODERN ART

Published by

The Solomon R. Guggenheim Foundation, New York, 1980

ISBN: 0-89207-024-2

Library of Congress Card Catalogue Number: 80-67038

Lenders to the Exhibition

Joachim Jean Aberbach, New York

Jan Dix

Morton D. May

Mr. and Mrs. Charles Meech, Minneapolis

The Hilla von Rebay Foundation

Thyssen-Bornemisza Collection, Lugano, Switzerland

Richard S. Zeisler Collection, New York

The Art Institute of Chicago

Brücke-Museum, Berlin

Busch-Reisinger Museum, Harvard University,
Cambridge, Massachusetts

The Detroit Institute of Arts

Germanisches Nationalmuseum, Nürnberg

The Solomon R. Guggenheim Museum, New York

Hamburger Kunsthalle

Leopold-Hoesch-Museum, Düren

Kunstmuseum Düsseldorf

Kunstsammlung Nordrhein-Westfalen, Düsseldorf

Landesmuseum für Kunst und Kulturgeschichte, Oldenburg

Ludwig-Roselius-Sammlung, Böttcherstrasse, Bremen

Museum am Ostwall, Dortmund

Museum Folkwang, Essen

Museum Ludwig, Cologne

The Museum of Modern Art, New York

Neue Galerie der Stadt Linz/Wolfgang-Gurlitt Museum

Nolde-Stiftung Seebüll

Pfalzgalerie Kaiserslautern

Saarland-Museum Saarbrücken

The St. Louis Art Museum

Staatliche Museen Preussischer Kulturbesitz,
Nationalgalerie, Berlin

Staatsgalerie moderner Kunst, Munich

Staatsgalerie Stuttgart

Städtische Galerie im Lenbachhaus, Munich

Städtische Kunstsammlung Gelsenkirchen

Städtische Museen Recklinghausen

Städtisches Karl Ernst Osthaus Museum, Hagen

Tate Gallery, London

Von der Heydt-Museum, Wuppertal

Walker Art Center, Minneapolis

Wilhelm-Lehmbruck-Museum der Stadt Duisburg

Galerie Klihm, Munich

Artists in the Exhibition

Paula Modersohn-Becker

Christian Rohlfs

Emil Nolde

Ernst Barlach

Erich Heckel

Ernst Ludwig Kirchner

Karl Schmidt-Rottluff

Max Pechstein

Otto Mueller

Franz Marc

Vasily Kandinsky

Alexej Jawlensky

Oskar Kokoschka

Lyonel Feininger

Ludwig Meidner

Jacob Steinhardt

George Grosz

Otto Dix

Max Beckmann

Table of Contents

Essays were translated from the German by Joachim Neugroschel

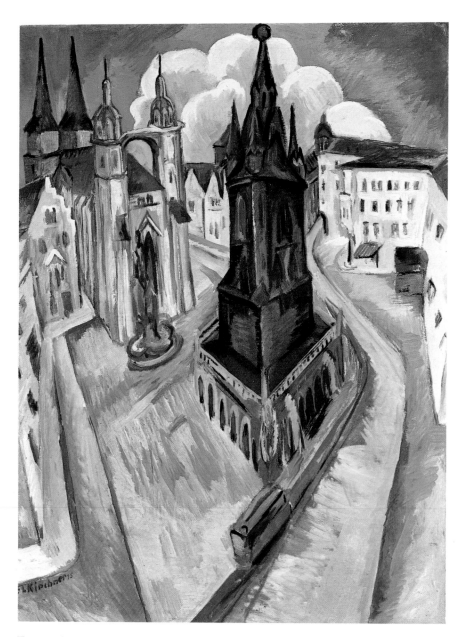

Ernst Ludwig Kirchner, cat. no. 141, *The Red Tower in Halle*. 1915
Collection Museum Folkwang, Essen

Art that Hitler condemned as degenerate has survived the Fuehrer as a fixed and vibrant feature in the continuum of world culture.

Philip Morris is proud to join with the Federal Republic of Germany and the National Endowment for the Arts in presenting this art now in an exciting exhibition, *Expressionism—a German Intuition, 1905–1920.*

One basic appeal for us at Philip Morris, a company with activities in many countries, is the cultural universality associated with German Expressionism. Shaped in part by French art, Oceanic and other primitive art, Munch and Ensor, this movement in turn has exerted enormous influence upon modern art everywhere.

Among the Expressionists were Russian, Austrian, and American artists bound in common purpose. However varied in outlook and approach, they were fiercely determined to give free rein to their individual spirit and talent. Enduring creativity is not produced by the indifferent or the unconcerned, and the German Expressionists labored with conviction, imagination, and passion for freedom. More than fifty years later, their work still retains the capacity to stun the emotions with its fury and force.

Philip Morris, long committed to the proposition that free art is essential in a free society, supports this exhibition as a tribute, above all, to the indomitable free spirit of artists.

GEORGE WEISSMAN, *Chairman of the Board*
Philip Morris Incorporated

Preface and Acknowledgements

Expressionism—a German Intuition, 1905–1920 is a survey that links a number of separate but related developments. The title reaffirms the generally held view that Expressionism of the early twentieth century is a style and a sensibility specifically German.

The brief chronological span of the exhibition eliminates from consideration immediate precursor movements such as Jugendstil—the German variant of Art Nouveau—or German Impressionism as well as Expressionism's deeper roots in nineteenth-century German Romanticism and in other expressive currents that revealed themselves throughout the history of art. At the other end, the closing year of 1920 is intended to restrict the survey to the originators of German Expressionism rather than to follow the transformation of the Expressionists' initiate awareness into late manifestations and into various successor movements.

Stylistically, German Expressionism is not so easily isolated. There remain interesting if art-historically unresolved issues, including the relationship of the *Brücke* to the *Blaue Reiter* on the one hand, and to a second generation of predominantly urban painters such as Grosz, Dix, and the young Beckmann on the other. Nevertheless, our purpose is to emphasize, within the fifteen years under consideration and from diverse though ultimately related geographic origins, those attributes that gave rise to the concept of Expressionism as a German intuition. What such attributes are is in part defined in the subsequent catalogue and perhaps should more reliably emerge as a visual rather than a theoretical experience from the works that comprise the exhibition itself.

This exhibition owes its inception to the curiosity and interest expressed on the East and West Coasts of the United States in a now famous twentieth-century art movement, which to date has received insufficient exposure in this country. Through the willingness of the West German source to respond with generosity and creative zest, the desire to present *Expressionism—a German Intuition, 1905–1920* has been realized.

The cultural office of the Federal Republic of Germany should be mentioned at the outset, as our proposal was met with munificent support and cooperation without which the loan of so many crucial works would not have been possible. Dr. Haide Russell, Cultural Attaché at the Embassy of the Federal Republic of Germany, and Dr. Marie-Cécile Schulte Strathaus, Counselor for Cultural Affairs at the German Consulate, have at different times given their unstinting support for

this undertaking from its formative stages and throughout its implementation. Professor Dr. Paul Vogt, Director of the Museum Folkwang, Essen, first mobilized essential good will for this project within the German museum community, then organized the selection of works from both public and private collections abroad. We are indebted to him for his unfailing advice and for the monumental efforts he made while occupying such a central position. Grateful acknowledgement is also due to Dr. Wolf-Dieter Dube for his active and fruitful participation in this same area of endeavor. Special thanks are extended to Dr. Ulrike Köcke, also of the Museum Folkwang, for her knowledgeable assistance and proficient handling of the difficult task of communication between Germany and New York.

We are grateful to Paul Vogt; Horst Keller, Museum Ludwig, Cologne; Martin Urban, Nolde-Stiftung Seebüll; Wolf-Dieter Dube, Bayerische Staatsgemälde-sammlungen, Munich; and Eberhard Roters, Berlinische Galerie, for sharing their insights and knowledge in the following catalogue texts. We are thankful to Joanne Greenspun for editing this publication and for her skillful handling of its production.

Among the many members of the Guggenheim's staff whose expertise was called upon, particular mention goes to Susan B. Hirschfeld, Curatorial Coordinator, for her intelligent and sustained work on all facets of the exhibition and publication. Acknowledgement is also due to Carol Fuerstein, Editor, who acted as catalogue consultant; Harold B. Nelson, registrar for the exhibition; and Louise Averill Svendsen, Senior Curator, and Vivian Barnett, Associate Curator, for their valuable curatorial advice. At the San Francisco Museum of Modern Art, we would like to thank Michael McCone, Deputy Director, who handled our Federal Council on the Arts and Humanities indemnification request. Henry Berg, the Guggenheim's Deputy Director, and S. C. St. John, Controller at San Francisco, jointly managed the highly complex budgetary and administrative aspects of this exhibition. Key among the staff contributions has been the work of Nona Ghent, Assistant to the Director, who handled all aspects of the indemnification process and managed many details of organization. Karen Tsujimoto, Louise Katzman, Robin Bryant, and Karen Lee of the Curatorial Department provided invaluable day-by-day assistance, as has Susan King of the Registration Department. Robert Whyte of the Education Department has coordinated the San Francisco educational component of the exhibition including lectures, films, musical and theater events with the considerable help and financial support of Ernst Schürmann, Director of the San Francisco Goethe Institute. Jean-Louis LeRoux of the San Francisco Contemporary Music Players and John Lion of the Magic Theatre provided essential components of our programming. Heinz Pallasch of the Consulate General of the Federal Republic of Ger-

many in San Francisco arranged original introductions and was helpful throughout the preparation period. To these and to many more our sincere professional thanks.

The high costs incurred in mounting an exhibition and producing an accompanying catalogue in this period of inflation cannot be met by museums alone. We are therefore particularly grateful to the Federal Republic of Germany not only for their organizational aid as previously mentioned, but also for their generous financial support. Philip Morris Incorporated, in addition to donating crucial funds for the exhibition, has provided their highly skilled and competent staffs to work with our own, thus ensuring an exposure of this project that reaches beyond the confines of the exhibition as such. And we are, again, the thankful recipients of monies from the National Endowment for the Arts, whose reliable support and interest have made possible so many of our most valuable past endeavors. To these, and to the Federal Council on the Arts and Humanities for indemnifying the exhibition, we owe our sincere appreciation and deep respect. Finally, it is a pleasure to report that Lufthansa German Airlines decided to join the above listed patrons and sponsors. By contributing the transatlantic shipments free of charge, this leading German concern has further reduced the financial burdens inherent in an undertaking of such ambitiousness and scope.

Our deepest indebtedness, however, is due to the lenders. Among these we are particularly grateful to the Museum Folkwang in Essen for the loan of well over one hundred works. We must also single out the Museum Ludwig in Cologne, the Nolde-Stiftung Seebüll, The Museum of Modern Art, New York, the Morton D. May Collection, and the Staatsgalerie moderner Kunst, Munich, for their magnanimous commitments of many works of extraordinary importance for this exhibition. Our gratitude toward those mentioned here, to those cited in this catalogue's list of lenders, as well as to those who have chosen to remain anonymous is correspondingly great. Their willingness to part temporarily with works of exceptional strength and pertinence has made possible the successful implementation of this exhibition in both New York and San Francisco.

THOMAS M. MESSER, *Director*
The Solomon R. Guggenheim Museum

HENRY T. HOPKINS, *Director*
San Francisco Museum of Modern Art

Catalogue

I

Introduction

PAUL VOGT

If one were to ask what the representative German contribution to European art of the twentieth century was, the first answer would be Expressionism. One promptly thinks of intensely expressive and stunningly immediate works; of colors that no longer correspond to traditional aesthetic notions but rather evoke legendary elements in violent and unwonted tones; of apocalyptic visions and hectic attitudes toward form. German art of that time followed the general European direction in a very special way. Europe was aiming at an immediate confrontation with reality, unburdened by tradition or history; and it was trying to express this new tension between the self and the world as forcefully as possible.

More than six decades have passed since Expressionism reached its highpoint in Berlin shortly before World War I. Nearly all art movements since then have had to deal with Expressionism in one way or another; but we have not yet come to any fundamental agreement about the true validity of this powerfully expressive style. Expressionism has been both highly lauded and condemned as "degenerate"; praised as an utterance of the "German essence" and branded "late-bourgeois idealism" or "bolshevistic." Even today, observers are still not unanimous about whether this was a style in the strict art-historical sense or merely an individually stamped, revolutionary shriek coming from a basic apocalyptic mood in Europe's agitated spiritual situation around 1900. The more scholars deal with this highly complex movement in the fine arts, music, and literature, the more sharply they realize how impossible it is to reduce Expressionism to an artistic or philosophical denominator. For one of the essential traits of Expressionism is its contradictions, its apparently chaotic multiplicity of divergent features, its contrasts between freedom and fettering, the individual and the masses, intellect and instinct, idealism and anarchy. However, two facts would be significant for any analysis.

First of all, German Expressionism is deeply stamped by the idea of a universal revolution, and not just one limited to the realm of aesthetics. The conviction of an urgent need to topple all values and relations is common to all its advocates, no matter what their individual views may be. Such conviction is the actual utopian goal of all Expressionist thinking and doing; and any means are justified for the revolution. The choice of means is in each instance determined by the ideological consciousness of the participating artists or groups.

Secondly, although highly typical of the beginning of the twentieth century, Expressionism has been a specific and familiar constant in German art for hundreds of years. Its essential features are deeply rooted in Germany's formal attitudes and specific ways of thinking. One must therefore regard this special view, order, and reading of the world as a national characteristic. Expressivity—as a synonym for an intense desire to utter, to communicate from the "universe of the interior"—is

virtually representative of the uniqueness of German art; hence it logically characterizes the position of German art versus the Latin sense of form.

This is merely one, albeit highly important, component of that peculiar dialectics between the desire for form and the elementary desire for utterance—a dialectics running like a red thread through the entire development of German art. We find this dialectics in the abstract ornamental style of early days—a style enlivened by urgent energy; we find it in the powerfully expressive gestures of early medieval manuscripts; we find it in the shattering sculptures of Gothic mysticism, whose emotional vehemence strains forms to the verge of dissolution. The tumultuous period of the Reformation and the religious wars strengthened the expressive trends; and we know the part these trends played in German Romanticism. In contrast to the art of the Latin countries, the German artists were not so much concerned with cultivating their artistic devices actively and theoretically, with making the painting a self-willed organism of strict formal rules and aesthetic demands. The art work was not meant to describe or arrange reality; it was supposed to interpret it, functioning as an intermediary between reality and mankind. The artist's task was "to show an unearthly Being that dwells behind everything" (Franz Marc), to fashion out a metaphysical conception of Being by heightening and transmuting the forms of objective Being into symbolic forms of the human world of emotion and expression.

Yet it is in terms of the above-mentioned dialectics, it is part of the secret contradiction in the expressive shriek, that artists seek those rules as a "new aesthetics" (rules that they actually feel are an unbearable restriction and obstruction of the immediate creative process). The European North, deeply entangled in the mysterious and tension-ridden creative process, nevertheless sees an ideal in the harmony of formal perfection. This explains why German artists gazed southward, toward Italy, for centuries, gradually shifting their eyes toward France, also a Latin country, in the late nineteenth century.

Art history reveals a great number of artists who tried to overcome this internal dichotomy by adopting preformed principles of order. One immediately thinks of Albrecht Dürer, one of the greatest German painters of the sixteenth century. His oeuvre clearly manifested this conflict between the two poles. But his journal also demonstrated that, at the end of his life, he no longer tried to grasp that absolute law which he called beauty. He thus typifies many other German artists past and present.

However, the fundamental difference in points of view and points of departure prevented any success of such efforts. Neither the great German masters of the Middle Ages nor those who followed them were basically interested in transmuting what they saw into pure, abstract form; but this was a matter of course for artists in Latin countries. The "Nordic" or "Germanic" artist—whichever we wish to call him in contrast to Mediterranean culture—did not see the visible as the material for intellectual activity pouring into the organizational principle of the painting. He did not believe in a perfection that can be realized in this world even though he did uphold the notion as a secret ideal. Instead, he opposed the principle of the ratio with a principle that struck him as more important: artistic creation as reflecting the tensions of human existence, reality as an imaginative counterimage. The world, as a reflection of the ego, becomes transcendent. The direct relationship to visible Being is replaced by the vision, in which the sense of self is exalted. It is obvious

that such expressive behavior emerged more vehemently in times of spiritual agitation than in calmer periods.

Dürer's woodcuts of *The Apocalypse* series (1498) and Mathias Grünewald's *Crucifixion* from the Isenheim altarpiece (completed in 1515) are telling examples of such conflict situations, in which the artist, suffering through the enormous tensions between the self and the world, finds the solution in shattering visions rather than in rigorous analytics. If we compare such works with contemporary ones of the Italian Renaissance, we will again confirm that German art understands form primarily as the bearer of expression.

In the North, the pictorial imagination freely ignores the traditional rules of perspective, proportion, or anatomy in favor of "internal necessity." The still-current misunderstandings between the two cultural areas are due to this very difference in attitude about the essence of a work of art. The Nordic work, with its seeming lack of form or restraint, must have appeared arbitrary to the Latin observer, who was frightened by its terrifying intensity, which was not subject to any traditional aesthetic rule.

Relations between "Gothic" elements of German art (as the emotional function of line, color, and form were frequently termed, though incorrectly) and post-1900 German Expressionism are obvious; art historians saw these relations early on. For their part, the painters of the revolutionary generation that was born in 1880 repeatedly pointed to the influence of such sources. For instance, the chronicles of the *Brücke* (Bridge) artists describe their preoccupation with Dürer's woodcuts in Nürnberg, a further impulse for the significant role of the woodcut in Expressionism. Numerous statements inform us of the young artists' aversion to anything classical and of their passionate interest in the "archaic" and the "primitive," that is, the unsophisticated. Similarly, the visions of Franz Marc of Munich, this "yearning for an indivisible Being," the faith in the cosmic integration of all living things—all this is part of the universal feeling of German Romanticism at the start of the nineteenth century.

However, one should not view such relationships too narrowly or define them as directly derived. Fundamentally germane, probably even "in the blood," as Werner Haftmann puts it, the common heritage nonetheless expresses itself in a different way during the twentieth century. To understand the initial circumstances of the Expressionist revolution after 1900, one would need a brief look at the end of the nineteenth century, from which the revolution developed.

If we regard the turn of the century from the viewpoint of official, academic art, little was felt of the imminent shocks which would come in the new century. True, there were still fresh memories of the scandal ignited by the Norwegian Edvard Munch at his Berlin show in 1892, a show which had to be closed upon public demand. The Berlin Secession, spawned by the protest against this action and led by the famous Max Liebermann, advocated the artist's freedom more than it admired the Norwegian's terrifying and cryptic paintings, which remained alien to it. Vincent van Gogh had been dead since 1890. The first exhibitions of his work, whose dimensions were spiritual, both shocked and impressed viewers. The European art scene had to pay as much heed to him as to the Belgian James Ensor, whose tormenting pictorial world of masks and phantoms already displayed the alienation between man and the world, the skepticism about the credibility of the visible—problems that the new century had to deal with.

In all three instances, it was not the crisis of a mentally disturbed artist, as contemporary critics tried to make their readers believe. It was really the beginning of the "direction pointing inward," to the world of human expression as a counterworld to visible reality, such as French Impressionism had so brilliantly depicted. Of course, society and the belief in tradition were still powerful enough to negate the critical situation and maintain a notion of reality that no longer coincided with the facts. But doubts multiplied. Any pretext would do to expose the crisis.

The simultaneity of numerous directions between historical painting and Nature Lyricism, between Jugendstil and plein-air painting, was as little help in clarifying the situation as was the emphatic predication of German art toward the landscape. Rapid industrialization and the new stratum of prosperous burghers connected with it promoted an art that profited from the economic boom, an art symbolizing education and flaunting the bourgeois life-style. The artist with academic training had grown dependent on social integration. He thus appeared as the representative of a social class whose notions did not always coincide with his, but which he had to respect in order to gain recognition. Last but not least, this made academism a symbol of devaluated artistic accomplishment in the eyes of the younger generation. At that time, only individuals, eccentrics, and renegades (in the eyes of the public) could stand out against the uniform background because of their deviating opinions and achievements. They generated that creative disquiet, without which the German academies would have become completely stultified by the end of the nineteenth century. None of these artists succeeded in making a decisive breakthrough. However, their ideas were so explosive that in a rigid artistic climate, they must be seen as revolutionaries.

Some of them were devotees of so-called Nature Lyricism. Away from the large art centers, in the solitude of heaths and moors—in Dachau in the South or Worpswede in the North—these legitimate descendants of German Romanticism developed their feelings "in an admiring contemplation of nature." At an early point, they manifested a powerful expressive yearning, which stylized nature as the bearer of metaphors for an overwhelming emotional experience. Glowing sunsets, white birches before an overcast sky, lonesome huts against the darkness of the moor were metaphors able to express a whole range of feelings. None of this required any new view of things. The paintings of these little landscape schools remained conventional. It took only a slight exaggerating of color, a minor simplifying of form, a marginal reordering of objects for a picture to evoke man's spiritual response to natural experience without the hitherto normal detour through allegory and mythology. As a result, something important was done for later Expressionism: the landscape artists had tested the linguistic power of pictorial devices, touched the expressiveness of color, and translated objects into emotions. Nature could turn from a mystery into a terror, the symbol of enigmatic fear and painful melancholy. The presence of Edvard Munch is felt in the background, bearing a germane sense of life, which appeared highly legitimate at this time. Later on, we will see how the young Expressionists reacted to such impulses. Remember that Emil Nolde spent some time in Dachau in 1899.

A powerful resonance came from plein-air painting. It is wrong to call it "German Impressionism," as is normally done. The differences in regard to France are too crass, the goals too distinct. If the French were realists, then the Germans were idealists. The French painter stringently divorced nature and art because he was

aiming at a parallel reality heightened by art. The Germans, however, were not content with fascinating the eye; they wanted to grasp the essence of things—here, too, the old myth of nature. This stamped the character of the colors. The Germans set greater store by their emotional values than by their coloristic values; hence, they used them not as light but as energy by means of a dynamic brush script emphasizing matter. No wonder Lovis Corinth, one of the most impetuous and energetic talents of this time, arrived at Expressionism in his late period through an Impressionism enhanced by visionary components.

Finally, another preliminary stage must be mentioned: Jugendstil, which was not just limited to art but had emphatically philosophical characteristics. As a movement of universal ethical renewal, it seized hold of leading minds in many areas. Countless stimuli came from the outside: Munch's expressive themes, the Swiss artist Ferdinand Hodler's monumentally rhythmic gestural style, Aubrey Beardsley's titillating lines with their erotic substance, bold arguments by the Belgian architect Henry van de Velde, plus artistic models from East European and East Asiatic sources. These stimuli prevented any confinement to nature-dependent ornamentation, to commercial art, jewelry, and handicrafts. In Munich, at an early point, artists were already discussing the "power of pure form over the human mind" and the metaphysical effect of color. These were thoughts that could not yet materialize but were laying the groundwork for the coming decades.

"A line," van de Velde taught, "is a force; it borrows its strength from the energy of whatever has drawn it." This bold concept alone—namely, that a line not only designates form but also has an equally abstract and formal function—is one of the most daring insights of the period. The same holds true for color. As early as 1896, Fritz Endell formulated his theory on the emotional effect of colors that are independent of nature. His thesis aimed at "creating utterly pure plane backgrounds in which a lost music of forms and colors floats." The perspective was extraordinary. It was directed at abstract painting, which Vasily Kandinsky created; it stimulated Symbolism and Nature Lyricism and had a lasting impact on early Expressionism.

In this situation of seeming calm on the outside and urgent disquiet on the inside, certain young artists appeared during 1905–6—artists who, just a short time later, were to be called Expressionists. The first two decades of our century mark the period of artistic conflicts. They brought the beginning, the flowering, and the end of Expressionism, which, more than a style in the traditional sense of the word, expanded into a comprehensive movement, indeed an attitude toward life. Initially, we pointed out that since the early period of German art, expressive tendencies have been the artist's response to crises or powerful spiritual tensions. The same holds true for the development after 1900. Like all previous epochs, Expressionism mirrors the artist's position in his milieu, his relationship to nature, and his agitated emotions: love and hate, enthusiasm and skepticism, melancholy and passion, aggressiveness and devotion, his attitude toward God and the world.

German artists were by no means alone in their strivings; their revolutionary aspiration, for all its subjectivity, was certainly part of the general European consciousness at the outset of our century—a consciousness that vastly altered the sense of life and stylistic expression. It operated mainly in France and the Nordic countries; Italy joined in only later on. The point of departure was the same, but the reactions were different. The crux was ultimately a critique of the reality

that had been the standard and the basis of faith for centuries of European art. The first well-founded doubts in the truth of visible reality were already uttered during the nineteenth century. The question arose whether the visible phenomena were not less important than the relationship that could be established between man and the world. With the start of the twentieth century, the question grew louder, the skepticism stronger. The old, seemingly self-evident, agreements crumbled, to be replaced by a tension that assigned a new task to art: "Art does not render the visible, but renders visible" (Paul Klee).

From now on, the artist no longer focused primarily on the content, the motif, the external appearance; rather, he concentrated on what was to be the field of realization. The picture became a tablet for registering intellectual experience. This was the point of departure for artists from van Gogh to the Expressionists. No longer accepting the traditional concepts of nature as systems related to reality, they advocated the opinion that what was really worthy of a picture was the "communication from within," and that a new form and different sensory devices had to be found for this. In any case, such a confrontation with the world on the level of intense human participation, of a heightened sense of self, had to take place. Thus, the younger generation consistently concerned itself with motivational forces, not with what could be copied. The goal was to forge ahead toward spiritual conditions beyond critical consciousness, to unleash instinct as an utterance of a new "naturalness." They saw nature elementally as an escape from the restraints of society, as a negation of traditional values. Following one's instincts uninhibitedly, smashing the prevailing aesthetic norms—these were tempting goals. But to translate all this into form required a complicated process. They believed they could master this process from sources outside artistic tradition: free forms, strong colors, the elemental expressions of art by laymen, or the works of primitive peoples, which promised a measure of energetic primitiveness that had long since grown alien to Europe.

The young painters had trouble finding acceptance for their revolutionary notions, which often formed only in the course of their development. These difficulties were caused not only by the resistance of the public, but also, and largely, by their own intentions and demands. They believed that every feeling, if only it is strong enough, must end directly in art; and this theory led to the false conclusion that the strength of an emotion directly determines the quality of a work. This accounts for the considerable number of works in which the unbridled shriek could not crystallize into form. Painting immersed itself in problems that it posed itself, raising impetuousness to an imperative, the uncontrollable to a measure, the role of the "spiritually agitated artist" (Haftmann) to a standard. The Expressionist could act with impunity as a provocateur or an esoteric. He implored the public to take part in his shriek for salvation while he simultaneously offended the public by scorning it as "the masses." This double role was part of his image as a "wild man"; it was not contradictory and was not inconsistent at the time. The public had grown accustomed to no longer seeing the artist as a guardian of the hallowed temple of art, but rather accepting him as a prophet thrusting open the gates to the future, as a potent force relentlessly creating the free space that the "normal man," restrained by the social order, did not have the courage to claim. The artist did not thereby grow closer to society, even if society gradually accepted his special position. By exemplifying a road to possible freedom and spiritual independence,

he actually widened the old gap. For the independence he propagated could only be the freedom of the individual, not the freedom of society. André Malraux had something similar in mind when he wrote: "Since Romanticism, writers, painters, and musicians have worked out a common world, in which all things relate to one another but not to the world of the others."

The role of art as a conservative, educational element was played out in Expressionism; its new function as a permanent revolutionary force quickly became the primary characteristic in, and later even the demand of, a society forming anew after each war. A logical result was that the old standards of evaluation had to shift. The new primitivism deliberately forced by the Expressionists was part of their battle against traditional authoritarian values that were tailored to certain educated strata. The flourishing of the woodcut at that time was an eloquent sign of this trend: since time immemorial the woodcut has been the most democratic means of expression for German artists.

Not everything expressive in Germany between 1905 and 1920 can be called Expressionism. The scale of subjective expression was so immense that its limits are vague: the accents changed with the impulses that provoked them. Thus Expressionism developed true artistic importance only in the works of a few leading artists, but its face remained Janus-like: genuine drama appeared next to reverberating bombast; profound agitation next to theatrical gestures; justified deformation next to a shattering of form. The grandiloquent expressive desire attributable to a North German painter like Emil Nolde confronted the symbolistic, romantic, and cosmic feelings of Franz Marc in Munich. The unrefined visions of the Berlin *Pathetiker* (bombastics) confronted the brilliant formulations of the Russian Vasily Kandinsky, who had chosen to settle in Germany.

The old landscape ties of German art survived in Expressionism. One of the most primal roots was in Germany's North. Here individual, independent artists worked—for instance, the sons of peasants like Nolde and Rohlfs, and Paula Modersohn-Becker. Their art comes from an unsophisticated instinct. It lives from a closeness to the native countryside, elaborating an expressive sense of nature and speaking a language filled with images. It contains visionary apparitions and the awareness of an intimate connection between man and nature. The literary is as alien here as the classical. Art is directly linked to life; it opens the door to the forces operating beyond external appearance.

A second root was in Central Germany. Here the revolution took place as a conscious process and, despite its passion, was ultimately determined by the intellect. The *Brücke* artists, who were at home here, looked to Nordic (Ibsen, Strindberg) and East European (Dostoyevsky) literature as sources of stimuli. They consulted the art of van Gogh and Munch as well as the works of primitive peoples in Africa and Asia. Like the North Germans, they were enthusiastic graphic artists; more than painting, graphics was their true forte.

However, the development in Southern Germany was different. Here, we find the counterparts to the Northern and Central German methods of expression: the imagination as the source of new subjective notions, sense-signs, and feelings; the poetry of nature; a pantheistic view of the world; and a mystical inwardness with a powerful East European strain (the Russian influence of Kandinsky and Jawlensky). All these are expressive elements. It does not seem proper to call them "Expressionistic" in the Northern sense. Only in the South could one find

that notion of the "spiritual in art" which was the basis for the rejection of the objective world—a rejection occurring in 1910 with Kandinsky's first abstract watercolor. Like the Russian influence, the French influence—Delaunay and the Fauves—was also powerful in Munich. It affected the climate, giving it a cosmopolitan air and opening it up to foreign impulses; these impulses are not to be found in the more introverted North German Expressionism, which concentrated entirely on its own problems.

Of course, both trends worked with the concordant awareness that they had to find the point at which the external and the internal coincide—the common root in German Romanticism. But the realization took place in different ways. The North used the elementary premises of formative rather than aesthetic means. It tried to destroy the shroud of visible Being in order to discover the true kernel of Being beyond pseudoreality. The South aspired more subtly to painting as an allegory of that "mystical, inward construction" of the image of the world, which Franz Marc had developed. This also marked the character of the colors. The North used powerful colors that were less rich in tone, because the artists cared less for the optical value of the painting than for its expressive function. The painters of the *Blaue Reiter* (Blue Rider) developed a sensitive palette whose luminosity is based on purity of tone as a correspondence to music, which Kandinsky dealt with extensively.

But both approaches could produce inadequate results: the North had an exaggerated depth of meaning or an unbridled shriek which deprived form and color of pictorial effectiveness; the South had an overemotional aestheticism, sometimes bordering on the saccharine or decorative.

Thus Germany was left with two separate developments. They were relatively brief, but the results turned out to be permanent. There was more than just the breakthrough of a "new generation whether of creative contributors or recipients" (E. L. Kirchner). Expressionism permanently altered the focus on reality. The fact that it could gain international acceptance after 1945 is based on an historical constellation that placed expressive feeling and behavior once again in the center of artistic efforts. However, the reasons for such recognition today are altogether different. They are based on our present-day mood, our nostalgia for a time that managed to gather the strength for revolutions, fully convinced that it could thus stamp the future.

II

Watercolors and Color Drawings in German Expressionism

HORST KELLER

Watercolor occupies a comfortable position between two extremes: on the one hand, the aggressive, colorful resoluteness of the painted canvas and the cuneiform-like rigor of the plain or colored woodcut; and, on the other hand, the wild gesticulation of lithography and the splintering prickliness of drypoint. Watercolor does not have to proclaim the stylistic unity of the Expressionists like comprehensive radiant painting; nor does it have to orient itself according to the emblematic simplicity of a previously unwonted language of graphics. Bold, calm, and with its roots thoroughly in expressivity, drawing and watercolor yield information about the initial artistic inspiration, the artist's *prima idea*. And that is all; they belong chiefly to the studio.

Thus watercolor and drawing can propagate a pictorial idea, but are not subject to this often slavish restraint, as they were in other stylistic epochs. On the contrary, in German Expressionism—and in Edvard Munch's previous work—graphics, especially etchings, repeat themes first fixed in pictorial form, and in so doing invite the surprise effect achieved through an unanticipated reversal of the image. Thus painting first appeared alone and on its own. This was especially true for the early years, that is, after 1905. In Max Beckmann, the pictorial genesis was again reversed. Drawing had its own laws—outside of a set program.

Watercolors on paper—the paper absorbent or nonporous, handmade or thin and with twisted fibers spreading under the weight of the pools of water, unless the filled brush is super-cautious about applying the pigments—often convey, in the grand period of German Expressionism, the purest renderings of the spiritual essence of the epoch. There is sheer delight in creativity, as well as a mutual effort to outdo creative ideas. In this context, one should recall the beguiling lightness and transparency of Vasily Kandinsky's very stately, almost canvas-sized *Horsemen on the Shore*, ca. 1910, which can be seen in this exhibition (cat. no. 262). It was painted during his Munich period. Supple, storming, gazelle-like equine creatures with their color-splotch riders are surrounded by, indeed dissolved in, the play of fabulous wave spots and fantastically shaped crests of breakers—this is free, unbridled delight in painting. Abruptly and swiftly, it follows the inventive mind. No other medium—whether a print or a painting on a deliberately chosen rough canvas—could equal this effect with the same intensity. Drawing is quick, fleeting; painting and graphics offer resistance to the artist.

These watercolors and colored drawings, stored for preservation either in public graphic collections or by private collectors, hence are all the more overpowering for the brief period of their glorious appearance in an exhibition. And it is still, or again, an event to see the juxtaposition of these large, often canvas-sized works on paper by Kirchner and Heckel, Kokoschka and Dix, Marc and Mueller, Schmidt-

Rottluff and Nolde, the latter outoing them all in the area of watercolors.

For an overall view of this exhibition, it would be useful to mention—besides their unifying attributes—certain stylistic peculiarities of the individual artists in their watercolors and drawings, as these suggest themselves by the works presented here. This automatically leads to themes whose interest limits are indicated. Format and technique also play a part. And for the great watercolorists, like Nolde and Kokoschka, a special word is due in this area of their creativity. For they have produced independent work in the most sublime technique since Dürer: the watercolor painting.

Let us proceed to particular examples. In original talent, Ernst Ludwig Kirchner, the "possessed" draftsman, looms head and shoulders above the rest. (Supposedly, he even doodled in a dark movie house.) This is true especially of the years through 1914, that is, both for the suppler, round style of his earliest melodic chalk drawings and for the second phase, the "prickly" style, with sharp angles and deliberate distortions, a style penetrating toward "ugliness" of physical appearance within a context of expressiveness. How can the procedures of artists be summed up?

The lightly oscillating, whisking brushstroke, which leaves its mark on the preliminary drawing as merely the most general hint, moves briskly across the paper, describing the individual forms. Color fills the planes, wherever they appear, as well as the broad contours, producing a great liveliness of hues. Kirchner's method of working is quick and sure. He pays little heed to the viewer's enjoyment. Kokoschka is like him in this respect. As the years go by, Kirchner, in his drawings, produces an interestingly anonymous masklike human type that is peculiar to him. This is especially true of his nudes. Increasingly bizarre, the color drawing rather accurately corresponds to the formal language of the paintings, particularly between 1908 and 1912.

In Erich Heckel—to stress further individual phenomena—the work of the early years follows a similar development, except that the closed color plane is more important to him. High-handedly, Heckel translates what he sees into an intentionally shrill juxtaposition of yellow, green, and red. Of course, the aggression is mellowed by the white paper, which is left unpainted. From the outset, Heckel has a feeling for pictorial narratives, for portrayals of mountain sceneries or seascapes that impressed him. And here the large surfaces of his watercolors ultimately enter a calm harbor. But this comes a long time after the period of "Fränzi," the irritating and erotic child-model, as well as the influence of South Seas art, which was later than the youthful and heated vying of friends for the boldest rendering of a landscape or a studio scene. Of course, the travelogue, whether in drawings or watercolors, occupies all of them—ever since Gauguin's *Noa-Noa*. Distant places beckon, whereas the artists initially saw only South Seas masks in the anthropological museum!

From the beginning, Schmidt-Rottluff and Pechstein resolutely sought wild and unruly expression in brush drawing. Schmidt-Rottluff, under the impact of South Seas art and African sculpture, moves furthest ahead in this respect; he deliberately and resolutely "coarsens" his woodcuts, while Pechstein makes his South Seas experience the center of his drawing reflections. His painting took a different direction, one of harmony, which was soon to separate him from the group.

To indicate further attitudes about the watercolor: Otto Mueller enveloped

himself in a Hungarian gypsy arcadia and saw the world animated only by youthfully slender, peculiarly reflective beauties who wade in swamps or sit on banks. He drew with coarse crayons or broad paths of thin watercolor on huge, sometimes gigantic, sheets of paper. Here, one could most readily say that his figurative compositions were preparatory to pictorial ideas if they did not already embody them. For all the sweet loveliness and timid over-the-shoulder peeks, everything remains chaste and austere. The figures in Mueller's fascinating "forest-nymph ballet" cannot be characterized individually: each has a pageboy and high cheekbones, revealing something like a Mueller iconography of bathers.

Further individual features should be noted. Feininger, in his watercolor pen drawing, with its wan, gray color tone, remains the tireless and inventive poet of the Cubist vision of cathedrals and village churches; like Klee, he subtly titles his motifs calligraphically at the bottom of a picture. In contrast, Otto Dix and George Grosz, and later Max Beckmann, are critical of their society and their era throughout their stately oeuvre of color drawings—an attitude that came naturally to the second generation through the altered situation after World War I. George Grosz, too, continued to find pleasure in drawing during the morass of the postwar years, noting and exposing events with a sensibility sharp as a knife's edge. His works therefore always aroused a specious interest on the part of the public—one directed not so much toward his art as toward his subject matter. This was the consequence of his precise descriptions of a sordid milieu. Pen and lively effervescent watercolors were his media for passing his themes in review, in his anxiously pointed way. The street and the brothel, high livers and philistines, were poetry perhaps—but a backstairs poetry.

In Otto Dix, there is a deeper critique of the world and of injustice, of disguising powder and tinselly trash. Even his portraits, albeit serious in intent, look almost like scarecrows. Nevertheless, this is virtuoso watercolor art, in which mordant matter-of-factness replaces the euphoric studio mood of the older artists.

The young Beckmann achieves a greater expressive power of pure stroke, which was initially based on the painterly drawing style of Lovis Corinth. Often pencil, pen and ink, and black chalk are enough for him to render apparitions with gaping eyes, heads of his time; he uses spare contours and simple hatching, that is to say, terser and terser devices. At times, in a drawing on tinted paper heightened by white, these apparitions are fully developed into plastic forms; images from his early days are validly transmitted to remote times. With their harmony and modeling, these works, like the paintings of this period, are among the most brilliant examples of Beckmann's oeuvre, which continued until the middle of the century. His later work produced an expressive style that was unique.

The watercolors of Emil Nolde and Oskar Kokoschka immeasurably widened the space and scope of this airy, transparent, and floating medium, which is receptive to the most vivid color dreams.

Kokoschka wove pictures of people from the "patchwork quilts" of his infallibly placed color spots and color stripes. Along with the giant mass of early portrait drawings (often done on lithographic transfer paper and conveying a piece of intellectual history in a superior manner), they are unique. Neither contemporaries nor disciples have attained the same density with so much formal arbitrariness. In contrast to his drawings, which in those days could be spare and wiry or calligraphically whirling, Kokoschka transfers the entire effect here to an adjacency

of swiftly drying color areas, without letting this device become mannered. He usually does this on very large sheets of paper, which thus have the dignity of canvases, even though the format initially corresponds only to his work method of dominating wide areas like a fresco painter.

Watercolors occupy a special place in the rich oeuvre of the painter and draftsman Kokoschka: never again did he give such free play to color, which is loosely applied, uninhibited by contours or borders. The tone per se, which does not always have to be harmonious, gives rise to the shape, which, like a bellows, grows together; the brushstroke even recalls oil painting.

And yet, for all this seeming arbitrariness of brush and liquid watercolor, the shape (in contrast to the more formative drawing) becomes a full "personality" in Kokoschka's terms. It is precisely the color that makes this artist's portrayal of an individual suggestive. The color brings an unruly, berserk quality to the physiognomy of the bodily phenomenon, even, inexplicably, imparting to it something of the artist's self-portrait, to the large cavity of the mouth and the long, narrow lane of the face (whether the sitter is male or female). For Kokoschka, at that time, in the quick jotting of the watercolor, the depiction of human beings takes precedence over other themes. This is associated with his intellectual curiosity and his "rapaciousness." Beckmann, on the other hand, approaches the portrait with scanning deliberateness.

For decades now, Emil Nolde's watercolors have marked a highpoint of delight. They are a closed province of expressive poetry or even of the willingness of that expressive art to admit the beauty of color. On his travels, he soaked his fine Japan paper in the enraptured magical world of the Alhambra overlooking Granada. Or he painted dark, threatening heads of South Sea Islanders in a watercolor style, accurately jotting with quick brushstrokes. He even used a white covering, always differently and often with ethnographic fidelity and meticulousness. Or else he gave shape to his North Frisian landscape, visions, fabulous creatures, half-beings through masses of pigment.

But whatever he did, his skill in this area bore witness to a deep talent. None of his watercolors has ever given rise to a difference of opinion about the value of his art. The reality of the world and of things is raised by his imagination to the heights of pure art in watercolors, which he summons or beckons to the most extreme intensifications. This pure art engages the eye for a long time, and over and over again. Yet, in this surge of color, in heaven and on earth, in the bold reflections, double shapes, in the mutually corresponding complementary colors, the internal stability of the composition seems endangered; still, none of his fascinating pictures ever loses the inner structure, the solid form. That is something overlooked by his many driveling, overexuberant, and bungling imitators, who most readily revealed themselves through such formlessness.

Quite deliberately, a considerable, even determining, portion of the watercolors in this exhibition are by Nolde, which is in keeping with their significance. They are an incomparable achievement by an individual within the group. Nonetheless, they do not in any way detract from the decisive contribution made by this Nordic lone wolf as a painter and creator of original graphics. On the contrary, the watercolors are virtually a gift beside the gigantic lifework, which was produced amid sacrifice. Nolde is similar in this respect to Kirchner or to Christian Rohlfs, who grew younger through his expressive creation.

Further characteristics of Expressionistic drawings are to be noted. For instance, the gentle, supple draftsmanship of Franz Marc, who ventured far enough away from the "academic animal painter" to invent his symbolic forms beyond animal anatomy. Or Paula Modersohn-Becker's severe charcoal drawings, with which the artist—who died early—paved the way toward a new monumentality in portraiture. For all these artists, the relationship to drawing is close, intimate, fraternal. But in this area of jotting on paper—a studio practice for many centuries—each of the artists produced something new: the drawing and the watercolor now go out into the world, no longer retained as working material which is always at the artist's disposal.

Peculiarities of Expressionist drawing—often art works produced incidentally—are thus described. The themes touched on included the joy in newly seen landscape and cityscape, the endless "conversation" with the model, to be viewed as an everlasting summer idyll with forest outings and lakes for swimming as well as a studio enchantment by the iron stove.

The unfettered appearance of the human being, the person, is envisaged. They are actually concerned with his being, not his doing. Of course, indolence is never portrayed anecdotally, just as pictorial narratives are never to be found. They are entrusted to graphics. The one-time Dresden dropouts from architecture school and their like-minded colleagues in the North and the South admittedly pay tribute to a cheerful existence even in the discipline of drawing and the colorful execution on paper. From a distance, we can no longer even guess how much calm and humor a sitter or a model maintained when first viewing his likeness.

Penetrating ugliness, wretchedness, or misery were not part of the thematic range during the great years until 1914. They came later, after tremendous shocks.

A few facts have been stated about the format and technique of these works, which were salvaged during a subsequent tumultuous period. Most of them have a stately format, which, however, does not mean that the artist was feinting with drawing fans! The large format allows the drawing hand the freedom to follow the motion "from the arm," which means not so much "neglect" of the art of drawing as spontaneous gestures in the creative process. This is evident not only in retrospect. These large graphics—some in pencil, some in pen and black ink with watercolor, then with a few crayons, and finally pure watercolors—were as extraordinary in their time and as stunningly new as Dürer's drawings had once been. Only the latter were done with a silverpoint; the watercolors were thick and grainy.

This unconventional method of drawing had been prefigured in the work of Lovis Corinth and a few others; this "jubilation of color," as it was called, is confined by angular, squarish, or boldly surging lines. But these stylistic devices are not arbitrary acts of one-upmanship by young rebels; they emerged from a totality of thinking and artistic feeling. They had understood and abandoned van Gogh's manner of painting and drawing as well as that of the color-parceling Pointillists. They had also understood and abandoned theorizing. It was a higher inspiration that allowed the Expressionists, from the very first stroke in their grand era, to capture the world of phenomena in an unfathomed pictorial language.

III

The North Germans: Paula Modersohn-Becker, Christian Rohlfs, Emil Nolde

MARTIN URBAN

Paula Modersohn-Becker, Emil Nolde, and Christian Rohlfs are the loners among the German Expressionists. Each worked in isolation, as if dwelling in a faraway place. Yet, they have much in common: Nolde and Rohlfs were the sons of peasants in Schleswig-Holstein, the northernmost province of the then German Empire; likewise, Paula Modersohn-Becker is inconceivable without the landscape and people of Northern Germany. At times, their paths crossed. In 1905 Rohlfs and Nolde joined the group around Karl-Ernst Osthaus in Hagen, and both spent time in the same Westphalian town of Soest. This was of little significance for their art, however, for direct connections and immediate points of comparison are not to be found. Their paintings are unmistakable (as opposed to some by the *Brücke* or even the French Fauves at certain phases of development). Those aspects of their work which were common to all three became clear only later, after their individual achievements were recognized as part of an overall intellectual movement known as German Expressionism.

Paula Modersohn-Becker (1876–1907)

Born in 1876, she was younger than Rohlfs and Nolde and was thus closer to the generation of the *Brücke* painters, who were born around 1880. As an artist, however, she had little in common, even indirectly, with the Expressionism of the *Brücke*. While she did know paintings by Munch and van Gogh (to whom the young Dresdeners were indebted), they had no influence on the development of her art. When she died in 1907, the "real" Expressionists were just beginning their artistic development, which quickly reached its climax; by 1910, with the crumbling of the Berlin Secession, they were already visibly revolutionizing artistic life in Germany. Paula Modersohn-Becker could no longer have participated in this development. When she was discovered outside her close circle (and relatively late at that), she was categorized as a "forerunner" of Expressionism. But this implied restriction does not do justice to the absolute autonomy and artistic status of her work.

A native of Dresden and the daughter of an engineer, Paula Becker grew up in Bremen, in a large, distinguished family. At fifteen she received her first drawing lessons from a Bremen painter. Spending a year with relatives in England, she entered the London School of Art. But her parents wanted her to become a teacher, and until her final examinations at Bremen's pedagogical seminary in 1895, she had to renounce nearly all artistic activity. Next she was allowed to attend the school for women painters in Berlin; but she was more interested in studying the old masters in museums than in academic instruction. In 1897 Paula Becker went to Worpswede, near Bremen, to the artists' colony that Fritz Mackensen had founded at Teufelsmoor. Worpswede became her home. But as much as she ultimately owed to

the landscape, the people, and her painter friends there, she nevertheless outgrew them all. At an early date, she felt hemmed in, living with a group of painters in isolation, and she resisted. Soon she was visiting Norway, Berlin, Vienna, and then, in 1900, Paris for the first time. During the following years, she led a kind of nomadic life, wandering between the moor village of Worpswede and Paris.

At the turn of the century, Worpswede constituted a center, on the periphery of the divergent styles of German painting. Here a group of friendly painters had assembled, seeking to escape the academism and pseudonaturalism of art schools and to find a harmony between their emotional world and the natural environment in the midst of an unspoiled landscape. "My feelings can keep developing only in an admiring contemplation of nature," said Mackensen, the actual founder and leading mind of the group. In 1897 Paula Becker chose him as her mentor. From her letters and diaries, we learn how deeply she loved the Worpswede countryside, the vast sky, the dark moor, the birch trees by shiny ditches of water, the moor cabins, and the people, marked by living in this world. But few of her paintings are pure landscapes, unlike the genuine Worpsweders.

In 1903 Rainer Maria Rilke wrote a book about Worpswede, a poetic monograph on the landscape and its painters ("freighted, the boat waits on the black waters of the canal, and then they move earnestly as though with coffins..."). Paula Modersohn-Becker is not mentioned in this book. Did the sensitive poet refuse to recognize this young woman as a painter (even though he treasured her as a conversationalist, who was friendly with his wife, the sculptress Clara Westhoff, and even though, after her death in 1907, he wrote his famous *Requiem for a Friend* in her memory)? Or did he perhaps realize that her art in no way reflected the Nature Lyricism of the Worpswede painters (including Otto Modersohn, whom she married in 1901), and that her art could not be brought into harmony with the moody, heavily charged painting that he celebrated so aptly?

Paula Modersohn had introduced Rilke to the art of Cézanne. His *Letters on Cézanne*, written in 1907 on the occasion of a memorial exhibition in Paris, were preceded by intense conversations with her. One of her last wishes was to view this exhibition. Four weeks before her death, she wrote to her mother: "I would like to go to Paris for a week. Fifty-six Cézannes are being shown there!"

In 1900, during her initial stay in Paris, she saw paintings by Cézanne for the first time when she and Clara Westhoff visited Vollard. According to the sculptress, Paula Modersohn-Becker saw Cézanne "as a big brother ... an unexpected confirmation of her own artistic quest." This encounter opened her eyes to the large, simple form. Returning home, she criticized Mackensen's manner as "not large enough, too genre-like." Her earliest drawings differed from those of her teacher (the only Worpsweder to do predominantly figurative paintings): they were harder in characterization, terser in gestures, and devoid of the anecdotal. "I feel a burning desire to become grand in simplicity," she noted in her journal (April 1903). Her art grew more and more away from that of the Worpsweders.

In 1906 she separated from Otto Modersohn, returning from Paris only after one year. Cézanne, as she herself put it, struck her "like a thunderstorm and a huge event" (October 21, 1907, to Clara Rilke). Furthermore, the encounter with paintings by Gauguin and the *Nabis*, as well as the Egyptian and Early Classical art in the Louvre, gave her the strength and the freedom to find herself in that she came to understand a painting as a consciously fashioned, autonomous formal structure. "I

believe that one should not think so much about nature when painting, at least not during the conception of the picture. Make the color sketch exactly as one has felt something in nature. But my personal feeling is the main thing. Once I have established it, lucid in form and color, I must bring in from nature the things that make my painting seem natural, so that a layman will only think that I have painted it from nature" (Diaries, October 1, 1902). By permeating one's own emotion with a strength of feeling, one can reject chance in external appearance, renounce anecdotal paraphernalia, recognize internal reality, and depict the human in things in their simplest, purest form.

Her own warm humanity is an unmistakable part of her paintings. The people in Worpswede, the peasant women and children, the wonderful rigorously dark portraits of Werner Sombart, Frau Hoetger, and Rainer Maria Rilke, and many still lifes—fruit, flowers, everyday objects, kitchen utensils, and toys—are brightly arranged and strongly outlined. They are either spread across the surface or densely crowded, with a deliberate rejection of perspective. All are economically arranged in strict order within the pictorial space. Objects in her paintings gain a monumentality that is never artificial, but bursting with nature. The dense, powerful, usually warm, sometimes almost dark, full colors have a sensual coexistence which sharply distinguishes her paintings from Cézanne's. As early as 1900 she had written from Paris that she would like "to have all colors deeper, more intense; [I] get quite angry at this lightness" (February 29, 1900, to Otto Modersohn).

Moor peasants, poorhouse inmates (see cat. no. 1), naked children, and mothers are not objects of pity for Paula Modersohn—lament and social criticism were alien to her. People, like things, have something familiar about them and yet maintain the earnestness and dignity of detachment. This also obtains for the countless self-portraits which she painted from the very outset and through the last few weeks before her death. Many are extremely daring, very self-assured and superior, for example, the late nudes or semi-nudes (*Self-Portrait on the Sixth Wedding Anniversary*, 1906). Others are totally concentrated on the head and the face. There is something icon-like about them; they are actually influenced by Late Classical mummy portraits. The bold simplicity of form turns the personal closeness and autonomy of the portrait into allegorical universality.

Paula Modersohn left an unmistakable oeuvre behind, which is all of a piece. Despite her early death, her work may be regarded as truly complete.

Christian Rohlfs (1849–1938)

Christian Rohlfs was born in 1849, twenty-seven years before Paula Modersohn; he was close to ninety when he died. His creative period embraces about seven decades during which he was confronted with opposing artistic events which helped to mark his work in a very peculiar way. The "early" Rohlfs was an important nineteenth-century painter, one of the leaders of German plein-air art. With the new century (biographically, the caesura coincides with his final departure from Weimar), we are surprised to find a man close to sixty with the Expressionists: while they were thirty years his junior, he remained their companion for three decades. In their enthusiasm for the "Expressionist" Rohlfs, people have almost forgotten the plein-air painter. This is unfair since there is more of a connection between the two than meets the eye of a casual observer.

Rohlfs was born in a peasant cottage in the village of Niendorf bei Leezen, Holstein. He was meant to take over his father's farm, but quite by chance he came to painting. After an accident which ultimately caused the amputation of one leg, the fifteen-year-old, during a long stay in the hospital, began to draw at a doctor's suggestion. The writer Theodor Storm, who happened to see the drawings, recognized his talent. He assisted the boy and saw to it that he studied with the painter Pietsch in Berlin, later entering the Weimar Kunstakademie in 1870.

This school, established by the grand duke, mainly cultivated the classicistic tradition handed down from the age of Goethe. Figurative art with educational and historical themes was what the academic painter-to-be had to master. Rohlfs's studies, interrupted by illness, lasted until about 1880.

In 1881 Rohlfs was given a "free studio" at the academy as a special award. His personal work commenced in the following years. The breakthrough to his own artistry did not occur through figurative painting. His academic training seemed to have been forgotten; in the two decades before the turn of the century, Rohlfs focused almost exclusively on landscape painting. He found his motifs in the immediate surroundings of Weimar or in Weimar itself: *Lime Quarry*, *Wild Ditch*, and *Castle Bridge in Weimar*. Certain subjects were painted again and again, thus recalling the French Impressionists, particularly Monet with his *Haystacks* or his twenty versions of the Cathedral of Rouen.

There is no doubt that French Impressionism influenced Rohlfs's painting. In Weimar, he saw canvases by Monet in 1890 and by Sisley and Pissarro in 1891. He must have studied them carefully, for his palette became brighter, and the inclusion of colored light first revealed his great coloristic talent. But the influence was limited. Rohlfs ignored the true principle of Impressionism: the permeation of light and color to the point of totally blurring contours and dissolving objective forms. He no more adopted this principle than did the other so-called German Impressionists, among whom he maintained a leading position. He was a painter who employed light and color to give things in nature an eminent luminosity, who sometimes applied pigments very loosely, almost dabbing them on, who had a vital temperament which made the critics call his work "bungling," that is, impudent or improper. Yet his goal was not to render atmospheric light; objects keep their weight in his canvases, determining the formal shape of the painting. (Thus, Rohlfs is closer to the realism of Courbet than to genuine Impressionism.) His style is quite unpretentious and as far removed from representation or idealism as from the intensely emotional Nature Lyricism cultivated at that time in Dachau and Worpswede.

Soon after the turn of the century, Rohlfs, with seeming abruptness, gave up everything he had attained. The impetus came from meeting Karl-Ernst Osthaus, the founder of the Folkwang Museum in Hagen, and from Henry van de Velde, the architect of the museum and an adviser to Osthaus. In 1901 Rohlfs followed the call to Hagen; however, he retained his studio in Weimar until 1904 and actively participated in new developments which had now reached the Weimar art school. In the Osthaus collection, Rohlfs saw paintings by Seurat, Signac, and Rysselberghe; their luminosity, their purity of color, must have fascinated him; he adopted the pointillist dogma, the splintering of color and the dissolving of the picture plane into a system of dots. Shortly thereafter his dialogue with Munch and van Gogh began.

The now fifty-five-year-old artist went through a stormy development. Freedom in dealing with the medium, the direct expressivity of color and form, the question

of the autonomy of the painting—those were problems he had to cope with. Rohlfs faced this challenge, in contrast to the other established German plein-air painters (for instance, Liebermann and Corinth, who maintained their positions or even fought against the new art), whereby the once revolutionary Secessionists became reactionaries in the eyes of the young artists. At the 1910 Sonderbund exhibition in Düsseldorf, Rohlfs, now sixty-one, was associated with the circle of young painters, along with Kirchner, Nauen, Nolde, Pechstein, Kandinsky, and Schmidt-Rottluff as one of them.

Birch Forest of 1907 (cat. no. 8) is one of the first paintings in which he fully succeeded in synthesizing his newly gained insights. The raw, powerful, pastose colors, applied in dabs, bands, or stripes, are woven into a dense network which transforms the surface into a field of rhythmic movement. The structure of the painting is devoid of emotional gestures; it is matter-of-fact and yet filled with warmth and serenity. Forests were one of the favorite motifs in Rohlf's early years; thus, the fact that he successfully assimilated this subject into his new style of painting is all the more remarkable. Subsequently, landscape became less and less important for him; it was replaced by the figurative composition and the architectural picture.

A frequent theme is the towers of Soest (see cat. no. 11). After the initial visit in 1904, Rohlfs returned frequently to the medieval town. He met Nolde there in 1906, and Nolde writes about the encounter: "Most likely, no two painters have ever spoken so little about problems of art." He "stood helpless before the big churches. ... I couldn't find my bearings." For Rohlfs, however, Soest, with the mighty towers of its churches over the red brick roofs of its homes, became the symbol of the "old town." After a series of watercolors, which assumed a major role in his oeuvre after about 1905, he began doing countless oil paintings after 1906. These firm compositions captured the image of a markedly medieval town.

At first the pictures were relatively faithful, at time almost jejune, but soon the details became more and more abbreviated. The beloved town, the "splendid nest," became so familiar to the artist that he was still painting it from memory years later. The towers grew closer together: in the center, the heavy and mighty St. Patroclus, the town's insignia, flanked by the towers of Sts. Pauli and Petri; in back, the spires of the Gothic Wiesenkirche. The composition grew denser, more compact and intricate; the picture seemed invincibly solid. The colors, at first applied with an intensity reminiscent of Impressionism, were soon spread out flatly; often brown, earthy tones predominate. In later paintings, the colors are heightened to a great luminosity. In abstractly geometric, crystalline form-fields, they achieve a diaphanous effect, as though illuminated from behind. The objects can be so greatly subordinated to the formal canon of the picture as to lose their individuality entirely and achieve a metaphorical character. Soest becomes the "old town" per se.

Ultimately, the subject is interesting only because of its colorful, structural quality. The autonomy of the pictorial architecture can verge on abstractness. In pictures like *Red Roof* or *Red Roofs Among Trees* the relationship to the real, objective world is just barely maintained. In contrast, *Blue Mountain* of 1912 consists primarily of blue color forms and broad strokes applied with a palette knife and towering to mountain-like formations. A variation on the theme of blue, it could also —less objectively—be a blue tower, blue city, or blue forest.

After abandoning landscapes, the artist focused on figurative compositions. At first, he did a series of nudes, which seem more like studies; then came paintings

with symbolic content, themes from the world of fantasy, visionary inventions, and Biblical motifs. The shock caused by World War I was reflected in themes that were previously alien to his work: *Driven Man, Gethsemane, War*. The dark side of existence, the chasms of destruction and violence, had never been the substance of his art; they belonged to an opposing world which deeply contradicted his inmost being. Thus, in this time of affliction, conciliatory and humane themes predominate: *Prodigal Son with Harlots, Return of the Prodigal Son* (cat. no. 9), *The Spirit of God over the Waters* (cat. no. 19), and *Angel Bearing the Light into the Graves*.

Large, simplified forms are the actual bearers of expression; gestures of figures become gestures of form: they rule the pictorial area with the size and simplicity of woodcuts. The form is emphatically that of drawing: linear structure in black contours. Color recedes in these paintings. It is limited to the rich and nuanced tones of planes; the sensual effect is gone. The participation of color in the impact of the painting is based on its immaterial, spiritual value.

Alongside the earnest, religious depictions, there are paintings which are simpler and more cheerful in content; these compositions are vivacious, dynamic, full of movement: the confusing headstands of *Acrobats* (cat. no. 12), the agitation and turbulence of *Street Scene*, the floating rhythm of *Dancing Couple*, or burlesque scenes like *Clown Conversation* or *The Uncle*. Colors, as essential bearers of expression and structural energy, grow more important, becoming brilliant and precious.

Christian Rohlfs's art is focused on life—perhaps one can view it as a legacy of his Weimar period. His art is voluptuous and cheerful; disharmonies and dramatics are remote. One may call him the lyrical poet among the Expressionists. No one—except perhaps Feininger—transformed color into such floating light. During his last few years, he was drawn to the South; he sojourned in the friendly town of Ascona as often as he could. Ultimately, he was not spared the humiliations and scorn of his art by the Nazis. Rohlfs died in 1938, at the age of eighty-eight.

Emil Nolde (1867–1956)

Nolde is the prototype of the North German Expressionist; more independent than the others, he lived apart, in self-imposed solitude. Even at eighty, he noted: "How glad I am to be almost alone as an artist among artists, with the whole swarm of artists somewhere else" (March 13, 1947).

Nevertheless, his course as a painter was not isolated; it ran parallel to and often in close connection with others. He took part in the first joint shows of the *Brücke* during 1906–7, sharing their rejections and their first successes. His public fight with Max Liebermann in 1910 led to the breakup of the Berlin Secession, the most powerful of all associations of German artists. This meant that younger artists could now find acceptance in the face of "well-established older forces," as the *Brücke* painters had formulated it in their manifesto. Nolde had become the spokesman of the young generation—he was almost frightened at realizing it—and he withdrew. He left the *Brücke* in 1907—just a year after it had made him a member as a tribute to his "color tempests." He wanted to be alone, far from the hustle and bustle of artist groups.

Emil Nolde's real name was Hansen. He was born in 1867, the son of a peasant who lived in the village of Nolde on the German-Danish border. Mustering all his strength against much resistance, he managed to free himself from his rustic milieu.

An apprenticeship as a furniture carver in Flensburg was followed by four years of factory work in Munich and Berlin. Then, from 1892 to 1897, he taught drawing at the Gewerbeschule (Arts and Crafts School) in St. Gallen, Switzerland. Only at thirty did he attend a private painting school in Munich; then he settled in Dachau to study with Hölzel, who advocated a tone painting à la German Nature Lyricism. However, he benefited little from schools and academies; he felt "like a pagan" with his teachers. He took only what was akin to his own sensibilities, whether it came from ancient or contemporary art, Egypt, Assyria, the masks of the South Seas and Africa, Titian, Rembrandt, Goya, and later Munch and Gauguin. In 1899 he went to Paris for nine months, studying at the Académie Julian. The Impressionists made little impact on him, except for two: Degas and Manet—"the great, important painter of bright beauty." In the summer of 1900, returning to his Jutland homeland, he brought back "only a couple of nudes, schoolwork" and a copy of a Titian painting in the Louvre. His was a sure instinct in picking Titian, the father of modern colorists, who had already been honored by Rubens and Delacroix, and would eventually inspire Cézanne and van Gogh.

During the next few years, he virtually commuted between Copenhagen and Berlin; in the fishing village of Lildstand on Jutland's northern coast, he produced strange pencil drawings, freely invented fantasies. He wrote about them in 1902 to his friend, Hans Fehr: They "hover before me now in drifting colors, more beautiful than I can possibly paint them . . . , I yearn for the day when I will have found my color harmonies, my harmonies."

A first fulfillment came with the paintings of flowers and gardens during 1906–7. He discovered the evocative power of color. It became the chief medium of his art. Nolde had an unusual, almost physical, relationship to flowers: "I felt as if they loved my hands." Elsewhere he noted: "Yellow can paint happiness and also pain . . . Every color harbors its soul within, delighting or repelling and inspiring me." He kept thinking about color: "The materials, the colors, were like friendship and love, both wanting to fulfill themselves in the most beautiful form." He wanted color, in its intellectual and physical force, to carry the substance of the painting and to summon it forth. "Colors are my notes for fashioning sounds and chords with and against one another." Such musical metaphors recur throughout the painter's notes.

Everything could become a picture now—dreams and fears, doubts and happiness. He painted in carefree subjectivity, with no external commitment. And that is how we must understand his religious paintings, which are almost unparalleled in modern art; they have to be viewed as personal interpretations, expressing his much-tempted faith, deep emotion, and skepticism. "If I were tied to the letter of the Scriptures and rigid dogma, I believe I could not have painted these profoundly felt paintings about the Eucharist and the Pentecost. I had to be artistically free—not have God before me, like a steely Assyrian ruler, but God in me, hot and holy like Christ's love." *Eucharist, Pentecost,* and *Mockery* were done in 1909; *Christ Among the Children* and *Dance Around the Golden Calf* (cat. nos. 28, 27) six months later; the large nine-part *Life of Christ* (cat. no. 30a–i) during 1911-12; and in the war year of 1915, *Burial of Christ, Tribute Money,* and *Simeon Meets the Virgin in the Temple.* As a counterpoise, virtually as an escape from intellectual exertion and profound emotion, Nolde painted, almost concurrently, children playing or dancing, *Landscape with Young Horses,* or pictures of Dionysian eroticism: *Candle Dancers, Warrior and Woman, Prince and Sweetheart* (cat. no. 35).

Nolde had a taste for antithetical conceptions in his paintings as in his thoughts and actions. This could lead to startling contradictions. Thus throughout his life he condemned technology for destroying the natural order. He fulminated against engineers, who, insensitive to its beauty, were already butchering the beloved countryside of his homeland with dikes and water engines. Yet the same Nolde was also fascinated by the dynamic character of the technological world when he discovered it as a painter—for example, in the Hamburg port during 1910. He lived in a cheap rooming house over a sailors' pub and sailed the pinnaces with the dockworkers; he was thrilled by the panorama of the harbor, the noisy bustle, the pulsating rhythm. Within three weeks, he had produced several oil paintings, the famous series of Hamburg etchings, and a set of large India ink brush drawings (see cat. nos. 72, 40). Dynamic and monumentally archaic, they form a highpoint in Nolde's oeuvre.

A further example is the Berlin paintings. In his letters and books, he scorned the metropolis of Berlin as a place of decay and degeneracy: "It stinks of perfume, they have water on their brains and they live as food for bacilli and shamelessly like dogs," he wrote to a friend in 1902; his books speak in a similar vein. How he cursed the whore of Babylon—Berlin—where he spent all his winters! Yet the painter forgot this scorn. He was fascinated by the splendor and sensory stimuli, by the light and shadow of nightly bustle; with open senses, he took in the beauty and bliss, the hubbub and vice, the corruption and humanity of this world. *Gentleman and Lady in a Red Room, A Glass of Wine* (cat. no. 29), *Audience in a Cabaret,* and *From the Ball* are the titles of some paintings that were done in the winter of 1910–11. There were also many watercolors and drawings of the theaters, honkytonks, and street cafés. The Berlin works form a closed unit in Nolde's oeuvre. But they are not isolated, even though he did not paint them in this form again. The insights and experiences manifested here remained a component of his art. They would return in other paintings, all the way to the Unpainted Pictures from the period of ostracism, when he was prohibited from painting.

Asked about the hierarchy of his themes, Nolde put the figurative paintings first, but then he took back his reply, saying that neither the theme nor the motif determined the rank of a painting. To be sure, he went on, the risk in painting free fantasies and Biblical pictures was incomparably greater than, say, flowers and gardens, which he did in times of relaxation. Perhaps, he opined, that was why these paintings had gained so many admirers, at least more than the other paintings; but that tended to make him skeptical.

In 1913, when Nolde was invited to go along on an expedition to the South Seas, he gave up other plans, tempted by an adventure to exotic coasts. The trip lasted one year. He traveled through Moscow, Siberia, Korea, Japan, and China to New Guinea. Here he did numerous drawings, many watercolors, and twenty paintings. He painted *Tropical Sun*, a dramatic picture with powerful colors built on the contrast of the complementary colors red and green and the ornamental rhythm of the white waves of the surf. He was attracted more to the people than to the landscape, however (see cat. no. 47). He sought the pure expression of humanity's early stages, but he saw forlornness and fear and an ineluctable fate: life, bound up with nature in the old social structures and tribal associations, was already doomed by the brutal practices of colonial masters. This realization cast a shadow of melancholy over his South Seas paintings.

After returning home at the start of the war, Nolde moved into an old farmhouse at Utenwarf, on the Western coast. It was not too far from the village of Nolde on the reedy shore of Wiedau, a broad river flowing into the North Sea. Here, and later on in nearby Seebüll, he did most of his subsequent paintings.

Anyone familiar with this landscape will find it again in Nolde's pictures. His colors really exist there—the sharp green of the huge meadows, the yellow of the rape fields, the deep blue of the lakes, rivers, and creeks, and, over the flat land, the light of the vast sky. During the long twilight of morning and evening, especially in the fall, the sky shines with wandering clouds in a wealth of colors, ranging from pale green to dark violet and blue, from yellow, brown, and orange to flowing red; light transforms everything in an unreal ocean of colors. This landscape, to which the nearby sea belongs, was as important for Nolde's art as Provence, near Aix, Tholenet, and Château-Noir were for Cézanne. "When the artist guides nature, she can be a wonderful helper for him," Nolde wrote in his old age (October 9, 1944).

Between Utenwarf and Seebüll, Nolde found the landscape that promised to fulfill a yearning—one of the fundamental experiences of German Expressionism— a yearning for the fusion of the self and the cosmos, the striving for the "primal states" of human life, when the outer world and the inner world were still one. The same yearning had sent Nolde to the South Seas, looking for the "primal stages" of man, the "primal nature." "Primitive men live in nature, they are one with nature and part of the entire universe." Both the painters and the writers of Expressionism loved the German prefix "ur," which means primal, primordial, original. In 1913, the year of the South Seas voyage, Gottfried Benn wrote *Gesänge* (*Chants*), which begins with the cry: "Oh, that we were our primal forbears!" The "images of the great primal dream [*Urtraum*]" (Benn) are our last remaining chance to experience attainable happiness. Perhaps that was what Nolde meant when he jotted on a small note, the kind to which he entrusted his thoughts during the time of ostracism: "Paintings can be so beautiful that they cannot be shown to profane eyes" (June 5, 1942).

After World War I, the area containing Utenwarf and the village of Nolde fell to Denmark, and Nolde became a Danish citizen. When the Danes began preparing new dikes and drainage projects, Nolde moved a few miles south, across the German border. Here, on an old high wharf, he built Haus Seebüll after his own designs. It towers like a citadel, defensive, self-willed, in the flat landscape, visible from afar. In the midst of the farming environment, it asserts itself by being different, a symbol of pride and solitude. Here the painter lived, withdrawn into his own world, accessible to only a small circle of friends.

Later the house became a kind of escape fortress which afforded the painter protection from attacks by the Nazis; Nolde had originally welcomed the "movement," and had become a member of the National Socialist party in 1933. Soon it became clear how much he had deceived himself; his exhibitions were closed, all of his works in German museums (1,052 altogether) were confiscated, sold abroad, or burned. He was not allowed to paint. This situation notwithstanding, Nolde, during those sinister years, created in Seebüll a series of images which constitute a kind of synopsis or culmination of his oeuvre; it consists of hundreds of small watercolors, which he called his Unpainted Pictures. Nolde died in 1956 in Seebüll at the age of eighty-nine. He was buried in a tomb which he had built during the war for himself and his wife at the edge of the flower garden in Seebüll.

Works in the Exhibition

EXPLANATORY NOTES

Measurements:

Dimensions are given in inches followed by centimeters. Height precedes width. Dimensions given for prints reflect image sizes.

† Not illustrated
*New York only
■ Not in the Exhibition

References:

Where applicable, catalogue raisonné or oeuvre catalogue numbers are given. Abbreviations are as follows:

Göpel Erhard Göpel and Barbara Göpel, *Max Beckmann: Katalog der Gemälde*, Bern, 1976, 2 vols.

Gordon Donald E. Gordon, *Ernst Ludwig Kirchner*, Cambridge, Mass., 1965

Hess Hans Hess, *Lyonel Feininger*, New York, 1961

Köcke Ulrike Köcke and Paul Vogt, *Christian Rohlfs: Oeuvre-Katalog der Gemälde*, Recklinghausen, 1978

Lankheit Klaus Lankheit, *Franz Marc*, Cologne, 1976

Vogt Paul Vogt, *Erich Heckel*, Recklinghausen, 1965

Wingler Hans Maria Wingler, *Oskar Kokoschka: The Work of the Painter*, Salzburg, 1958

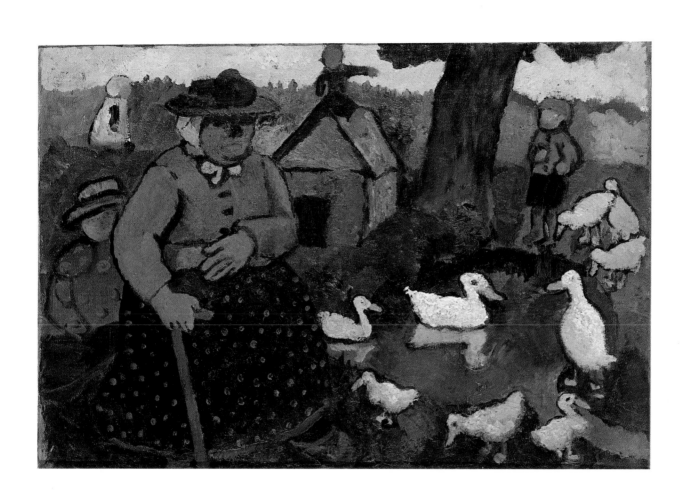

PAULA MODERSOHN-BECKER

1 *Poorhouse Woman at Duck Pond (Armenhäuslerin am
 Ententeich).* 1904
 Oil on canvas, 16½ x 24⅝″ (42 x 62.5 cm.)
 Not signed or dated.
 Ludwig-Roselius-Sammlung, Böttcherstrasse, Bremen

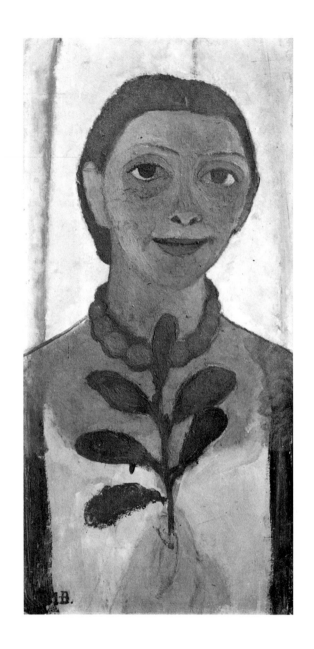

PAULA MODERSOHN-BECKER

2 *Self-Portrait with Camelia Branch (Selbstportrait mit
 Kamelienzweig)*. ca. 1906–7
 Oil on paperboard, 27⁷⁄₁₆ x 11¹³⁄₁₆" (62 x 30 cm.)
 Signed l.l.: *P.M.-B.* Not dated.
 Collection Museum Folkwang, Essen

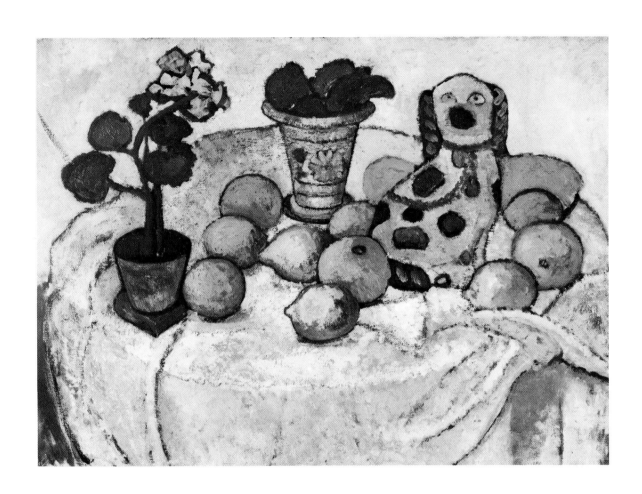

PAULA MODERSOHN-BECKER

3 *Still Life with Oranges and Stone Dog (Stilleben mit*
 Orangen und Steinguthund). ca. 1907
 Oil on canvas, 25⅝ x 35⅝″ (65 x 90.5 cm.)
 Not signed or dated.
 Collection Landesmuseum Oldenburg

PAULA MODERSOHN-BECKER

4 *Still Life with Jug, Candlestick, and Fruit (Stilleben mit Krug, Leuchter, und Früchten)*. n.d.
Oil on canvas, 21¹³⁄₁₆ x 23⅝″ (55.5 x 60 cm.)
Not signed or dated.
Collection Von der Heydt-Museum, Wuppertal

†5 *Female Nude with Crossed Legs and Hat (Weiblicher Akt mit übergeschlangenem Bein und Hut)*. n.d.
Lead pencil, 11⅝ x 6³⁄₁₆″ (29.5 x 15.8 cm.)
Not signed or dated.
Collection Museum Ludwig, Cologne

†6 *Head of a Child (Kinderkopf)*. n.d.
Charcoal, 12¾ x 9⅝″ (32.3 x 24.5 cm.)
Signed l.r.: *P M-B*. Not dated.
Collection Museum Ludwig, Cologne

7 *Head of a Child (Kinderkopf)*. n.d.
Black crayon, 5½ x 5⅞″ (14 x 14.9 cm.)
Not signed or dated.
Collection Museum Ludwig, Cologne

8 *Birch Forest (Birkenwald)*. 1907
Oil on canvas, 43⁵⁄₁₆ x 29⁹⁄₁₆" (110 x 75 cm.)
Signed and dated l.r.: *C Rohlfs 07*.
Köcke, cat. no. 415
Collection Museum Folkwang, Essen

9 *Return of the Prodigal Son (Rückkehr des verlorenen Sohnes).* 1914
Tempera on canvas, 39$\frac{11}{16}$ x 31$\frac{5}{8}$" (100.8 x 80.3 cm.)
Signed and dated l.r.: *CR 14.*
Köcke, cat. no. 548
Collection Museum Folkwang, Essen

10 *Dance Around the Fire Ball (Tanz um den
 Sonnenball).* 1914
 Tempera on canvas, 39⅜ x 49¼″ (100 x 125 cm.)
 Signed l.r.: *CR.* Not dated.
 Köcke, cat. no. 574
 Collection Städtische Museen Recklinghausen

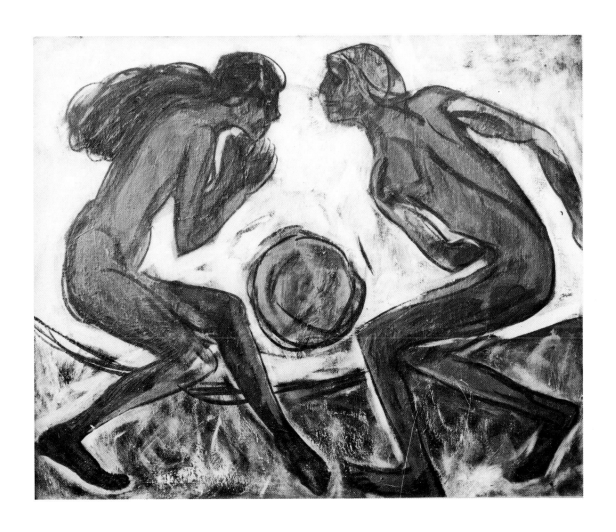

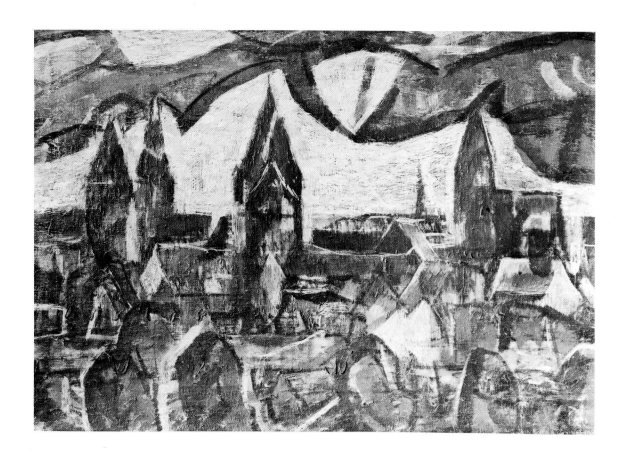

CHRISTIAN ROHLFS

11 *The Towers of Soest (Die Türme von Soest).* ca. 1916
 Tempera and oil on canvas, 29¹⁵⁄₁₆ x 43½″ (76 x 110.5 cm.)
 Signed l.r.: *CR.* Not dated.
 Köcke, cat. no. 567
 Collection Museum Folkwang, Essen

12 *Acrobats (Akrobaten)*. ca. 1916
 Tempera on canvas, 43⁵⁄₁₆ x 29¾″ (110 x 75.5 cm.)
 Signed l.r.: *CR*. Not dated.
 Köcke, cat. no. 577
 Collection Museum Folkwang, Essen

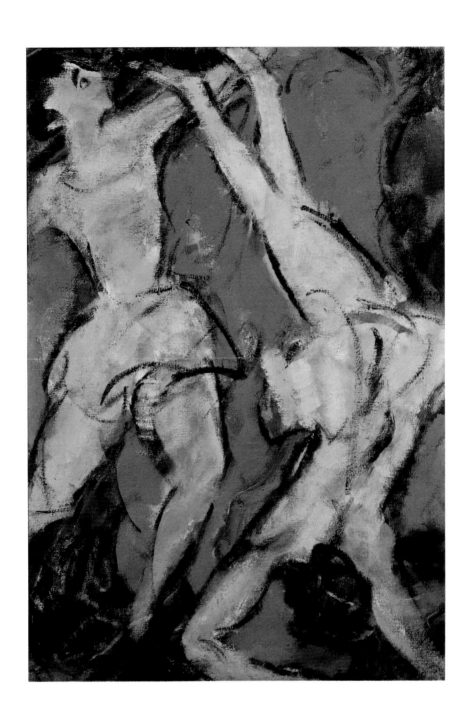

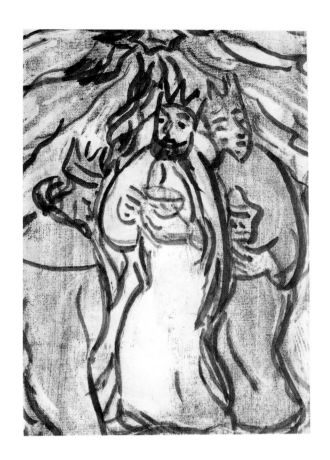

CHRISTIAN ROHLFS

13 *The Three Magi (Die Heiligen Drei Könige)*. ca. 1910
 Brush, 12¹³⁄₁₆ x 9⅛" (32.6 x 23.2 cm.)
 Signed l.r.: *Chr. Rohlfs*. Not dated.
 Collection Museum Ludwig, Cologne

14 *Philodendron Against Red Background (Philodendron vor rotem Grund)*. 1920
Watercolor and gouache, 26⅞ x 19¾″ (68.3 x 50.2 cm.)
Signed and dated l.r.: *CR 20*.
Collection Museum Ludwig, Cologne

CHRISTIAN ROHLFS

15 *The Smoker (Der Raucher)*. 1912
 Woodcut, 9⅜ x 7½″ (23.8 x 19.1 cm.)
 Collection Museum Folkwang, Essen

†16 *Songbird (Singvogel)*. 1912
 Color woodcut, 10⅞ x 11⅝″ (27.6 x 29.5 cm.)
 Collection Museum Folkwang, Essen

17 *Cerberus*. 1912
 Color woodcut, 9⁵⁄₁₆ x 9⅜″ (23.6 x 23.8 cm.)
 Collection Museum Folkwang, Essen

†18 *The Fallen Man (Der Gestürzte)*. 1913
 Color woodcut, 8⁹⁄₁₆ x 21¹¹⁄₁₆″ (21.7 x 55 cm.)
 Collection Museum Folkwang, Essen

CHRISTIAN ROHLFS

19 *The Spirit of God over the Waters (Geist Gottes über den Wassern)*. 1915
Woodcut, 21¹³⁄₁₆ x 18¼" (55.4 x 46.3 cm.)
Collection Museum Folkwang, Essen

†20 *Return of the Prodigal Son (Rückkehr des verlorenen Sohnes)*. 1916
Color woodcut, 18¹⁵⁄₁₆ x 13¾" (48 x 35 cm.)
Collection Museum Folkwang, Essen

†21 *Sermon on the Mount (Bergpredigt)*. 1916
Woodcut, 17⁵⁄₁₆ x 16½" (44 x 42 cm.)
Collection Museum Folkwang, Essen

22 *Expulsion from Paradise (Vertreibung aus dem Paradies)*. 1917
Color woodcut, 21 x 27¹⁄₁₆" (53.4 x 68.8 cm.)
Collection Museum Folkwang, Essen

CHRISTIAN ROHLFS

†23 *Prisoner (Der Gefangene)*. 1918
 Color woodcut, 25⁷⁄₁₆ x 20¼″ (64.6 x 51.4 cm.)
 Collection Museum Folkwang, Essen

 24 *Deluge (Sintflut)*. 1918
 Color woodcut, 26⅝ x 20⅛″ (67.6 x 51.2 cm.)
 Collection Museum Folkwang, Essen

†25 *Death as Juggler (Tod als Jongleur)*. 1918–19
 Woodcut, 14⅜ x 19¹¹⁄₁₆″ (36.5 x 50 cm.)
 Collection Museum Folkwang, Essen

 26 *Vae Victis*. 1922
 Woodcut, 14⅜ x 19¹¹⁄₁₆″ (36.5 x 50 cm.)
 Collection Museum Folkwang, Essen

27 *Dance Around the Golden Calf (Tanz um das Goldene Kalb).* 1910
Oil on canvas, 24⅝ x 41⁹⁄₁₆″ (88 x 105.5 cm.)
Signed l.r.: *Emil Nolde.* Not dated.
Collection Staatsgalerie moderner Kunst, Munich

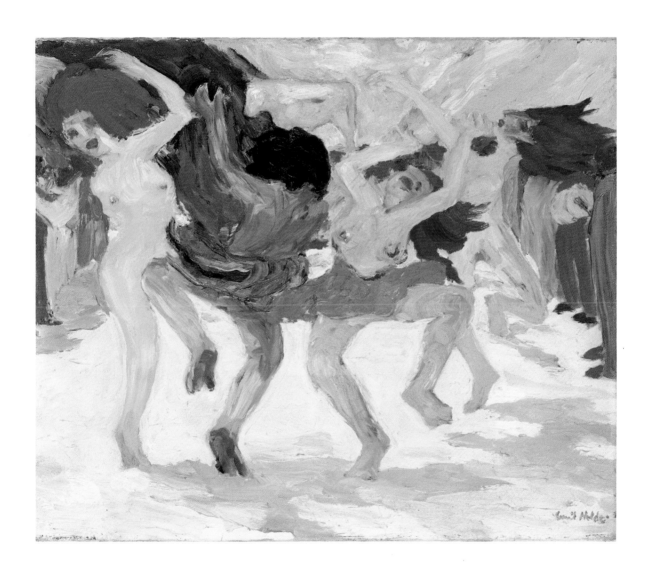

*28 *Christ Among the Children (Christus und die Kinder).* 1910
Oil on canvas, 34⅛ x 41⅞″ (86.7 x 106.4 cm.)
Signed l.l.: *Emil Nolde.* Not dated.
Collection The Museum of Modern Art, New York, Gift of
Dr. W. R. Valentiner, 1955

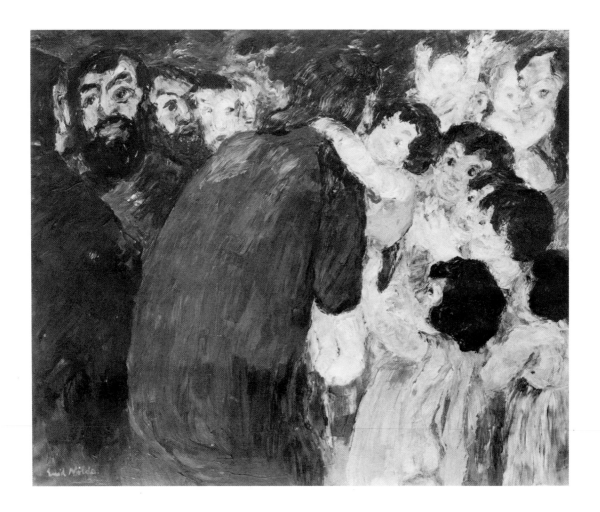

29 *A Glass of Wine (Am Weintisch)*. 1911
Oil on canvas, $34^{11}/_{16}$ x $28^{13}/_{16}$" (88 x 73.2 cm.)
Signed l.r.: *Nolde*. Not dated.
Nolde-Stiftung Seebüll

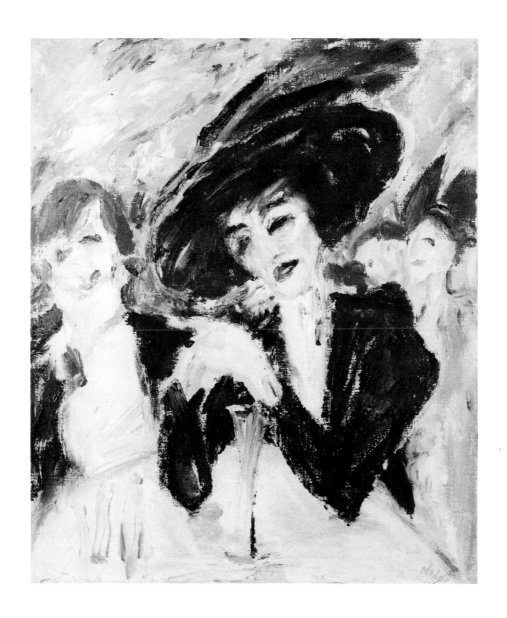

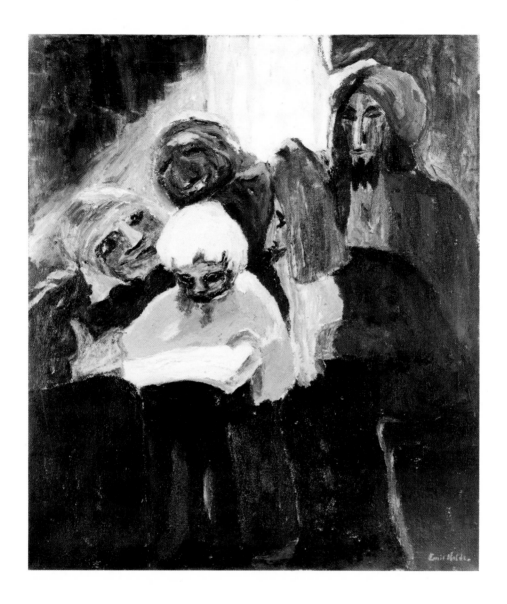

EMIL NOLDE

*30a-i. *The Life of Christ (Das Leben Christi)*. 1911–12
Oil on canvas, 9 sections
Nolde-Stiftung Seebüll

30a. *The Life of Christ (Das Leben Christi): The 12-Year-Old
Christ (Der zwölfjährige Christus)*. 1911
39⅜ x 33⅞″ (100 x 86 cm.)
Signed l.r.: *Emil Nolde.* Not dated.

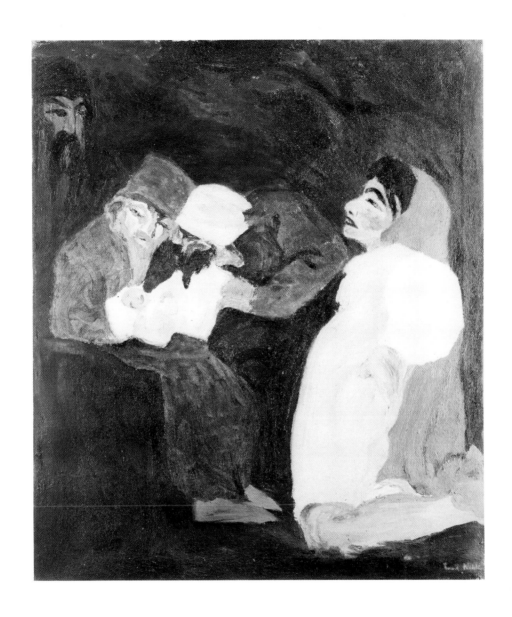

EMIL NOLDE

30b. *The Life of Christ (Das Leben Christi): The Three Magi*
(Die Heiligen Drei Könige). 1911
39⅜ x 33⅞" (100 x 86 cm.)
Signed l.r.: *Emil Nolde.* Not dated.

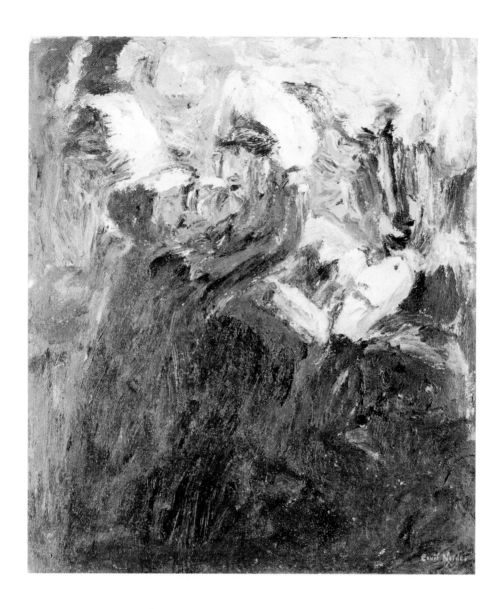

EMIL NOLDE

30c. *The Life of Christ (Das Leben Christi): Christ and Judas
(Christus und Judas).* 1911
39⅜ x 33⅞″ (100 x 86 cm.)
Signed l.r.: *Emil Nolde.* Not dated.

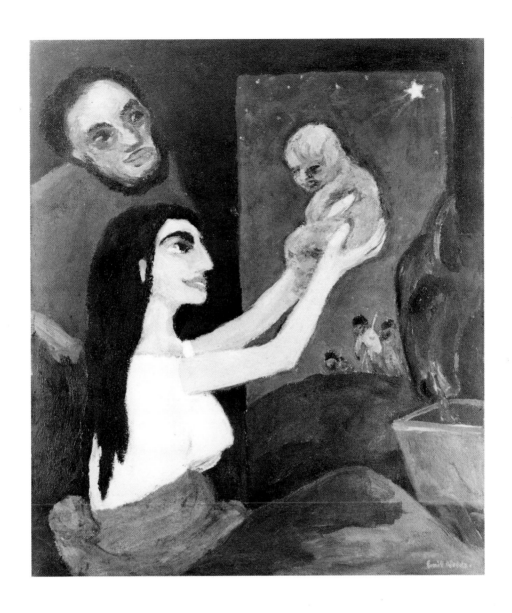

EMIL NOLDE

30d. *The Life of Christ (Das Leben Christi): Holy Night
(Heilige Nacht)*. 1912
39⅜ x 33⅞″ (100 x 86 cm.)
Signed l.r.: *Emil Nolde.* Not dated.

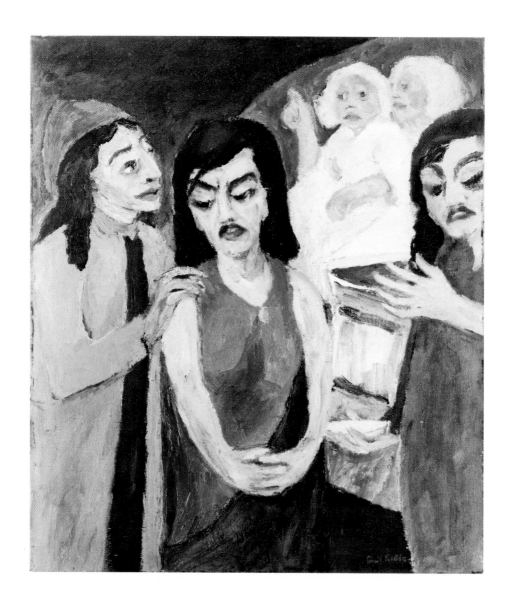

EMIL NOLDE

30e. *The Life of Christ (Das Leben Christi): Women by the Tomb
(Frauen am Grabe).* 1912
39⅜ x 33⅞″ (100 x 86 cm.)
Signed l.r.: *Emil Nolde.* Not dated.

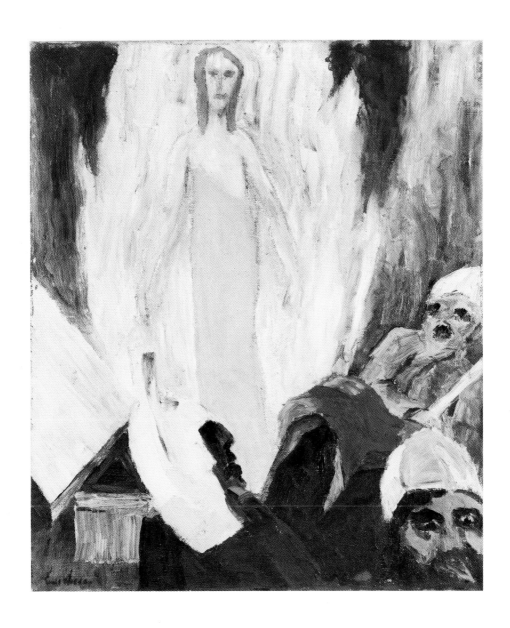

EMIL NOLDE

30f. *The Life of Christ (Das Leben Christi): The Resurrection
(Auferstehung).* 1912
39⅜ x 33⅞″ (100 x 86 cm.)
Signed l.l.: *Emil Nolde.* Not dated.

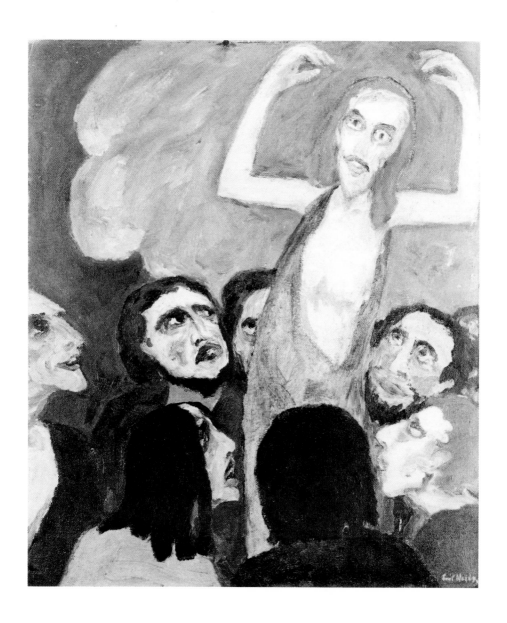

EMIL NOLDE

30g. *The Life of Christ (Das Leben Christi): The Ascension
(Himmelfahrt).* 1912
39⅜ x 33⅞" (100 x 86 cm.)
Signed l.r.: *Emil Nolde.* Not dated.

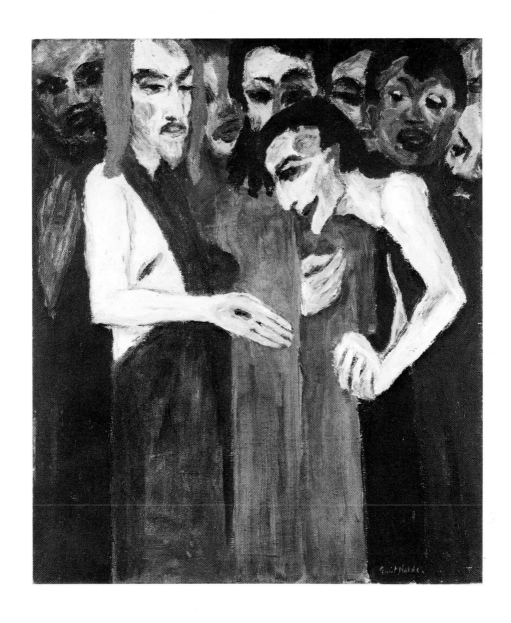

EMIL NOLDE

30h. *The Life of Christ (Das Leben Christi): Doubting Thomas
(Der ungläubige Thomas).* 1912
39⅜ x 33⅞″ (100 x 86 cm.)
Signed l.r.: *Emil Nolde.* Not dated.

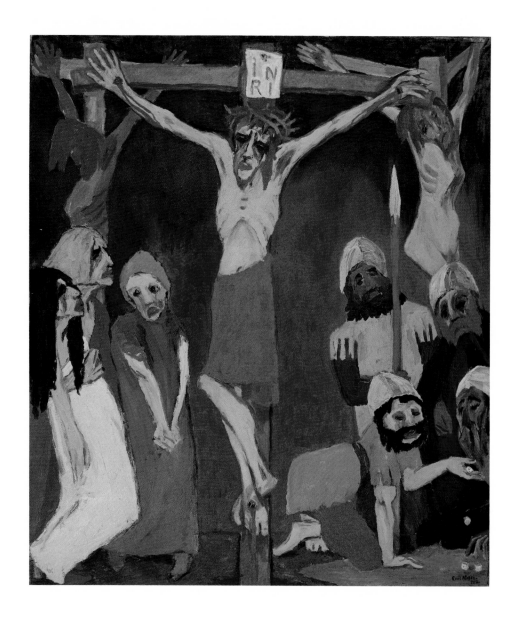

EMIL NOLDE

30i. *The Life of Christ (Das Leben Christi): The Crucifixion
(Kreuzigung)*. 1912
86⅝ x 75³⁄₁₆″ (220 x 191 cm.)
Signed and dated l.r.: *Emil Nolde 1912.*

31 *Portrait of a Gentleman (Gustav Schiefler) (Herrenbild
[Gustav Schiefler]).* 1915
Oil on canvas, 30⅛ x 24⁷⁄₁₆″ (76.5 x 62 cm.)
Signed u.l.: *Emil Nolde.* Not dated.
Nolde-Stiftung Seebüll

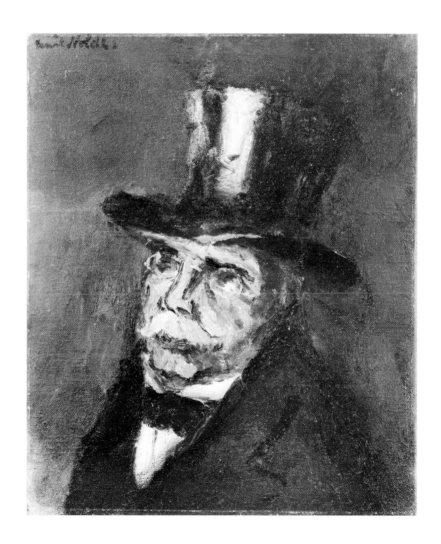

32 *Russian Peasants (Zwei Russen)*. 1915
 Oil on canvas, 29 x 35½″ (73.7 x 90.2 cm.)
 Signed l.l.: *Emil Nolde*. Not dated.
 Collection The Museum of Modern Art, New York, Matthew T.
 Mellon Foundation Fund, 1954

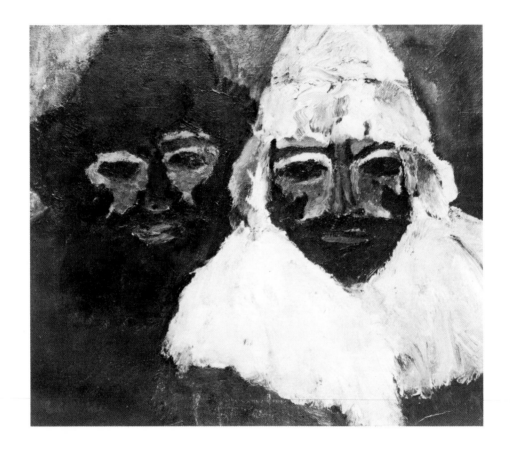

33 *The Mulatto (Mulattin)*. 1915
Oil on canvas, 30½ x 28¾″ (77.5 x 73 cm.)
Signed l.l.: *Nolde*. Not dated.
Collection Busch-Reisinger Museum, Harvard University, Cambridge, Massachusetts, Purchase, G. David Thompson Fund

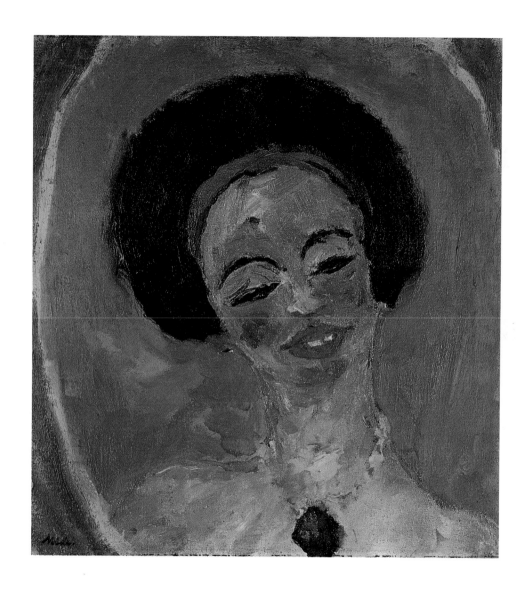

34 *The Sea III (Das Meer III)*. 1915
Oil on canvas, 34$\frac{1}{16}$ x 39$\frac{9}{16}$" (86.5 x 100.5 cm.)
Signed l.l.: *Emil Nolde*. Not dated.
Nolde-Stiftung Seebüll

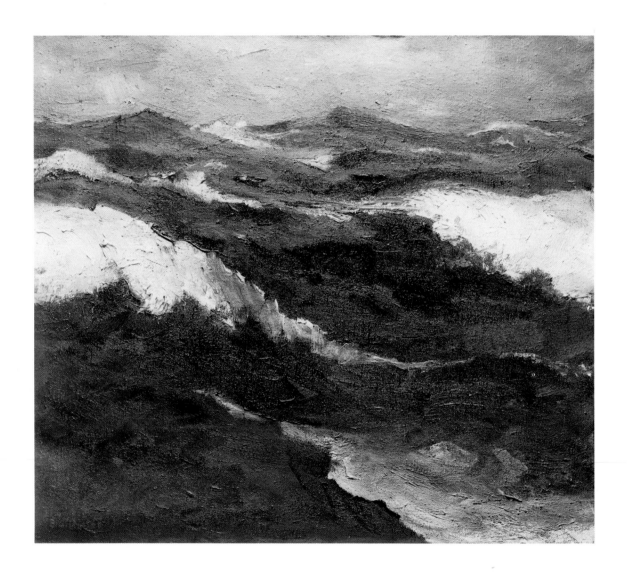

35 *Prince and Sweetheart (Fürst und Geliebte).* 1918
 Oil on canvas, 34⅞ x 27″ (88.5 x 68.5 cm.)
 Signed l.r.: *Emil Nolde.* Not dated.
 Nolde-Stiftung Seebüll

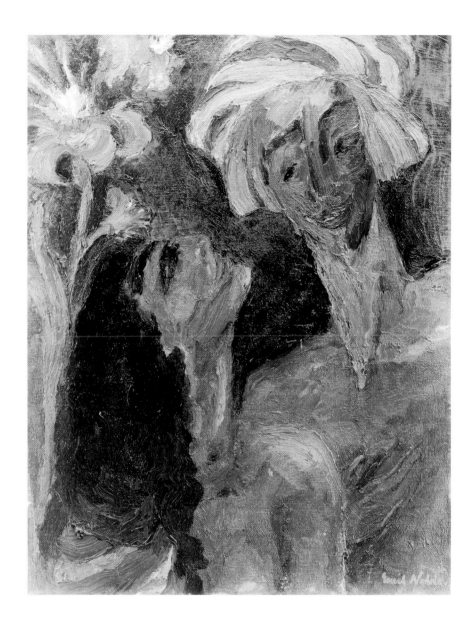

36 *Self-Portrait (Selbstbildnis).* 1907
Brush and India ink and watercolor, 19¼ x 14¼″ (49 x 36.1 cm.)
Signed and dated l.r.: *Nolde. 07.*
Nolde-Stiftung Seebüll

†37 *Woman in Red Dress (Dame in rotem Kleid).* 1907
Watercolor, 19⁷⁄₁₆ x 14¼″ (49.1 x 36.2 cm.)
Signed and dated l.r.: *Nolde. 07.*
Nolde-Stiftung Seebüll

†38 *In the Café (Two Women and a Man) (Im Café [Zwei
Damen und ein Herr]).* 1910
India ink and pen and wash, 11⁹⁄₁₆ x 12¼″ (29.3 x 31.5 cm.)
Signed and dated l.r.: *Nolde. 10.*
Nolde-Stiftung Seebüll

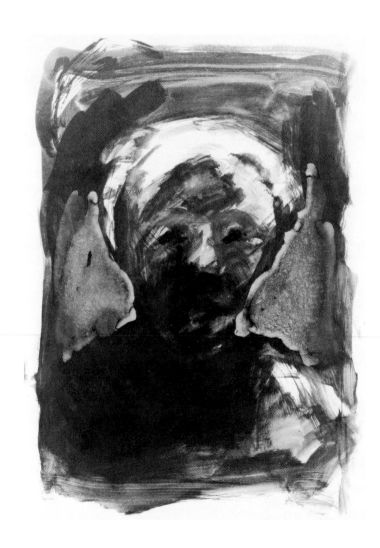

EMIL NOLDE

39 *Steamboat (Dampfer).* 1910
 Brush and India ink, $15\frac{13}{16}$ x $18\frac{1}{4}''$ (40.2 x 46.3 cm.)
 Signed l.l.: *Nolde*. Not dated.
 Nolde-Stiftung Seebüll

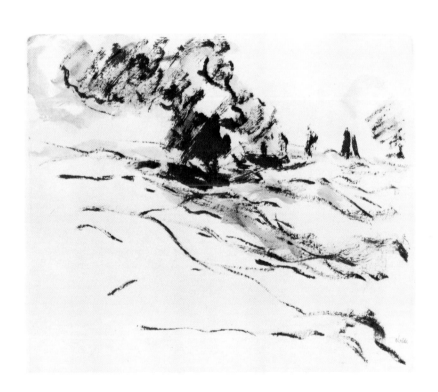

EMIL NOLDE

40 *In the Port of Hamburg (Im Hamburger Hafen)*. 1910
Brush and India ink, 12⅞ x 19¹⁵⁄₁₆″ (32.7 x 50.7 cm.)
Signed l.r.: *Nolde*. Not dated.
Nolde-Stiftung Seebüll

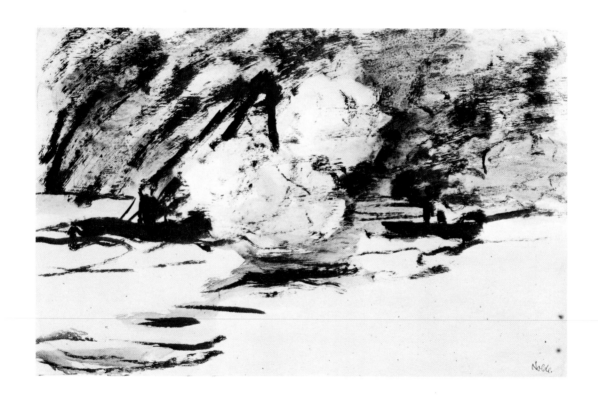

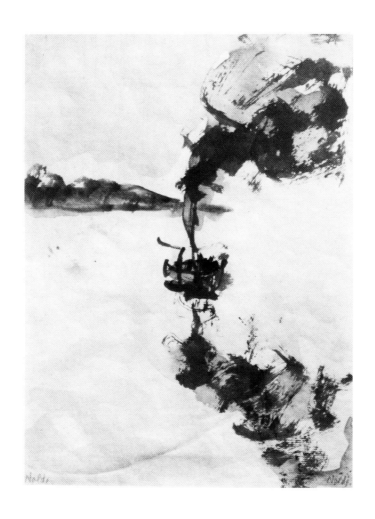

EMIL NOLDE

41 *Steamboat on the Elbe (Dampfer auf der Elbe).* ca. 1910
 Brush and watercolor, 13³⁄₁₆ x 9⅞″ (33.5 x 25 cm.)
 Signed l.l. and l.r.: *Nolde.* Not dated.
 Collection Museum Ludwig, Cologne

42 *Cabaret Dancer (Tänzerin im Kabarett).* 1910-11
 Watercolor, 13¾ x 10³⁄₁₆″ (35 x 25.8 cm.)
 Signed l.r.: *Nolde.* Not dated.
 Nolde-Stiftung Seebüll

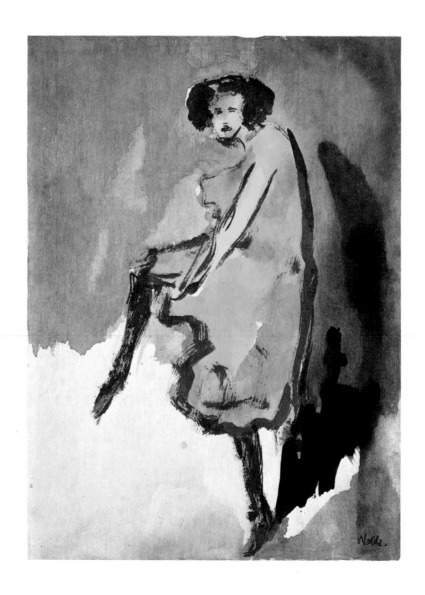

43 *Dancing Couple (Tanzendes Paar)*. 1910–11
 Watercolor, 13¼ x 10¹⁵⁄₁₆″ (33.6 x 27.8 cm.)
 Signed l.r.: *Nolde.* Not dated.
 Nolde-Stiftung Seebüll

†44 *Dancing Couple (Tanzendes Paar)*. ca. 1911
 Tempera, 13 x 9¼″ (33 x 23.5 cm.)
 Signed l.r.: *Nolde.* Not dated.
 Collection Museum Ludwig, Cologne

†45 *Dancer (Tänzerin)*. ca. 1911
 Tempera and watercolor, 12¼ x 10⅞″ (31 x 27.5 cm.)
 Signed l.r.: *Nolde.* Not dated.
 Collection Museum Ludwig, Cologne

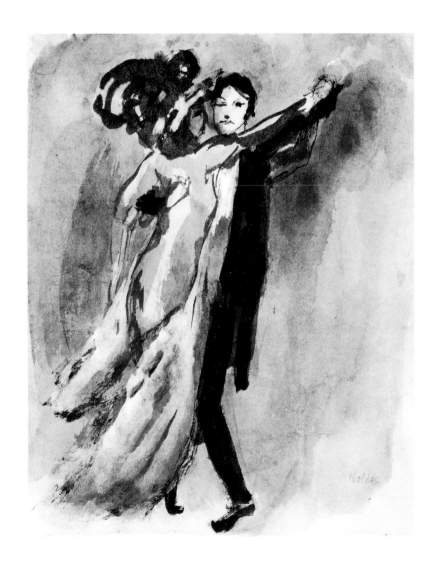

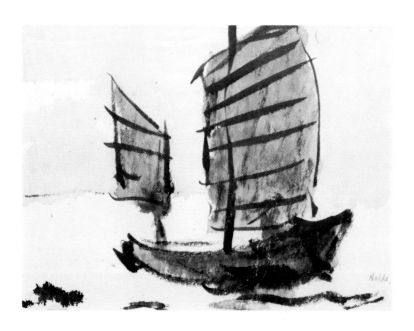

EMIL NOLDE

46 *Chinese Junk (Dschunke)*. ca. 1913
 Brush and watercolor, 9⅞ x 13″ (23.9 x 33 cm.)
 Signed l.r.: *Nolde*. Not dated.
 Collection Museum Ludwig, Cologne

47 *South Sea Islander (Südseeinsulaner)*. 1913–14
 Watercolor, 19 x 13⅝″ (48.2 x 34.5 cm.)
 Signed l.r.: *Nolde*. Not dated.
 Nolde-Stiftung Seebüll

†48 *South Sea Islander with Child (Südseeinsulanerin mit Kind)*.
 1913–14
 Watercolor, 18¹¹⁄₁₆ x 13¹³⁄₁₆″ (47.5 x 35.1 cm.)
 Signed l.r.: *Nolde*. Not dated.
 Nolde-Stiftung Seebüll

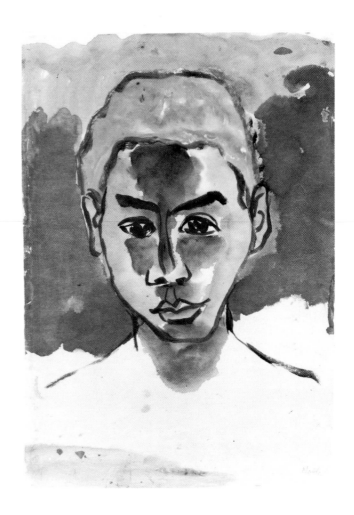

49 *Head of a Spanish Woman (Kopf einer Spanierin).* ca. 1914
Tempera and watercolor, 15¹⁵/₁₆ x 12⅝″ (40.5 x 32 cm.)
Signed l.r.: *Nolde.* Not dated.
Collection Museum Ludwig, Cologne

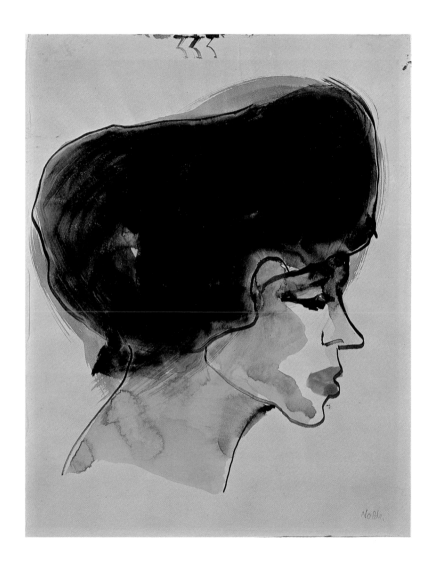

50 *Lion's Court in Alhambra (Löwenhof in der Alhambra).*
 ca. 1914
 Tempera and watercolor, 18⁹⁄₁₆ x 13¾″ (47.2 x 35 cm.)
 Signed l.r.: *Nolde.* Not dated.
 Collection Museum Ludwig, Cologne

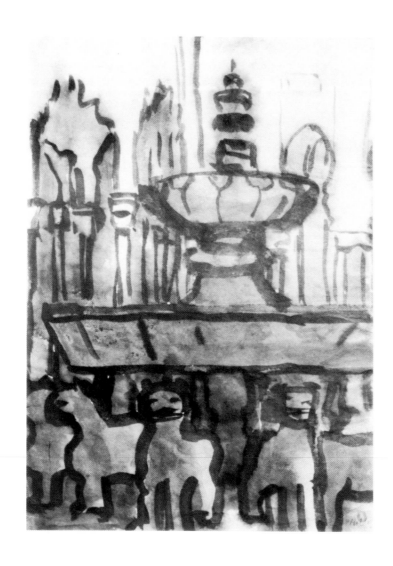

51 *Portrait of a Woman (Emmy Frisch) (Frauenbildnis [Emmy Frisch])*. 1916
Watercolor, 19⅛ x 13⅞″ (48.5 x 35.2 cm.)
Signed l.l.: *Nolde*. Not dated.
Nolde-Stiftung Seebüll

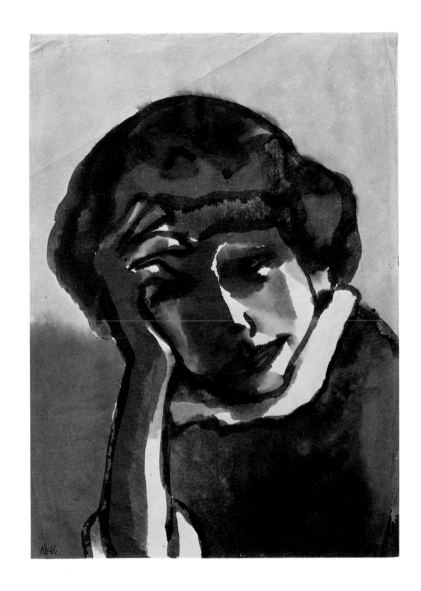

†52 *Couple (Paar)*. n.d.
 Watercolor, 8¹⁵⁄₁₆ x 12¹³⁄₁₆″ (22.7 x 32.5 cm.)
 Signed u.r.: *Nolde*. Not dated.
 Collection Museum Ludwig, Cologne

†53 *Portrait of a Lady (Auburn Hair) (Frauenbildnis*
 [Rotblondes Haar]). n.d.
 Watercolor, 19⁹⁄₁₆ x 14″ (49.6 x 35.5 cm.)
 Signed l.r.: *Nolde*. Not dated.
 Nolde-Stiftung Seebüll

†54 *Estuary with Boat (Flussmündung mit Kahn)*. n.d.
 Watercolor, 12⁵⁄₁₆ x 18″ (31.2 x 45.7 cm.)
 Signed l.r.: *Nolde*. Not dated.
 Collection Museum Ludwig, Cologne

†55 *On the Lake (Auf dem See)*. n.d.
 Watercolor, 13⅞ x 19″ (35.2 x 48.2 cm.)
 Signed u.r.: *Nolde*. Not dated.
 Nolde-Stiftung Seebüll

 56 *Flood (Überschwemmung)*. n.d.
 Watercolor, 13¾ x 18½″ (35 x 47 cm.)
 Signed l.r.: *Nolde*. Not dated.
 Nolde-Stiftung Seebüll

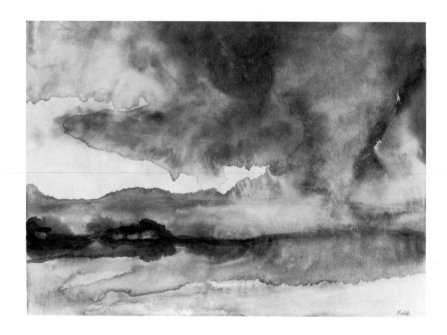

57 *Marsh Landscape in Winter (Marschlandschaft im Winter).*
n.d.
Watercolor, 13¾ x 19¼″ (35 x 48.9 cm.)
Signed l.r.: *Nolde.* Not dated.
Nolde-Stiftung Seebüll

†58 *Gloomy Sea (Dunkles Meer).* n.d.
Watercolor, 14⁵⁄₁₆ x 18″ (36.4 x 45.8 cm.)
Signed l.l.: *Nolde.* Not dated.
Nolde-Stiftung Seebüll

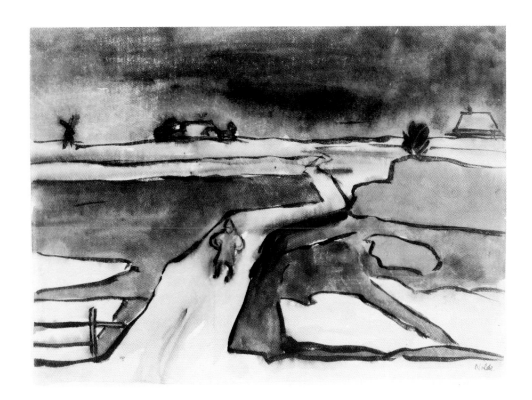

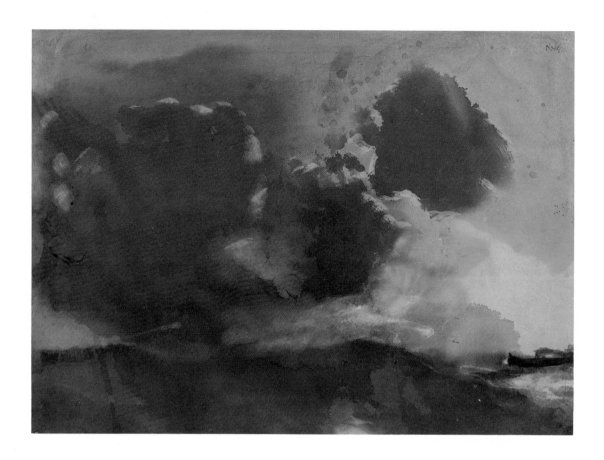

EMIL NOLDE

59 *Sea with Mauve Clouds (Meer mit hellvioletter Wolke).* n.d.
 Watercolor, 14⅜ x 20″ (36.5 x 50.8 cm.)
 Signed u.r.: *Nolde.* Not dated.
 Nolde-Stiftung Seebüll

†60 *Lily and Iris (Lilie und Iris).* n.d.
 Watercolor, 18 x 13¹¹⁄₁₆″ (45.7 x 34.8 cm.)
 Signed l.l.: *Nolde.* Not dated.
 Nolde-Stiftung Seebüll

61 *Dahlias (Dahlien).* n.d.
 Watercolor, 13⅝ x 17¹⁵⁄₁₆″ (34.7 x 45.5 cm.)
 Signed l.r.: *Nolde.* Not dated.
 Nolde-Stiftung Seebüll

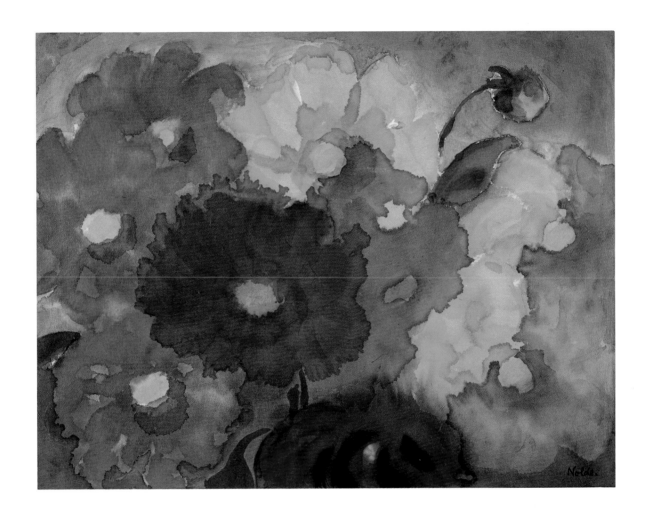

62 *Fantail (Schleierschwänze)*. n.d.
 Watercolor, 14³⁄₁₆ x 18½″ (36.1 x 47 cm.)
 Signed l.r.: *Nolde*. Not dated.
 Collection Museum Ludwig, Cologne

†63 *Gypsy Woman (Zigeunerin)*. n.d.
 Watercolor, 18⁵⁄₁₆ x 13⅝″ (46.6 x 34.7 cm.)
 Signed l.l.: *Nolde*. Not dated.
 Collection Museum Ludwig, Cologne

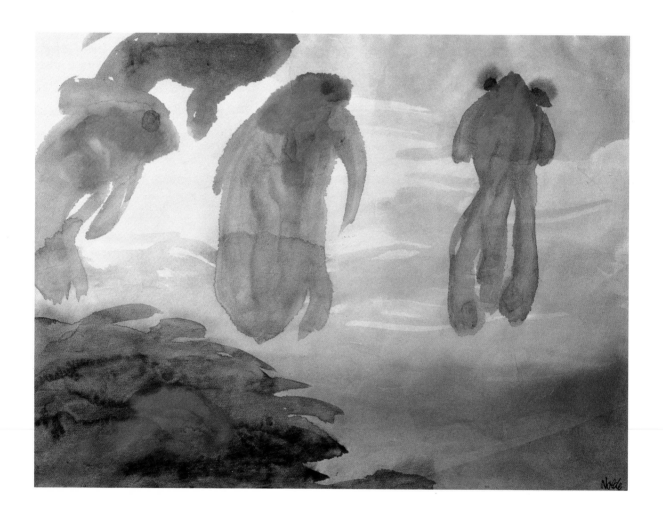

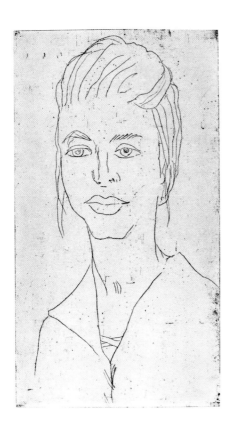

64 *Young Girl (Junges Mädchen)*. n.d.
Etching, 17¼ x 9¹³⁄₁₆″ (43.9 x 24.9 cm.)
Collection Museum Folkwang, Essen

65 *Honky Tonk II (Tingel Tangel II)*. n.d.
Color lithograph, 16¹⁵⁄₁₆ x 24″ (43 x 61 cm.)
Collection Museum Folkwang, Essen

†66 *Young Couple (Junges Paar)*. n.d.
Color lithograph, 24⁷⁄₁₆ x 20¹⁄₁₆″ (62 x 51 cm.)
Collection Museum Folkwang, Essen

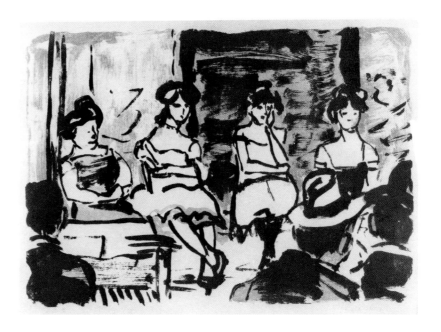

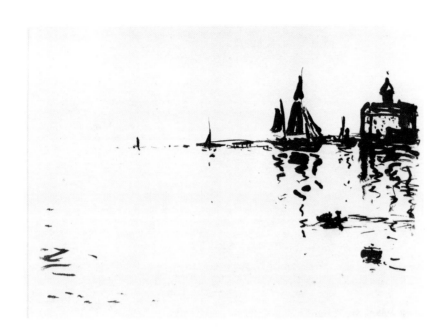

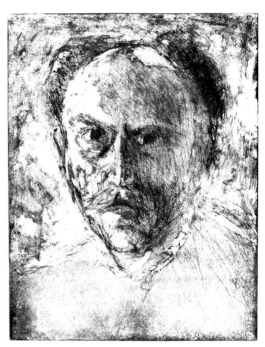

EMIL NOLDE

67 *Bright Day (Heller Tag)*. 1907
 Lithograph, 11 x 18¹¹⁄₁₆″ (28 x 47.5 cm.)
 Collection Museum Folkwang, Essen

†68 *The Three Magi (Die Heiligen Drei Könige)*. n.d.
 Color lithograph, 29½ x 25³⁄₁₆″ (75 x 64 cm.)
 Collection Museum Folkwang, Essen

69 *Self-Portrait (Selbstbildnis)*. 1908
 Etching, 12³⁄₁₆ x 9¼″ (31 x 23.5 cm.)
 Collection Museum Folkwang, Essen

†70 *Hamburg Free Port (Hamburger Freihafen)*. 1910
 Woodcut, 12 x 15¹⁵⁄₁₆″ (30.4 x 40.5 cm.)
 Collection Museum Folkwang, Essen

†71 *Large and Small Steamboats (Grosser und kleiner
 Dampfer)*. 1910
 Woodcut, 11¹³⁄₁₆ x 15¹¹⁄₁₆″ (30 x 39.8 cm.)
 Collection Museum Folkwang, Essen

EMIL NOLDE

72 *Hamburg Inner Port (Hamburger Binnenhafen)*. 1910
Etching, 12³⁄₁₆ x 16⅛" (31 x 41 cm.)
Collection Museum Folkwang, Essen

†73 *Hamburg Free Port (Hamburger Freihafen)*. 1910
Etching, 11⅞ x 15¹⁵⁄₁₆" (30.2 x 40.5 cm.)
Collection Museum Folkwang, Essen

74 *Saul and David*. 1911
Etching, 11¹³⁄₁₆ x 9⅞" (30 x 25 cm.)
Collection Museum Folkwang, Essen

†75 *Bible Scholars (Schriftgelehrte)*. 1911
Etching, 10⁹⁄₁₆ x 11¹³⁄₁₆" (26.9 x 29.9 cm.)
Collection Museum Folkwang, Essen

76 *Woman Standing (Stehende Frau)*. 1911
Lithograph, 22¹⁄₁₆ x 15⅜" (56 x 39 cm.)
Collection Museum Folkwang, Essen

77 *Prophet.* 1912
 Woodcut, 14¾ x 10½" (37.4 x 26.6 cm.)
 Collection Museum Folkwang, Essen

†78 *Jumping Jacks (Hampelmänner).* 1913
 Color lithograph, 17⅞ x 21¹¹⁄₁₆" (45.4 x 55 cm.)
 Collection Museum Folkwang, Essen

†79 *Actress (Schauspielerin).* 1913
 Color lithograph, 21¹¹⁄₁₆ x 18¹⁵⁄₁₆" (55 x 48 cm.)
 Collection Museum Folkwang, Essen

80 *Russian Woman (Russin).* 1913
 Color lithograph, 27¹⁵⁄₁₆ x 22⁷⁄₁₆" (71 x 57 cm.)
 Collection Museum Folkwang, Essen

†81 *Flirtation (Tändelei).* 1917
 Woodcut, 12⁵⁄₁₆ x 9½" (31.2 x 24.1 cm.)
 Collection Museum Folkwang, Essen

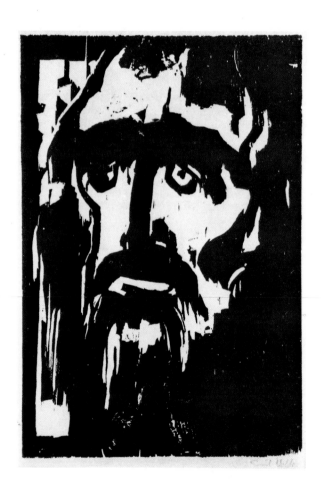

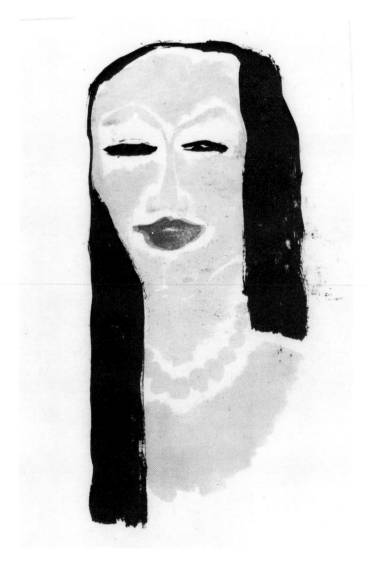

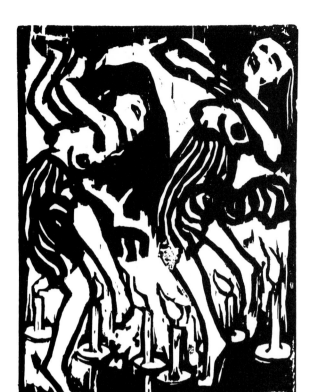

EMIL NOLDE

82 *Candle Dancers (Kerzentänzerin).* 1917
Woodcut, 11¹³⁄₁₆ x 9¼″ (30 x 23.5 cm.)
Collection Museum Folkwang, Essen

†83 *Young Prince and Dancer (Junger Fürst und Tänzerin).* 1918
Etching, 10¼ x 8⅝″ (25.9 x 21.9 cm.)
Collection Museum Folkwang, Essen

†84 *Eve (Eva).* 1923
Etching, 18¹¹⁄₁₆ x 12³⁄₁₆″ (47.5 x 31 cm.)
Collection Museum Folkwang, Essen

ERNST BARLACH

85 *The Metamorphosis of God, The Cathedrals (Die Wandlungen Gottes, Die Dome).* 1922
Woodcut, 12¹³⁄₁₆ x 17¹¹⁄₁₆″ (32.5 x 44.9 cm.)
Collection Museum Folkwang, Essen

†86 *The Metamorphosis of God, The First Day (Die Wandlungen Gottes, Der 1. Tag).* 1922
Woodcut, 13 x 17⅝″ (33 x 44.8 cm.)
Collection Museum Folkwang, Essen

†87 *The Metamorphosis of God, God Belly (Die Wandlungen Gottes, Gott Bauch).* 1922
Woodcut, 12¹³⁄₁₆ x 17¹¹⁄₁₆″ (32.6 x 44.9 cm.)
Collection Museum Folkwang, Essen

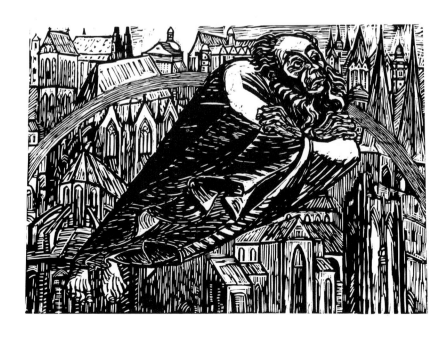

IV

The Artists Group *Die Brücke*

WOLF-DIETER DUBE

It is a strange phenomenon: four of the most important artists who influenced German art in our century are still better remembered as a group rather than as individual personalities. If the name Ernst Ludwig Kirchner, Erich Heckel, Karl Schmidt-Rottluff, or Otto Mueller is mentioned, it is, more often than not, the *Brücke* group association that comes to mind. The collective image of this group clouds the achievements of the individual artists, focusing attention on a very brief span in their lives and works.

By 1913, the four remaining members of the *Brücke* had gone their separate ways. This was undoubtedly necessary. Each, according to his own temperament, had tried to make the painful break more or less abruptly, but none had succeeded. Decades later, Heckel was still evoking the ideal of his youth in portraits of his friends. Fifty years later, Schmidt-Rottluff established the Brücke-Museum in Berlin. And even Kirchner could not remove himself from the grand experience of the friendship, although in 1919 he had written to Gustav Schiefler, the most steadfast promoter of his art: "Since the *Brücke* has never counted in my artistic development, any mention of it in an article on my work is superfluous." In 1926 he began a painting entitled *A Group of Artists*, which now hangs in the Museum Ludwig in Cologne (fig. 1). Otto Mueller, absorbed in thought and quietly puffing on his pipe, is sitting on a stool in front, at the left. Kirchner stands behind him, pointing to the group's chronicle, which led to the dissolution of the *Brücke*. He is staring at Schmidt-Rottluff, who stands at the right, enduring the stare without responding. Between them is Heckel in a frontal position, which enables him to turn to either side to mediate if need be. The tension among the figures, their interrelationship as depicted by Kirchner at a distance of fifteen years, existed from the very day the *Brücke* was founded.

There were many communities of artists in the early twentieth century. Some began purely as exhibition groups, such as the entire Secession movement, which then separated into the New and Free Secessions. Others, like the *Nabis*, were joined by a common aesthetics. And still others, like the Fauves, had emerged out of friendship. It is precisely because of certain features they had in common that a comparison with the Fauves may clarify what was so special about the group of artists known as the *Brücke*.

In 1905, when the *Brücke* was launched, the group of painters around Matisse exhibited at the Salon d'Automne, which, as we know, brought them the name Fauves. At that time, Matisse was thirty-six; not only had he been trained in Moreau's studio, but he was already an experienced painter. Dresden's *Brücke*, however, consisted of four students of architecture, the oldest being twenty-five. None of them could point to any appreciable experience or training as painters,

much less to any public exposure as artists. The initial stage was not a process of artistic development leading inevitably to a union. It was faith in their own unproven strength, a revolutionary, optimistic impetus linking all the youth of Europe that became the mainspring here. The shore on which they stood had to be abandoned. But no one could say with what methods a bridge could be built to the other side. The founders of the *Brücke* shared the conviction of Franz Kafka, who was their age: "Only the end matters. What we call 'road' is hesitation." That is why the program of the *Brücke*, which Kirchner authored in 1906 and carved in wood, contains no aesthetic maxim. "With faith in development, in a new generation whether of creative contributors or recipients, we call together all youth, and as youth who hold the future we want to gain elbow room and freedom of life against the well-established older forces. Everyone who with directness and authenticity conveys that which drives them to create belongs to us."

The basic group consisted of Ernst Ludwig Kirchner, Fritz Bleyl, Erich Heckel, and Karl Schmidt-Rottluff. Kirchner, who was born the son of a paper chemist in Aschaffenburg in 1880, had been attending school in Chemnitz, Saxony, since 1890. In 1901 he began studying architecture at the Technische Hochschule in Dresden, passing his examinations in 1905. During his final years in Chemnitz, Kirchner had taken private lessons in drawing; later, he gratefully recalled his British teacher of watercolors. At twenty-one, he decided to study architecture, probably more out of consideration for his family than of his own accord, for he was already solidly imbued with "the dream of painting." During 1903–4, he at-

fig. 1
Ernst Ludwig Kirchner
A Group of Artists. 1926
Collection Museum Ludwig, Cologne

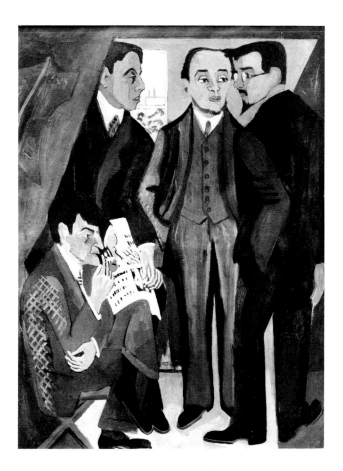

tended the Munich art school run by Wilhelm von Debschitz and Hermann Obrist. There he studied composition and drawing from the nude. During 1901, in Dresden, he had met Fritz Bleyl, an architecture student, who also had been born in 1880. Together they experimented with drawing and painting. Bleyl remained a member of the *Brücke* until 1909, when he was forced to devote himself entirely to his architectural profession.

In 1901, when they were both high-school students in Chemnitz, Erich Heckel (born in Döbeln, Saxony, in 1883) and Karl Schmidt-Rottluff (born in Chemnitz in 1884) met in a literary circle. Along with their proclivity for literature, they quickly discovered their joint love of painting, and they began to draw and paint together. For Heckel, literature was at first as important as painting, so that for a long time he was undecided as to whether he should become a writer or a painter. In 1904 he moved to Dresden to study architecture. There he soon met Kirchner and Bleyl through his older brother. In 1905, after three semesters, he dropped out of school, devoting himself fully to painting, even though he initially worked as a draftsman in an architectural office in order to earn a living. Finally, in 1905, Karl Schmidt-Rottluff came to Dresden, also to study architecture, but he dropped out after only two semesters.

The *Brücke* program stated the goal of a group which had a common desire; and in line with this goal, the group could not and should not be limited to the four painters, who were bound by personal friendship. In 1906, when Emil Nolde had a show at the Galerie Arnold in Dresden, the older man was invited to join the group. Schmidt-Rottluff wrote the letter:

> *To be blunt—the local group of artists,* die Brücke, *would consider it a great honor to welcome you as a member. Of course, you probably know as little about the* Brücke *as we knew about you before your exhibition at the Arnold. Well, one of the aspirations of the* Brücke *is to attract all revolutionary and fermenting elements—this is expressed in the name "Brücke." Moreover, the group puts on several shows a year, which we send on tours of Germany, so that the individual does not have to deal with business matters. A further goal is to create an exhibiting space of our own—an ideal goal for now, since the wherewithal is still lacking. Well, dear Mr. Nolde, however and whatever you may feel, we wanted to pay our tribute in this way for your color tempests. Sincerely and truly yours, the A[rtists'] C[ollective]* die Brücke.

Nolde became a member for a year and a half.

In the summer of 1906, Erich Heckel met Max Pechstein. Pechstein, born in Zwickau, Saxony, in 1881, had finished an apprenticeship as a scenic painter and had entered Dresden's Kunstgewerbeschule in 1900. From 1902 until 1906 he completed his training as a master pupil at the Dresden Akademie, which awarded him the Saxon State Prize, the so-called Rome Prize. These studies certainly gave Pechstein a headstart, and his less aggressive temperament was also an advantage, so that subsequently he was the first to gain recognition.

In 1906 Cuno Amiet, a Swiss, and in 1907 Axel Gallén-Kallela, a Finn, joined the *Brücke* for a while, after contact with them was made through exhibitions. They were roughly the same age as Nolde, and their membership, like his, was confined to participating in the *Brücke* exhibitions. In 1908 Franz Nölken, born

in Hamburg in 1884, became a member temporarily, but then headed for Paris to study with Matisse.

In 1910, when entries from Nolde, Pechstein, Otto Mueller, and others for the exhibition of the Berlin Secession were rejected, they founded the New Secession. After making Pechstein a member of their board, they exhibited together with the *Brücke* painters. Heckel later recalled: "The first encounter with Otto Mueller's paintings was in Berlin, at the showing of the 'Rejects of the Berlin Secession,' which took place at the Galerie Macht in the spring of 1910. And we met him personally the very same day in his studio on Mommsenstrasse. This meeting was significant for all of us and occurred at a fruitful moment; and, as a matter of course, he belonged to the *Brücke* community from then on." Otto Mueller was six years older than Kirchner. Born in Liebau, Silesia, in 1874, he had begun a lithographic apprenticeship in 1891; then in 1894 he entered the Dresden Akademie. Travels with his cousin, the writer Gerhart Hauptmann, took him to Italy and Switzerland. During 1898–99 he attended the Munich Akademie, returning to Dresden and then moving to Berlin in 1908, the same year as Pechstein. Finally, in 1911, Bohumil Kubišta of Prague joined the *Brücke*, without, however, establishing close contact with the others.

The actual artistic activity of the *Brücke*, as we see in retrospect, was essentially confined to its members, who enhanced each other through their continuous, joint efforts. Nonetheless, it was remarkable of them to try to include foreign artists. For example, in 1908 they asked Kees van Dongen to show at the *Brücke*. The gathering of progressive talents was always put above the artistic path of the individual.

Today, when reading the program of the *Brücke*, that terse appeal, one can hardly agree with the opinion of art critics expressed to date according to which the statement was fairly general and did not say much. Just as the *Brücke* itself differed from other artists groups by being a strict militant force, so too its proclamation differed essentially from other manifestoes. Here in Dresden, in 1906, the viewer, the consumer, was, for the first time, brought into the picture as an equal. The artists' faith was accorded in equal measure to the "new generation whether of creative contributors or recipients." Thus the point was not only for artists to become effective agents, but through the creation, at the same time, of analogous agencies among recipients, to raise public consciousness as well. The *Brücke*, therefore, solicited a so-called passive membership. For yearly dues of twelve marks, the "passive members"—some of whom having made considerable contributions to the promotion and understanding of new art—received a progress report and a folder of graphics, the "*Brücke* folders," which later became famous and much sought after. The campaign brought in sixty-eight members.

What was also seen as a possibility by the *Brücke* artists was the idea of reaching a wider audience through multiple reproductions of an artwork. Of course, this idea meant different things to different members. Erich Heckel was most open to such suggestions, which is why he became the business manager of the group. For him printed graphics always spelled a means of achieving a broader impact, so that numerous woodcuts of his were printed in very large editions. For Kirchner, however, who, with rare exception, pulled his graphics himself, every print shows an individual character. He was less interested in broad distribution. And Schmidt-Rottluff never acknowledged any print that was not signed by him. Admittedly— and the situation has scarcely changed today—they could reach only people who

were already interested or converted; nonetheless, the effort was a sound one.

The earlier joint drawing and painting sessions of the young students had inevitably generated the need for more and more intense work. Thus the founding of this group of artists did not bring any change for them; it was merely an outer manifestation of a life-style that they were already practicing. In 1923 Kirchner noted in his journal:

A happy coincidence brought together the really talented men whose characters and gifts, even in human terms, left them with no other choice than the profession of artist. This form of living, of dwelling and working, though peculiar for a regular human being, was not a deliberate épater le bourgeois, *but simply a very naive and pure necessity to harmonize art and life. And it was precisely this more than anything else that so tremendously influenced the forms of present-day art. Of course, it was mostly misunderstood and totally distorted, for there [the will] fashioned the form and gave it meaning, whereas here the unfamiliar form is affixed to habit, like a top hat on a cow.*

The path of development in these matters of external life, from the first decorated ceiling in the first Dresden studio to the completed harmonious space in the Berlin studios of the individual artists, is an uninterrupted logical intensification, going hand in hand with the painterly development of the paintings, graphics, and sculptures. The first bowl that was carved—because no appealing bowl was purchasable—brought three-dimensional form into the two-dimensional form of the painting, and thus the personal form was thoroughly manipulated by the various techniques until the final stroke. The painter's love for the girl, who was his companion and assistant, was transferred to the carved figure, ennobled itself [through] the surroundings [in] the painting and again rendered the special form of a chair or table from the living habits of the human model. Such was the path of artistic creation in a simple example. Such was the artistic attitude of the Brücke.

This utter devotion shone in Erich Heckel's eyes the first time he came to my place to draw from the nude and loudly declaimed Zarathustra *as he climbed the stairs; and [a few] months later, I saw the same radiance in* S[chmidt]-R[ottluff]'s *eyes when he came to us, seeking freedom, like myself, in free work; and the first thing for the painters was free drawing of free people in free naturalness. With Kirchner, it began as an attempt to take advantage of an opportunity. The artists drew and painted. Hundreds of pieces a day, with talking and playing in between, the painters also acted as models, and vice versa. All encounters in everyday life were thus integrated into our memories. The studio became a home for the people who were drawn: they learned from the painters, the painters from them. The pictures absorbed life, immediately and richly.*

The goal of these young sons of the middle class was to fuse art and life in sensual harmony. This struck them as a chance to find their way out of the random and noncommittal art of their fathers, out of an Impressionistic practice which represented bourgeois society, bourgeois dominance: "Impressionism," wrote Hermann Bahr in 1920, "is man's apostasy from the intellect; the Impressionist is man reduced to a Gramophone of the external world." The crux of the conflict, however,

was not about formal, artistic problems. Franz Marc, in the almanac of the *Blaue Reiter* (1912), raised this issue: "It is impossible to explain the latest works of these wild men [that is, the artists of the *Blaue Reiter* and the *Brücke*, who were working in Munich and Berlin] in terms of a formal evolution and a reinterpretation of Impressionism. The loveliest prismatic colors and the famous Cubist style have become meaningless in terms of the objectives of the iconoclasts. Their thinking has a different aim: with their labor, they want to create symbols for their era, symbols that belong on the altars of the coming spiritual religions behind which the technical producer will vanish."

The antagonism between bourgeois society and the critical spirit of youth molded the art of Expressionism. The Expressionists, including the members of the *Brücke*, viewed bourgeois society as an economic one determined by the capitalistic *grande bourgeoisie*, which shared power with the aristocracy. The strongest mainsprings of this society were felt to be crass materialism and shameless egotism. Materialism and egotism are the basis of the closed economic system that Otto Flake describes in his novel *Die Stadt des Hirns (The City of the Brain)*: "The holy things were statute labor, coercion, encumbrance, necessity—things that were not voluntary and that keep man from finding himself. Work itself, the system—which pulled people into its mills with iron arms—the desire for money, profit, power, ambition, and satisfaction, these were lies, slavery, exploitation of egotistic instincts, a lack of love among all men." This is the counterprinciple to the future and to ecstasy, to which youth had to be committed.

In order to gain elbow room and freedom of life, the young painters settled in a working-class area of Dresden. Dealing with the apparently unsophisticated people living here was not just meant to document externally the break with the artists' own backgrounds. Rather, Kirchner and his friends hoped to get closer to an original feeling. They hoped to find origins from which a new human being could emerge, the man that Nietzsche had set up as a goal. These ardent admirers of Nietzsche had their faith, their yearning, their hope and confidence confirmed in *Zarathustra*, the fourth prologue of which most likely supplied the name of their group:

Man is a rope, tied between the animal and the superman, a rope across a chasm.

A perilous crossing, a perilous wayfaring, a perilous staying-behind, a perilous shuddering and halting. The greatness of man is that he is a bridge and not a purpose: the lovableness of man is that he is a going-across and going-under.

I love those who do not know how to live except by going under, for they are the ones who go across.

I love the great despisers, for they are the great venerators and arrows of yearning toward the other shore.

I love those who do not first look beyond the stars for a reason to go under and be sacrificed, but who sacrifice themselves to the earth so that the earth may some day become the superman's.

This also makes it understandable why van Gogh had to have such a strong impact on Kirchner, Heckel, and Schmidt-Rottluff. Van Gogh's point of departure,

like theirs, was not artistic calculation but existential necessity. For van Gogh, painting was the only way he could express his ecstatic love of people and things. He exposed himself to them immediately. He empathized with things in order to penetrate the reflection of the external world and communicate a different reality, which he experienced with intense excitement. This communication took place through the heightened sound of blazing colors, through a dynamically darting brush script whose spontaneous strokes directly mirror the artist's psychological state. The compulsion to expose himself, unshielded, to the world in order to experience its truth devoured the artist's energy in a few brief years. His way—creating art as a response to existential ordeal and giving up his life when the tension was no longer to be borne—was an exemplary and tragic destiny, which ultimately also became Kirchner's doom.

Heckel had rented a butcher shop on Dresden's Berlinerstrasse for a studio. Here they worked with obsessive zeal and utmost intensity. The point of departure was Neo-Impressionism and van Gogh, whose works had been shown in Dresden during 1905 and 1906. From the very outset, they made woodcuts, which became highly significant as a means of clarifying form since a woodcut demands a strict, terse shaping of the pictorial idea as no other technique does. Kirchner described the importance of graphics as follows:

> *The will driving the artist to do graphic work is perhaps in part an effort to stamp the unique loose form of the drawing solidly and definitively. On the other hand, the technical manipulations release energy in the artist, forces that do not come into play with the much easier handling of drawing and painting. The mechanical process of printing unites the various work phases; the task of creating the form can be safely extended as long as one likes. There is something very attractive about reworking over and over again, for weeks, indeed months on end, without the plate's losing its freshness. The mysterious charm, the aura around the invention of printing in the Middle Ages is still felt today by anyone dealing seriously and in detail with the graphic craft. There is no greater joy than watching the printer's roller the first time it moves across the wood block, which you have just finished carving; or etching the lithographic plate with nitric acid and gum arabic and observing whether the desired effect comes about; or testing the final maturation of the definitive version of the prints. How interesting it is to feel your way around graphics, print after print, down to the slightest detail, without feeling the hours go by. In no way can you get to know an artist better than through his graphics.*

The themes of this early period were taken from the everyday environment: landscapes, street views, portraits, and nudes. The woodcuts clearly show the influence of Vallotton and of Jugendstil. The equal ranking of painting and graphics was evident in the first two *Brücke* exhibitions, which took place in Dresden during the fall of 1906: one was for painting and the other for woodcuts.

Emil Nolde, who, after joining the *Brücke*, spent part of the winter of 1906–7 in Dresden, introduced the young painters to his etching technique. The novel feature was that individual portions of the plate were more or less covered during the etching phase; this produced richly nuanced, flat, chiaroscuro effects. Nolde, in turn, took over the woodcut technique of the *Brücke*. In 1907 they became inter-

96

ested in lithography, at a point when formal development necessitated painterly, pictorial solutions.

In the summer months the friends normally separated, and then assimilated their individual experiences under mutual supervision. Schmidt-Rottluff spent the autumn of 1906 at Nolde's place in Alsen, while Kirchner and Pechstein worked in Goppeln, near Dresden. In 1907 Pechstein traveled to Italy and Paris; Heckel and Schmidt-Rottluff painted together—as they did in the following years—in Dangast, Oldenburg, on the North Sea. In 1908 Pechstein moved to Berlin, and Kirchner sojourned for the first time on the Baltic island of Fehmarn. In 1909 Heckel visited Italy, and then he and Kirchner went to the Moritzburg lakes, near Dresden, to study drawing from the nude. Pechstein discovered Nidda, East Prussia, on the Baltic Sea. In 1910 Heckel, Kirchner, and Pechstein spent the summer on the Moritzburg lakes. Heckel and Pechstein then joined Schmidt-Rottluff in Dangast. In 1911 Schmidt-Rottluff traveled from Dangast to Norway, Heckel painted in Prerow on the Baltic Sea and then, with Kirchner, in Moritzburg. Pechstein stayed in Italy and Nidda, while Kirchner and Mueller went to Bohemia. And, finally, in 1912 Schmidt-Rottluff went to Dangast, Kirchner to Fehmarn, and Heckel to Rügen, eventually joining Kirchner on his island.

Pechstein recalled the summer of 1910:

When we were together in Berlin, I arranged with Heckel and Kirchner for the three of us to work by the lakes surrounding Moritzburg, near Dresden. We had long since grown familiar with the landscape, and we knew we would have the possibility of painting nudes undisturbed in the open countryside. When I arrived in Dresden and dropped in at the old shop in Friedrichstadt, we discussed the realization of our plans. We had to find two or three people who were not professional models and who would therefore guarantee movements without studio training. I remembered my old friend, the janitor at the academy—I now know that his name was Rasch—and he immediately offered not only good advice, but had someone at hand, and so he helped us in our distress. He told us about the wife of an artist who had died and her two daughters. I presented our earnest artistic plan to her. She visited us in our shop in Friedrichstadt, and since she found a familiar milieu there, she agreed to let her daughters go to Moritzburg with us.

We had luck with the weather too: there was not a rainy day. Now and then, a horse market would take place in Moritzburg [see cat. no. 209]. In a painting and in countless studies I captured the throng around the shiny animal bodies. Otherwise, we painter people set out early every morning, heavily laden with our instruments, behind us the models with bags full of things to eat and drink. We lived in absolute harmony, working and swimming. If a male model was lacking as a counterpole, then one of us would come to the rescue. Off and on, the mother showed up like a nervous hen to convince herself that no harm had come to her little ducklings on the pond of life. With her mind at ease and imbued with respect for our work, she would head back to Dresden. Each of us produced numerous sketches, drawings, and paintings.

The impressions were captured in countless sketches, jotted down on drawing pads, or pierced into metallic plates with the "cold needle." Watercolors, which

were soon mastered with great ability, also assumed an important place. The main thing was spontaneity of expression, which was to be drawn from natural, virtually random poses. That was why, from the very start, the artists had practiced catching the models in quickly changing positions. But through the subsequent translation of the nudes into paintings or woodcuts in the studio, moderation and artistic order were always preserved.

The thematic center of the *Brücke*'s creativity during its first few years was the nude in the landscape. Intensive studies of the nude, especially the nude in swift motion, served to establish form. The landscape, on the other hand, was the motif that evoked emotions and sensations. Such sensations, detached from the motif, were translated into color. The emotional value of color was the point of departure for painting. First, the artist applied color planes, from which objective forms gradually took shape. The result was the color/plane style, which was practiced as of 1910 by all members of the *Brücke*. The nude and the landscape were joined together into a single motif. Naked people in the open countryside became the expression of original and pristine Being, a way of overcoming social restraints. Man was viewed as an integral part of nature. This also applied to the liberation of eros, the release of the physical from the confinement of hypocritical bourgeois moral notions.

Some examples: in 1910, on the Moritzburg lakes near Dresden, Kirchner painted *Nudes Playing Under Tree* (cat. no. 131). Spontaneously applied colors produce a decorative harmony of planes that is mainly ruled by green. The intense hues and sketchy brushwork impart a vibrant, expressive immediacy. The dramatic form of the large tree is taken up by the motion of the figures. Through colors these figures are integrated into the expression of the painting, both repeating the colorfulness and, in a complementary fashion, intensifying it.

Such existential unity in nature was ultimately compressed by Schmidt-Rottluff in 1913 into a few essential abbreviations and semantic signs, as in the painting *Summer* (fig. 2). Two female figures stand in a landscape, which is presented in terms of signs, with the sparest devices, a few jags of bushes and curves of dunes. Large color planes are inserted between these lines. Man and nature fuse into radiant red. The monumental rigor of this art aims at symbols; it does not intend to render visible spiritual states by way of emotions, but rather to depict fundamental truths.

This striving is true not only for Kirchner, but also for Heckel, who painted *Crystalline Day* (fig. 3), also in 1913. Here, too, the order of things and their equivalent mutual tension are sought in one another. The deliberately angular and awkward structure, which has its origin in large woodcuts, allows a peculiar depiction of light. Reflections, refractions, and reflexes are transformed into crystalline forms. Sky, earth, water, and man are blended into a unity with the aid of the visible atmosphere.

Along with this theme, the experience of the circus and the music hall are dealt with as expressions of intensified life (see cat. no. 138). This intensification, like naturalness, is viewed as a way of overcoming encumbered middle-class behavior; it offers paths to the "new man." For this to be altogether clear, the individual had to recede behind the universal. Even in portraits, the title merely describes the person instead of giving his name.

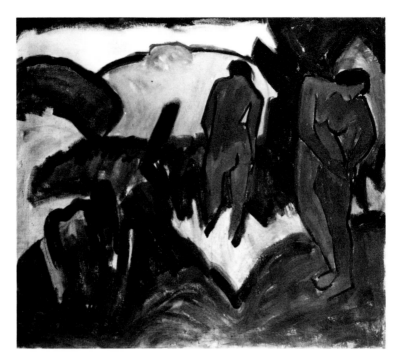

fig. 2
Karl Schmidt-Rottluff
Summer. 1913
Collection Kunstmuseum Hannover mit Sammlung
Sprengel

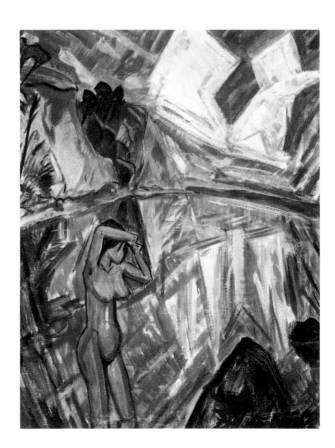

fig. 3
Erich Heckel
Crystalline Day. 1913
Courtesy Mrs. Siddi Heckel

The results were presented in exhibitions, some of which traveled through Germany and Switzerland. Participation in the shows of the New Secession in Berlin led to many contacts, including some with the *Neue Künstlervereinigung München (NKVM)* around Kandinsky. The greater impact of the new art and the better economic potential in Berlin induced the members of the *Brücke* to move there in 1911.

Although the *Brücke* kept appearing as a group, the six years of joint work had so sharply marked the artistic personalities that each of them began going his own way more and more. Their self-assurance about their artistic methods was also documented by the fact that Kirchner and Pechstein founded a school, the MUIM-Institut (Moderner Unterricht in Malerei: Modern Instruction in Painting), which, however, was not successful. The most obvious confirmation of their achievements was the Sonderbund exhibition in Cologne (1912), a joint show of contemporary German and French art. Heckel and Kirchner were commissioned to decorate a chapel at the exhibition—a sensational event.

When the group decided to leave the New Secession, Pechstein, who did not want to follow the others, was excluded from the *Brücke*. The members hoped to re-emphasize their common aims by publishing the chronicle of the *Brücke* group of artists; but their plan was unsuccessful. Kirchner's text was turned down by his friends because of his subjective interpretation. What had been conceived of as a joint avowal led to the final rupture in 1913. However, the true causes lay deeper. As hard as the artists tried, as arduously as they attempted to maintain an optimistic impetus, they were forced to admit that they could do little for the sufferings of the world. On the one hand, they saw that in Paris artists were concentrating on a formal grasp of the world with the help of Cubism. On the other hand, they saw that in Munich the original demand of the *Blaue Reiter*— for a synthesis of experiences from the outer world with those from the inner world—varied according to the ultimately subjective depiction of individual sensations and emotions. They saw that the Futurists, in their first manifesto (1909), were seeking salvation in violence, when Marinetti proclaimed: "We want to praise war—that sole hygiene of the world—militarism, patriotism, the destructive gesture of the anarchists, the beautiful thoughts that kill, and the scorn of woman."

The painters of the *Brücke* could no longer respond as a group to this altered consciousness. They now realized how differently the various temperaments had to react. For whether suffering is caused by society, whether its roots are in the social system, or whether it stems from personal fate or disease, it is borne by the individual. And the individual has to react. It became especially obvious to Erich Heckel that he could do nothing without personal involvement. His subject matter had the most distinct personal reference. As of 1912, Heckel dealt increasingly with themes such as the suffering woman, corpses, sick people, Pierrot dying, and "madmen eating" (see cat. nos. 96, 97). Even the world of circus performers now acquired the aspect of the tragic presence of man. Melancholy supplanted the relief of good cheer. These works anticipated much of what Heckel was to do after the outbreak of World War I. In 1915 he became a medical orderly in Flanders. The familiar motifs were now joined by wounded men, recovering or dying.

Karl Schmidt-Rottluff, who had done little figurative painting until then, also turned to a new theme under the impact of imminent disaster: the clothed woman

by the sea. In the 1914 woodcut *Mourners on the Beach*, the wordless conversations of two women are mutely earnest and filled with grief. These figures with over-sized heads and small, expressively convulsed hands move as through a dream. For the first time, Schmidt-Rottluff's figures show spiritual affliction and human closeness that are not absorbed by the surrounding nature. On the contrary, the now subtler landscape emphasizes the unresolved tension. The colors, predominantly ochre, reddish brown, and dark green, underscore the melancholy character of these paintings. The phenomenal unity of nature and man is shattered: man is alienated from nature.

Until he was drafted in 1915, the artist continued to paint individual figures, portraits, or nudes filling the entire picture space (see cat. no. 187). The necessity of rendering psychology purely through the expressive force of lines and colors made him resort to the African and South Seas sculptures he had discovered earlier in Dresden. From these sculptures, he borrowed both conciseness of form and organic abstraction.

However, the artist who reacted most violently was Ernst Ludwig Kirchner. He found his new theme in the hectic and unnatural condition of the modern metropolis. He was the only one to show the helpless compulsion, the desolation of the alienated man, which he was himself. The years 1913–14 brought the famous Berlin street scenes. The cocottes animating the nocturnal streets became his symbol of abandonment, a symbol of unstable, precarious existence (cat. no. 137). The large painting *Potsdamer Platz, Berlin*, 1914, stresses the isolation, the love-lessness of all toward all, by putting the two women on a traffic island in the street (fig. 4). The nervously fanning brushstroke relays the disquiet, the imperilment of the artist.

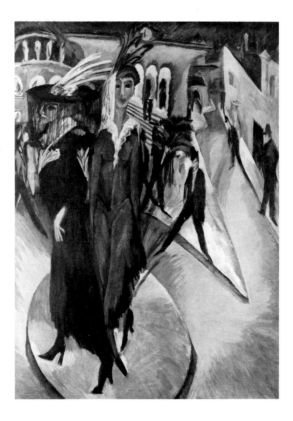

fig. 4
Ernst Ludwig Kirchner
Potsdamer Platz, Berlin. 1914
Private Collection

The mental affliction peaked in a destructive crisis when Kirchner was drafted into the army. Although discharged within six months, he was panic-stricken at the idea of having lost himself by wearing a uniform. This was his mood when, in 1915, he did the woodcut cycle *The Peculiar Story of Peter Schlemihl* (see cat. no. 164) after Adalbert von Chamisso's tale. Kirchner garbs the shattering experience of military service in the form of this fantastic romantic narrative. The peculiar story of Peter Schlemihl, who sells his shadow, only to enter into a conflict with his soul and vainly tries to regain his shadow, is, for Kirchner, an allegory of his own existence, the biography of a paranoiac, as he himself terms it. During 1918–19, that is, after moving to Switzerland, Kirchner did the seven woodcuts of *Absalom*. This series illustrates the story of Absalom, King David's son, as told in the Second Book of Samuel. Absalom rebels against his father, drives him out, and establishes his own brief rule, until he succumbs to David in battle and is killed. Kirchner was basically illustrating the struggle, hope, and defeat of his generation.

Thus each artist continued working on his own. But each maintained the ideal by which they had lived together: absolute honesty, consistency, and responsibility as artists and human beings. The outbreak of World War I and its consequences, which affected each one differently, had cruelly shattered the faith in the new generation, in the new and better man. In 1915, while still in basic training, Kirchner suffered a complete mental and physical collapse. Friends brought him to Switzerland, near Davos. Here, in the vast solitude of the mountains, he discovered a simple way of life. The sensitive portrayer of the big city became the most important Alpine painter of our century (see cat. no. 142).

Heckel, who spent the war as a medical orderly in Flanders, had no choice but to muster all of his spiritual discipline in order to gain control of overwhelming emotions and find his way to a purged artistic existence. Schmidt-Rottluff served in Russia for three years. He too required all his strength to overcome the excessive shock of war. The awareness of imminent death and incomprehensibly restored life inspired a set of religious woodcuts (see cat. nos. 199, 200), which led him to harmony, to a comprehensive view of the world. Only Otto Mueller, who had to fight on the Western front, still lived, as always, in a world of his own. He emerged from the Great War virtually untouched, so that he might expand his limited yet rich themes.

The phenomenon discussed at the start of this essay cannot be explained solely by the artistic importance of these painters. That a group of young men succeeded in moving the world with unconditional will and faith is what is far more fascinating about their experience.

88 *The Elbe near Dresden (Elbe bei Dresden)*. 1905
Oil on canvas, 19⁵⁄₁₆ x 26⁵⁄₈″ (49 x 67.5 cm.)
Inscribed, signed, and dated on reverse: *Elbe bei Dresden/
Heckel 05.*
Collection Museum Folkwang, Essen

89 *Brick Factory (Ziegelei in Dangast)*. 1907
 Oil on canvas, 26¾ x 33⅞″ (68 x 86 cm.)
 Signed and dated l.r.: *EH 07*.
 Vogt, cat. no. 1907/4
 Thyssen-Bornemisza Collection, Lugano, Switzerland

ERICH HECKEL

90 *White House (Weisses Haus [Dangast]).* 1908
Oil on canvas, 28⅜ x 31⅞″ (72 x 81 cm.)
Signed and dated l.r.: *Heckel 08.*
Vogt, cat. no. 1908/8
Thyssen-Bornemisza Collection, Lugano, Switzerland

91 *Windmill in Dangast (Windmühle bei Dangast)*. 1909
 Oil on canvas, 27¾ x 31¾" (70.5 x 80.5 cm.)
 Signed and dated l.l.: *EH 09*.
 Vogt, cat. no. 1909/9
 Collection Wilhelm-Lehmbruck-Museum der Stadt Duisburg

ERICH HECKEL

92 *Girl Reclining (Liegendes Mädchen)*. 1909
 Oil on canvas, 38$\frac{1}{16}$ x 47$\frac{11}{16}$″ (96.7 x 121.2 cm.)
 Signed and dated on reverse: *Heckel 1909*.
 Vogt, cat. no. 1909/8
 Collection Staatsgalerie moderner Kunst, Munich

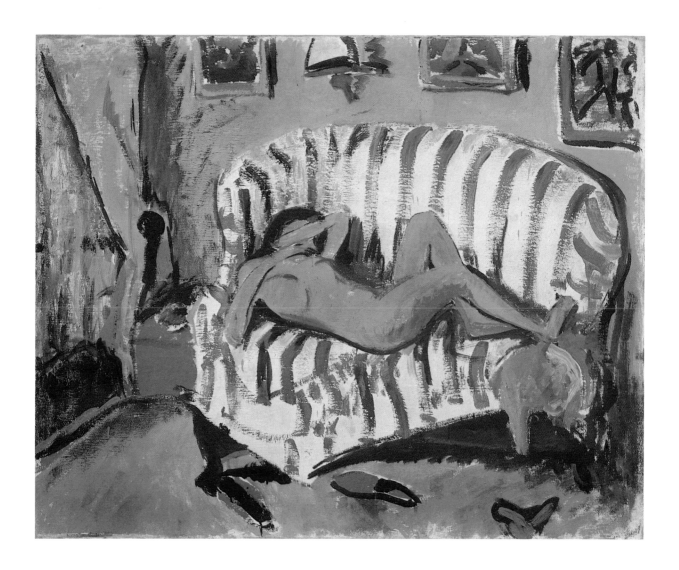

ERICH HECKEL

93 *Landscape with Bathing Women (Badende am Teich*
 [Moritzburg]). 1910
 Oil on canvas, 38¾ x 33″ (98.4 x 83.8 cm.)
 Signed and dated l.l.: *E Heckel 10.*
 Vogt, cat. no. 1910/14
 Collection Busch-Reisinger Museum, Harvard University,
 Cambridge, Massachusetts, Museum Purchase

ERICH HECKEL

*94 *Fränzi with Doll (Fränzi mit Puppe)*. 1910
 Oil on canvas, 25⅝ x 28¾″ (65.1 x 73 cm.)
 Signed and dated l.r.: *Erich Heckel 10.*
 Vogt, cat. no. 1910/16
 Private Collection, New York, Courtesy of Serge Sabarsky
 Gallery, New York

ERICH HECKEL

95 *Walkers at Grunewald Lake (Spaziergänger am Grunewaldsee).* 1911
Oil on canvas, 27⁵⁄₁₆ x 31¹¹⁄₁₆″ (71 x 80.5 cm.)
Signed and dated l.l.: *EH 11.*
Verso: *Harbor of Varel (Hafen von Varel).* 1909–18
Vogt, cat. no. 1911/11
Collection Museum Folkwang, Essen

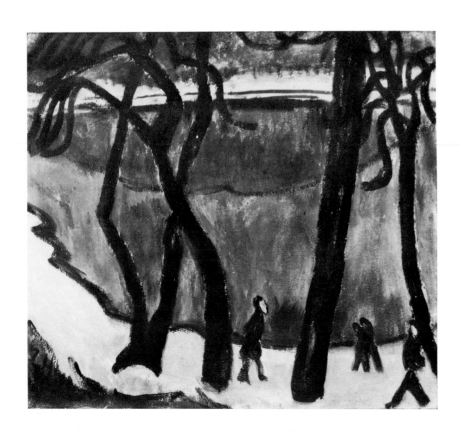

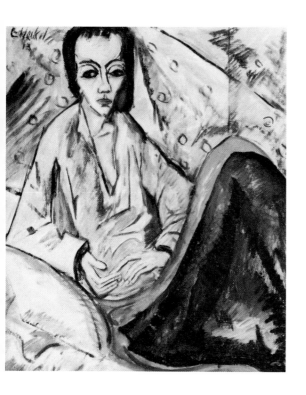

ERICH HECKEL

96 *To the Convalescent Woman (Genesende).* 1913
 Oil on canvas, triptych, each section: 32 x 27⅞"
 (81.3 x 70.8 cm.)
 Signed and dated u.l. of center section: *E Heckel/13.*
 Vogt, cat. no. 1913/3
 Collection Busch-Reisinger Museum, Harvard University,
 Cambridge, Massachusetts, Purchase, Mrs. Busch Greenough
 Fund

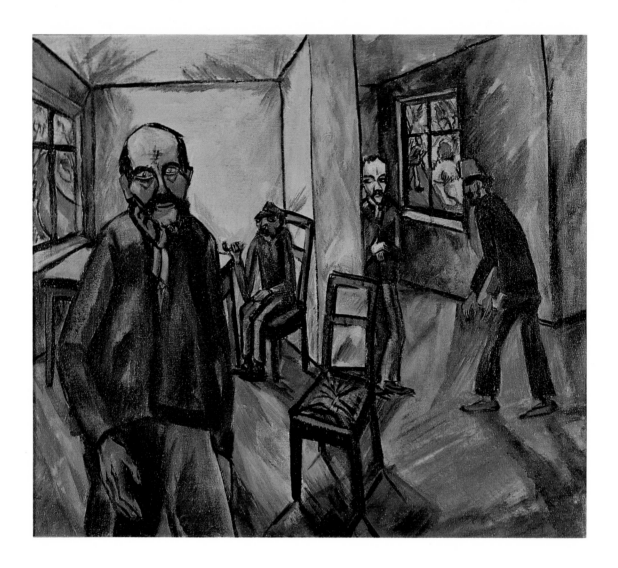

ERICH HECKEL

97 *The Madman (Der Irre)*. 1914
 Oil on canvas, 27¾ x 31¾" (70.5 x 80.5 cm.)
 Signed and dated l.r.: *Heckel 1914*.
 Vogt, cat. no. 1914/7 (collection listed incorrectly)
 Städtische Kunstsammlung Gelsenkirchen

ERICH HECKEL

98 *Dilborn Park (Park von Dilborn).* 1914
Oil on canvas, 32¹¹⁄₁₆ x 37¹³⁄₁₆″ (83 x 96 cm.)
Signed and dated l.l.: *Erich Heckel 14.*
Vogt, cat. no. 1914/14
Private Collection

ERICH HECKEL

99 *Spring in Flanders (Frühling in Flandern).* ca. 1916
 Tempera on canvas, 32⁹⁄₁₆ x 38″ (82.7 x 96.7 cm.)
 Signed l.r.: *EH*. Not dated.
 Vogt, cat. no. 1916/8
 Collection Städtisches Karl Ernst Osthaus Museum, Hagen

ERICH HECKEL

100 *Woman at Rest (Frau auf Ruhelager)*. 1914
Lead pencil and watercolor, 14¼ x 18¹⁵⁄₁₆″ (36.1 x 48.1 cm.)
Signed and dated l.r.: *Erich Heckel 14*.
Collection Museum Ludwig, Cologne

ERICH HECKEL

101 *Woods in the Evening (Gehölz am Abend).* 1919
Watercolor, gouache, lead pencil, and oil crayon, 16¹⁵⁄₁₆ x 23″
(43 x 58.3 cm.)
Signed and dated l.r.: *Erich Heckel 19.*
Collection Museum Ludwig, Cologne

102 *Portrait of the Artist's Brother (Bildnis des Bruders des*
 Künstlers). 1923
 Watercolor, gouache, and black crayon, 24⅛ x 18⁷⁄₁₆″
 (61.2 x 46.8 cm.)
 Signed and dated l.l.: *Erich Heckel 23/Männerkopf*.
 Collection Museum Ludwig, Cologne

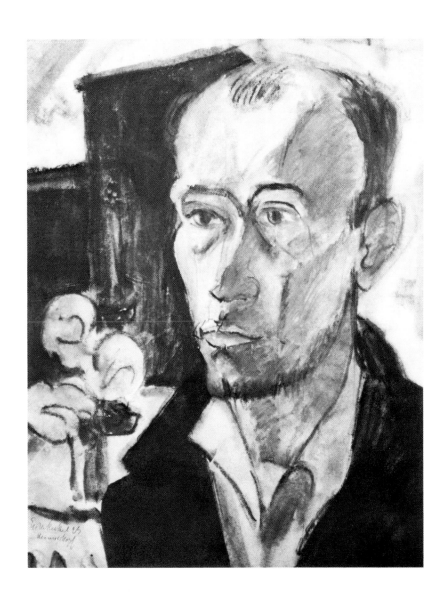

ERICH HECKEL

103 *Windmill (Windmühle)*. 1907
 Lithograph, 10¾ x 12¹⁵⁄₁₆″ (27.2 x 32.9 cm.)
 Collection Museum Folkwang, Essen

†104 *Boat in the Wind (Boot am Wind)*. 1908
 Etching, 6⁵⁄₁₆ x 7¹³⁄₁₆″ (16 x 19.8 cm.)
 Collection Museum Folkwang, Essen

105 *Elbe Tugboat (Elbschlepper)*. 1908
 Etching, 5¾ x 4″ (14.6 x 10.2 cm.)
 Collection Museum Folkwang, Essen

†106 *In the Theater (Im Theater)*. 1908
 Etching, 6⅝ x 5⅜″ (16.8 x 13.7 cm.)
 Collection Museum Folkwang, Essen

ERICH HECKEL

107 *Man Harpooning (Elgernder Mann).* 1909
Etching, 5½ x 9″ (13.9 x 22.8 cm.)
Collection Museum Folkwang, Essen

†108 *Reclining Woman (Liegende).* 1909
Color woodcut, 15¹¹⁄₁₆ x 11¾″ (39.9 x 29.8 cm.)
Collection Museum Folkwang, Essen

109 *Italian Landscape (Italienische Landschaft).* 1909
Woodcut, 13³⁄₁₆ x 9³⁄₁₆″ (33.5 x 23.3 cm.)
Collection Museum Folkwang, Essen

†110 *Landscape near Rome (Landschaft bei Rom).* 1909
Woodcut, 11⁷⁄₁₆ x 15³⁄₁₆″ (29 x 38.5 cm.)
Collection Museum Folkwang, Essen

†111 *Tightrope Walker (Seiltänzer).* 1910
Etching, 7¹³⁄₁₆ x 9⅝″ (19.8 x 24.5 cm.)
Collection Museum Folkwang, Essen

†112 *Horsemen (Reiter).* 1911
Etching, 6¹¹⁄₁₆ x 7⅞″ (17 x 20 cm.)
Collection Museum Folkwang, Essen

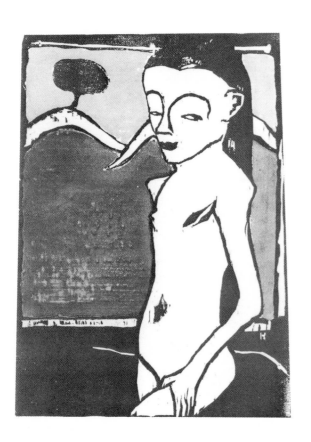
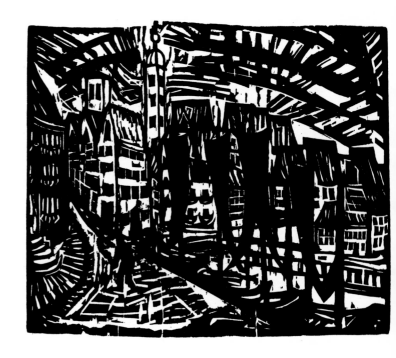

ERICH HECKEL

113 *Standing Child (Stehendes Kind)*. 1911
 Color woodcut, 14¾ x 10¹³⁄₁₆″ (37.5 x 27.5 cm.)
 Collection Museum Folkwang, Essen

114 *Stralsund*. 1912
 Woodcut, 12¼ x 14¼″ (31.2 x 36.3 cm.)
 Collection Museum Folkwang, Essen

†115 *White Horses (Weisse Pferde)*. 1912
 Color woodcut, 12³⁄₁₆ x 14¼″ (31 x 36.3 cm.)
 Collection Museum Folkwang, Essen

†116 *Landscape in Alsen (Landschaft auf Alsen)*. 1913
 Color woodcut, 10½ x 11¹⁄₁₆″ (26.8 x 28.1 cm.)
 Collection Museum Folkwang, Essen

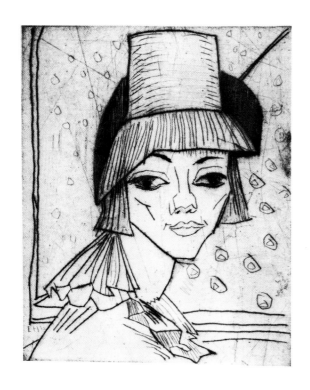

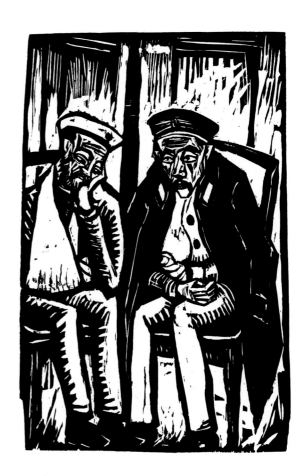

ERICH HECKEL

117 *Girl with High Hat (Mädchen mit Hohem Hut)*. 1913
 Etching, 9¹³⁄₁₆ x 7¹⁵⁄₁₆″ (24.9 x 20.2 cm.)
 Collection Museum Folkwang, Essen

118 *Two Wounded Men (Zwei Verwundete)*. 1914
 Woodcut, 16¾ x 11″ (42.5 x 28 cm.)
 Collection Museum Folkwang, Essen

†119 *Between Rocks (Zwischen Steinen)*. 1914
 Lithograph, 13 x 10¹³⁄₁₆″ (33 x 27.5 cm.)
 Collection Museum Folkwang, Essen

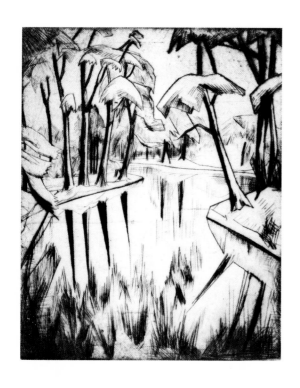

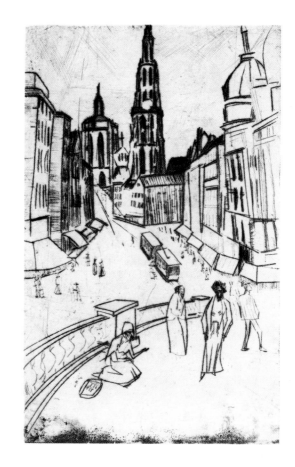

ERICH HECKEL

120 *Park Lake (Parksee)*. 1914
Etching, 9¹¹⁄₁₆ x 10¾″ (24.7 x 27.4 cm.)
Collection Museum Folkwang, Essen

121 *Antwerp (Antwerpen)*. 1914
Etching, 12⅜ x 7⅝″ (31.5 x 19.4 cm.)
Collection Museum Folkwang, Essen

†122 *Crouching Woman (Hockende)*. 1914
Woodcut, 16⁵⁄₁₆ x 12¹⁄₁₆″ (41.4 x 30.7 cm.)
Collection Museum Folkwang, Essen

†123 *By the Sea (Am Meer)*. 1916
Etching, 9¹⁄₁₆ x 6″ (23 x 15.2 cm.)
Collection Museum Folkwang, Essen

†124 *Self-Portrait (Selbstbildnis)*. 1917
Woodcut, 14½ x 11½″ (36.9 x 29.6 cm.)
Collection Museum Folkwang, Essen

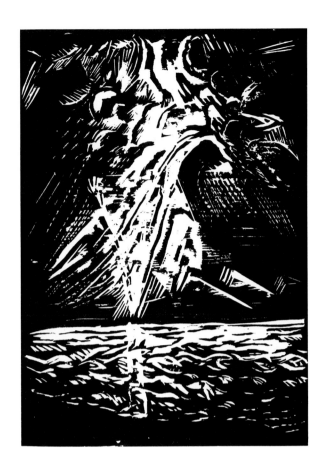 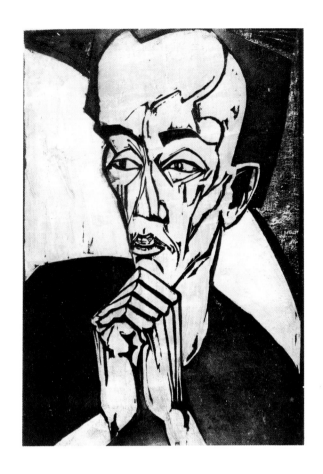

ERICH HECKEL

125 *Clouds (Wolken)*. 1917
Woodcut, 14⅜ x 10¹³⁄₁₆″ (36.5 x 27.5 cm.)
Collection Museum Folkwang, Essen

126 *Head of a Man (Männerkopf)*. 1919
Color woodcut, 18³⁄₁₆ x 12⅞″ (46.1 x 32.7 cm.)
Collection Museum Folkwang, Essen

*127 *Street, Dresden (Strasse, Dresden)*. 1908
Oil on canvas, 59¼ x 78⅞″ (150.5 x 200.4 cm.)
Signed and dated l.l.: *EL Kirchner 07*; dated on reverse:
07; Estate stamp on reverse: *KN-Dre/Bb 1.*
Gordon, cat. no. 53
Collection The Museum of Modern Art, New York,
Purchase, 1951

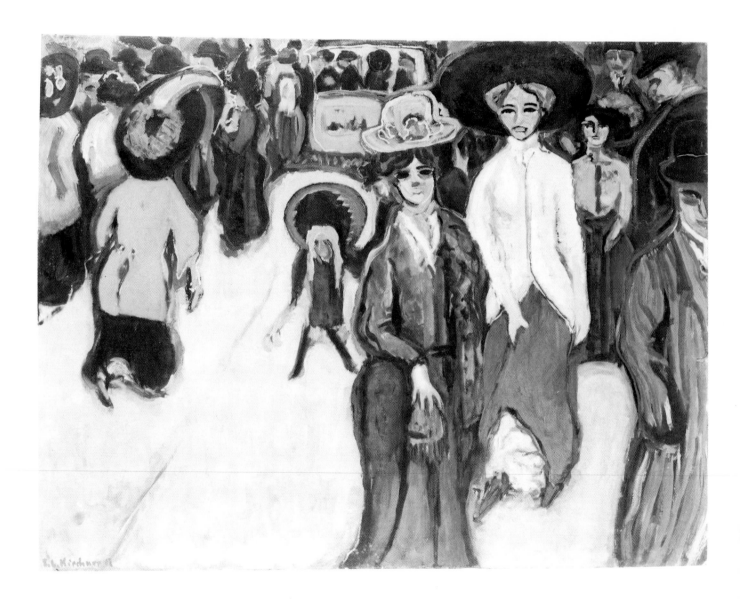

128 *Landscape in Spring (Frühlingslandschaft).* 1909
Oil on canvas, 27¹¹⁄₁₆ x 35⁹⁄₁₆″ (70.3 x 90.3 cm.)
Signed l.c.: *E. L. Kirchner.* Not dated.
Gordon, cat. no. 62
Collection Pfalzgalerie Kaiserslautern

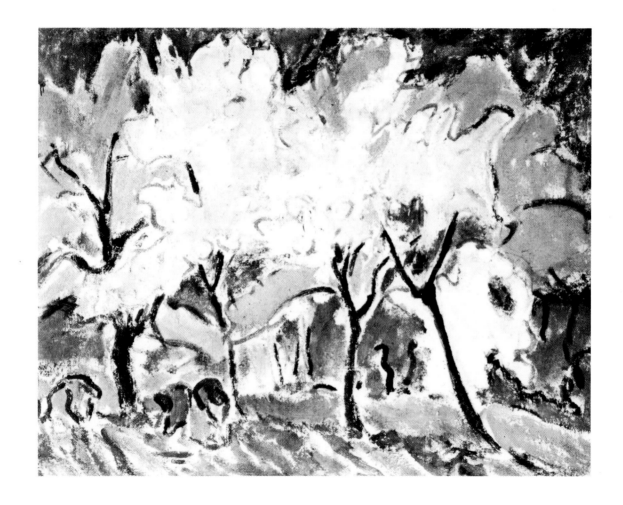

129 *Tavern (Weinstube)*. ca. 1909–10
 Oil on canvas, 27¾ x 31¾" (70.5 x 80.7 cm.)
 Signed l.r.: *EL Kirchner*; Estate stamp on reverse:
 KN-Be/bi 4a.
 Gordon, cat. no. 71
 Collection of Morton D. May

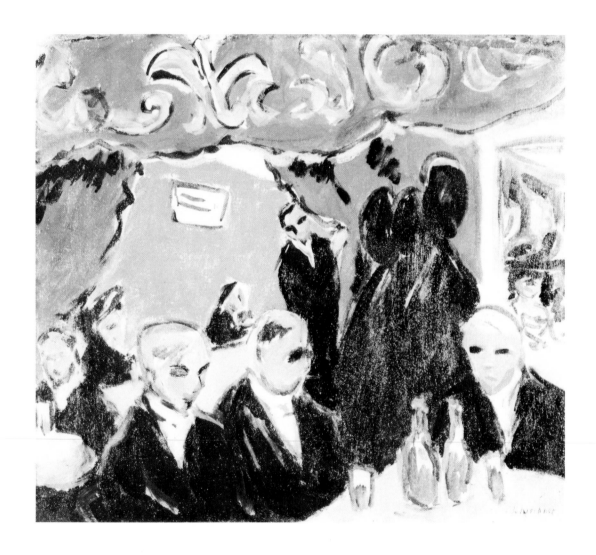

130 *Fränzi in Carved Chair (Fränzi vor geschnitztem Stuhl)*. 1910
Oil on canvas, 27¾ x 19¹¹⁄₁₆″ (70.5 x 50 cm.)
Signed l.r.: *EL Kirchner*; Estate stamp on reverse:
KN-Dre/Ba 14a.
Gordon, cat. no. 122
Thyssen-Bornemisza Collection, Lugano, Switzerland

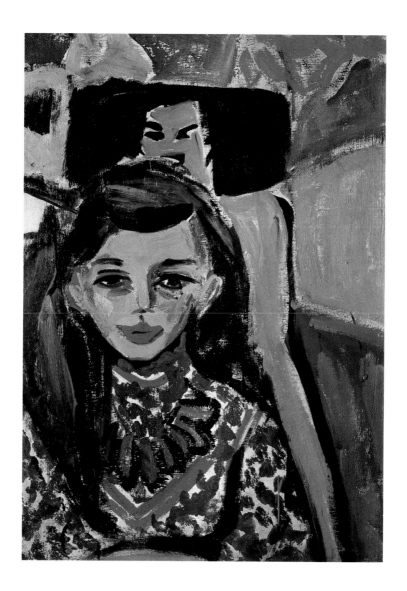

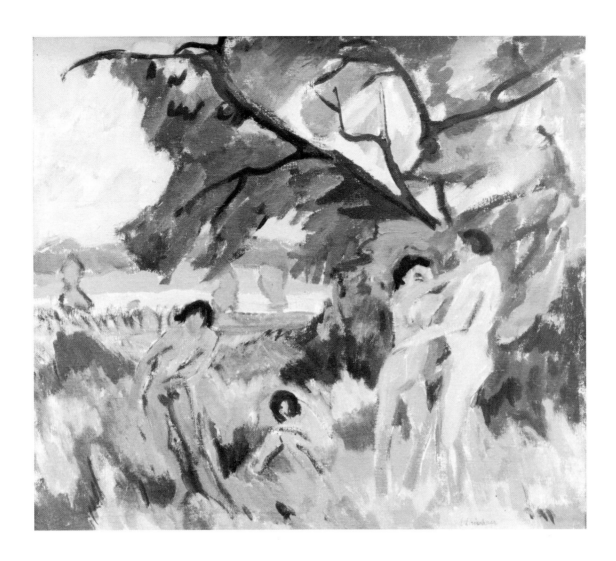

ERNST LUDWIG KIRCHNER

131 *Nudes Playing Under Tree (Spielende nackte Menschen
 unter Baum)*. 1910
 Oil on canvas, 30⁵⁄₁₆ x 35¹⁄₁₆″ (77 x 89 cm.)
 Signed l.r.: *EL Kirchner*. Not dated.
 Gordon, cat. no. 141
 Private Collection

132 *Dance Training (Ballettraining)*. 1910–11
 Oil on canvas, 47 x 35¼″ (119.4 x 89.5 cm.)
 Signed u.r.: *EL Kirchner*; u.l.: *K*; Estate stamp on
 reverse: *KN-Be/Bg 1a*. Not dated.
 Gordon, cat. no. 172
 Collection Mr. and Mrs. Charles Meech, Minneapolis

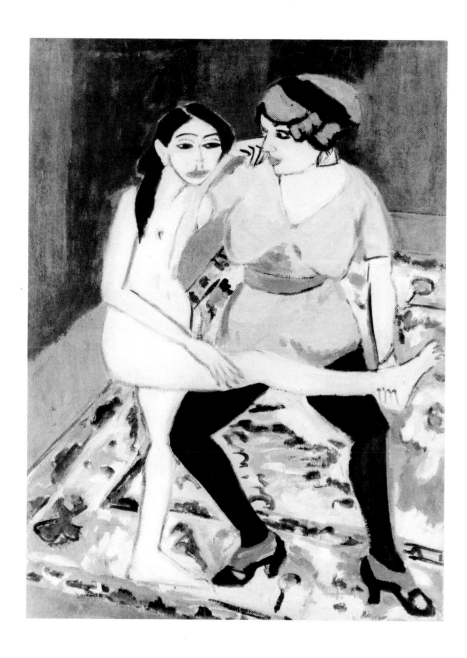

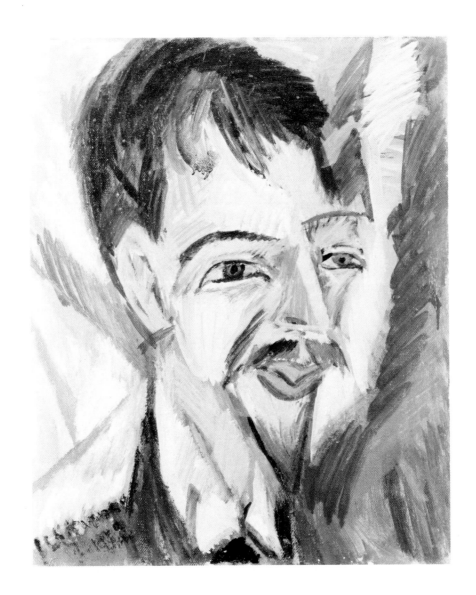

ERNST LUDWIG KIRCHNER

133 *Portrait of Alfred Döblin.* 1912
 Oil on canvas, 20 x 16¼″ (50.8 x 41.3 cm.)
 Signed l.l.: *E.L. Kirchner.* Not dated.
 Gordon, cat. no. 290
 Collection Busch-Reisinger Museum, Harvard University,
 Cambridge, Massachusetts, Purchase–Museum Association
 Fund

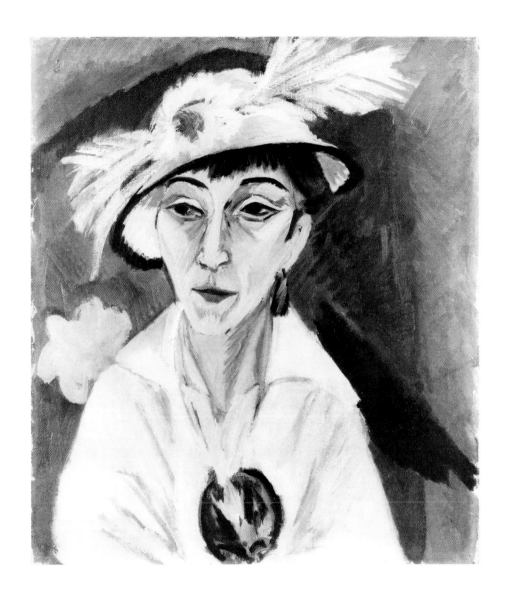

ERNST LUDWIG KIRCHNER

134 *Sick Woman; Woman with Hat (Kranke Frau; Dame mit Hut)*. 1913
Oil on canvas, 28⅛ x 23⅞″ (71.5 x 60.5 cm.)
Signed u.l.: *EL Kirchner.* Not dated.
Gordon, cat. no. 298
Private Collection

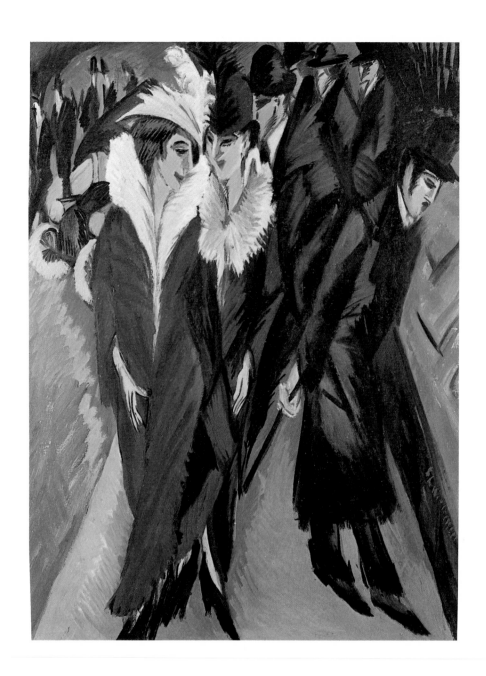

ERNST LUDWIG KIRCHNER

*135 *Street, Berlin (Strasse, Berlin)*. 1913
Oil on canvas, 47½ x 35⅞″ (120.6 x 91 cm.)
Signed l.r.: *EL Kirchner.* Not dated.
Gordon, cat. no. 364
Collection The Museum of Modern Art, New York,
Purchase, 1939

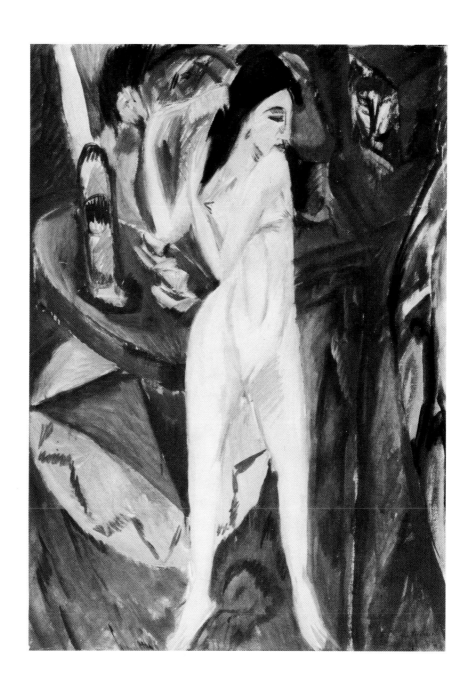

ERNST LUDWIG KIRCHNER

136 *Nude Woman Combing Her Hair (Sich kämmender Akt).*
1913
Oil on canvas, 49¼ x 35⁷⁄₁₆″ (125 x 90 cm.)
Signed l.r.: *EL Kirchner.* Not dated.
Gordon, cat. no. 361
Collection Brücke-Museum, Berlin

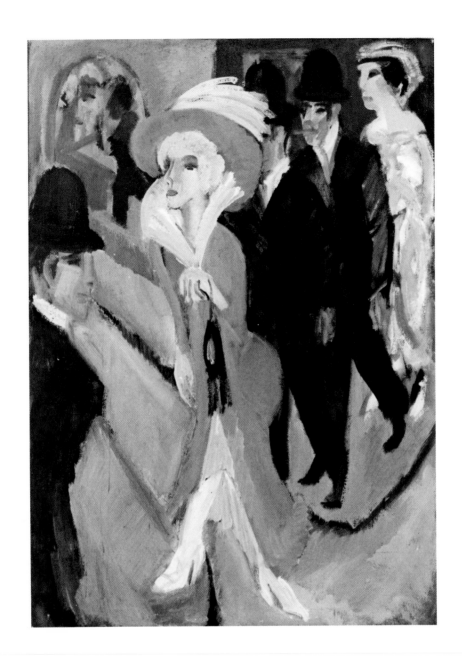

ERNST LUDWIG KIRCHNER

137 *Street with Red Cocotte (Strasse mit roter Kokotte)*. 1914
 Oil on canvas, 47¼ x 35⁷⁄₁₆″ (120 x 90 cm.)
 Not signed or dated. Estate stamp on reverse: *14, KN-Be/Bb 2.*
 Gordon, cat. no. 366
 Thyssen-Bornemisza Collection, Lugano, Switzerland

138 *Circus Rider (Zirkusreiter)*. 1914
Oil on canvas, 80 x 60″ (203.2 x 152.4 cm.)
Not signed or dated.
Gordon, cat. no. 382
Collection of Morton D. May

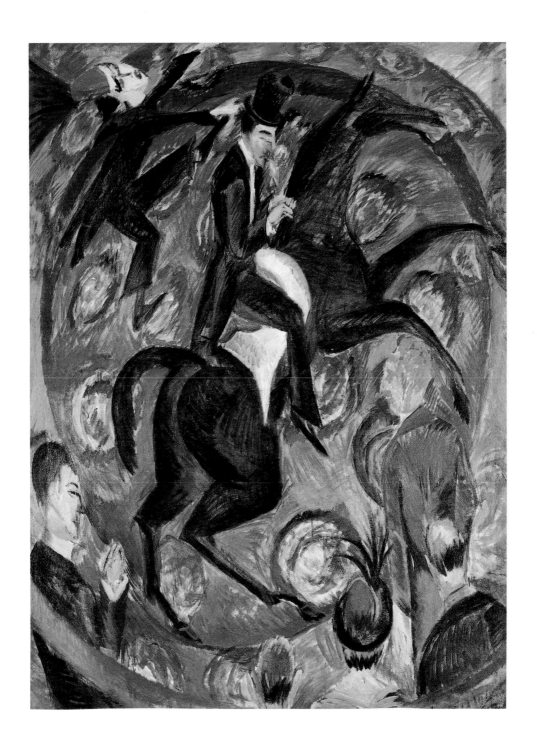

139 *View from the Window (Blick aus dem Fenster).* 1914
 Oil on canvas, 47½ x 36" (120.7 x 91.4 cm.)
 Signed on reverse: *E.L. Kirchner.* Not dated.
 Gordon, cat. no. 380
 Collection of Morton D. May

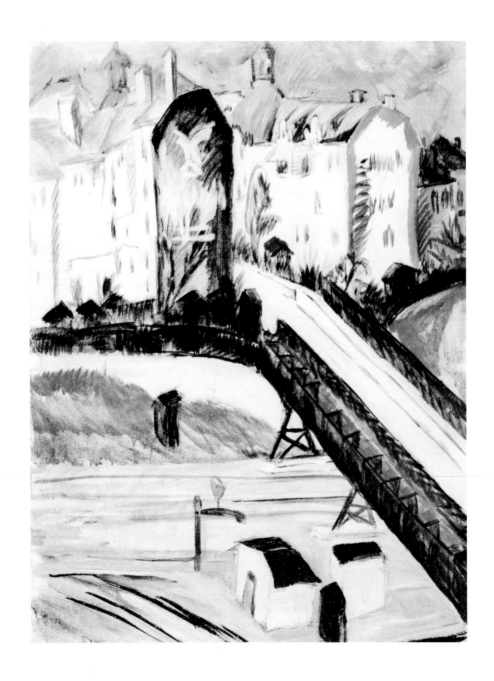

140 *The Drinker; Self-Portrait (Der Trinker; Selbstbildnis)*.
1915
Oil on canvas, 47 x 35⅝″ (119.5 x 90.5 cm.)
Signed and inscribed on reverse: *E.L. Kirchner, Der Trinker*.
Not dated.
Gordon, cat. no. 428
Collection Germanisches Nationalmuseum, Nürnberg

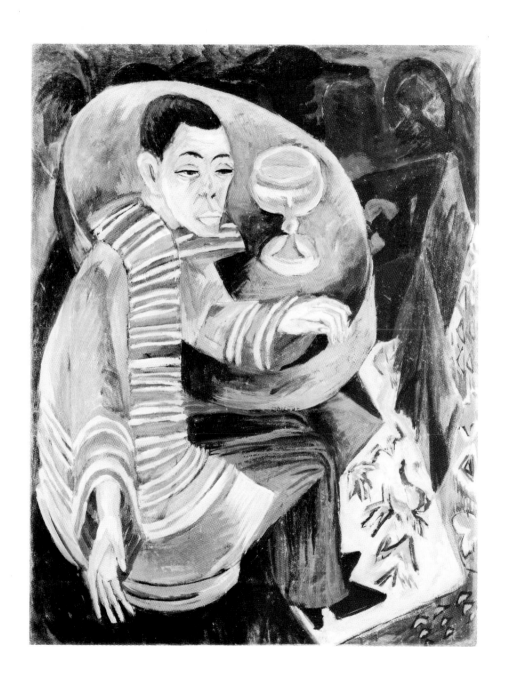

141 *The Red Tower in Halle (Der Rote Turm in Halle)*. 1915
 Oil on canvas, 47¼ x 35¹³⁄₁₆″ (120 x 91 cm.)
 Signed and dated l.l.: *EL Kirchner 15.*
 Gordon, cat. no. 436
 Collection Museum Folkwang, Essen

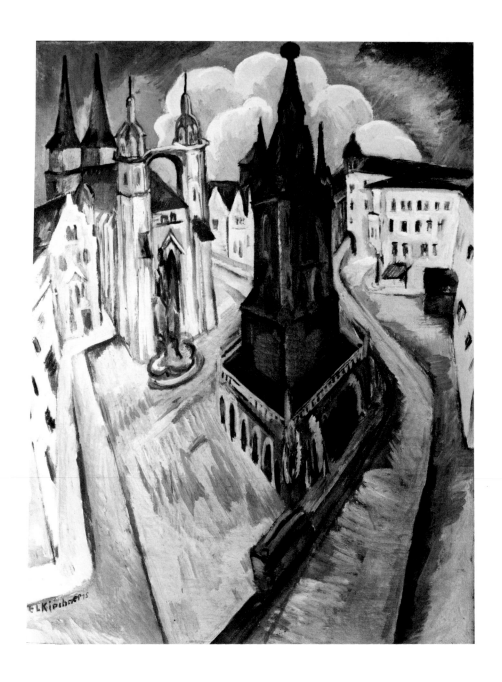

142 *Alpine Landscape (Alpenlandschaft)*. 1919
Oil on canvas, 47½ x 47½″ (120.6 x 120.6 cm.)
Signed l.r.: *EL Kirchner*. Not dated.
Gordon, cat. no. 558
Collection The Detroit Institute of Arts, Gift of Curt Valentin,
Buchholz Gallery, New York, presented in memory of the
artist on the occasion of Dr. Valentiner's 60th birthday

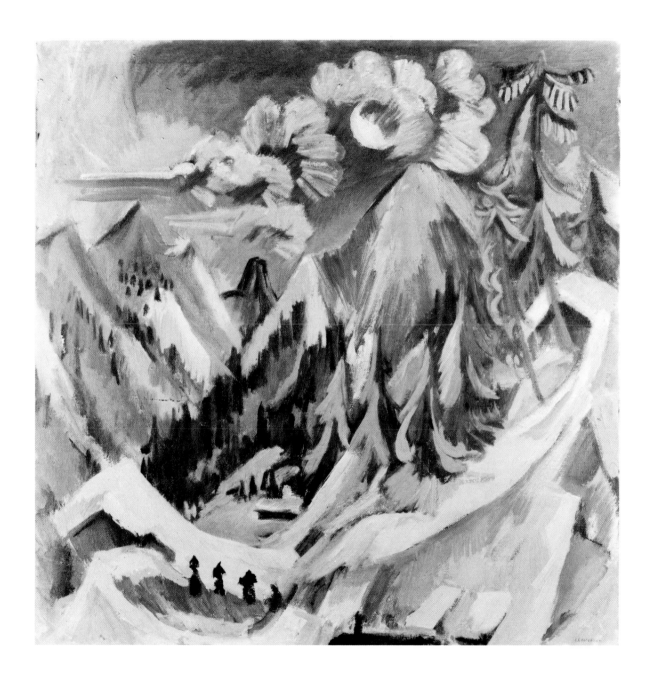

143 *Self-Portrait with a Cat (Selbstporträt mit Katze)*. 1920
Oil on canvas, 47¼ x 31½″ (120 x 80 cm.)
Signed l.l.: *E.L. Kirchner*. Not dated.
Gordon, cat. no. 621
Collection Busch-Reisinger Museum, Harvard University,
Cambridge, Massachusetts, Museum Purchase

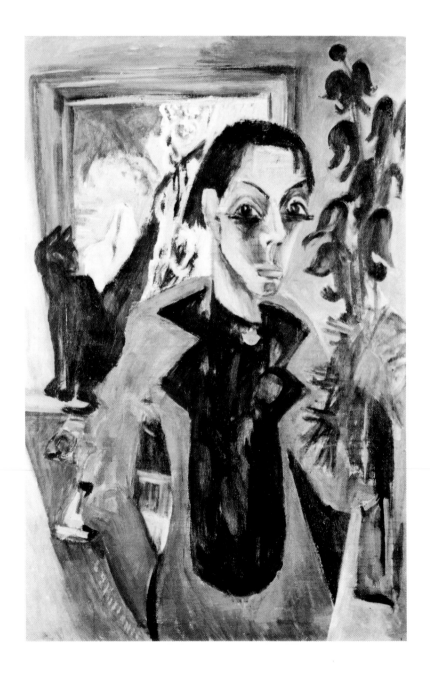

144 *Barges on the Elbe (Elbezillen)*. 1905
Watercolor, gouache, and lead pencil, 13¾ x 17¾″
(35 x 45 cm.)
Signed and dated l.l.: *EL Kirchner 05.*
Collection Museum Folkwang, Essen

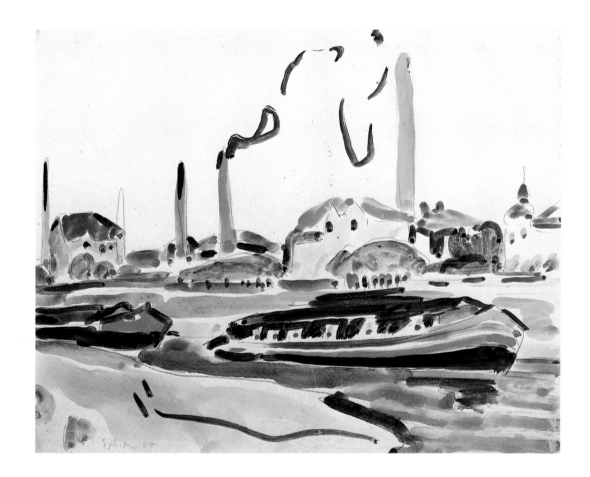

145 *Two Girls on a Rug (Zwei Mädchen auf einem Teppich)*.
1905
Tempera, 17⁷/₁₆ x 23″ (44.3 x 58.4 cm.)
Signed and dated l.r.: *EL Kirchner 05.*
Collection Museum Folkwang, Essen

146 *Female Nude by Patterned Curtain (Frauenakt vor
gemustertem Vorhang).* ca. 1910
Gouache, 17 x 14″ (43.2 x 34.7 cm.)
Verso: *Study of a Male Nude (Studie eines männlichen
Aktes)*
Inscribed on reverse with Estate stamp. Not dated.
Collection Museum Folkwang, Essen

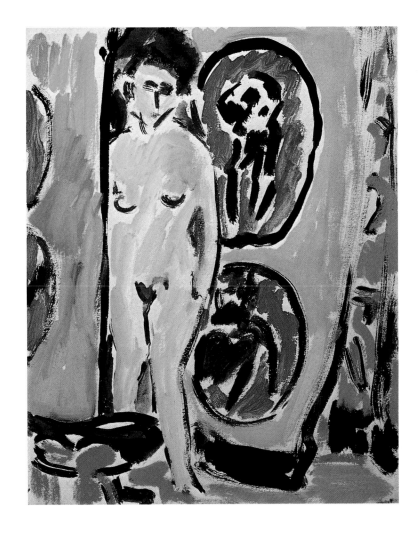

147 *Female Nude (Frauenakt).* ca. 1911
Black crayon, 17½ x 13⁹⁄₁₆″ (44.5 x 34.5 cm.)
Signed l.r.: *EL Kirchner.* Not dated.
Collection Museum Folkwang, Essen

ERNST LUDWIG KIRCHNER

148 *Sleeping Woman (Schlafende)*. ca. 1911–12
 Lead pencil and colored grease pencil, 10¾ x 13⅜″
 (27.1 x 34 cm.)
 Signed on reverse: *E. L. Kirchner*. Not dated.
 Collection Museum Ludwig, Cologne

ERNST LUDWIG KIRCHNER

149 *Artillery Site (Artillerieplatz).* ca. 1915
 Black tempera, 3⅛ x 4⁵⁄₁₆″ (8 x 11 cm.)
 Inscribed on reverse with Estate stamp. Not dated.
 Collection Museum Folkwang, Essen

150 *Shepherd with Two Calves (Hirt mit zwei Kälbern)*. ca. 1920
Watercolor and lead pencil, 19¹¹⁄₁₆ x 14⅜″ (50 x 36.5 cm.)
Signed l.r.: *K.* Not dated.
Collection Museum Ludwig, Cologne

ERNST LUDWIG KIRCHNER

151 *Black Stallion, Horsewoman, and Clown (Rappenhengst,*
 Reiterin und Clown). 1907
 Color lithograph, 23¼ x 20¹⁄₁₆″ (59 x 51 cm.)
 Collection Museum Folkwang, Essen

†152 *Nude Girl (Mädchenakt).* 1908
 Woodcut, 17¼ x 9⅜″ (43.8 x 23.8 cm.)
 Collection Museum Folkwang, Essen

153 *Sailboats (Segelboote).* 1908
 Lithograph, 15¹⁄₁₆ x 12¹⁵⁄₁₆″ (38.3 x 32.9 cm.)
 Collection Museum Folkwang, Essen

†154 *Self-Portrait with Pipe (Selbstbildnis mit Pfeife).* 1908
 Etching, 8¾ x 7⅞″ (22.2 x 20 cm.)
 Collection Museum Folkwang, Essen

†155 *Performer's Child (Artistenkind).* 1909
 Lithograph, 15¹⁄₁₆ x 15⅜″ (38.3 x 39 cm.)
 Collection Museum Folkwang, Essen

†156 *Cake-Walk.* 1910
 Lithograph, 13⅜ x 15⅜″ (34 x 38 cm.)
 Collection Museum Folkwang, Essen

ERNST LUDWIG KIRCHNER

†157 *Railway Station: Friedrichstadt, Dresden (Bahnhof
 Dresden Friedrichstadt).* 1911
 Etching, 10⅛ x 14¹³⁄₁₆″ (25.8 x 37.7 cm.)
 Collection Museum Folkwang, Essen

 158 *Girl Bathing in Tub with Hand Mirror (Badendes Mädchen
 im Tub mit Handspiegel).* 1911
 Etching, 12⅝ x 9¾″ (32 x 24.7 cm.)
 Collection Museum Folkwang, Essen

†159 *Städtischer Platz in Dresden.* 1911
 Lithograph, 13 x 15³⁄₁₆″ (33 x 38.5 cm.)
 Collection Museum Folkwang, Essen

†160 *Fehmarn Girl (Fehmarnmädchen).* 1913
 Woodcut, 16½ x 14⅝″ (42 x 37.2 cm.)
 Collection Museum Folkwang, Essen

†161 *Woman with Two Boys in Sailboat (Frau mit zwei Buben im
 Segelboot).* 1914
 Woodcut, 20½ x 15⅛″ (52 x 38.4 cm.)
 Collection Museum Folkwang, Essen

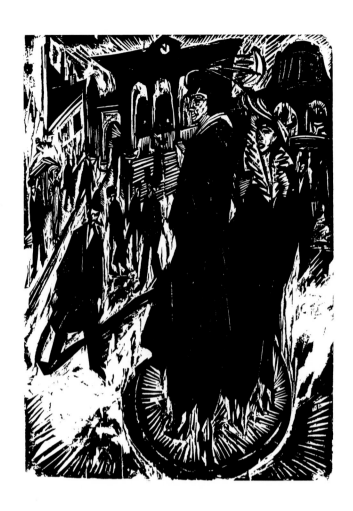

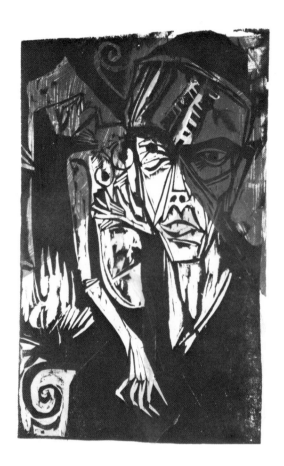

ERNST LUDWIG KIRCHNER

162 *Women on the Potsdamer Platz (Frauen am Potzdamer Platz)*. 1914
Woodcut, 20½ x 15⅛″ (52 x 38.4 cm.)
Collection Museum Folkwang, Essen

163 *Fighting (Kämpfe)*. 1915
Color woodcut, 13 x 8¼″ (33.1 x 21 cm.)
Collection Museum Folkwang, Essen

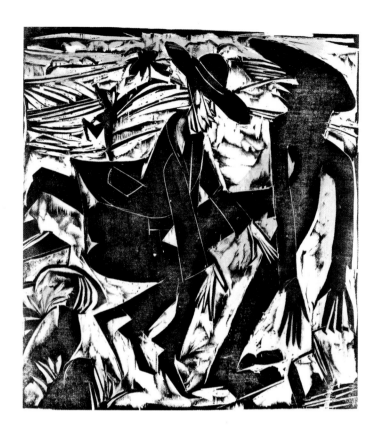

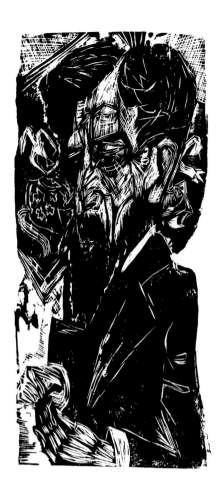

ERNST LUDWIG KIRCHNER

164 *Schlemihl's Encounter with the Shadow (Schlemihls Begegnung mit dem Schatten).* 1915
Color woodcut, 12⅛ x 11¼" (30.8 x 28.6 cm.)
Collection Museum Folkwang, Essen

†165 *Artillery Site (Artillerieplatz).* 1915
Color woodcut, 12¹³⁄₁₆ x 19³⁄₁₆" (32.5 x 48.8 cm.)
Collection Museum Folkwang, Essen

166 *Portrait of van Vloten.* 1917
Woodcut, 23¼ x 16¹⁵⁄₁₆" (59 x 43 cm.)
Collection Museum Folkwang, Essen

†167 *Portrait of Dr. Griesebach.* 1917
Woodcut, 16⅝ x 10⅞" (42.2 x 27.6 cm.)
Collection Museum Folkwang, Essen

ERNST LUDWIG KIRCHNER

†168 *Portrait of Dr. Binswanger.* 1917
Woodcut, 20⅜ x 10¼″ (51.8 x 26 cm.)
Collection Museum Folkwang, Essen

†169 *Young Girl with Cigarette (Junges Mädchen mit
Zigarette).* 1918
Woodcut, 19⁹⁄₁₆ x 15⅝″ (49.7 x 39.8 cm.)
Collection Museum Folkwang, Essen

†170 *Self-Portrait with Dancing Death (Selbstporträt mit
tanzendem Tod).* 1918
Woodcut, 19¹¹⁄₁₆ x 13⅜″ (50 x 34 cm.)
Collection Museum Folkwang, Essen

†171 *Portrait of Ludwig Schames.* 1918
Woodcut, 22⅝ x 10¼″ (57.5 x 26 cm.)
Collection Museum Folkwang, Essen

 172 *Staffel Alp (Staffelalp).* 1918
Woodcut, 14 x 17¹⁵⁄₁₆″ (35.5 x 45.5 cm.)
Collection Museum Folkwang, Essen

173 *Winter Moon Night (Wintermondnacht)*. 1919
Color woodcut, 11¹⁵⁄₁₆ x 11½″ (30.3 x 29.3 cm.)
Collection Museum Folkwang, Essen

†174 *Alpine Path with Storm Firs (Alpenweg mit Wettertannen)*.
1921
Color etching, 11⅛ x 9⅞″ (28.2 x 25 cm.)
Collection Museum Folkwang, Essen

175 *White House in Meadows (Weisses Haus in Wiesen)*. 1920
Woodcut, 15³⁄₁₆ x 22¾″ (38.5 x 57.8 cm.)
Collection Museum Folkwang, Essen

176 *Self-Portrait (Selbstbildnis)*. 1906
 Oil on paperboard, 17⅝₁₆ x 12⅝″ (44 x 32 cm.)
 Signed and dated l.l.: *Schmidt-Rottluff 1906.*
 Nolde-Stiftung Seebüll

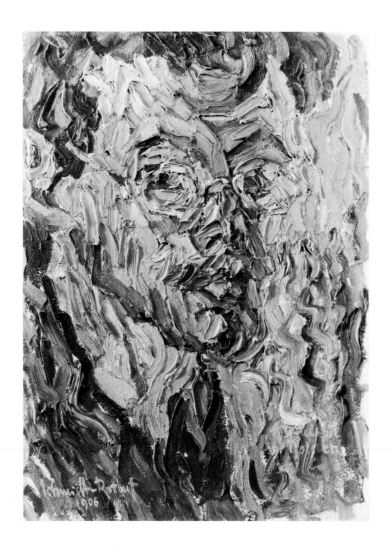

177 *Autumn Landscape in Oldenburg (Oldenburgische Herbst-landschaft)*. 1907
Oil on canvas, 29½ x 38³⁄₁₆″ (75 x 97 cm.)
Signed and dated l.r.: *S. Rottluff 1907.*
Thyssen-Bornemisza Collection, Lugano, Switzerland

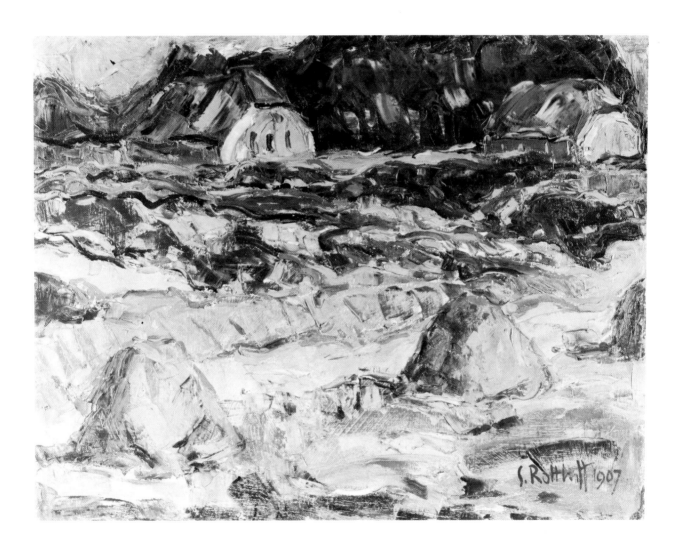

178 *Midday in the Moor (Mittag am Moor [Dangast])*. 1908
Oil on canvas, 27⅞₁₆ x 32½″ (70 x 82.5 cm.)
Signed and dated l.l.: *S. Rottluff 1908*.
Collection Landesmuseum Oldenburg

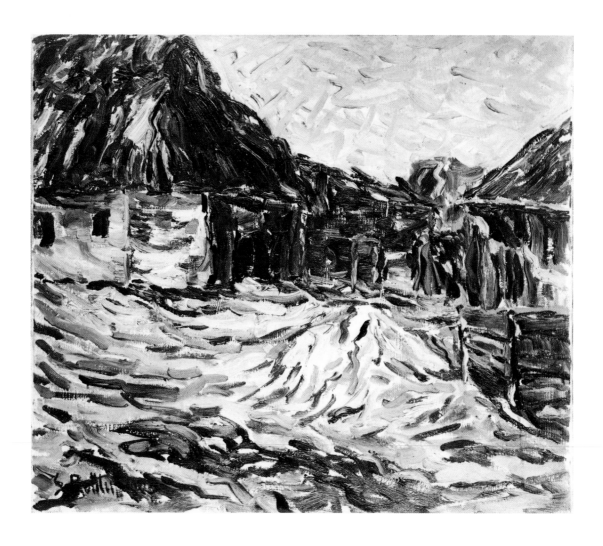

179 *Farmhouse in Dangast (Gutshof in Dangast)*. 1910
Oil on canvas, 34 1/16 x 37 3/16″ (86.5 x 94.5 cm.)
Signed l.l.: *S. Rottluff*. Not dated.
Collection Staatliche Museen Preussischer Kulturbesitz,
Nationalgalerie, Berlin

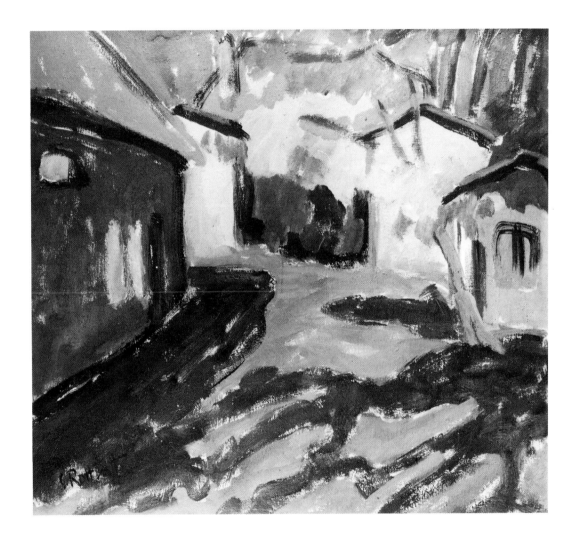

180 *Bursting Dam (Deichdurchbruch)*. 1910
Oil on canvas, 29¹⁵⁄₁₆ x 33¹⁄₁₆″ (76 x 84 cm.)
Signed and dated l.l.: *S-Rottluff 1910*.
Collection Brücke-Museum, Berlin

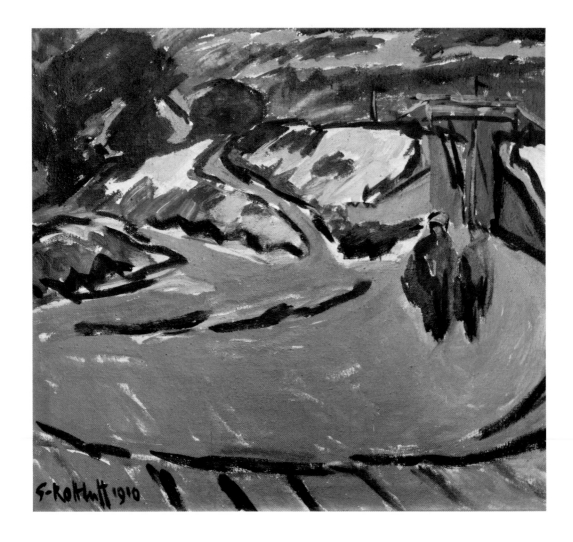

181 *Fir Trees in Front of a White House (Tannen vor weissem Haus)*. 1911
Oil on canvas, 31⅛ x 33¼" (79 x 84.5 cm.)
Signed and dated l.r.: *S. Rottluff 1911*.
Collection Staatliche Museen Preussischer Kulturbesitz,
Nationalgalerie, Berlin

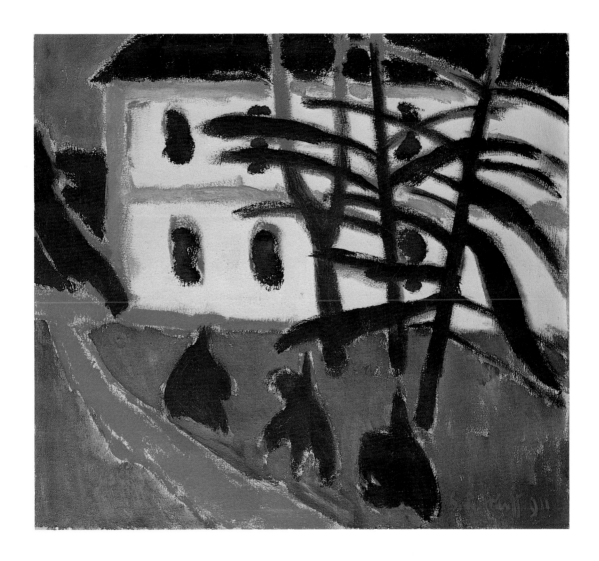

182 *Rising Moon (Aufgehender Mond).* 1912
 Oil on canvas, 34½ x 37½″ (87.6 x 95.3 cm.)
 Signed l.r.: *S. Rottluff.* Not dated.
 Collection of Morton D. May

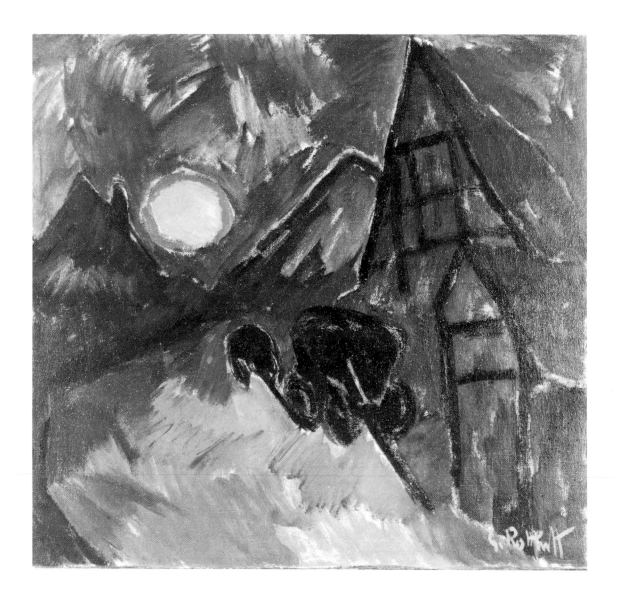

183 *Tower of St. Petri in Hamburg (Petriturm in
Hamburg).* 1912
Oil on canvas, 33$\frac{1}{16}$ x 29$\frac{15}{16}$″ (84 x 76 cm.)
Signed l.r.: *S. Rottluff.* Not dated.
Private Collection, Essen, West Germany

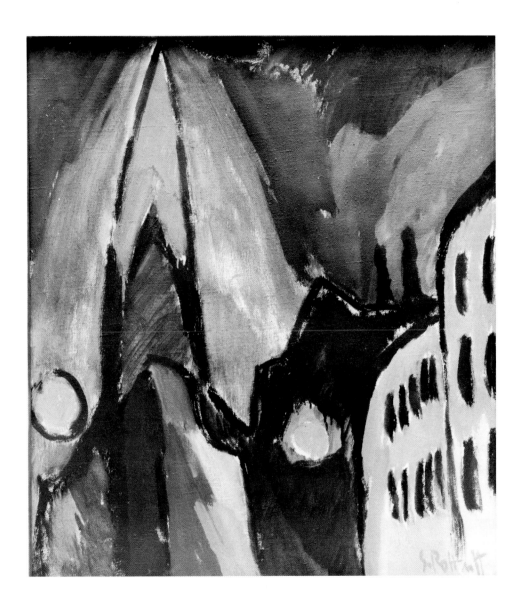

184 *Pharisees (Pharisäer).* 1912
 Oil on canvas, 29⅞ x 40½″ (75.8 x 102.9 cm.)
 Signed and dated l.r.: *S. Rottluff 1912.*
 Collection The Museum of Modern Art, New York,
 Gertrude A. Mellon Fund, 1955

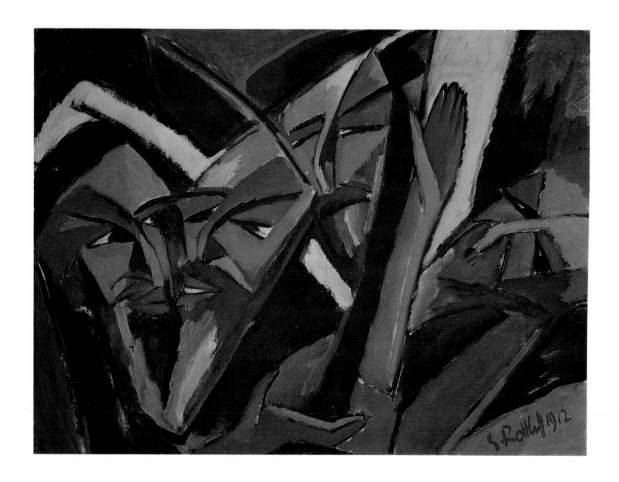

185 *Girl at Her Toilette (Mädchen bei der Toilette)*. 1912
Oil on canvas, 33⅟₁₆ x 29¹⁵⁄₁₆″ (84 x 76 cm.)
Signed and dated l.r.: *S. Rottluff 1912*.
Collection Brücke-Museum, Berlin

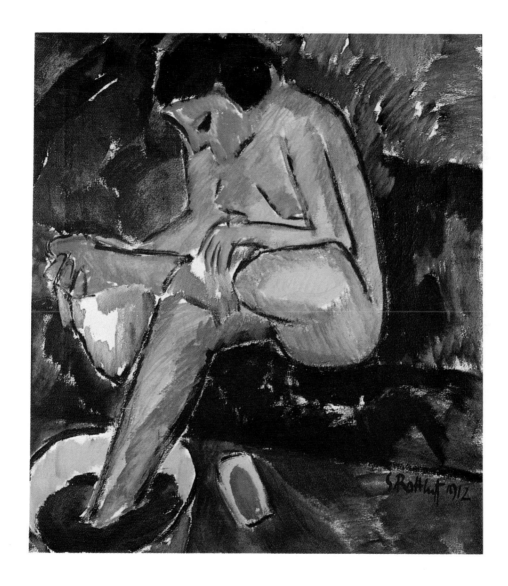

186 *Newspaper Stall (Im Kiosk)*. 1912–19
 Oil on canvas, 34½ x 37⅜″ (87.5 x 95.5 cm.)
 Signed and dated l.r.: *S. Rottluff 12/19*.
 Private Collection

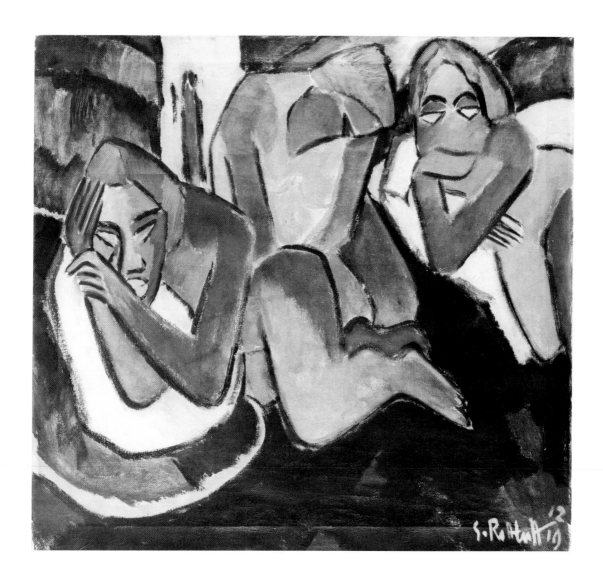

187 *Three Nudes (Drei Akte)*. 1913
Oil on canvas, 41 7/8 x 38 5/8" (106.5 x 98 cm.)
Signed and dated l.r.: *S. Rottluff 1913.*
Collection Staatliche Museen Preussischer Kulturbesitz,
Nationalgalerie, Berlin

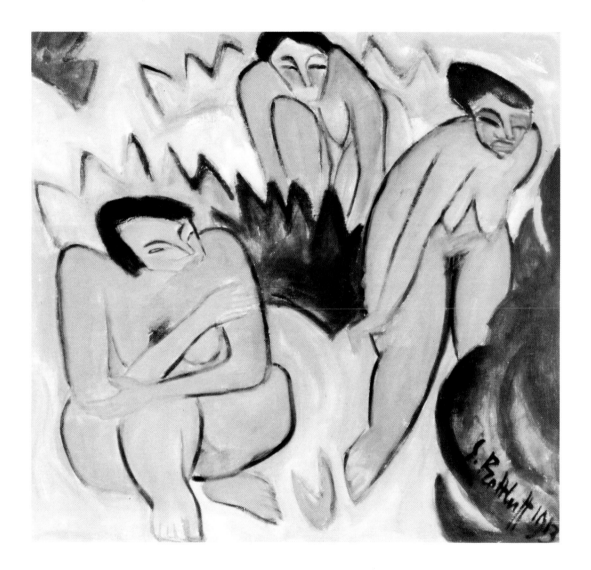

188 *Double-Portrait (Self-Portrait with Wife) (Doppelportrait [Selbstbildnis mit Frau]).* 1919
Oil on canvas, 35⅞ x 30″ (90.4 x 76.2 cm.)
Signed and dated l.l.: *S. Rottluff 1919.*
Collection Staatsgalerie moderner Kunst, Munich

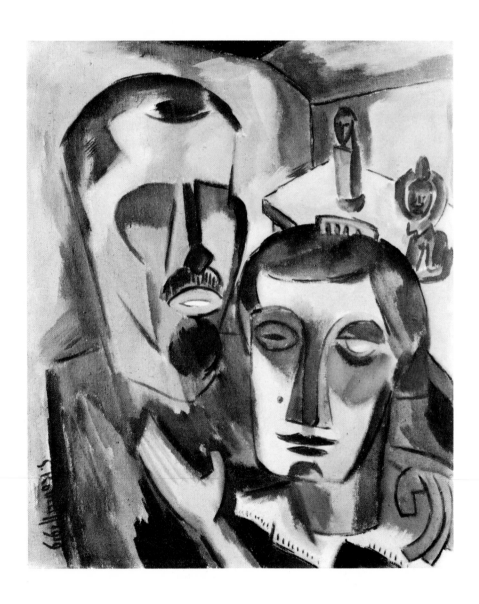

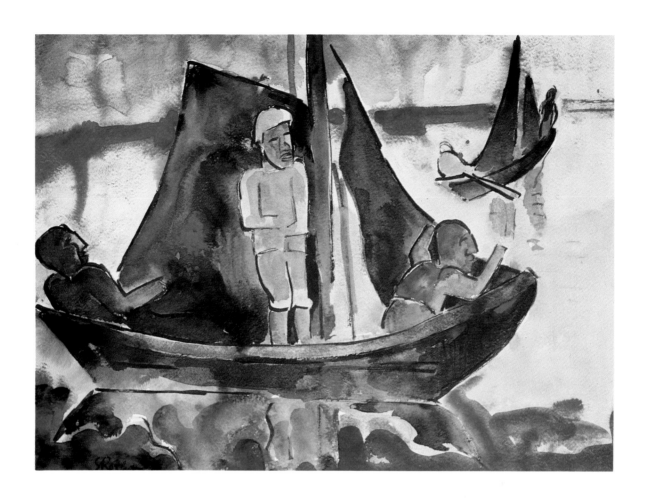

KARL SCHMIDT-ROTTLUFF

189 *Fishing Boats in the Calm (Fischerboote in der Flaute).*
ca. 1919–22
Reed pen with watercolor and tempera, 19⁹⁄₁₆ x 26⅞″
(49.6 x 68.3 cm.)
Signed l.l.: *S. Rottluff*; inscribed on reverse: *Vom Künstler
betitelt.* Not dated.
Collection Museum Ludwig, Cologne

†190 *House on Mountain (Haus am Berg).* 1910
Lithograph, 13¼ x 15⁹⁄₁₆″ (33.7 x 39.8 cm.)
Collection Museum Folkwang, Essen

KARL SCHMIDT-ROTTLUFF

191 *Nude (Akt)*. 1911
Lithograph, 13⅜ x 15¾″ (34 x 40 cm.)
Collection Museum Folkwang, Essen

192 *Villa with Tower (Villa mit Turm)*. 1911
Woodcut, 19¹¹⁄₁₆ x 15½″ (50 x 39.2 cm.)
Collection Museum Folkwang, Essen

KARL SCHMIDT-ROTTLUFF

193 *From Rastede (Aus Rastede)*. 1912
Lithograph, 13¹³⁄₁₆ x 17″ (32.5 x 43.2 cm.)
Collection Museum Folkwang, Essen

†194 *Ships in Harbor (Schiffe im Hafen)*. 1913
Woodcut, 11⅛ x 12¹¹⁄₁₆″ (28.2 x 32.2 cm.)
Collection Museum Folkwang, Essen

195 *Firs (Tannen)*. 1914
Woodcut, 15¹³⁄₁₆ x 19¹¹⁄₁₆″ (40.1 x 50 cm.)
Collection Museum Folkwang, Essen

†196 *Sisters (Die Schwestern)*. 1914
Woodcut, 15⅞ x 19⅝″ (40.3 x 49.9 cm.)
Collection Museum Folkwang, Essen

KARL SCHMIDT-ROTTLUFF

197 *Dunes and Pier (Dünen und Mole)*. 1917
 Color woodcut, 11⁵⁄₁₆ x 13³⁄₈″ (28.8 x 34 cm.)
 Collection Museum Folkwang, Essen

†198 *Head of a Woman (Frauenkopf)*. 1918
 Woodcut, 14³⁄₁₆ x 11½″ (36 x 29.1 cm.)
 Collection Museum Folkwang, Essen

199 *Walk to Emmaus (Gang nach Emmaus)*. 1918
 Woodcut, 15⁵⁄₁₆ x 19¹¹⁄₁₆″ (39.8 x 50 cm.)
 Collection Museum Folkwang, Essen

170

KARL SCHMIDT-ROTTLUFF

200 *Christ and Judas.* 1918
Woodcut, 15⁷⁄₁₆ x 27½″ (39.3 x 69.8 cm.)
Collection Museum Folkwang, Essen

†201 *Disciple (Jünger).* 1918
Woodcut, 19¾ x 15¹⁵⁄₁₆″ (50.3 x 40.5 cm.)
Collection Museum Folkwang, Essen

†202 *Woman Reclining at Edge of Forest (Liegende Frau am Waldrand).* 1920
Etching, 14³⁄₁₆ x 16½″ (36 x 42.5 cm.)
Collection Museum Folkwang, Essen

203 *Sun in Forest (Sonne im Wald).* 1923
Etching, 13⅛ x 15¾″ (33.3 x 40 cm.)
Collection Museum Folkwang, Essen

204 *River Landscape (Flusslandschaft)*. ca. 1907
 Oil on canvas, 20⅞ x 26¾″ (53 x 68 cm.)
 Signed l.r.: *HMP*. Not dated.
 Collection Museum Folkwang, Essen

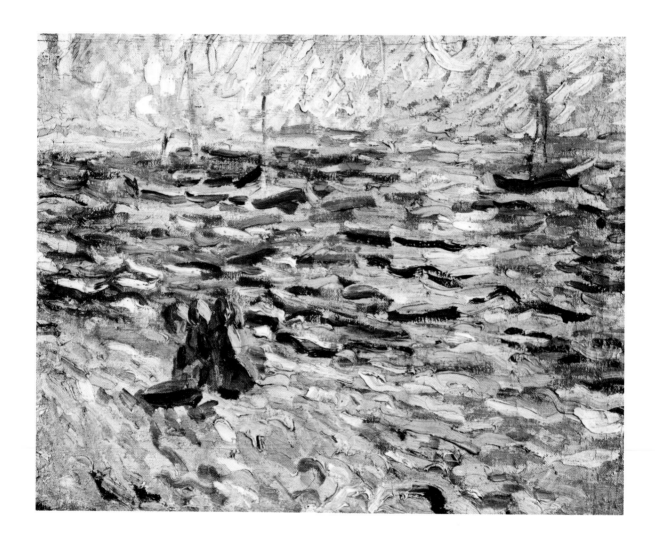

■205 *At the Lake (Am Seeufer)*. 1910
Oil on canvas, 27½ x 31½" (70 x 80 cm.)
Signed and dated l.l.: *HMP 1910*.
Private Collection

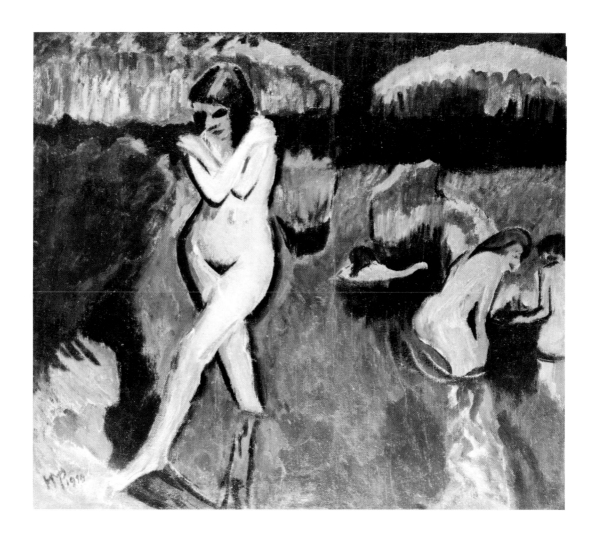

206 *Dance (Tanz)*. 1910
 Oil on canvas, 37⅜ x 47¼″ (95 x 120 cm.)
 Not signed or dated.
 Private Collection

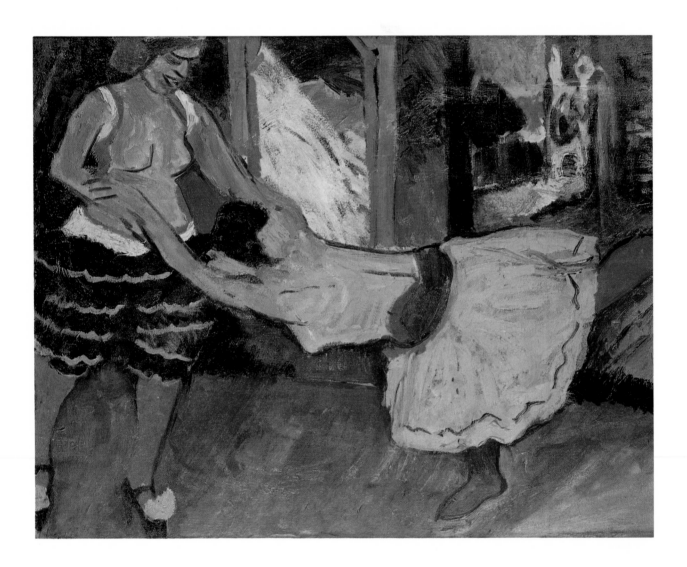

207 *Indian and Woman (Inder und Weib)*. 1910
Oil on canvas, 32¼ x 26¼″ (81.9 x 66.7 cm.)
Signed and dated l.l.: *HMP 1910.*
Collection of Morton D. May

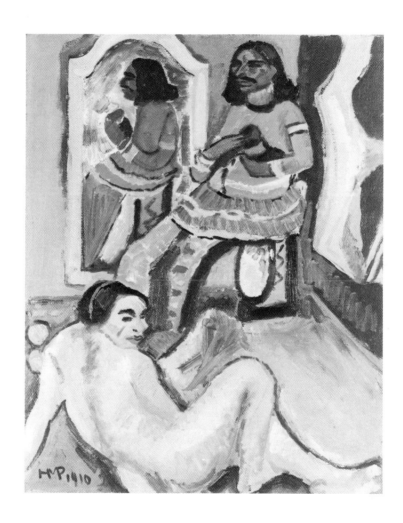

208 *The Great Indian (Der grosse Inder)*. 1910
 Oil on canvas, 35 x 35″ (88.9 x 88.9 cm.)
 Signed and dated u.l.: *HMP 1910*.
 Collection of Morton D. May

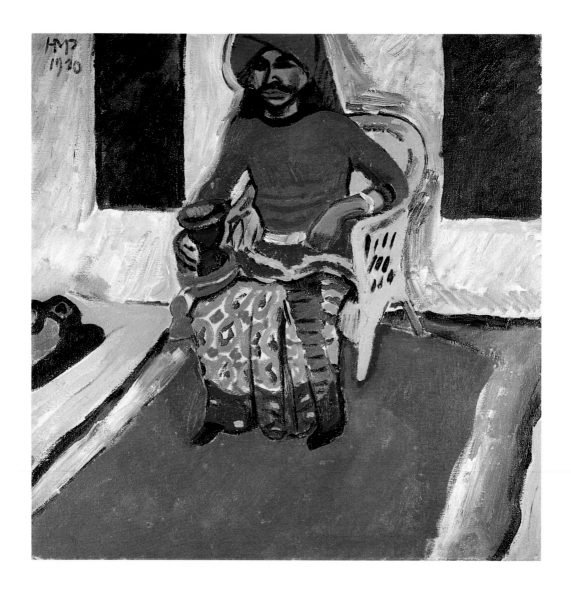

209 *Horse Market near Moritzburg (Pferdemarkt bei Moritzburg).*
1910
Oil on canvas, 27⅜ x 31¹¹⁄₁₆″ (69.5 x 80.5 cm.)
Signed and dated l.r.: *HMP 1910.*
Thyssen-Bornemisza Collection, Lugano, Switzerland

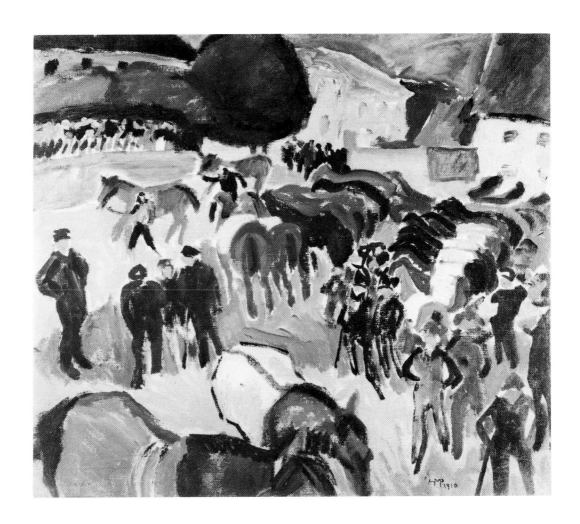

210 *Nude in a Tent (Akt im Zelt)*. 1911
 Oil on canvas, 27¹³⁄₁₆ x 31¹¹⁄₁₆″ (70.6 x 80.5 cm.)
 Signed and dated l.r.: *Pechstein 1911*.
 Collection Staatsgalerie moderner Kunst, Munich

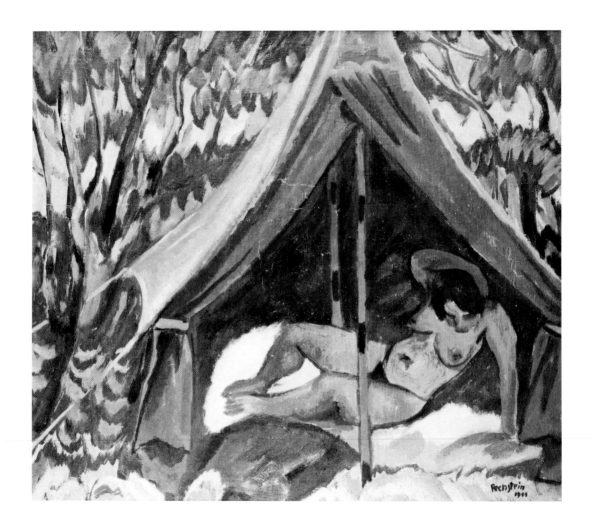

211 *Self-Portrait with Death (Selbstbildnis mit Tod).* 1920
Oil on canvas, 31½ x 27½″ (80 x 70 cm.)
Signed l.l.: *HM Pechstein.* Not dated.
Private Collection

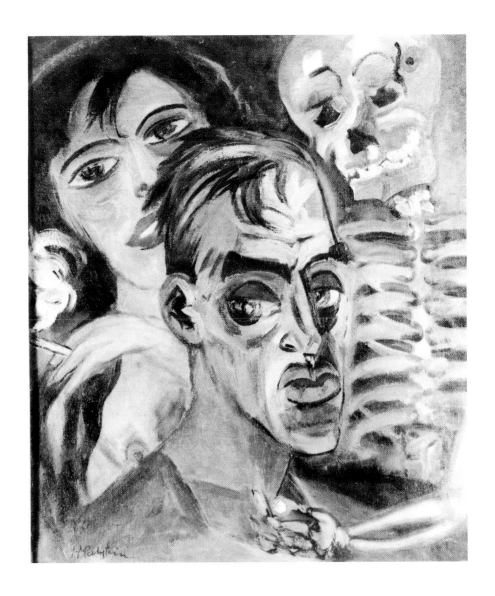

212 *Fishermen in the Surf (Fischer in der Brandung)*. 1920
Lead pencil and watercolor, 20³⁄₁₆ x 29³⁄₈″ (51.2 x 74.6 cm.)
Signed and dated l.r.: *HM Pechstein 1920*.
Collection Museum Ludwig, Cologne

213 *Vaudeville (Varieté)*. 1909
Color lithograph, 11 x 14⅞″ (28 x 37.7 cm.)
Collection Museum Folkwang, Essen

†214 *Female Head (Weiblicher Kopf)*. 1909
Lithograph, 22¹⁄₁₆ x 16⅞″ (56 x 42.8 cm.)
Collection Museum Folkwang, Essen

215 *Landscape with Cows (Landschaft mit Kühen)*. 1919
Woodcut, 12½ x 15¾″ (31.8 x 39.9 cm.)
Collection Museum Folkwang, Essen

216 *Dialogue (Zwiesprache)*. 1920
Color woodcut, 15¾ x 12⁹⁄₁₆″ (40 x 31.9 cm.)
Collection Museum Folkwang, Essen

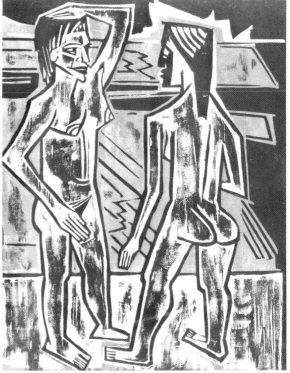

217 *Bathers in Reedy Ditch (Badende im Schilfgraben)*. 1914
Distemper on canvas, 36¼ x 31⅛″ (92 x 79 cm.)
Signed l.l.: *O.M.* Not dated.
Collection Staatliche Museen Preussischer Kulturbesitz,
Nationalgalerie, Berlin

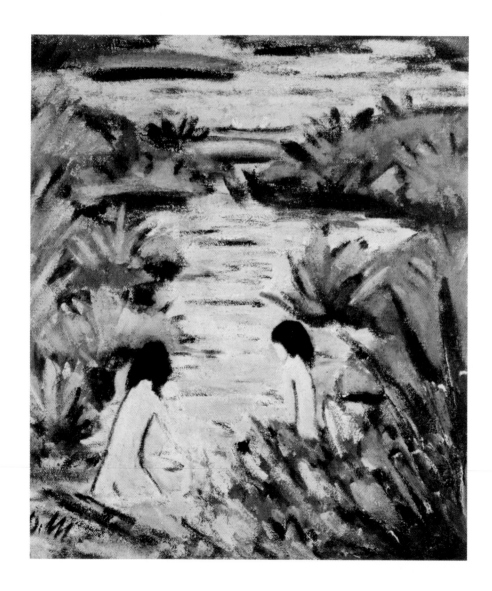

218 *Pair of Lovers Between Garden Walls (Liebespaar zwischen Gartenmauern).* 1916
Distemper on canvas, 26 x 35⁷⁄₁₆″ (66 x 90 cm.)
Signed and dated on reverse: *Otto Mueller 1916.*
Collection Brücke-Museum, Berlin

219 *Maschka with Mask (Maschka mit Maske)*. 1919–21
 Distemper on canvas, 37$\frac{11}{16}$ x 26$\frac{9}{16}$″ (95.8 x 67.5 cm.)
 Signed l.l.: *OM*. Not dated.
 Collection Museum Folkwang, Essen

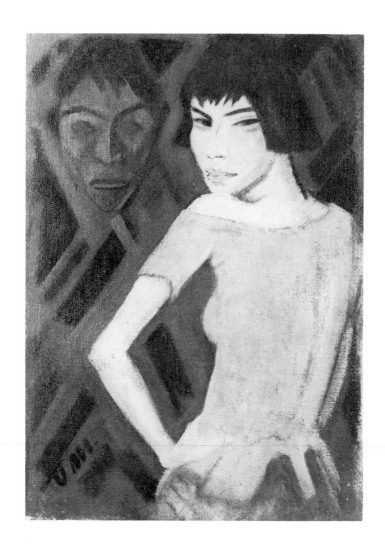

220 *Female Nudes in Open Air (Weibliche Akte im Freien)*.
1920
Oil on canvas, 33⅞ x 43¹¹⁄₁₆″ (86 x 111 cm.)
Signed on reverse: *Otto Mueller*. Not dated.
Collection Von der Heydt-Museum Wuppertal

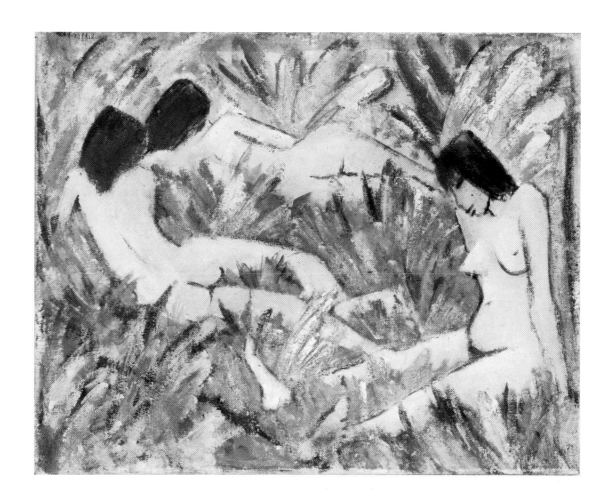

221 *Nude on a Couch (Akt auf Sofa).* n.d.
Distemper on canvas, 37⅜ x 47¼″ (95 x 120 cm.)
Signed l.r.: *OM*; signed on reverse: *Otto Mueller.* Not dated.
Private Collection

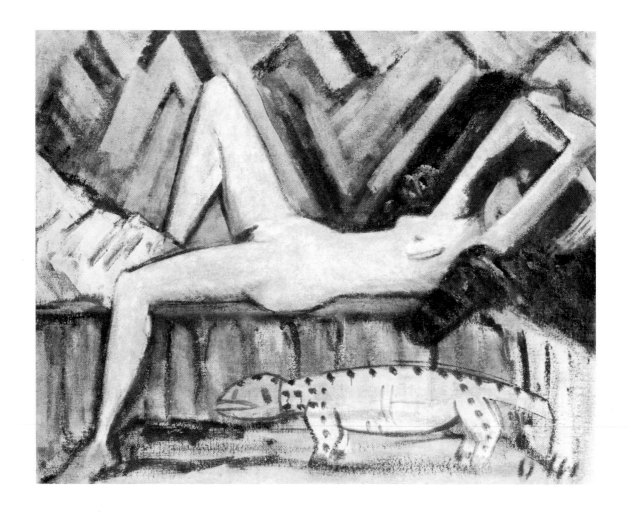

222 *Nude Girl on the Sofa (Mädchenakt auf dem Sofa)*. n.d.
Black and colored crayon, 24⅜ x 18½″ (62 x 47 cm.)
Signed l.l.: *Otto Mueller.* Not dated.
Collection Museum Ludwig, Cologne

OTTO MUELLER

223 *Crouching Woman (Hockende).* n.d.
Watercolor with black and colored crayon, 26⅞ x 20½″
(68.2 x 52 cm.)
Signed l.r.: *Otto Mueller.* Not dated.
Collection Museum Ludwig, Cologne

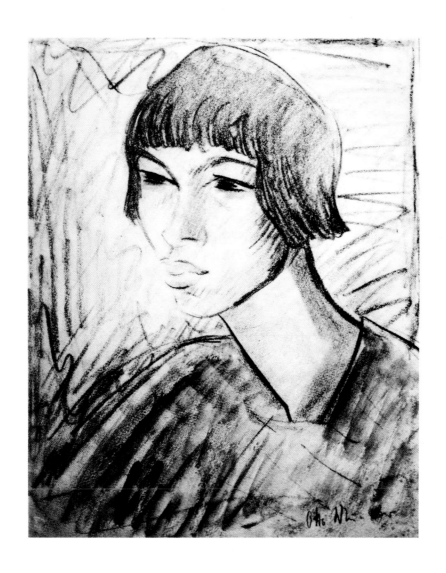

OTTO MUELLER

224 *Portrait of the Artist's Wife (Bildnis der Frau des Künstlers)*. n.d.
Black and colored crayon, 22³⁄₁₆ x 17⅞″ (56.4 x 45.4 cm.)
Signed l.r.: *Otto Mueller*. Not dated.
Collection Museum Ludwig, Cologne

225 *Two Girls Sitting in Dunes II (Zwei in Dünen sitzende Mädchen II)*. 1920
Color lithograph, 13⅞ x 18⅛″ (35.2 x 46.1 cm.)
Collection Museum Folkwang, Essen

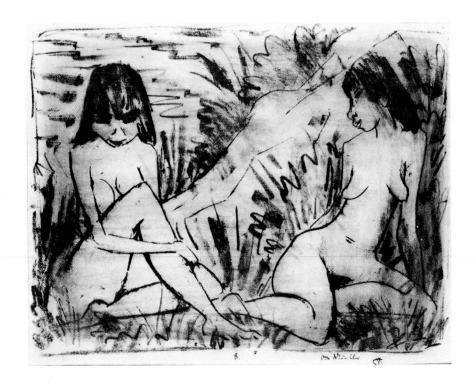

226 *Portrait of a Woman (Frauenbildnis)*. 1922
Lithograph, 15⅜ x 11⁷⁄₁₆″ (39 x 29 cm.)
Collection Museum Folkwang, Essen

227 *Gypsy Family (Zigeunerfamilie)*. 1922
Lithograph, 10³⁄₁₆ x 7⁷⁄₁₆″ (25.9 x 18.8 cm.)
Collection Museum Folkwang, Essen

†228 *Self-Portrait (Selbstbildnis)*. n.d.
Lithograph, 15¹³⁄₁₆ x 11¼″ (40.2 x 28.5 cm.)
Collection Museum Folkwang, Essen

†229 *Five Nudes (Fünf Akte)*. n.d.
Color lithograph, 16¹⁵⁄₁₆ x 20½″ (43 x 52 cm.)
Collection Museum Folkwang, Essen

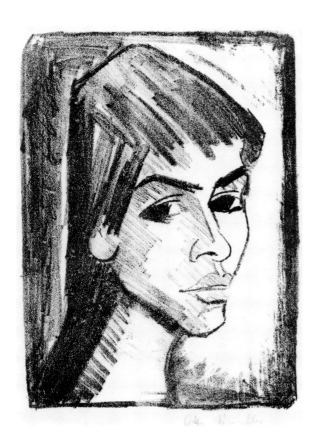

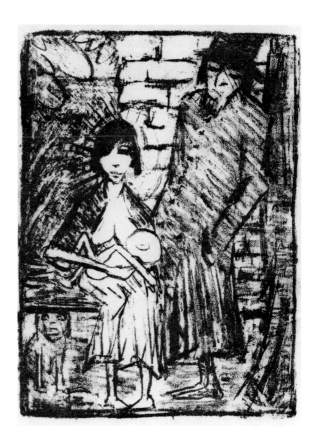

V

The *Blaue Reiter*

PAUL VOGT

In German art of the twentieth century, there is a special ring to the name *Blaue Reiter* (Blue Rider). Strictly speaking, it designated only an almanac, which was meant as a chronicle of artistic events around 1911. The almanac originated with two friends, the painters Franz Marc and Vasily Kandinsky, both of whom resided in Munich, and it was published in 1912 by Piper Verlag. Though still regarded today as a major artistic document of its time, the almanac also lent its name to a hypothetical group of artists from several countries, an association that left deep traces in the warp and woof of our anxiety-ridden century.

Art historians view the *Blaue Reiter* as a part of German Expressionism. And they are certainly not unjustified, since without the *Blaue Reiter* we could not arrive at any precise definition of Expressionism itself, a visionary and intensely expressive style focusing on man's inner world. However, we would fail to properly appreciate the role of these artists within their spiritual scope were we to judge them purely by those of North and Central German Expressionism, which had its center in Berlin beginning around 1910. The painters themselves felt the differences in their positions very sharply. While they all participated in avant-garde exhibitions in Munich, Berlin, and Cologne, they did not maintain close personal contacts or exchange ideas, like artists in Munich and Paris.

The *Blaue Reiter* had an artistic importance not only in Germany, but throughout the European art scene. To appreciate its position, a glance into the past will reveal the premises for the unique international fusion between East and West, which marked the character of the *Blaue Reiter*.

In the overall crisis around 1900, the latent tension between the artist and the world manifested itself in a young and revolutionary generation of artists. This state of affairs established new goals for art. The sharper the focus on reality, the more alien reality became. French Impressionism—the last and aesthetically brilliant demonstration of European realism—had still shown a deep concordance with the objective world. But Neo-Impressionism was already voicing the first doubts about the credibility of purely sensory perception. The methodical mind of a Seurat or a Cézanne, the symbolist strivings of the *Groupe Synthétiste* around Gauguin in France, the burning passion of the Dutchman van Gogh, the psychological probings of the Belgian Ensor or the Norwegian Munch—these were all different ways of seeking the pictorial equivalent for the new relationships emerging between man and the object. Art now no longer limited itself to reproducing the visible; it developed an urge to render visible. But the artists chose different paths toward this common goal. Cézanne's reminder that "art is a harmony parallel to nature" pointed out the direction of French art. Nature was no longer reproduced; instead, it was represented through the self-sufficient communication of color, line,

and form. The painting, now the product of the investigating and cognizant mind, became autonomous.

The situation was different in the North of Europe, which was dominated by the desire for formative communication revealing man's internal and expressive world. Visible reality, replaced by the artist's vision, was thus pervious or impervious depending on the degree of human participation. An exalted sense of self, with destructive psychological tensions, accepted the given forms only as symbols, as communication signs, which were to reveal the crisis, the tragic sense of life, an almost pathological antinomy between man and the world: Expressionism.

This new direction may be regarded as a final common spiritual basis, but not as a style with general validity. The North and the South established their own paths. Munich, a traditional German art metropolis around 1900, offered especially felicitous conditions for the coming revolution in art. Jugendstil was named after the magazine *Jugend* (youth), which was published in Munich in 1896. By the end of the century, this German Art Nouveau had created many of the premises for the new trends. Early on artists were discussing the possibilities of line in their goal of absolute form independent of nature. In 1896 Fritz Endell formulated his theory on the emotional effect of nonobjective colors. Such ideas pointed directly to the abstract painting that Kandinsky was to introduce. He had already come to Munich from Moscow in 1896.

In 1908 Wilhelm Worringer, a young university instructor, wrote in his book *Abstraktion und Einfühlung (Abstraction and Empathy)* that art could originate out of an urge for abstraction and was not tied to the appearances of the objective world. His conclusion (bold for that time and parallel to some of Cézanne's ideas) was that "the work of art can be an autonomous organism, existing equivalently next to nature and with no connection to nature in its deepest innermost essence." Such concepts fell on fertile soil in Munich, as did the stimulating discoveries of science, which the Munich painters referred to over and over again. Franz Marc, under the impact of Einstein's space-time continuum and Planck's atomic theory, offered the following forecast: "Future art will give form to our scientific conviction." The issue was not the existential situation of the individual (a problem the North was coping with), but rather man's existential relationship to the cosmos, the "mystical infrastructure of a world view" as "the major problem of today's generation" (Franz Marc).

A further decisive influence came from the Russian colony in Munich. The Russians were aiming at a pantheistic view of the world, a mystical spiritualization; they regarded the imagination as a source of subjective insights into the texture of existence. New formal sensory signs and harmonies of color and music had to be worked out. Such reflections led to Kandinsky's notion of the "spiritual in art," a notion that could only have emerged in Munich at that time. It was preliminary to the imminent rejection of the objective world, to which the North and Central German Expressionists clung until the very end.

In this context, we can also mention the French influence, which went deeper in Munich because of personal contacts between French and German artists. French Fauvism and Cubism left their impact: in the North, without influencing the stylistic trend there; and in the South by forming the basis for the fruitful spiritual struggles which gave the *Blaue Reiter* its unmistakable countenance.

Let us now look at those artists who not only provided theoretical formulations

for contemporary trends, but also confirmed them in their own work. Two such artists were the Russian Vasily Kandinsky and the German Franz Marc, the initiators of the *Blaue Reiter*.

Kandinsky was at the beginning of his development. In 1901 he had founded *Phalanx*, an artists group and painting school, which lasted until 1904. In 1902 he began his regular visits to Paris. His early works showed a range of development from Russian Jugendstil to late French Impressionism and Fauvism. Thus, in close contact with the French development, he had thought of *Phalanx* as a culmination point for the European vanguard; and in pursuit of this goal, he organized a series of remarkable exhibitions.

However, the first crucial thrust was that of the *Neue Künstlervereinigung München (NKVM)*, founded in 1909, with Kandinsky as its president. The membership list included such illustrious names as Alexej Jawlensky (a Russian like Kandinsky), Adolf Erbslöh, Gabriele Münter (Kandinsky's student since 1902), and Alfred Kubin, as well as the German Neo-Impressionist Paul Baum, Karl Hofer, Vladimir von Bechtejeff, and Moissey Kogan. Their circular offered bold ideas: "We are proceeding from the idea that the artist, aside from his impressions of the outer world, nature, is constantly gathering experiences in an inner world. The quest for artistic forms that must be freed of any trivia and strongly express only the essential—in short, the striving for an artistic synthesis: this seems to us to be a solution which now increasingly unites artists spiritually."

Such formulations reveal Kandinsky's restless mind; at that time, he was probably the only artist who could more or less estimate the possible artistic consequences. Naturally, such ideas aroused the resistance of those members of the *NKVM* who, as painters of the Munich milieu, between Symbolism, Jugendstil, and Nature Lyricism, rejected the idea of abstraction. Kandinsky found his ideas supported only by Franz Marc, a still unknown painter, who instinctively recognized the Russian artist's superior creative power. Preoccupied with notions that he could not yet realize in painting, Marc understood the implications of Kandinsky's ideas and their fruitful effects upon his work.

August Macke, a Rhinelander and a friend of Marc, corresponded with the latter, exchanging ideas and following the unfolding development with some skepticism. Macke himself did not have an expressive orientation. His cheerful, colorful art, schooled in the style of Matisse and Robert Delaunay, was a metaphor for a pure and well-ordered beauty of the world. Despite his personal commitment, Macke was untouched by the impulses from Munich. He was perceptive enough to discern the problem of the situation. In a letter of 1910, he pointed out that "the expressive means are too great for what they are trying to say." This statement precisely designated the as yet unresolved gap between Expressionist theory and practice.

The year 1911 brought a rift between the innovators and the traditionalists in the *NKVM*. Kandinsky resigned from the group along with his close friends Marc and Münter. They were soon followed by Jawlensky and Marianne von Werefkin, who had attempted once more to bridge the differences.

In 1910 Kandinsky had already painted his first abstract composition, a watercolor. It documents experimental notions for which the artist established a foundation only in the following years. The solution, however, was thus being formulated, and the goal was obvious—not just in Munich. In 1911 Larionov did his first

abstract work in Moscow. In 1912 Delaunay and Kupka followed suit in Paris. Among his friends, however, Kandinsky was alone in his bold step, at least for the time being. As for the *Brücke*, an artists group forming the nucleus of Central German Expressionism, their works during the early years were so strikingly similar that individual authorship was frequently hard to determine. The painters around Kandinsky went their separate ways, limiting themselves at all times to merely spiritual agreement. Marc crossed the threshold to abstraction only during the last years of his life. Jawlensky and Paul Klee (who arrived on the scene later) initially pursued visible reality, although for different reasons.

In 1911, during their difficulties with the *NKVM*, Marc and Kandinsky had begun working on the publication that was later to be called *Der Blaue Reiter*. Thus, there was never any group or association of artists with this name, as Kandinsky later re-emphasized. Strictly speaking, the so-called *Blaue Reiter* was simply an editorial board consisting of Marc and Kandinsky. All the other artists expressly invited to participate maintained more or less close contact with Marc and Kandinsky, taking part in their exhibitions and discussions or in the planned publication. These artists included the tirelessly supportive August Macke, Paul Klee, Alfred Kubin, Gabriele Münter, Marianne von Werefkin, and Alexej Jawlensky—names that are generally known to us from the *NKVM*. We must also include the renowned composer Arnold Schönberg. His Munich debut in 1911 made such an impact on Marc that he immediately reported it to Macke. "Can you imagine a music that completely ignores tonality (that is, the consistent use of one key)? I had to keep thinking of Kandinsky's great compositions, which do not allow any trace of a tone . . . and Kandinsky's 'leaping spots' when I heard this music, which lets every note stand by itself (a sort of white canvas between the color spots!) . . ." We will find Schönberg as both author and painter in the almanac and at the first group show.

The almanac of the *Blaue Reiter* was published in 1912, the same year that Kandinsky brought out his fundamental essay *Über das Geistige in der Kunst (On the Spiritual in Art)*, which he had been working on since 1910. Both books programmatically reflected the spiritual situation of that decisive, pivotal year of 1911, shortly before the universal breakthrough to abstraction, which occurred throughout Europe beginning in 1912. At first sight, the variety of texts and illustrations in the almanac seems rather confusing. Painters, scientists, musicians, literati, and sculptors wrote for the anthology; contemporary art was presented alongside works from classical antiquity, drawings by children, or works by primitives. Kahnweiler had sent photographs of paintings by Picasso. Matisse refused to write an article, but he allowed the reproduction of any of his works.

If we arrange the texts and pictures in terms of their meaning, we can perceive the overall spiritual conception, based on the notion of the *Gesamtkunstwerk*. It unites music and fine arts; it builds a bridge from Bavarian *verre églomisé* to Russian folk art; it connects children's art with masks and sculptures from Africa and the South Seas; it links the classical works of East Asia, Greece, and Egypt to those of the German Middle Ages.

The vivid tone that emanates from this unusual volume even today reveals something of the intense wish of its initiators. These men wanted to establish spiritual signals for an age that the younger generation saw as diseased. Marc pointed to the symptom of the "general lack of interest in new spiritual treasures." What a sense of

mission can be found in his words: "But we will not tire of saying so, and we will not tire of stating new ideas and showing new paintings, until the day comes when we can encounter our ideas on the highway."

New ideas. This was Kandinsky's conviction, advocated in *Der Blaue Reiter*, that there are two poles, "great abstraction" and "great realism," which ultimately fuse in a common goal. This conviction was founded on the idea that "form . . . is the external expression of the internal content." The painter's gaze had shifted from the outer world. He had abandoned the dialogue with the objective world in favor of a focus upon the inner world. This struggle no longer required the traditionally formed symbols of objectivity. Form per se no longer had meaning; the meaning lay in "the inner sound, the life" of form (Kandinsky). Despite the kinship with France, such interpretations are very different from French interpretations. It is a matter of Latin reason versus Northern and East European intuitive emotion.

The conception of compelling inner necessity, which becomes an argument for the work of art independent of abstraction or realism, is a fundamental theme in all the contributions in the *Blaue Reiter* almanac. Understandably, the two editors had included several of their own texts. Marc wrote "Spiritual Treasures," "The German Fauves" (which first mentioned the *Brücke*, albeit peripherally), as well as "Two Paintings." Kandinsky penned the important discussion "On the Question of Form," which is indispensable for understanding his paintings. The range of his efforts is obvious in his text "On Stage Composition," which prefaces his play *The Yellow Sound*, also published in the almanac. Arnold Schönberg wrote "The Relationship to the Text," while the composer and painter Thomas von Hartmann (born in Moscow and ultimately settling in the United States) wrote "Anarchy in Music." We should also mention Erwin von Busse's "Compositional Devices in Robert Delaunay," David Burljuk's "The Fauves of Russia," August Macke's "Masks," Leonid Sanejew's examination of Scriabin's *Prometheus*, the Frenchman Roger Allard's "Characteristics of Renewal in Painting," as well as quotations by Delacroix and Rosanow. This list rather thoroughly outlines a publication that was highly unusual for its time.

Musical problems received much attention in the almanac—and not without good reason. The relations between music and fine art, the color-harmony basis of Kandinsky's paintings, the analogy between musical overtones and color chords were issues very much on the minds of both painters and musicians. In *Prometheus*, Scriabin had tried to make music agree with color illumination and to match the notes with certain visual sounds. These efforts were preliminary to the later color-light piano. Similar efforts were made by Kandinsky in his daring play *The Yellow Sound*, in which he tried to blend color, pantomime, and music in a mystical and romantic mood. It is in these terms that we can appreciate efforts by the *Blaue Reiter* artists to deal with the musical qualities of pictorial vocabulary and to develop a theory of harmony for colors and forms—a theory as applicable as the parallel theory in music. Such detachment from objectivity did not harm their emotional character, which neither the Germans nor the Russians wanted to omit. However, this detachment did liberate them from the ballast of content and allegory. Expressiveness as observed here has a very different modality from Expressionism in the North.

If we look at so-called *Brücke* Expressionism, we can immediately see the difference in attitudes. While the North and the South had their roots in German

Romanticism, each proceeded along a different path. The North tried to uncover formalist means, such as the expressive function of powerful colors. The South was concerned with the mystical, inner meaning behind external data. Its sensitive palette found a correlation with the pure tones of music. Neither approach was totally successful, however. At times the North tended to exaggerate significance, while the South verged on the decorative.

This makes it clear why a certain aloofness persisted between the North and the South. Franz Marc did visit the *Brücke* artists in Berlin and was fascinated by the strength of their pronouncements as well as by their impetus. But no deeper sympathy developed between the contrasting positions. Kandinsky totally rejected the work of the *Brücke*. Their direct commitment, the spontaneous and impulsive reactions, the form-shattering intensity of their self-expression struck him as too unfiltered, too unspiritual. He could not find any contribution here to the development of contemporary art as he imagined it. Hence, even though the almanac contained countless reproductions of Matisse, Delaunay, Cézanne, and Le Fauconnier, he refused to include any works by the Expressionists. "Such things have to be exhibited; but in my eyes it is not right to immortalize them in a documentation of today's art (which our book is to be) as a somewhat crucial and directing force. So I would at least be against large reproductions... a small reproduction means: this *too* is being done; a large reproduction means: *this* is being done." Kandinsky's viewpoint was accepted. The Expressionists did take part in the graphics show of the *Blaue Reiter*; but Max Pechstein's originally planned text was not included in the publication. Nolde, Pechstein, Mueller, Heckel, and Kirchner are present in the almanac by virtue of reproductions of their prints.

Both publications—*Über das Geistige in der Kunst* and the *Blaue Reiter*—are milestones in the history of modern German art. They made the artist aware of his freedom from a traditional attachment to the object. They demonstrated that he was in accordance with the spirit of the times when his imagination found pictures to be beyond visible reality. Everything urged the artists to paint the conception of an expanded creation, of its imaginary and material structures.

If we review the development, which is so clear in the *Blaue Reiter*, then we will see the two positions of the European scene (the synthesis of which was attempted in Munich). These two positions were the expressive and the Cubist—or rather, the Orphic—which the German and Russian painters saw as points of departure for future painting, points of departure that were powerful and could be developed.

The "expressive" referred both to German Expressionism, between the elementary and the cosmic-romantic, and to French Fauvism, which, by passionately tackling visible reality, hoped to heighten reality in the pictorial counterreality. Both Matisse and Kandinsky provide evidence of this in their works. The Frenchman, using the spiritual order formula of the painting, tried to fuse the duality between the self and the world into a convincing unity. The Russian negated the limits of visible reality in order to use newly found communication signs in the painting; his goal was to reach that point at which the human state of being touches the more universal cosmic order.

Such discoveries could not be entrusted to the unfiltered urge for expressive communication with the ultimate goal of pictorial realization. Marc's very German cosmic feeling—a feeling rooted in Romanticism—and Kandinsky's color-harmony synthesis were both confirmed by French painting. At the same time, French paint-

ing offered the necessary pointers for the active and theoretical cultivation of color and form. The aesthetics of the *Blaue Reiter*, halfway between the expressive and the constructive, had gradually been turning away from the motif as subject matter. It had focused more and more on the painting as a self-sufficient organism and on formal unity. In light of such ideas it is easy to understand why Orphic painters like Delaunay exerted such strong influence upon the *Blaue Reiter* artists. Delaunay discovered that color, in the same sense as form, can evoke motion and rhythm by itself. His *sens giratoire* of colors quite logically brought him to abstract paintings of pure color; and their significance was no longer objective: it lay in their content and expression. Color stood for that superordinated rhythm that determines Being and the world; color looked for the sound that can express and enclose the harmony of the whole. Such a notion of painting as sheer orchestration of color and light was bound to enter into a convincing synthesis with the speculative ideas of the Munich painters.

The exhibitions put on by the *Blaue Reiter* editorial board were meant to strengthen the theoretical foundations. Two shows, in 1911 and 1912, were exemplary in summing up the actual situation. On November 18, 1911, the friends of the future *Blaue Reiter* had their first exhibition at the Thannhauser gallery. It was meant as a demonstration and it therefore opened at the very same moment that the *NKVM*, which these painters had broken away from, was showing works by its members in the other rooms of the gallery.

Obviously Kandinsky, Marc, Macke, and Münter were represented in this show, which also included the Rhinelander Campendonk; the Russian brothers Burljuk; Albert Block; Eugen von Kahler, who died at an early age; Jean Bloe Niestle; Arnold Schönberg; and two important Frenchmen, Henri Rousseau and Robert Delaunay. Unquestionably we can sense Kandinsky's hand in this selection, which, especially in regard to the two Frenchmen, embodied the two antitheses in art that he constantly cited and discussed in his writings: the "great abstract" and the "great real."

Subsequently the exhibition traveled through Germany. It was shown in Cologne in 1912, where it left an impact on the Rhenish scene, which already had close contacts with Munich through Macke and Campendonk. In Berlin Herwarth Walden opened his Sturm gallery with the exhibition; he showed his farsighted artistic vision by adding works by Paul Klee, Alexej Jawlensky, and Alfred Kubin that had been left out in Munich. The exhibition then went to Bremen, Hagen, and Frankfurt.

The second exhibition, in 1912, not meant as a spontaneous reaction, was carefully planned and prepared. Although limited to graphics under the title *Schwarz-Weiss (Black and White)*, it also included drawings and watercolors. "Marc and I took everything that struck us as right, and we selected freely, without worrying about anyone's opinions or wishes." Once again, artists of many nations participated. From Germany, along with the *Brücke* (minus Schmidt-Rottluff) and the *Blaue Reiter* artists, there was the Worpsweder Tappert, the Westphalian Morgner, and also Alfred Kubin and Paul Klee (the latter with seventeen works from the years 1911 and 1912). The French contribution, as expected, was vast. There were works by Georges Braque, Robert Delaunay, Roger de la Fresnaye, André Derain, Pablo Picasso, and Maurice Vlaminck—a selection indicating the state of affairs between Fauvism and Cubism. Switzerland was represented by Hans Arp, Moriz

Melzer, Wilhelm Gimmy, and Oskar Lüthy. Russia had sent its vanguard: Natalia Goncharova, Mikhail Larionov, and Kazimir Malevich.

Such a broad overview was never to be repeated. The *Blaue Reiter* painters took part in the famous Sonderbund exhibition of 1912 in Cologne, a huge gathering of Europe's younger generation of artists. That same year, in Berlin, Herwarth Walden showed works by Kandinsky, Jawlensky, Werefkin, Block, Münter, and Marc, who had not taken part in the Sonderbund. In 1913 the Sturm gallery put on the *Erster Deutscher Herbstsalon* (in imitation of the renowned Salon d'Automne in Paris). Here the Munich painters were shown once again with the international trends parallel to theirs. In 1914 Walden sent their works on tour through the Scandinavian countries. Then the war broke out, terminating the cooperative work in Munich too.

Measured against the time that Dresden's *Brücke* had for its development, the *Blaue Reiter* was only a brief episode. But its significance for the European art scene was comprehensive. Its impact on the future surpassed that of Central and North German Expressionism. The artists saw themselves as trailblazers for a new era of spiritual culture, with the motto: "The renewal must not be formal; it is a rebirth in thinking." The special quality of their vision was that art was the center of this renewal although not its exclusive goal. Art was seen as part of a superordinated existential connection between this life, that is, nature, and the beyond; between man's inner world and his expressive world. The artist's position was at the point of entry between these two worlds. He was given the task of "creating symbols for his time, symbols that belong on the altars of the coming spiritual revolution." The *Blaue Reiter* marked a path whose full significance was recognized only by the following generations.

230 *Large Lenggries Horse Painting I (Grosses Pferdebild
 Lenggries I).* 1908
 Oil on canvas, 41¼ x 81⅛″ (104.8 x 206.2 cm.)
 Not signed or dated.
 Collection Joachim Jean Aberbach, New York

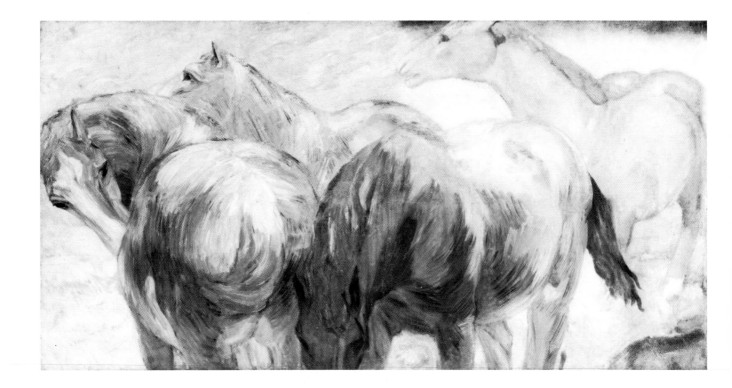

FRANZ MARC

*231 *Cows (Die Kühe).* 1911
Oil on canvas, 32¹³⁄₁₆ x 54″ (83.3 x 137.2 cm.)
Not signed or dated.
Private Collection

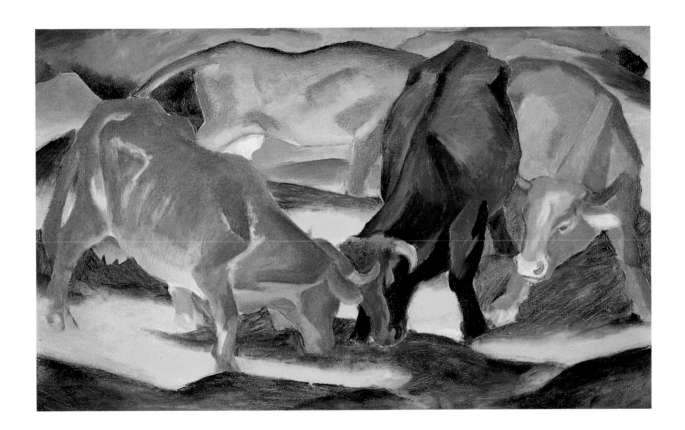

232 *The Large Blue Horses (Die grossen blauen Pferde)*. 1911
Oil on canvas, 41¼ x 71½″ (104.8 x 181.6 cm.)
Not signed or dated.
Lankheit, cat. no. 155
Collection Walker Art Center, Minneapolis; Gift of the
T. B. Walker Foundation

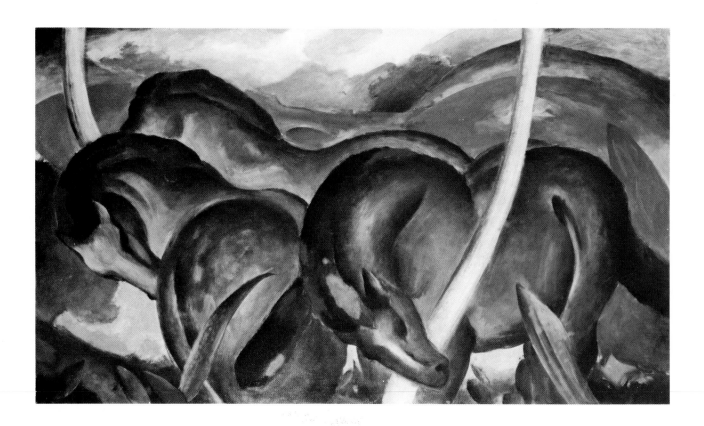

233 *The Small Blue Horses (Die kleinen blauen Pferde)*. 1911
Oil on canvas, 24¼ x 39¾″ (61.5 x 101 cm.)
Signed l.l.: *Marc*. Not dated.
Lankheit, cat. no. 154
Collection Staatsgalerie Stuttgart

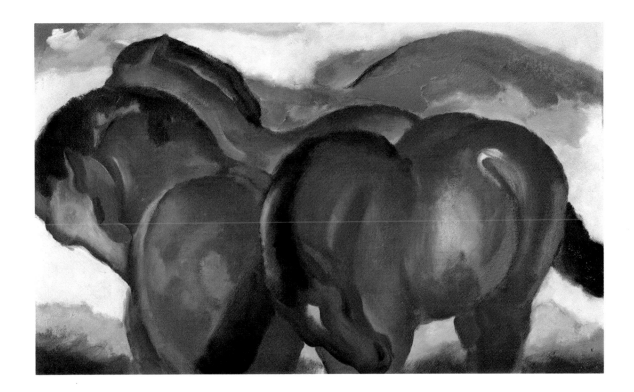

234 *White Bull (Stier)*. 1911
 Oil on canvas, 39⅜ x 53¼″ (100 x 135.3 cm.)
 Signed, dated, and inscribed on reverse: *Fz. Marc ii/ „Stier.″*
 Lankheit, cat. no. 150
 Collection The Solomon R. Guggenheim Museum, New York,
 51.1312

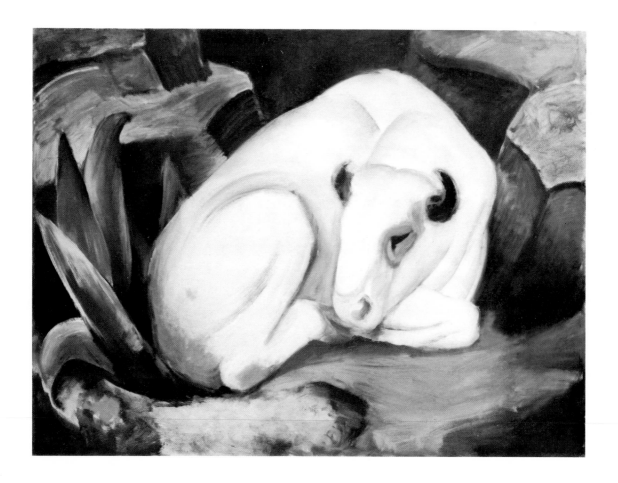

235 *Doe in Cloister Garden (Reh im Klostergarten)*. 1912
Oil on canvas, 29¹³⁄₁₆ x 39¾" (75.7 x 101 cm.)
Signed l.r.: *Marc.* Not dated.
Lankheit, cat. no. 187
Collection Städtische Galerie im Lenbachhaus, Munich

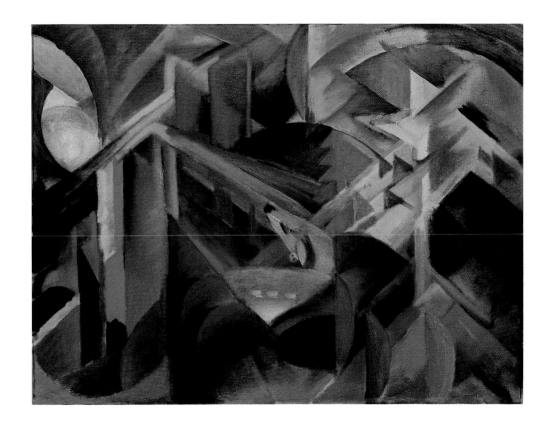

236 *Foxes (Füchse)*. 1913
Oil on canvas, 34⅝ x 26″ (88 x 66 cm.)
Signed l.r.: *M*. Not dated.
Lankheit, cat. no. 204
Collection Kunstmuseum Düsseldorf

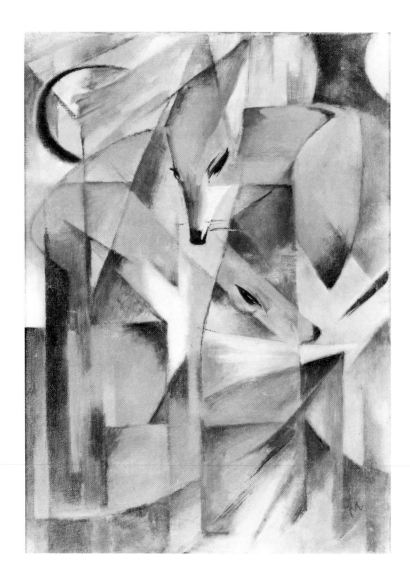

237 *Stables (Stallungen)*. 1913
Oil on canvas, 29 x 62″ (73.6 x 157.5 cm.)
Signed l.r.: *M*; inscribed and signed on reverse: *Stallungen/*
Fz. Marc Sindelsdorf/Ob. Bayern. Not dated.
Lankheit, cat. no. 221
Collection The Solomon R. Guggenheim Museum, New York,
46.1037

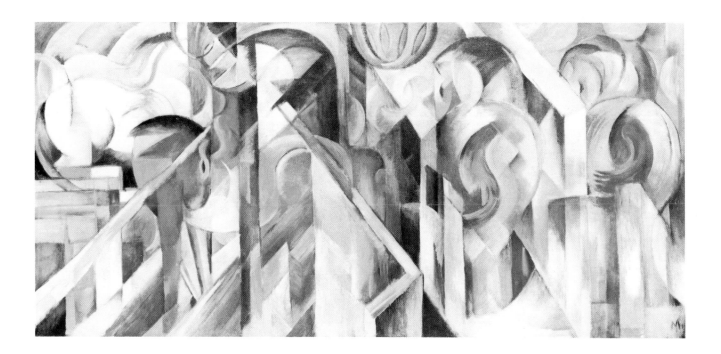

238 *Cattle (Rinder [Bild mit Rindern II]).* 1913–14
Oil on canvas, 36¼ x 51½″ (92 x 130.8 cm.)
Signed l.l.: *M*; signed and inscribed on reverse: *Fz. Marc*
Sindelsdorf Ob. Bayern. Not dated.
Lankheit, cat. no. 222
Collection Staatsgalerie moderner Kunst, Munich

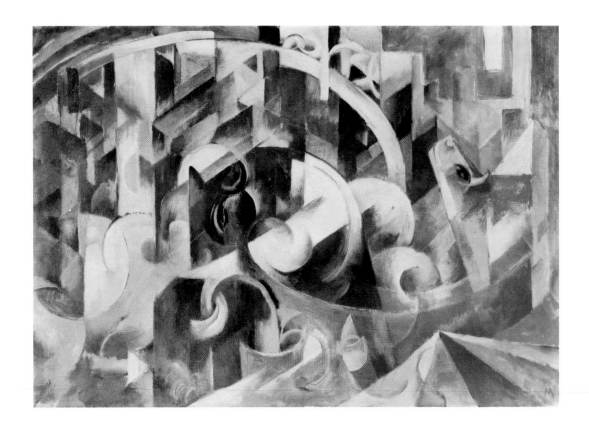

239 *The Unfortunate Land of Tyrol (Das arme Land Tirol)*. 1913
Oil on canvas, 51⅝ x 78¾″ (131.1 x 200 cm.)
Inscribed l.l.: *M./das arme Land Tirol*. Not dated.
Lankheit, cat. no. 205
Collection The Solomon R. Guggenheim Museum, New York,
46.1040

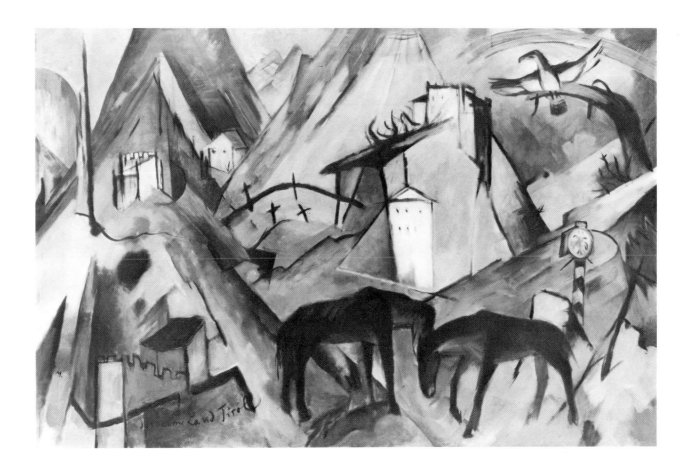

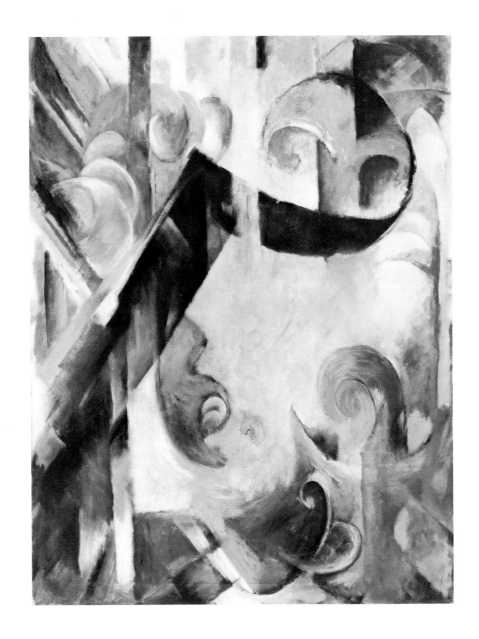

FRANZ MARC

240 *Broken Forms (Zerbrochene Formen).* 1914
 Oil on canvas, 44 x 33¼″ (111.8 x 84.5 cm.)
 Not signed or dated.
 Lankheit, cat. no. 236
 Collection The Solomon R. Guggenheim Museum, New York,
 50.1240

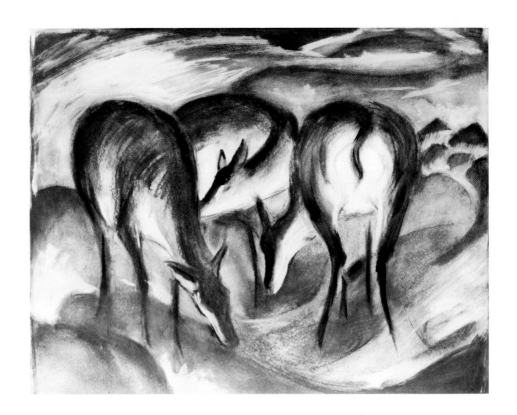

FRANZ MARC

*241 *Does at the Spring (Rehe an der Quelle).* ca. 1911
Charcoal, tempera, and opaque white, 16⅛ x 19½″
(41 x 49.5 cm.)
Not signed or dated.
Collection Museum Ludwig, Cologne

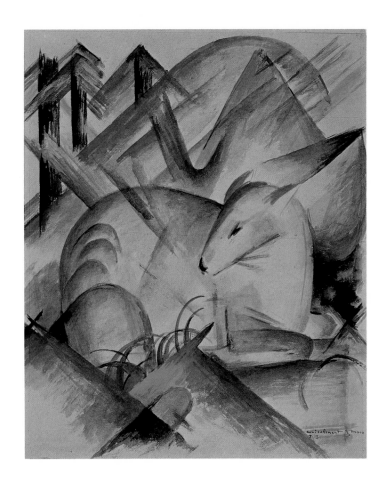

FRANZ MARC

242 *Red Deer (Rotes Reh)*. 1913
 Gouache, 16⅛ x 13⅜″ (41 x 34 cm.)
 Inscribed l.r.: *amicalement Fz Marc/I. 13.*
 Collection The Solomon R. Guggenheim Museum, New York,
 48.1180

FRANZ MARC

243 *St. Julien L'Hospitalier (Der Heilige Julian)*. 1913
Gouache with ink and gold, 18 x 15¾″ (45.8 x 40 cm.)
Signed l.r.: *F.M.* Not dated.
Collection The Solomon R. Guggenheim Museum, New York,
47.1099

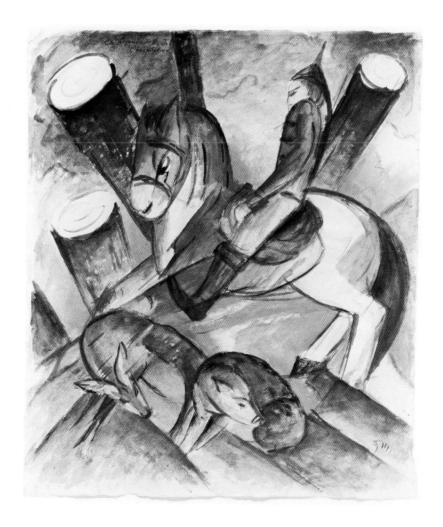

244 *Horse Asleep (Träumendes Pferd, Schlafendes Pferd)*. 1913?
 Gouache and charcoal, 15⅞ x 18½" (40.3 x 47 cm.)
 Signed r.c. margin: *M*. Not dated.
 Collection The Solomon R. Guggenheim Museum, New York,
 44.937

†245 *Tiger*. 1912
 Woodcut, 7¹³⁄₁₆ x 9⁷⁄₁₆" (19.8 x 24 cm.)
 Collection Museum Folkwang, Essen

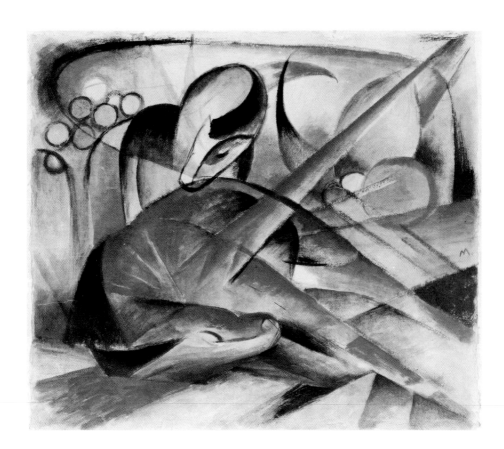

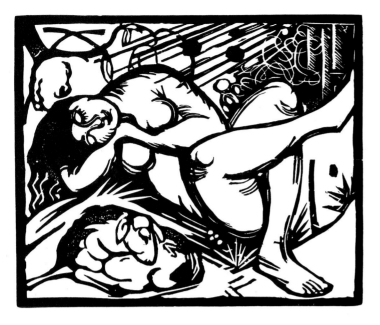

246 *Sleeping Shepherdess (Schlafende Hirtin)*. 1912
Woodcut, 7¹³⁄₁₆ x 9⁷⁄₁₆″ (19.8 x 24 cm.)
Collection Museum Folkwang, Essen

†247 *Riding School (Reitschule)*. 1913
Woodcut, 10⁹⁄₁₆ x 11¾″ (26.9 x 29.8 cm.)
Collection Museum Folkwang, Essen

248 *Animal Legend (Tierlegende)*. 1912–13
Woodcut, 7¹³⁄₁₆ x 9⁷⁄₁₆″ (19.8 x 24 cm.)
Collection Museum Folkwang, Essen

249 *Creation II (Schöpfungsgeschichte II)*. n.d.
Color woodcut, 25³⁄₁₆ x 19³⁄₁₆″ (64 x 48.8 cm.)
Collection Museum Folkwang, Essen

250 *Murnau Landscape (Murnauer Landschaft)*. 1909
Oil on paperboard, 27¼ x 37¼″ (69.2 x 94.6 cm.)
Signed and dated l.l.: *Kandinsky/09*.
Richard S. Zeisler Collection, New York

251 *View of Murnau (Ansicht von Murnau)*. 1909
Oil on paper mounted on wood, 27⅜ x 38″ (69.5 x 96.5 cm.)
Signed and dated l.l.: *Kandinsky 1909*.
Collection Kunstmuseum Düsseldorf

252 *Mountain (Berg)*. 1909
 Oil on canvas, 42$^{15}/_{16}$ x 42$^{15}/_{16}$″ (109 x 109 cm.)
 Signed and dated l.l.: *KANDINSKY 1909*; inscribed on
 reverse: *KANDINSKY—Berg (1909)*.
 Collection Städtische Galerie im Lenbachhaus, Munich

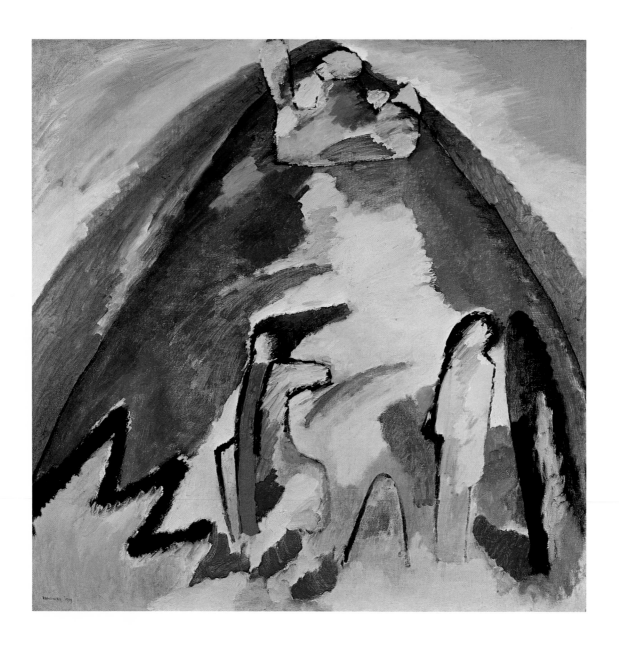

253 *Church in Murnau (Kirche in Murnau).* 1910
 Oil on paperboard, 25½ x 19¾″ (64.7 x 50.2 cm.)
 Not signed or dated. Inscribed by Gabriele Münter on
 reverse: *Kandinsky Kirche.*
 Collection Städtische Galerie im Lenbachhaus, Munich

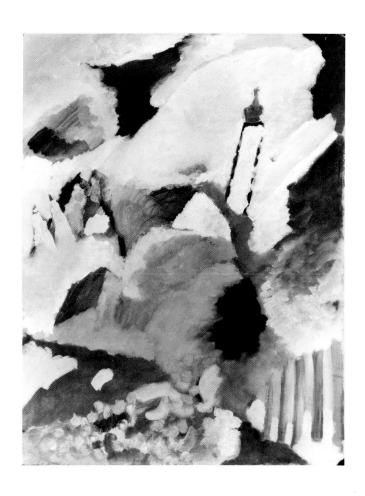

254 *The Cow (Die Kuh)*. 1910
 Oil on canvas, 37⅝ x 41⁵⁄₁₆″ (95.5 x 105 cm.)
 Signed and dated l.l.: *KANDINSKY 1910*; inscribed on
 reverse: *KANDINSKY Die Kuh (1910)*.
 Collection Städtische Galerie im Lenbachhaus, Munich

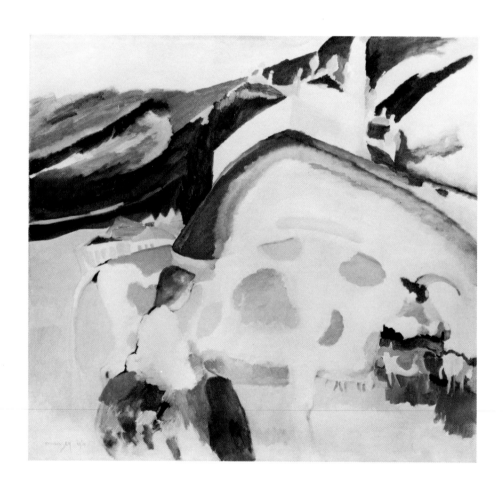

255 *Pastorale*. 1911
 Oil on canvas, 41⅞ x 61¾″ (106.3 x 156.8 cm.)
 Signed and dated l.r.: *Kandinsky i9ii*.
 Collection The Solomon R. Guggenheim Museum, New York,
 45.965

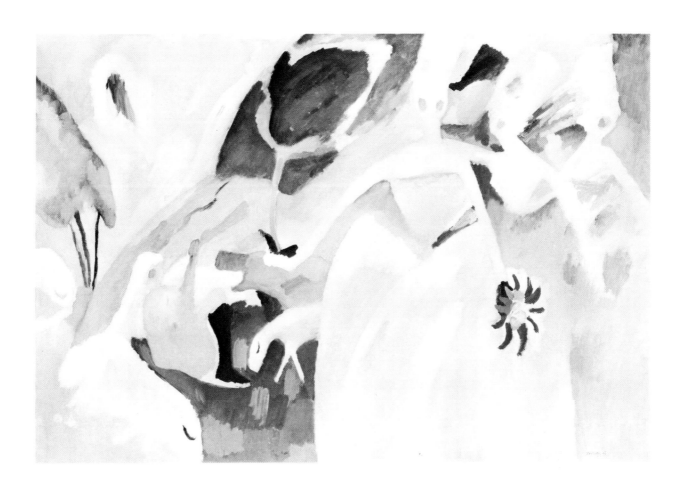

256 *Improvisation—Deluge (Improvisation Sintflut)*. 1913
Oil on canvas, 37⅜ x 59¹⁄₁₆″ (95 x 150 cm.)
Signed, dated, and inscribed on reverse: *Kandinsky 1913*
Sintflut Improvisation.
Collection Städtische Galerie im Lenbachhaus, Munich

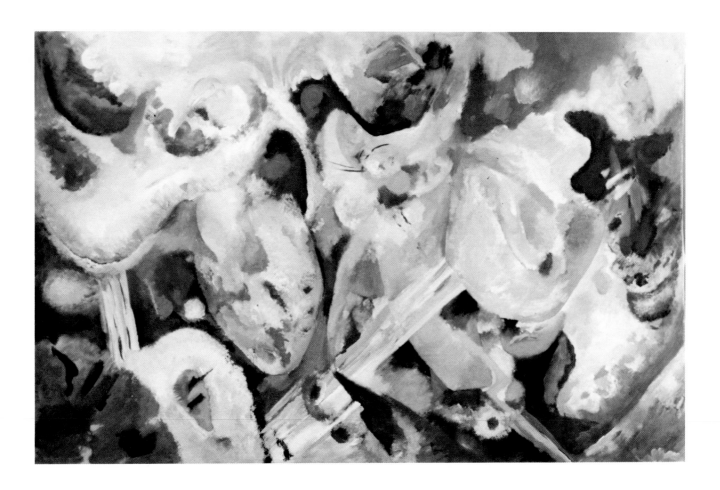

257 *Small Pleasures (Kleine Freuden; No. 174)*. 1913
Oil on canvas, 43¼ x 47⅛" (109.8 x 119.7 cm.)
Signed and dated l.l.: *Kandinsky i9i3*; inscribed on stretcher:
Kandinsky Kleine Freuden (i9i3)/(N 174).
Collection The Solomon R. Guggenheim Museum, New York.
43.921

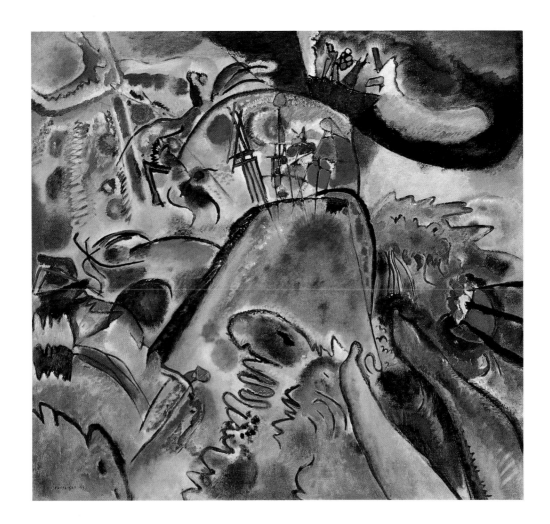

*258 *Panel (4)*. 1914
 Oil on canvas, 64 x 31½″ (162.5 x 80 cm.)
 Signed and dated l.l.: *K/1914.*
 Collection The Museum of Modern Art, New York,
 Mrs. Simon Guggenheim Fund, 1954

Cat. nos. 258–61 were commissioned in 1914 by Edwin R. Campbell for his New York apartment. These four panels have also been identified as the four seasons: cat. no. 258, *Spring*; cat. no. 259, *Summer*; cat. no. 260, *Autumn*; and cat. no. 261, *Winter.*

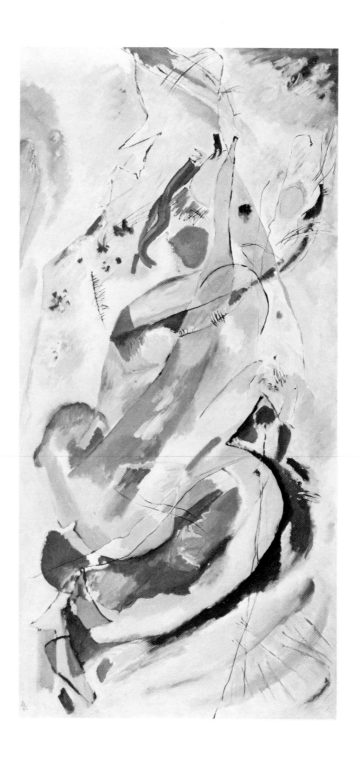

259 *Panel (3)*. 1914
Oil on canvas, 64 x 36¼" (162.5 x 92.1 cm.)
Signed and dated l.l.: *K/1914*.
Collection The Museum of Modern Art, New York,
Mrs. Simon Guggenheim Fund, 1954

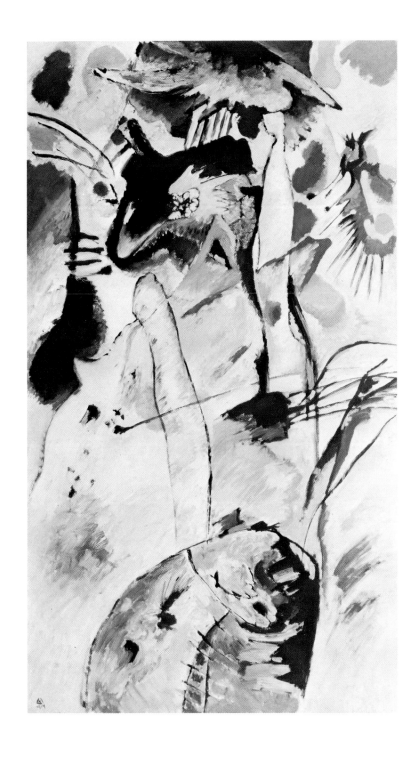

*260 *Painting No. 199.* 1914
 Oil on canvas, 63⅞ x 48⅛″ (162.4 x 122.3 cm.)
 Signed and dated l.l.: *K/1914.*
 Collection The Solomon R. Guggenheim Museum, New York,
 41.869

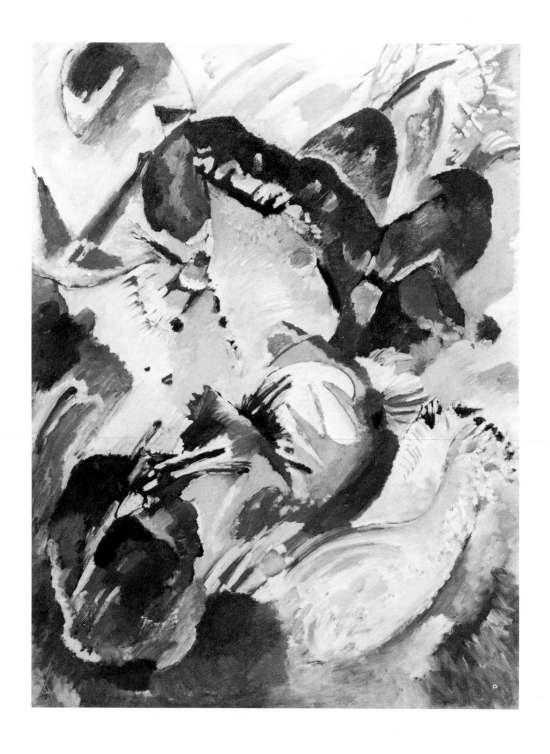

261 *Painting No. 201.* 1914
Oil on canvas, 63⅞ x 48⅛″ (162.3 x 122.8 cm.)
Signed and dated l.l.: *K/1914.*
Collection The Solomon R. Guggenheim Museum, New York,
41.868

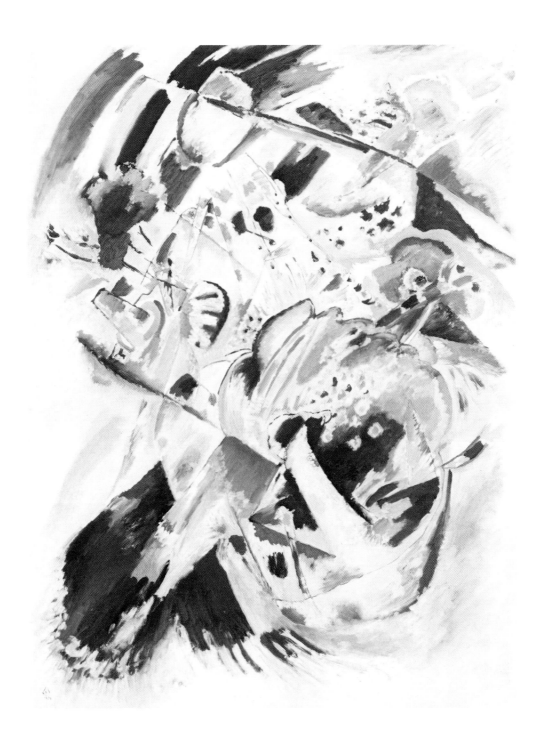

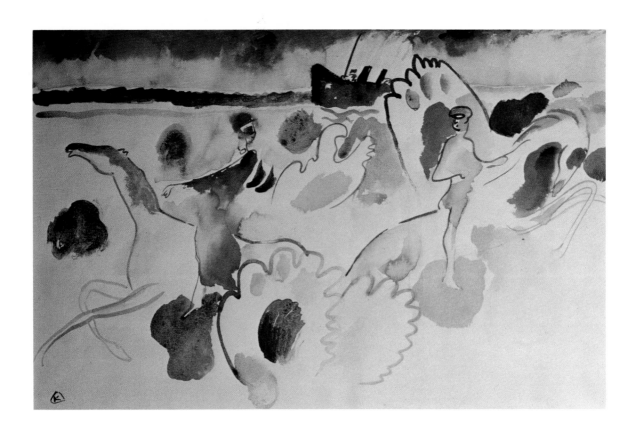

VASILY KANDINSKY

*262 *Horsemen on the Shore (Reiter am Strand)*. ca. 1910
Watercolor, 12⅜ x 19⅞" (31.5 x 48 cm.)
Signed l.l.: *K*. Not dated.
Collection Museum Ludwig, Cologne

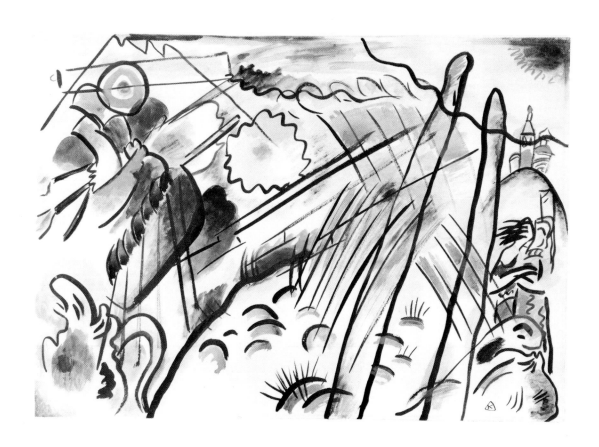

VASILY KANDINSKY

263 *Study for No. 160b (Improvisation 28?) (Entwurf zu Nr. 160b).* 1911–12
Watercolor, wash, and India ink, 15⅜ x 22⅛″ (39 x 56.1 cm.)
Signed l.r.: *K.* Not dated.
Collection The Hilla von Rebay Foundation, 1970.127

264 *Motif of Garden of Love (Study for Improvisation 25?)*
(Entwurf zu Liebesgarten). 1912
Watercolor, 12⅜ x 18¾″ (31.3 x 47.6 cm.)
Signed l.r.: *K.* Not dated.
Collection The Solomon R. Guggenheim Museum, New York,
48.1162

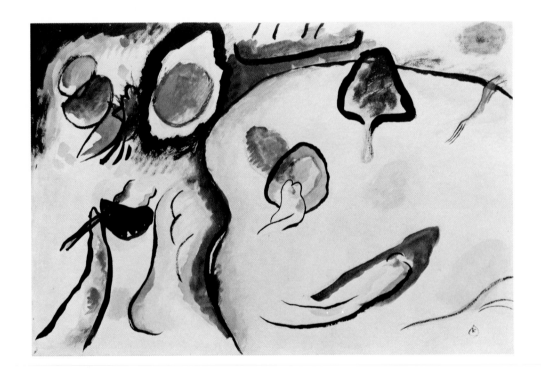

265 *Untitled (Ohne Titel).* 1913
 Watercolor and pencil, 16⅛ x 14⅛″ (41 x 36 cm.)
 Signed l.r.: *K.* Not dated.
 Collection The Solomon R. Guggenheim Museum, New York,
 47.1057

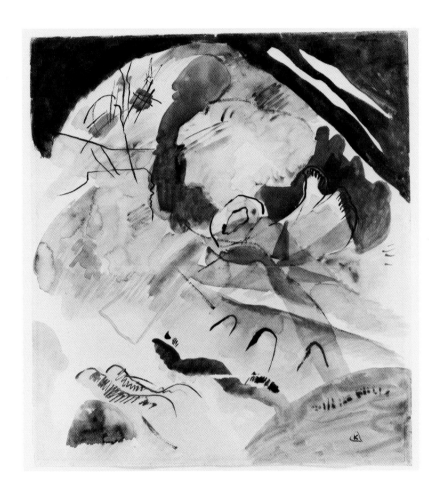

266 *Mediterranean near Marseilles (Mittelmeer bei Marseille)*.
ca. 1905
Oil on paperboard, 17⅞ x 26″ (45.4 x 66 cm.)
Signed l.r.: *A. Jawlensky*. Not dated.
Collection Museum Folkwang, Essen

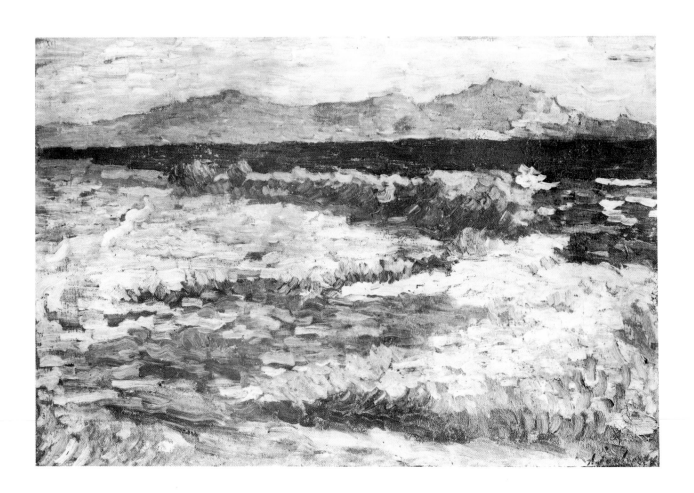

ALEXEJ JAWLENSKY

267 *Still Life with Vase and Pitcher (Stilleben mit Vase und Krug)*. 1909
Oil on paperboard, 19½ x 17⅛″ (49.5 x 43.5 cm.)
Signed l.l.: *A. Jawlensky*; signed and dated on reverse: *Jawlensky 1909*.
Museum Ludwig, Cologne, Collection Dr. Haubrich

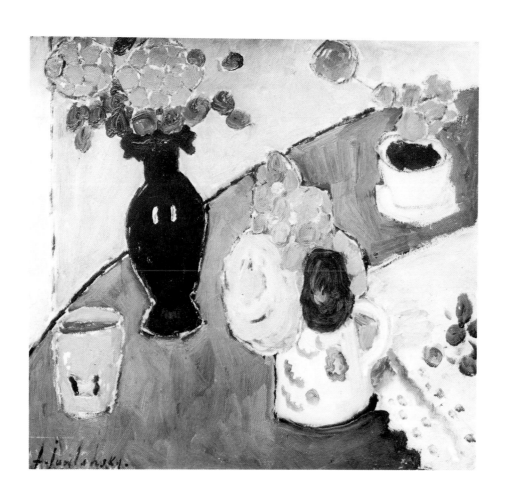

268 *Helene with Colored Turban (Helene mit buntem Turban).*
1910
Oil on board, 37⅛ x 31⅞″ (94.2 x 81 cm.)
Signed and dated u.l.: *A. Jawlensky/1910*; inscribed on
reverse, not by the artist: *No. 19 1910/Helene mit/buntem
Turban.*
Collection The Solomon R. Guggenheim Museum, New York,
65.1773

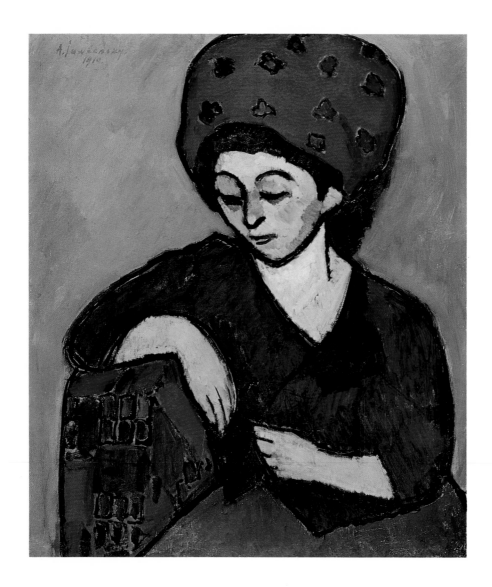

269 *Girl with Red Bow (Mädchen mit roter Schleife)*. 1910
 Oil on paperboard, 21⁷⁄₁₆ x 19¹¹⁄₁₆″ (54.5 x 50 cm.)
 Not signed or dated.
 Collection Leopold-Hoesch-Museum, Düren

270 *Still Life (Stilleben)*. 1911
 Oil on paperboard, 27¹⁵⁄₁₆ x 29¾″ (71 x 75.5 cm.)
 Signed and dated u.l.: *A. Jawlensky 1911.*
 Collection Hamburger Kunsthalle

271 *Spanish Woman with White Mantilla (Spanierin mit weissem*
 Spitzenschal). 1913
 Oil on paperboard, 26¾ x 18¾″ (68 x 47.7 cm.)
 Signed l.l.: *A.J.* Not dated.
 Private Collection

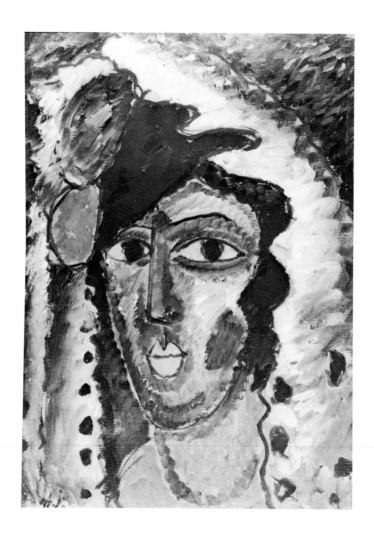

272 *Spanish Woman (Spanierin)*. 1913
 Oil on paperboard, 26⅜ x 19⅛″ (67 x 48.5 cm.)
 Signed and dated u.l.: *A. Jawlensky/13.*
 Collection Städtische Galerie im Lenbachhaus, Munich

273 *Head (Kopf)*. n.d.
 Pen and watercolor, 7⅜ x 6″ (18.8 x 15.3 cm.)
 Signed l.l.: *A.J.* Not dated.
 Collection Museum Ludwig, Cologne

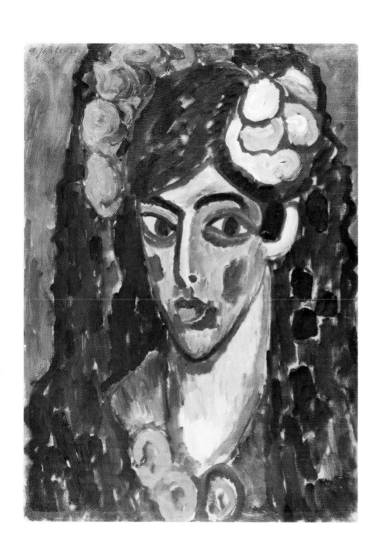

VI

Big-City Expressionism:
Berlin and German Expressionism

EBERHARD ROTERS

German Expressionism was not born in Berlin. But it was in Berlin that the word Expressionism first circulated, then spread quickly as it found acceptance. At first, it was a highly imprecise stylistic term referring to almost any art that deviated from the prevailing aesthetic standard through a vehement intensity of form and color.[1]

The birthplace or rather birthplaces of Expressionism were the German provinces: capitals like Dresden and Munich and their rustic centers and epicenters, such as Worpswede, the Moritzburg lakes, the Westphalian landscape around Soest and Hagen, as well as the small towns of Sindelsdorf and Murnau on Lake Staffel in Bavaria, or the coastal areas of Dangast and the island of Fehmarn. From the outset, German Expressionists tended to flee the city and "go back to nature," a tendency linked to the quest for primal living and creating. Thus the move of the Expressionists and their works to the metropolis contradicted the initial inclination. This new twist presumed a spectacular climax and a termination of the first phase, which was so important for the development of the style. For now the risky venture of dominating art judgments in the big city was based on this turn of events. Furthermore, the artists now succumbed to their need to present the documents of their artistic revolution to the expertise of the metropolitan public, which was the most demanding, most skeptical, most recalcitrant, most fickle, but also most open and therefore most important art audience in existence. Expressionism's encounter with the city of Berlin launched a social process akin to a seething chemical reaction. An exchange of inherent qualities caused a two-fold transformation; ultimately, both the style of Expressionism and the metropolitan society of Berlin clearly and distinctly altered their nature.

The way in which this development took place was obviously associated with the political events that gave historical shape to the epoch. The life of Berlin's big-city Expressionism lasted something like a decade, beginning precisely in 1910 and ending roughly in 1920. In its political course, the decade was like a fever curve, its peak being the years of World War I. Berlin Expressionism, which changed significantly because of its dealings with the political developments in Germany and Berlin, can be seen today as falling into three phases: the prewar period from 1910 to 1914; the war period from 1914 to 1918; and the postwar period from 1918 to 1920 and later. During all three phases, Berlin was a capital city of social contradictions.

Until 1914, Berlin was the capital of the German Empire, an empire which—being an anachronism among European nations—was founded in 1871, at a time when other European countries had just come to realize how old-fashioned it was to dress their hegemonic demands in the outmoded notion of an empire. In the first dec-

238

ade of the twentieth century, the last Hohenzollern emperor, Kaiser Wilhelm II, his royal household, and his cabinet ludicrously combined modern imperialistic power politics with a loudmouthed imperial operatic romanticism. In those years, however, Berlin was not just the capital of a technologically progressive empire philosophically bent on restoration, whose ruler, in attempting to reconcile the unreconcilable, pulled off certain theatrical achievements that were unintentionally comic. Berlin was also the capital of a liberal German bourgeoisie, who received some of its impulses from the emancipated Jewish-German middle class and who openly opposed the policies of the emperor's court. For this reason, Berlin was also the capital of the intellectual vanguard, who discussed radical ideas for both a political and an aesthetic revolution. Long before the outbreak of World War I, those circles had developed a resistance to the power politics of the Kaiser's empire. The term "prewar years" for this phase—not final years of peace—has been chosen deliberately, for it evokes the sense of life and the feeling for the world, a mood of doomsaying—all of which were revealed in the imagery of painting and poetry.

During the war years of 1914 to 1918, Berlin was the capital of a declining empire. It was also the capital of an aggressive imperial war and the capital of deprivation and poverty. And it was the capital of a nation in whose profoundly shaken social structure a political upheaval was already brewing.

In the postwar years after 1918, Berlin was the capital of the first German republic and also the capital of an abortive revolution as well as the wishful goal of both restorational and reactionary forces. In the strained relations of mutually opposing factions—between right-wing and left-wing radicals, between Spartacus and the Kapp putsch—Berlin, after 1918, became the European capital of obvious and openly contested social contradictions. The experience of a tension reaching the breaking point within the social structure patently affected the goals of art. Artists were challenged to take a stand with their works in the political struggle, and they accepted the challenge. The sense of life and the mood of the era, as felt by city dwellers in the decade from 1910 to 1920, were clearly reflected in the fine arts and in literature. The gamut runs from the prewar apocalyptical vision to the postwar artistic stand, with artists touching directly on current political events. In 1920 Kurt Pinthus brought out the first major collection of Expressionist poetry, published by Rowohlt Verlag of Berlin. The title of the book was *Menschheitsdämmerung (Twilight of Humanity)*.[2] The first ten poems are: "World's End" by Jakob van Hoddis; "Umbra Vitae" by Georg Heym; "My Time" by Wilhelm Klemm; "Decay" by Johannes R. Becher; "The God of the City" by Georg Heym; "Berlin" by Johannes R. Becher; "City Dwellers" by Alfred Wolfenstein; "The City" by Jakob van Hoddis; "House of Beasts" by Alfred Wolfenstein; and "The Twilight" by Alfred Lichtenstein. These very titles brought into focus Expressionism's sense of life and its sense of the world. The book was illustrated with portraits of writers by important Expressionist artists, including pen-and-ink drawings by Oskar Kokoschka and Ludwig Meidner.

In Berlin, German Expressionism became urban; in Berlin, the Expressionism of fine arts joined forces with the Expressionism of belles lettres; in Berlin, Expressionism gained political substance and political form; in Berlin, Expressionism lost its innocence.

Jakob van Hoddis's poem *"Weltende"* ("World's End"), which opens Kurt Pinthus's anthology, reads as follows:

Dem Bürger fliegt vom spitzen Kopf der Hut.
In allen Lüften hallt es wie Geschrei.
Dachdecker stürzen ab und gehn entzwei,
und an den Küsten—liest man—steigt die Flut.

Der Sturm ist da, die wilden Meere hupfen
An Land, um dicke Dämme zu zerdrücken.
Die meisten Menschen haben einen Schnupfen.
Die Eisenbahnen fallen von den Brücken.

The hat flies from the burgher's pointed head.
The air resounds with something like a shriek.
Roof menders fall to earth and come apart,
and on the coasts—we read—the tide is rising.

The tempest has arrived, the unruly seas
all hop ashore to smash the thickest dams.
Most of the people have a runny nose.
The railroad trains are dropping from the bridges.

Bombast blends with mockery, an apocalyptic vision with sarcasm, despair with cheeriness; in the tone of Expressionist evocation, we hear anarchistic humor. The end of the world is taken lightly. Dada is perceptible here. This poem was written in 1911.

Prewar Years

A series of events during 1910 and 1911 indicated the arrival of Expressionism in Berlin. In 1910 young Berlin artists founded the New Secession. The first issue of Herwarth Walden's journal *Der Sturm* appeared. That spring, Ernst Ludwig Kirchner of Dresden came to Berlin for his first protracted stay. He lived in the studio of his friend Max Pechstein and painted the first Berlin city views. Oskar Kokoschka also paid his first visit to Berlin in 1910. The previous year, Adolf Loos had recommended him to Walden, asking the latter, before the founding of *Der Sturm*, whether he knew of a suitable gallery for the artist.[3] That was the start of a close friendship between the two eccentrics; from then on, until the outbreak of World War I, Kokoschka repeatedly sojourned in Berlin for months at a time. February 1911 brought the first issue of Franz Pfemfert's magazine *Die Aktion*. That October, Kirchner moved to Berlin, to be followed by his Dresden *Brücke* comrades Karl Schmidt-Rottluff and Erich Heckel. Kirchner fixed up a studio over Pechstein's in Berlin-Wilmersdorf, and the two artists founded the MUIM-Institut (Moderner Unterricht in Malerei: Modern Instruction in Painting).

Pechstein had settled in Berlin during 1908. His inclination for a large, decorative form enabled him to present easily the intense emotion of the Expressionist style. Thus, his version of the *Brücke* style appealed to the Berlin art

public at a point when it was still having difficulty with the works of other Expressionists. Pechstein—active, adroit, vital, energetic, and pugnacious—knew how to move about in Berlin's art society. In 1909 he had his first show at the Berlin Secession. It was remarkable that the jury admitted the works of this young and unconventional newcomer.

The Berlin Secession was founded in 1898 under the chairmanship of Max Liebermann. In 1900 it brought together the antiacademic artists of Berlin realism, Jugendstil, Impressionism, and plein-air painting; but as the members grew older, their pent-up emotions openly erupted around 1910. A grumpy "Protest of German Artists" accused Liebermann, head of the Secession, as well as his friend Hugo von Tschudi, director of Berlin's Nationalgalerie, of preferring French Impressionists to German artists. The resulting arguments led to Tschudi's resignation and to a split of the Secession members into progressives and conservatives. The Secession, forgetting the impetus that had led to its founding, was in danger of turning into a club for established old "alumni," unable to comprehend the stylistic originality of the subsequent generation. In December 1908, the sixteenth exhibition, devoted to drawings, still included younger artists such as Max Beckmann, Lyonel Feininger, Vasily Kandinsky, Paul Klee, Emil Nolde, and those of the Dresden *Brücke*. The eighteenth exhibition, in 1909, granted much less space to the young artists: of the *Brücke*, only Max Pechstein was represented. With the twentieth exhibition, in 1910, there was a huge falling-out. The contributions of all the younger artists, including Pechstein, were turned down. Under the leadership of Pechstein and Georg Tappert, the rejected artists promptly formed the New Secession.

Their first exhibition took place from May to July 1910 at Maximilian Macht's art salon under the title *Kunstausstellung Zurückgewiesener der Secession Berlin* (Art Exhibition of the Artists Rejected by the Berlin Secession). The poster and the catalogue cover show Pechstein's picture of a kneeling female archer. At the second show, devoted to graphics, the number of participants had greatly increased. The third show, from February to April 1911, made it clear that the young German Expressionists had come together in the New Secession. Nevertheless, there was no striving for a programmatic alliance. The young men wanted to remain open. The fourth show, in November 1911, brought the group its greatest success. Wilhelm Morgner of Soest and Bohumil Kubišta of Prague joined in. The *Neue Künstlervereinigung München (NKVM)* participated, with works by Alexej Jawlensky, Vasily Kandinsky, Alexander Kanoldt, Franz Marc, Marianne von Werefkin, and others. But of utmost importance for the New Secession was Pechstein's feat of getting the Dresden *Brücke* to participate. In 1912 the *Brücke* artists resolved not to exhibit any longer with Liebermann and the Berlin Secession. Anyone flouting this resolution was to be excluded from the group. But Pechstein did not abide by this rule: that same year, he sent three works to the Berlin Secession, thereby not only sealing the dissolution of the *Brücke*, but also launching the disintegration of the New Secession.

Pechstein's delight in organizing and dispersing groups was revealed several times during those years of dynamic art and artistic politics. He made new friends among the Berlin Expressionists, including personalities who, like him, were committed to, and active in, art politics: Georg Tappert, Moriz Melzer, and Heinrich Richter in Berlin. Of the three artists, Tappert was stylistically closest to the

Brücke. A native Berliner, he moved to Worpswede in 1906, opening an art school there. His best-known pupil was Wilhelm Morgner. Returning to Berlin in 1910, Tappert, in his paintings and graphics, developed a solid big-city Expressionism that was overtly sensuous. His coarse, voluptuous nudes show female figures in the full bloom of fleshliness, painted with verve and passionate contours—nudes in the studio, women with large "wheel" hats in cafés or on the street. Tappert's own contribution to Expressionism, remaining in the shadow of the *Brücke*, was overlooked for a long time and deserves a more detailed appreciation. Melzer, an eccentric with his head in the clouds, began with a religiously accented Expressionist figurative style, from which he soon proceeded to a pictorial diction formulated in Cubo-futurist terms. Around 1913, Richter, under the influence of Futurism, created his "whirligig style," which he retained all his life. His magnum opus is the painting *Our Dear Lady of Tauentzienstrasse*, 1913, whose motifs are related to those in Kirchner's street scenes.

Berlin's changing influence on German Expressionism, ultimately leading to a specific big-city Expressionism, was nowhere so evident as in Ernst Ludwig Kirchner. By moving to Berlin, the *Brücke* artists exposed the bombastic forms and colors of Central German Expressionism to their new experiences with the metropolis. In the immediately preceding years, these artists, seeking primal life and work, had devoted their emotional intensity to an outdoor life while bathing naked in the Moritzburg lakes. Ernst Ludwig Kirchner, the most high-strung among those forming the circle of *Brücke* artists and the one most receptive to rhythmic dynamism, shows the most intensive stylistic assimilation of urban sensibility. This neurasthenic enjoyment reaches all the way down to his fingertips, and the dancing gesture of his penmanship intensifies until it becomes a hectic staccato of sharp brushstrokes, whose rhythmical adjacencies make the motifs oscillate in the huge Berlin street scenes of 1913–14: streetwalkers in rayon and ostrich feathers, rustling through the streets, pulling along cascades of their swift admirers, echelons of men in dark suits and pointed hats—an erotic-neurotic street ballet. Kirchner's *Potsdamer Platz, Berlin*, 1914 (fig. 5), is the most important work in Berlin's big-city Expressionism. On the circular form of a traffic island, which looks like a rotating disk, the composition unfolds from the high-heeled pas de deux at the feet of the two cocottes; resting on its tip, the composition opens upward into a funnel, making the entire scene, generated by the radiations of the whirligig whirling, look as if it were beginning a hectic dance.

The scintillating discharges of such colorful streetwalking tempests also make their impact in the paintings of two other Expressionists, who were inspired around 1910 by the flickering nervousness of the big city. The work of the North German, Emil Nolde, is marked by a mystical bent in its subject matter and by color splotches floating in and out of one another like clouds. During 1911 and 1912, he did a few paintings of couples at coffeehouse tables, ladies and gentlemen in tête-à-têtes, unveiling their colorfully iridescent elegance in the wan shine of a big-city aura, a sun as yellow as acetylene gas. Oskar Kokoschka brings the overbred hypersensitivity of an urbanite from Vienna, where he did his first portraits—intuitive, brilliantly penetrating psychograms—like the one of architect Adolf Loos of 1909. In Berlin, during 1910, he painted the profile portrait of his like-minded promoter, the coffee-drinking, chain-smoking, nature-hating Herwarth Walden. The picture sharply registers the maniacal, motional tempo of the subject. An intellectual fig-

242

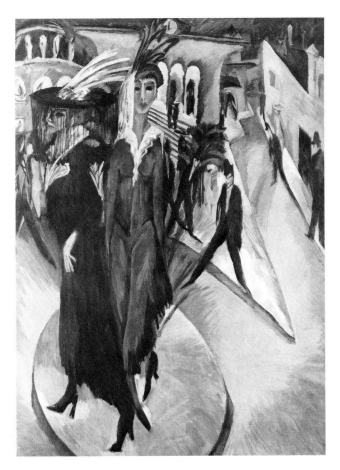

fig. 5
Ernst Ludwig Kirchner
Potsdamer Platz, Berlin. 1914
Private Collection

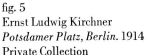

fig. 6
Title page from *Der Sturm*, Berlin, October 1916.
Drawing by Oskar Kokoschka of Hermann Essig
Courtesy The Hilla von Rebay Foundation

ure, vibrating to his nerve endings, utterly self-absorbed, draws past the viewer, phantom-like. The transparency of his thoughts seems to be born from the quivering of the electric light. Kokoschka's pen-and-ink drawings were the first graphic adornment on the title pages of *Der Sturm* (see fig. 6): portraits of artistic colleagues in Vienna and Berlin—Karl Kraus, Paul Scheerbart, Rudolf Blümner—as well as the poetry of scenes growing out of masses of pen strokes, with titles like *Anybody Can Kiss Beautiful Lilith's Hair.*[4]

Fine artists and literati encountered one another in Berlin. They talked and worked together, and a fusing process began between the fine arts, literature, and politics, between imagination and intellect. This produced the specific climate of Berlin's artistic and literary Expressionism. The speed of this integration was aided by countless avant-garde weeklies for literature, art, culture, and politics, especially two in newspaper format: *Der Sturm* and *Die Aktion.*

Herwarth Walden, with a background in music and composition, married the poet Else Lasker-Schüler in 1901, but their marriage lasted only a few years. He then married Nell Roslund, a Swede. Walden was one of the most important talent scouts of his time. It was primarily because of him that Berlin became a

melting pot for modern art during the 1910s and 1920s. *Der Sturm* was a radical magazine of cultural criticism, publishing the literary and artistic vanguard. Along with the texts—critical essays and poems—the magazine included original graphics, both woodcuts and lithographs by young artists, lithographs by Kokoschka, and graphics by the *Blaue Reiter*, the French Cubists, and many others. This visual material, together with its logo, produced the unmistakable image of *Der Sturm*.

In March 1912, Walden opened the Sturm gallery, which quickly became both famous and infamous through a series of exhibitions that followed one another like drumbeats. The opening show—with the *Blaue Reiter*, Oskar Kokoschka, and the Expressionists—was followed in April by an exhibition of Italian Futurists and in June and July by a show of artists rejected by Cologne's Sonderbund, which until then had been looked upon as avant-garde. In August the gallery showed French Expressionists, including Braque and Derain.

The most important event of the prewar period was the *Erster Deutscher Herbstsalon*, which opened in September 1913 and ran for three months. It showed some four hundred works by seventy-three artists, including the Germans Heinrich Campendonk, Alfred Kubin, August Macke, Franz Marc, and Gabriele Münter; the Swiss Paul Klee; the Austrian Oskar Kokoschka; the German-American Lyonel Feininger; the French Robert Delaunay, Sonia Delaunay, Albert Gleizes, and Fernand Léger; the Italians Umberto Boccioni, Luigi Russolo, and Gino Severini; and the Russians Alexander Archipenko, David Burljuk, Marc Chagall, Natalia Goncharova, Alexej Jawlensky, Vasily Kandinsky, Mikhail Larionov, and Marianne von Werefkin. This event, a financial and critical disaster, was the first exhibition to bring together, with real assurance, the outstanding accomplishments of the European vanguard. Its fame was conditioned by a small band of artists and art lovers who were open to the new developments.

In the brewing storm, the flickering atmosphere of those last months of a hale European society, when the colors of the brilliance of life were shining intensely one last time, the portents of the approaching demise were perceived by the clearsighted artists.

In November 1912, the Sturm gallery showed the *Pathetiker* (bombastics), a group of three painters: Ludwig Meidner, Richard Janthur, and Jacob Steinhardt. Meidner was the leading artist of the group. His paintings are written on the canvas with broad, pasty brushstrokes, in the gesture of a breathless, ecstatic Expressionism. Created under the pressure of emotions erupting from within, his paintings of cityscapes appear to burst apart. The composition explodes from its center. The horrors of war and the violence of revolution seem to be anticipated in these pictures. Houses burn and ruins smoke. The twisted corpses of the dead lie naked at the edges of gigantic craters. *Revolution* is the title of a 1913 painting now in the Nationalgalerie, Berlin (fig. 7). A flag bearer with a bandaged head, his mouth torn open for a shriek, storms out of the explosive chaos of a barricade battle—the end of the world. A poetic parallel was a 1911 poem entitled "War," by the Berliner Georg Heym:

> *Aufgestanden ist er, welcher lange schlief,*
> *aufgestanden unten aus Gewölben tief.*
> *In der Dämmrung steht er, gross and unbekannt,*
> *und den Mond zerdrückt er in der schwarzen Hand....*

Now he has arisen, he who slept so long,
Now he has arisen from the deepest vaults.
He stands up in twilight, towering and unknown,
Crushing the moon in his swarthy hand. . . .

Not only the *Pathetiker* but also the *Neo-Pathetikers* spoke their minds in those years. December 1911 brought an evening of the "Neo-Bombastic Cabaret" in Berlin. A second evening followed in 1912. This cabaret, organized by Erich Loewenson and Kurt Hiller, had as its main participants Carl Einstein and Salomon Friedländer, both of whom were prominent contributors to *Der Sturm* and *Die Aktion*. Their sharply polished topical satires are masterpieces of Berlin's Expressionist essay. In their commentaries, parables, and poems, which radically challenge the self-image of the bourgeoisie and thus its own self-image, Expressionism already shows self-destructive features; its bombast is replete with crystal-clear irony. In 1912 Einstein published his *Bebuquin*,[5] a pre-Surrealist novel whose dream-analytical depiction of a ghostly image of society is still practically unknown outside a small group of connoisseurs. Friedländer, the philosopher, who published his satirical writings under the pseudonym Mynona,[6] was already working on his philosophical treatise entitled *Creative Indifference*,[6] which was influenced by his struggle with Nietzsche. It did not appear until 1918, however.

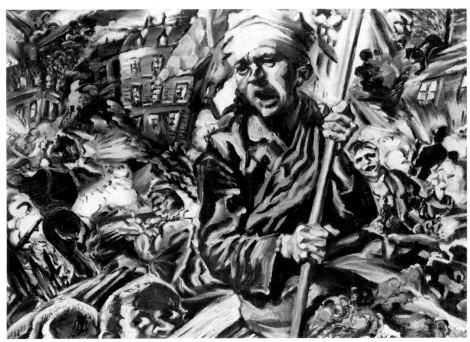

fig. 7
Ludwig Meidner
Revolution. 1913
Collection Staatliche Museen Preussischer Kulturbesitz,
Nationalgalerie, Berlin

The intrinsic features of Expressionism include bombast, ecstasy, dynamics, tension, eroticism, intensification of the sense of life—but not irony. Ironic and sarcastic tones in the writings of Mynona and Einstein were the first symptoms of the causative destruction of Expressionism out of the kernel of its own substance. The process was launched immediately before the outbreak of the war—characteristically in literature and not in the fine arts. This revealed the traits of an aesthetic and intellectual anarchism, which, previously latent, was, albeit not prompted but nevertheless hastened by the war. It soon reached a virulent stage. The writings of Einstein and Mynona announced Dada.

The War Years

The international Dada movement began in 1916 with the evenings at the Cabaret Voltaire in Zürich. The time and place of this initial spark are so familiar that we often forget the prerequisites leading up to them. The Dada movement has a prehistory as well as a history. The fuse that caused the bomb to explode in 1916 had been lit a few years earlier, during the final moments of world peace. Most of the Dadaists did not first meet in Zürich or later; they already knew one another—in Berlin. Berlin's big-city Expressionism created the atmosphere in which Dada, with its anarchism and belligerent pacifism, was hatched. The future Dadaists had contributed texts to *Der Sturm* and *Die Aktion* during the prewar years. *Der Sturm* published Einstein and Mynona, as well as Apollinaire, Aragon, Breton, Eluard, and Tzara; *Die Aktion* published writers like Hugo Ball, Emmy Hennings, Otto Gross, Franz Jung, and Walter Serner.

One's first impression of the two magazines is that they seem quite similar. Both have a newspaper format; both combine Expressionist poetry and prose with original graphics; and both offer pointed and polished texts, most of which, politically, advocate a left-wing liberal stance. Both magazines often published the same authors and occasionally the same visual artists. The essential contrast is not discernible at first glance. It is based on the different tones of the publishers in their utterances on the relationship between art and politics. Walden stated: "Revolution is not art, but art is revolution." Pfemfert, in contrast, saw art as an instrument of revolutionary politics. Franz Pfemfert, whose burning interest in politics had brought him into anarcho-communist groups at the very start of the century, proclaimed pacifism in *Die Aktion*—a pacifism carried by humane ideals and delivered in aggressively stylized articles. In 1912 he wrote:

> *Europe's madness seems incurable. What gives us the right to drivel about the progress of a mankind that so enthusiastically displays its wretched instincts? A mankind so criminal as to loudly proclaim murder upon orders as a duty of "national honor"? A mankind that cheers fanatical ignorance as courage? What gives us the right to describe as civilized an era that kneels before ghosts from the dawn of history? Europe's madness is incurable. What do all the phrases of our platonic pacifists mean? Not one single bullet remains in gun barrels because a few harmless visionaries take a stand for peace. Peace awards are handed out and peace conferences are convened, but no time remains to get at the madness with serious remedies.*

In August 1914, World War I began.

In spring 1915, the recruit, Ernst Ludwig Kirchner, was furloughed from his field artillery unit because he did not prove adequate to the demands of service. The diagnosis said: "because of affected lungs and feebleness." But the true cause was a profound physical and spiritual crisis, which brought him to a sanatorium in Königstein, Taunus. Artistic efforts at overcoming the trauma are revealed in works such as the 1915 *Self-Portrait as a Soldier* (fig. 8). The artist presents himself in the masquerade of a uniform; his face is a mask of isolation; a bleeding arm stump looms out of the right sleeve; the painter's active hand seems chopped off. That same year brought the woodcut series on Adalbert von Chamisso's tale *Peter Schlemihl* (see cat. no. 164), the parable of a man who sells his shadow, thereby forfeiting his identity.

In 1915, in Ostende, the volunteer orderly Erich Heckel met another volunteer orderly from Berlin, Max Beckmann. Both were united in their admiration for the works of the old visionary James Ensor, who lived in Ostende. In the autumn of 1915, Beckmann was released from the military because of a nervous breakdown. He moved to Frankfurt. In the shattering *Self-Portrait with a Red Scarf* of 1917 (fig. 9), both the face and the style bear the acute stamp of the spiritual collapse that the war experience had carved into the artist's soul.

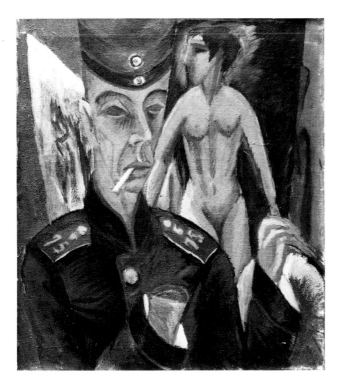

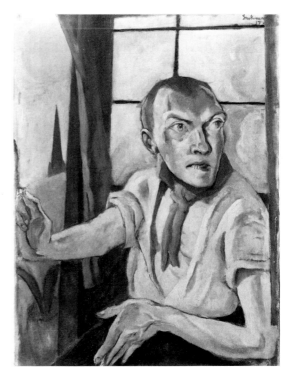

fig. 8
Ernst Ludwig Kirchner
Self-Portrait as a Soldier. 1915
Collection Allen Memorial Art Museum, Oberlin College,
Oberlin, Ohio, Charles F. Olney Fund, 50.29

fig. 9
Max Beckmann
Self-Portrait with a Red Scarf. 1917
Collection Staatsgalerie Stuttgart

In May 1915, George Grosz, the army volunteer from Berlin, was discharged for being 4-F. Returning to Berlin, he was drafted in 1916 and then promptly put into a sanatorium, only to be released on the spot and then drafted once again on January 4, 1917. On January 5, he landed in the Guben field hospital and in late February 1917 in the Görden Sanatorium near Brandenburg. In late April, he was finally discharged from the military for good. In Berlin, Grosz met Franz Jung, who had volunteered for the service, then deserted and was interned in a lunatic asylum for a while. During this period, Grosz drew mordantly nervous doodling pictures of soldiers helplessly exposed to the horrors of the battlefield. In 1917, in a letter to his brother-in-law, Otto Schmalhausen, he wrote from Görden: "My nerves fell apart before I saw the front this time, the decaying corpses and piercing wire; for a while, they made me harmless, locking me up in order to undertake a special diagnosis of whatever military ability I might still have. The nerves, every last fiber, repugnance, repulsion!"[7] In 1916, on the Western front, the machine gunner and combat-patrol leader Otto Dix of Dresden became a fanatical opponent of war (see cat. no. 313).

These episodes require no further comment to explain why German art was so altered by the war, which it had anticipated. The stylistic devices discovered during the final prewar years by Berlin's big-city Expressionism now served as the basis for displaying a stylistic change. Art, coming from Expressionism, was now antimilitaristic, extremely aggressive in its manner of formulation, and politically committed. By taking a stand, it attempted to plunge directly into current political events. In this context, the biting irony and sarcastic satire, originally alien to Expressionism and first occurring at the periphery of big-city Expressionism before the war, now became the chief expressive elements. This conditioned the art of the postwar period. Furthermore, during the war years, a new generation, ten to twenty years younger than the Expressionists of the first wave, made itself felt.

Postwar Years

Franz Pfemfert had already met young Conrad Felixmüller of Dresden during the final years of the war. Felixmüller supplied him with the weekly title woodcuts for *Die Aktion* (see fig. 10): these were visual comments on current political problems, with the Berlin publisher assigning the themes by phone to the artist in Dresden. Their effective cooperation was continued after the war. This was the first time that the Expressionist woodcut was pointedly used as a means of political agitation. The precedent launched a fashion. The black-and-white contrast of the woodcut, which forced a poster-like stylization upon the formal language, was eminently suited to an artistic leaflet in a manner totally consistent with the block books and single-leaf woodcuts of the fifteenth and sixteenth centuries. Thus the woodcut became the basic medium of a politically committed postwar Expressionism. It was practiced by countless artists in the Weimar Republic: Lea and Hans Grundig, Sella Hasse, Alfred Frank, Carl Meffert, and others. The chief models for these artists were the woodcuts of Käthe Kollwitz.

After the war, Felixmüller founded the Dresden Secession of 1919, which put out *Der Mensch*, a magazine of postwar Expressionism. Felixmüller's magnum opus at that time was the painting *Death of the Poet Walter Rheiner*, 1925 (fig. 11). Rheiner, a close friend of his, had killed himself by jumping out a window. In a

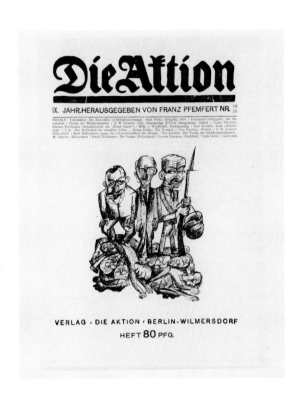

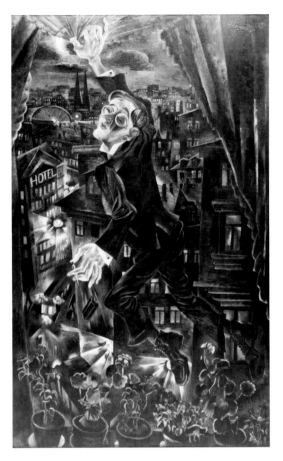

fig. 10
Title page from *Die Aktion*, Berlin, April 19, 1919.
Illustrated by Conrad Felixmüller
Courtesy of The Robert Gore Rifkind Foundation,
Beverly Hills

fig. 11
Conrad Felixmüller
Death of the Poet Walter Rheiner. 1925
Collection Klaus Osterhoff, Berlin

boxed-in, dramatically agitated composition—a constellation of points, angles, and edges—the painting shows the suicide's leap into the sucking depth, the light-filled abyss of the urban night. That was the last major big-city painting of German Expressionism—an apotheosis *ex negativo*.

Before the war, the Expressionists of the Dresden *Brücke* had come to Berlin; and now once again, after the war, close ties were formed between the two cities. Felixmüller and Dix came from Dresden, where both Grosz and Dix had studied under Richard Müller. In their painting, the Dresdeners showed a conspicuous bent for an objectivity of belligerent colors and exaggerated forms. This had a fermenting effect in Berlin's postwar art. During the twenties, the work of both Dix and Grosz was characterized by socially critical realism, which they gained from the sharp, bulky, stinging forms of a kind of teeth-gnashing leftover Expressionism; in the early canvases of both artists, this was influenced by Futurism.

Max Beckmann in Frankfurt also found his way from the impulses of a traumatically broken Expressionism to the impressive mode of an individual style.

In 1917 he painted *The Descent from the Cross* (cat. no. 320), and in March 1919 he completed *The Night.* In the concentrated thrust of an aggressiveness turned against itself and against the world, *The Night* has a symbolism that encompasses the mood of the era. This magnum opus of the epoch shows a gang of murderers who have climbed through the window of a house from the dark night. In the attic, a man is being strangled by a butcher while someone else is breaking off his arms. His wife's wrists are tied. One candle burns, the other has gone out. A Gramophone with a huge, black, yawning funnel has dropped to the floor. In the narrow space, forms of people and of things afflict and torment one another. In its spiritual stance, the picture acts as a bridge back to German painting of the fifteenth century—more to Hans Multscher than to Matthias Grünewald.

In Berlin, trends and groups re-formed after the war. The Berlin Dadaists— who, along with Grosz and Dix, included John Heartfield, Raoul Hausmann, Johannes Baader, Walter Mehring, Richard Huelsenbeck, and others—produced their spectacular scenes of direct artistic action. Dada, which, as we saw, had demonstrable origins in big-city Expressionism, no longer had anything to do with Expressionism; instead, it embodied something very different, something utterly new. The after-effects of Expressionism could be found in the other Berlin groups that were launched. In late 1918 the *Arbeitstrat für Kunst* (Labor Council for Art) was

fig. 12
Lyonel Feininger
Cathedral: Cathedral of Socialism. 1919
Courtesy of The Robert Gore Rifkind Foundation,
Beverly Hills

250

established in Berlin; it demanded "influence and cooperation in all architectural tasks." The ideas that led Walter Gropius to found the Bauhaus had already been formulated here. Feininger designed his woodcut signet of *The Cathedral of Socialism* (fig. 12) in this context. Determining in their debates was the young architect Bruno Taut, who, in autumn 1919, invited his colleagues to correspond with him. Under the title *Gläserne Kette (Glass Chain)*, this exchange of letters among friends continued for five years. In texts, drawings, and watercolor sketches, they devised a utopian scheme of Expressionist architecture, which, alas, with a few exceptions, fails owing to the practical and political demands of reality. This movement too had its Berlin prophet, the visionary poet Paul Scheerbart, who, in 1914, published the book *Glass Architecture*.[8] Ultimately, the Labor Council for Art merged into another association, the *Novembergruppe*, which was established in December 1918. This Berlin association of artists developed during the twenties from its initial impulses for a cultural revolution to a motley group exhibiting German artists as well as guest artists from other European countries. The Expressionist origin is still visible in the works of many members of the group. But the mutual influences of formal inventions, brought in by artists of diverse directions—Futurists, Cubists, Constructivists, and Abstractionists—merged into a stylistic blend. This synthesis led to a stylistic syncretism characteristic of art during the 1920s—especially Central European art, German, Hungarian, and Czech. Despite recent studies of the art of the twenties, no one has so far properly appreciated the historic quality of this stylistic syncretism.

Notes

1. Cf. Donald E. Gordon, "On the Origin of the Word 'Expressionism,' " *Journal of the Warburg and Courtauld Institutes*, vol. xxix, 1966, pp. 368-85

2. Kurt Pinthus, *Menschheitsdämmerung: Symphonie jüngster Dichtung*, Berlin, 1920. New edition, Hamburg, 1959

3. The original is in the *Sturm* Archive, Staatsbibliothek der Stiftung Preussischer Kulturbesitz, Berlin. The text was published in the catalogue *Der Sturm: Herwarth Walden und die Europäische Avantgarde*, Nationalgalerie, Berlin, 1961.

4. *Der Sturm*, vol. 1, no. 32, 1910

5. Carl Einstein, *Bebuquin oder die Dilletanten des Wunders*, Berlin, 1912. Reprinted Frankfurt, 1974

6. Salomo[n] Friedländer, *Schöpferische Indifferenz*, Munich, 1918

7. Uwe M. Schneede, ed., *George Grosz: Leben und Werk*, Stuttgart, 1975, p. 34

8. Paul Scheerbart, *Glasarchitektur*, Berlin, 1914. Reprinted Munich, 1971

274 *Old Man–Father Hirsch (Alter Mann–Vater Hirsch).*
ca. 1907
Oil on canvas, 27¾ x 24⅝″ (70.5 x 62.5 cm.)
Signed u.l.: *OK.* Not dated.
Wingler, cat. no. 4
Collection Neue Galerie der Stadt Linz/Wolfgang-Gurlitt
Museum

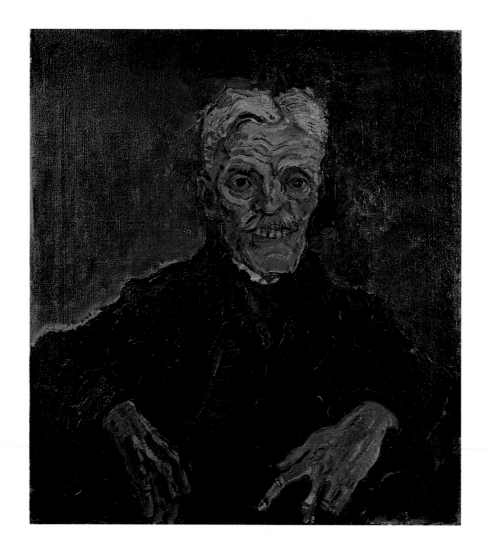

*275 *Hans Tietze and Erica Tietze-Conrat.* 1909
Oil on canvas, 30⅛ x 53⅝″ (76.5 x 136.2 cm.)
Signed l.r.: *OK.* Not dated.
Wingler, cat. no. 29
Collection The Museum of Modern Art, New York,
Abby Aldrich Rockefeller Fund, 1939

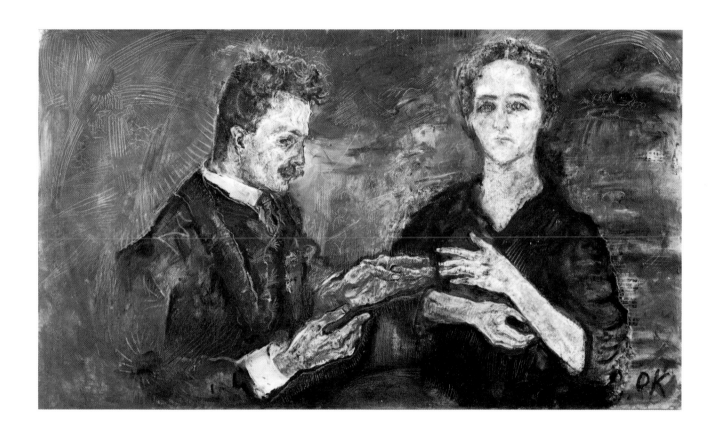

276 *Tilla Durieux.* 1910
 Oil on canvas, 22 x 25⅝″ (56 x 65 cm.)
 Signed u.l.: *OK*. Not dated.
 Wingler, cat. no. 46
 Museum Ludwig, Cologne, Collection Dr. Haubrich

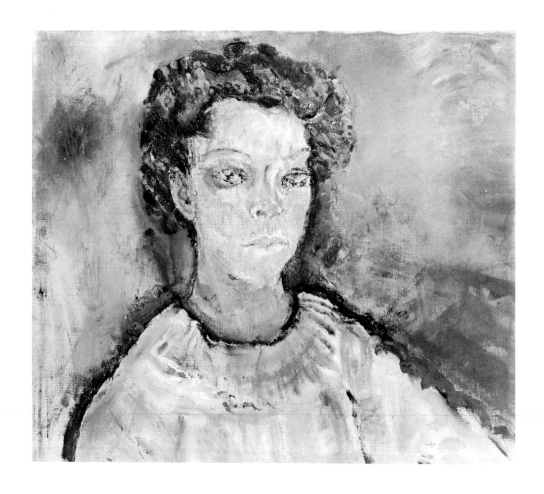

277 *Herwarth Walden.* ca. 1910
 Oil on canvas, 39⅜ x 27⅜″ (100 x 69.5 cm.)
 Signed l.r.: *OK.* Not dated.
 Wingler, cat. no. 38
 Collection Staatsgalerie Stuttgart

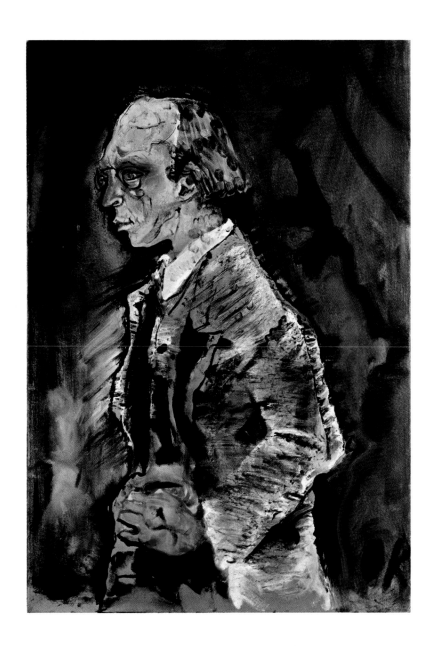

OSKAR KOKOSCHKA

278 *The Annunciation (Verkündigung)*. ca. 1911
Oil on canvas, 32¹¹⁄₁₆ x 48¼″ (83 x 122.5 cm.)
Signed l.l.: *OK*. Not dated.
Wingler, cat. no. 59
Museum am Ostwall, Dortmund/Sammlung Gröppel

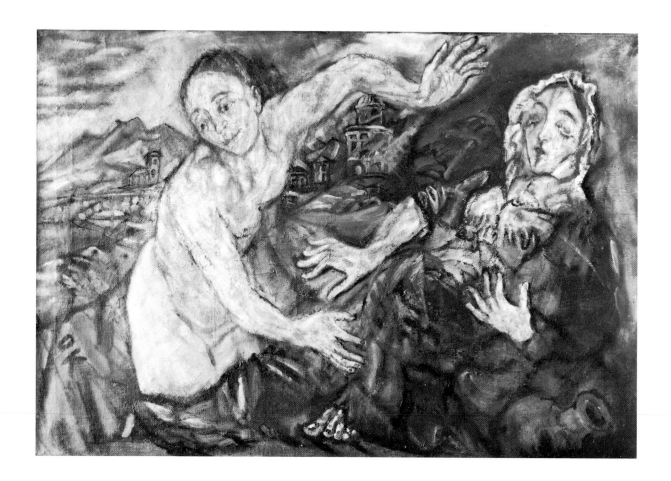

279 *Alpine Landscape near Mürren (Alpenlandschaft bei
Mürren).* ca. 1913
Oil on canvas, 27¾ x 37⅝″ (70.5 x 95.5 cm.)
Signed l.l.: *OK.* Not dated.
Wingler, cat. no. 79
Private Collection

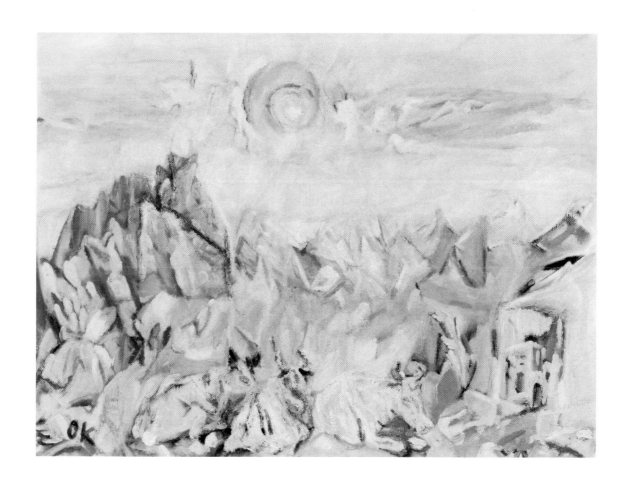

280 *Self-Portrait with Brush (Selbstbildnis mit Pinsel).* 1914
 Oil on canvas, 31½ x 25³⁄₁₆″ (80 x 64 cm.)
 Signed u.l.: *OK*; inscribed on reverse: *24. Dezember 1914/*
 Der aus dem Bild sieht bin ich/der auf mich schaut bist Du
 (Looking out of the picture am I, looking at me are you).
 Wingler, cat. no. 102
 Private Collection

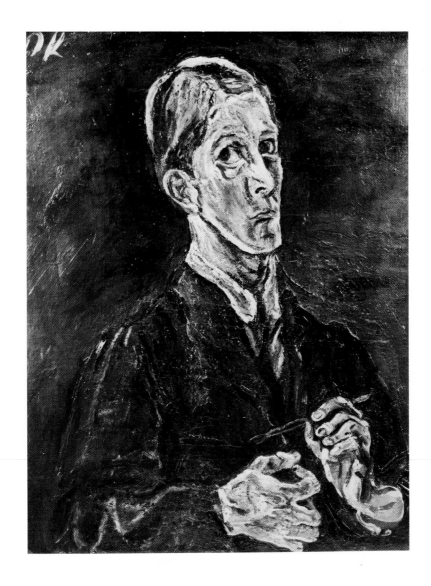

281 *Knight Errant (Der irrende Ritter)*. 1915
Oil on canvas, 35¼ x 70⅛″ (89.5 x 180.1 cm.)
Signed l.r.: *OK*; inscribed on reverse: *OKOXOK*. Not dated.
Wingler, cat. no. 105
Collection The Solomon R. Guggenheim Museum, New York,
48.1172x380

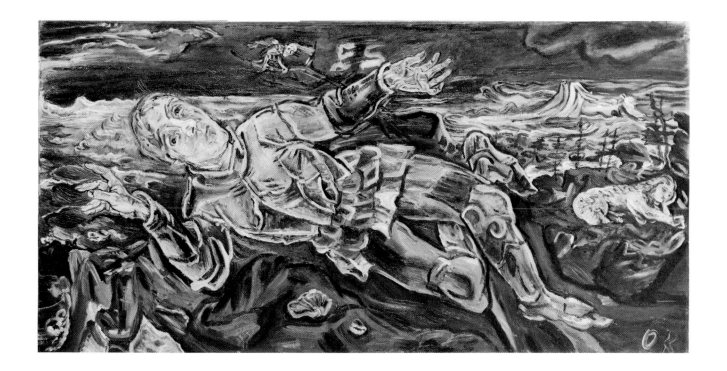

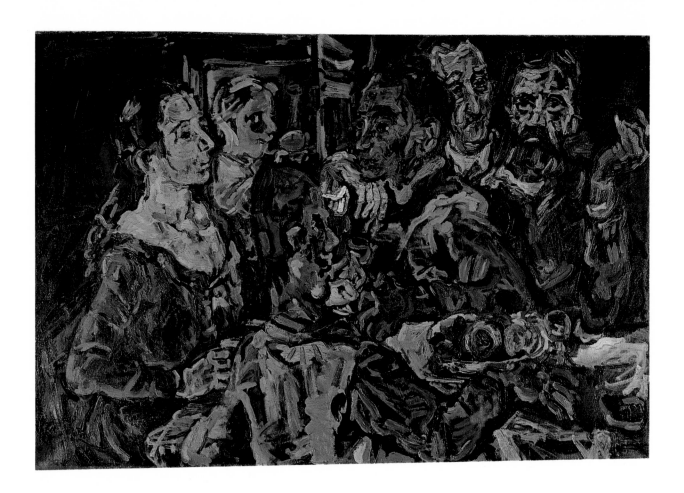

OSKAR KOKOSCHKA

282 *The Friends (Die Freunde)*. 1917–18
 Oil on canvas, 40⅛ x 59½″ (102 x 151 cm.)
 Signed u.l.: *OK*. Not dated.
 Wingler, cat. no. 119
 Collection Neue Galerie der Stadt Linz/Wolfgang-Gurlitt
 Museum

OSKAR KOKOSCHKA

283 *Elbe River near Dresden (Elbe bei Dresden).* 1919
 Oil on canvas, 31⅝ x 44″ (80.3 x 111.8 cm.)
 Signed l.r.: *OK.* Not dated.
 Wingler, cat. no. 131
 The Art Institute of Chicago, Joseph Winterbotham
 Collection

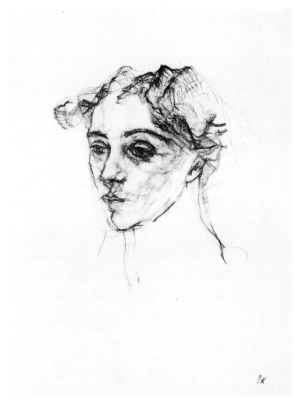

OSKAR KOKOSCHKA

284 *Portrait of Mrs. A. M. Mahler.* 1912
Black crayon, 17½ x 12¹⁄₁₆″ (44.5 x 30.7 cm.)
Dated and signed l.r.: *Am 12. April 1912 OK.*
Collection Museum Folkwang, Essen

285 *Portrait of Mrs. Lotte Franzos.* ca. 1912
Black crayon, 17⅝ x 12⁷⁄₁₆″ (44.8 x 31.6 cm.)
Signed l.r.: *OK.* Not dated.
Collection Museum Folkwang, Essen

286 *Sitting Woman (Sitzende)*. ca. 1922–23
Watercolor, 27⅞ x 20½″ (70.2 x 52 cm.)
Signed l.r.: *O Kokoschka.* Not dated.
Collection Museum Ludwig, Cologne

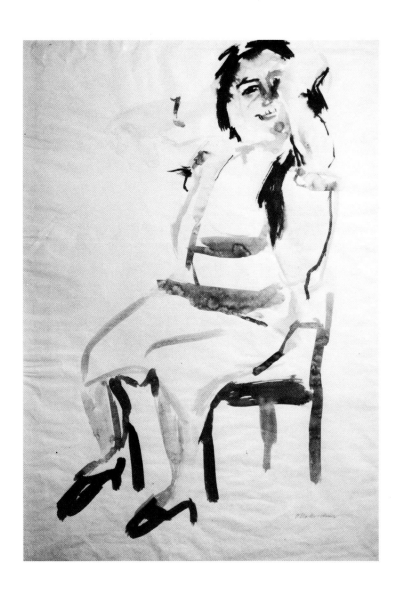

287 *Half-Figure of a Girl with Propped-up Arm*
(Halbfigur eines Mädchen mit aufgestütztem Arm).
ca. 1922–23
Watercolor, 21¼ x 26¹³⁄₁₆″ (51.3 x 68.1 cm.)
Signed l.r.: *O Kokoschka.* Not dated.
Collection Museum Ludwig, Cologne

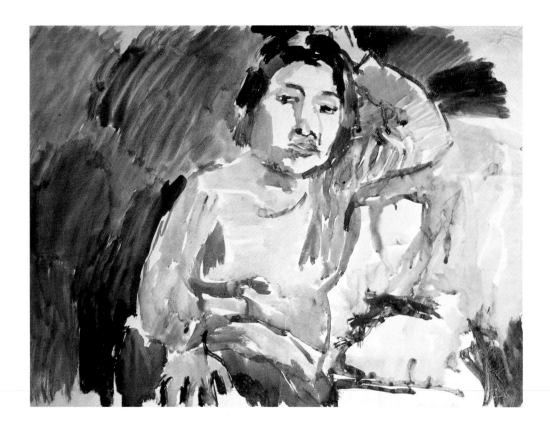

288 *Woman's Head with Green Eyes (Frauenkopf mit grünen Augen)*. 1915
Oil on canvas, 27¾ x 24½″ (70.5 x 62.2 cm.)
Signed and dated u.l.: *Feininger 15*.
Hess, cat. no. 136
Collection of Morton D. May

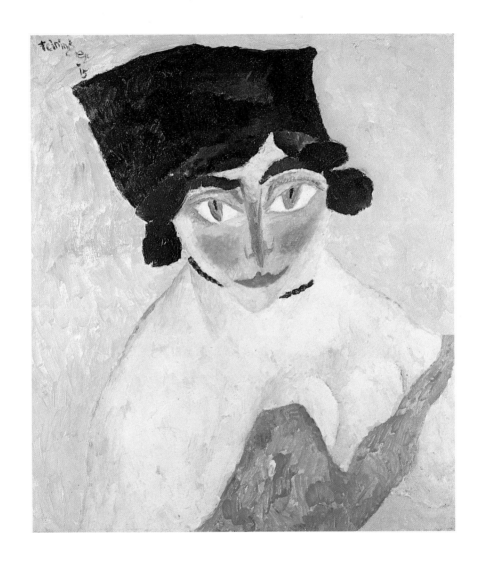

289 *Yellow Still Life with Samovar (Gelbes Stilleben mit
 Samowar).* 1916
 Oil on canvas, 31½ x 39⅜″ (80 x 100 cm.)
 Signed and dated u.r.: *Feininger 16.*
 Hess, cat. no. 156
 Collection Kunstmuseum Düsseldorf

290 *Portrait of a Tragic Being (Bildnis eines tragischen Wesens)*. 1920
 Oil on canvas, 33½ x 31½″ (85 x 80 cm.)
 Signed and dated l.r.: *Feininger 20.*
 Hess, cat. no. 212
 Private Collection, Courtesy of Serge Sabarsky Gallery, New York

291 *Village, Alt-Sallenthin (Alt-Sallenthin)*. 1912
Charcoal, 9⁵⁄₁₆ x 12⁷⁄₁₆″ (23.7 x 31.6 cm.)
Inscribed across bottom: *Feininger ALT = SALLENTHIN*
5. August 1912.
Collection Museum Ludwig, Cologne

292 *Village (Heiligenhafen)*. 1922
 Pen and watercolor, 11½ x 14⅞″ (29.6 x 37.8 cm.)
 Inscribed across bottom: *Feininger Heiligenhafen*
 Mont. d. 20. Feb. 1922.
 Collection Museum Ludwig, Cologne

293 *Village (Klein-Schwabhausen).* 1924
 Pen and watercolor, 10⁵⁄₁₆ x 13⅞″ (26.2 x 35.2 cm.)
 Inscribed across bottom: *Feininger Kl. Schwabhausen*
 Sonnabend d. 26. Januar 1924.
 Collection Museum Ludwig, Cologne

†294 *Gelmeroda II.* 1918
 Woodcut, 11¼ x 9⅛″ (28.5 x 23.2 cm.)
 Collection Museum Folkwang, Essen

295 *Church (Kirche).* 1919
 Woodcut, 10⅛ x 12½″ (25.7 x 30.8 cm.)
 Collection Museum Folkwang, Essen

†296 *Mill (Mühle)*. 1919
 Woodcut, 10¼ x 15¹⁵⁄₁₆″ (26 x 40.5 cm.)
 Collection Museum Folkwang, Essen

297 *Benz*. 1919
 Woodcut, 9¼ x 11½″ (23.5 x 29.2 cm.)
 Collection Museum Folkwang, Essen

298 *Parisian Street (Pariser Strasse)*. 1920
 Woodcut, 20⅜ x 14⁹⁄₁₆″ (51.9 x 37 cm.)
 Collection Museum Folkwang, Essen

299 *Burning City (Brennende Stadt).* 1913
 Oil on canvas, 26½ x 31¼″ (67.3 x 79.4 cm.)
 Signed and dated l.r.: *LM/1913.*
 Verso: *Burning City (Brennende Stadt).* 1913
 Collection of Morton D. May

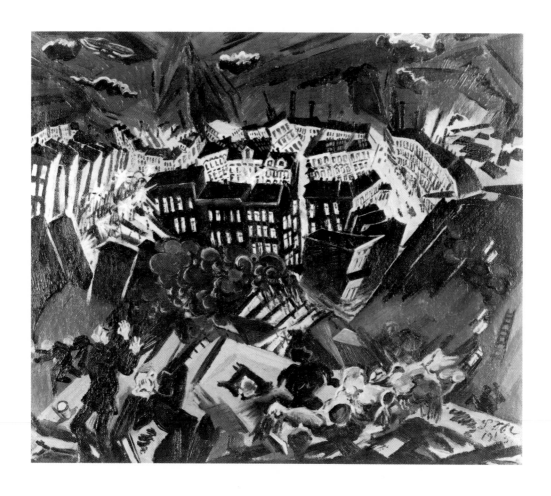

300 *Apocalyptic Landscape (Apokalyptische
Landschaft).* 1913
Oil on canvas, 31⅞ x 45¹¹/₁₆″ (81 x 116 cm.)
Signed and dated l.r.: *LM 1913.*
Collection Saarland-Museum Saarbrücken

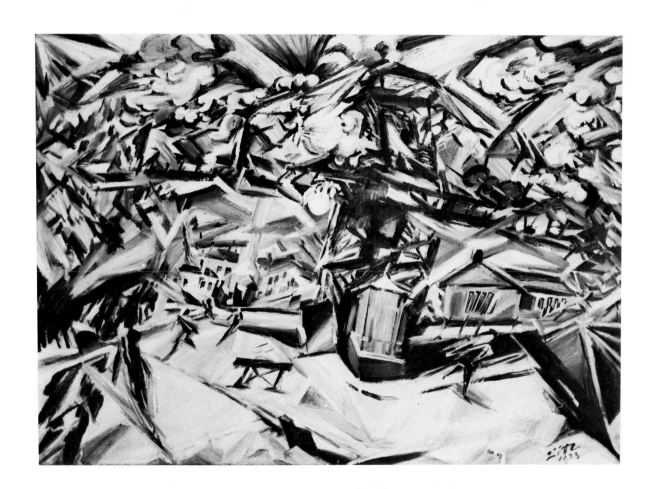

301 *Portrait of Max Hermann-Neisse.* 1913
 Oil on canvas, 35¼ x 29¾″ (89.5 x 75.5 cm.)
 Signed and dated u.l.: *L Meidner Dez 1913.*
 Collection The Art Institute of Chicago, Gift of
 Mr. and Mrs. Harold M. Weinstein

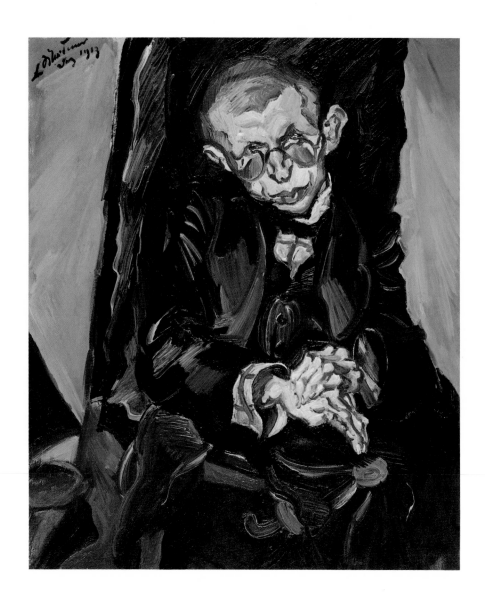

302 *The Stranded (Die Gestrandeten).* 1911
Tempera, 15¾ x 20⁹⁄₁₆″ (40 x 52.3 cm.)
Not signed. Dated l.r.: *Okt. 1911.*
Collection Museum Ludwig, Cologne

†303 *Cholera.* 1912
Tempera, 15 x 20⅜″ (38.1 x 51.8 cm.)
Signed and dated l.l.: *L M 1912.*
Collection Museum Ludwig, Cologne

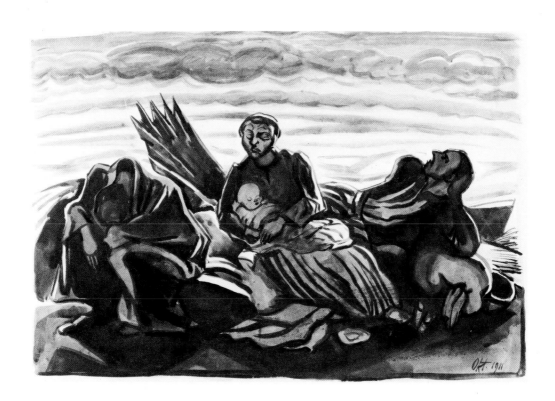

304 *The City (Die Stadt)*. 1913
 Oil on canvas, 24 x 15¾″ (61 x 40 cm.)
 Signed and dated l.r.: *J. Steinhardt 1913.*
 Collection Staatliche Museen Preussischer Kulturbesitz,
 Nationalgalerie, Berlin

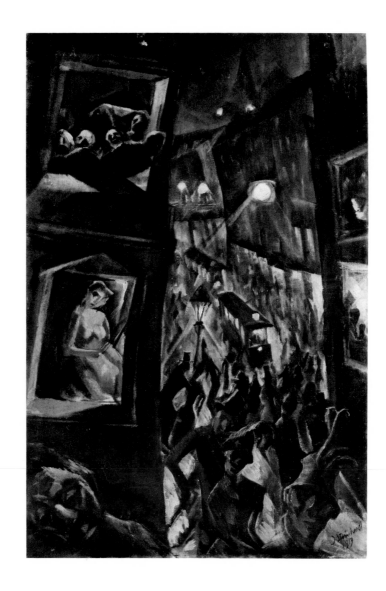

305 *The Street (Die Strasse).* 1915
Oil on canvas, 17¹⁵⁄₁₆ x 14″ (45.5 x 35.5 cm.)
Signed, dated, and inscribed on reverse: *Grosz—Grosz*
1915 Südende.
Collection Staatsgalerie Stuttgart

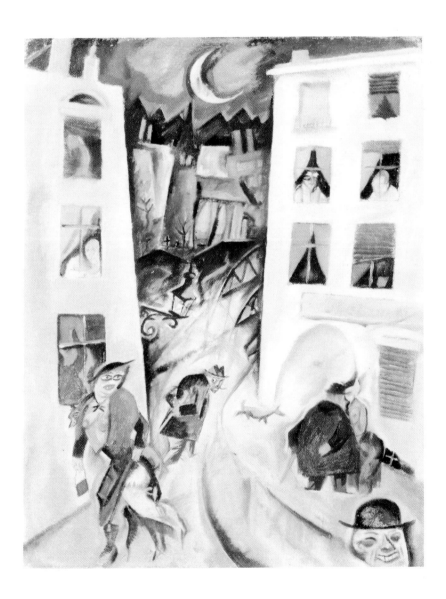

306 *Suicide (Selbstmord)*. 1916
 Oil on canvas, 39⅜ x 30½″ (100 x 77.5 cm.)
 Signed, dated, and inscribed on reverse:
 Grosz/bis Oktober/1916/Südende.
 Collection of The Trustees of the Tate Gallery, London

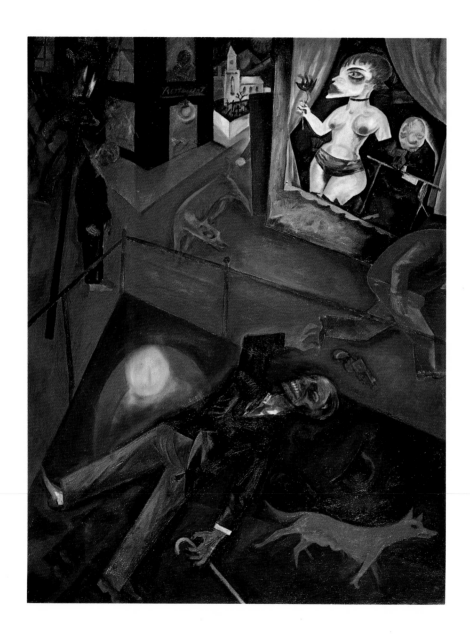

307 *The Lovesick Man (Der Liebeskranke)*. 1916
Oil on canvas, 39⅜ x 30¾″ (100 x 78 cm.)
Not signed or dated.
Kunstsammlung Nordrhein-Westfalen, Düsseldorf

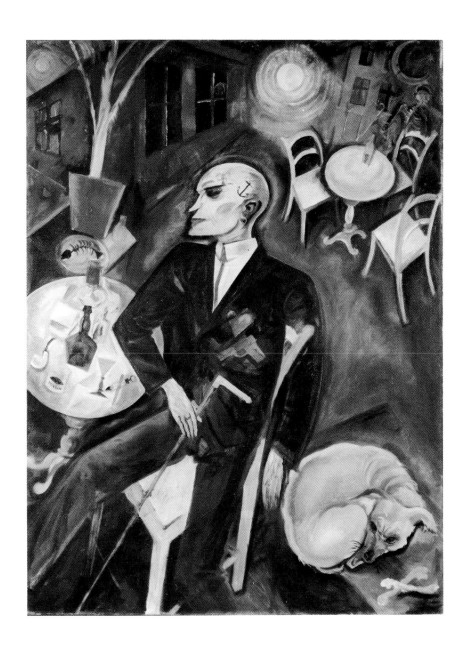

308 *The Big City (Die Grosstadt)*. 1916–17
Oil on canvas, 39⅜ x 40⅛″ (100 x 102 cm.)
Signed and dated on reverse: *Grosz Dezember 1916-
August 1917*.
Thyssen-Bornemisza Collection, Lugano, Switzerland

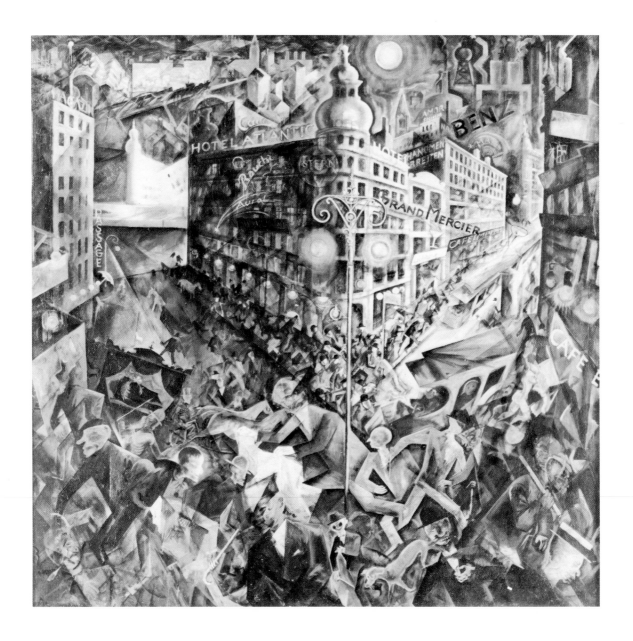

309 *Metropolis.* 1917
 Oil on cardboard, 26¾ x 18¾″ (68 x 47.6 cm.)
 Signed and dated on reverse: *Grosz 1917.*
 Collection The Museum of Modern Art, New York;
 Purchase

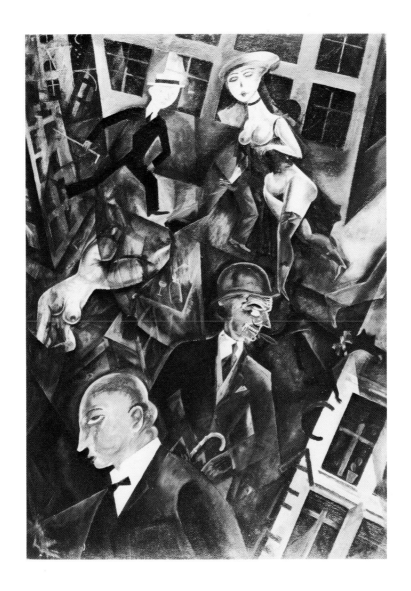

310 *Power and Grace (Kraft und Anmut).* ca. 1922
 Watercolor and pen, 21 x 17⁵⁄₁₆″ (53.3 x 44 cm.)
 Signed l.r.: *GROSZ*. Not dated.
 Collection Museum Ludwig, Cologne

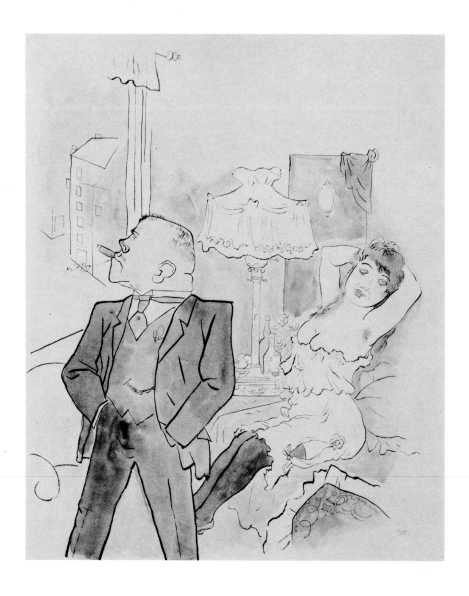

311 *Small Café (Kleines Café).* ca. 1922–24
Pen and watercolor, 24 x 18¹³⁄₁₆″ (60.9 x 47.9 cm.)
Signed l.r.: *Grosz.* Not dated.
Collection Museum Ludwig, Cologne

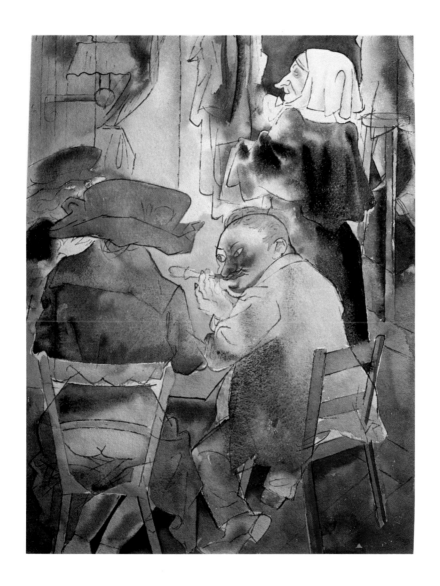

312 *Street with Gas Lanterns (Strasse mit Gaslaternen)*.
1913
Oil on paperboard, 19¹¹⁄₁₆ x 24⅝″ (50 x 62.5 cm.)
Signed and dated l.r.: *Dix 13*.
Collection Jan Dix

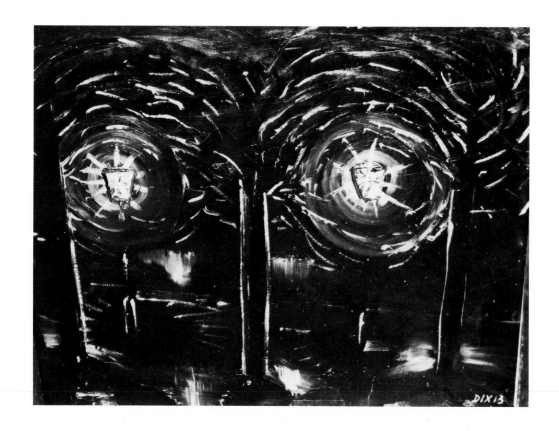

313 *Dying Warrior (Sterbender Krieger).* 1915
 Oil on paperboard, 26¾ x 21⁷⁄₁₆″ (68 x 54.4 cm.)
 Signed u.r.: *D*ix; inscribed and dated on reverse: *Sterbender Krieger 1915.*
 Collection Galerie Klihm, Munich

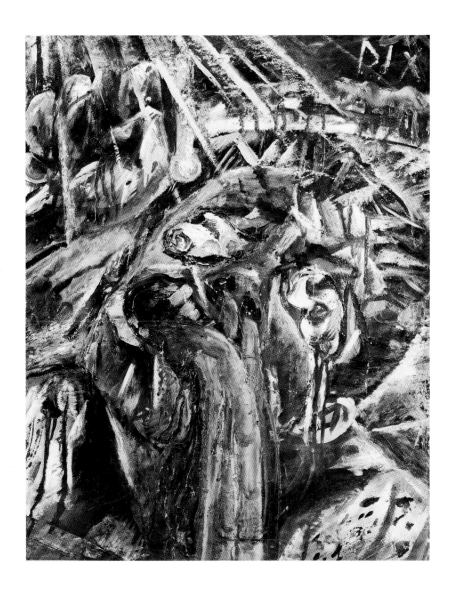

314 *The Felixmüller Family (Familie Felixmüller).* 1919
Oil on canvas, 30 x 36″ (76 x 91 cm.)
Signed and dated u.l.: *Dix 1919.*
Collection of Morton D. May

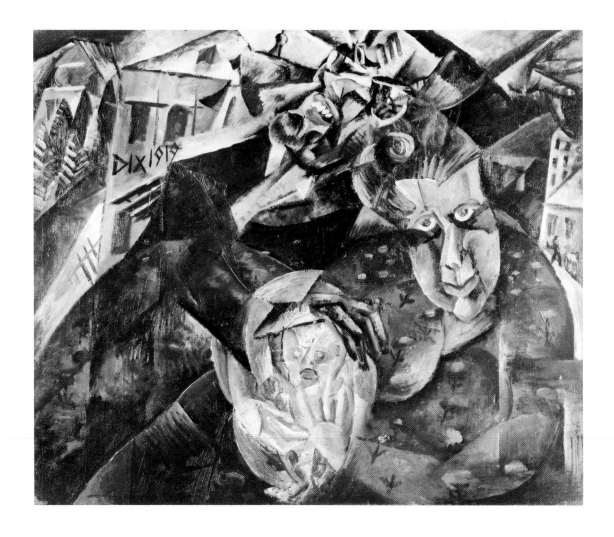

315 *Suburban Scene (Vorstadtszene)*. 1922
 Pen and watercolor, 19⅜ x 15⅝" (49.3 x 39.7 cm.)
 Signed and dated l.l.: *Dix 22.*
 Collection Museum Ludwig, Cologne

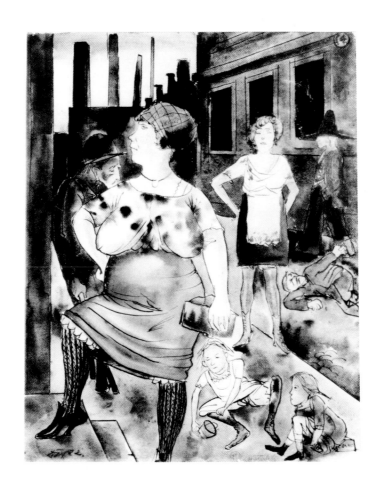

316 *Portrait of Dr. Koch.* 1923
 Watercolor and lead pencil, 23⅞ x 19″ (60.6 x 48.2 cm.)
 Signed and dated l.l.: *Dix 23/227.*
 Collection Museum Ludwig, Cologne

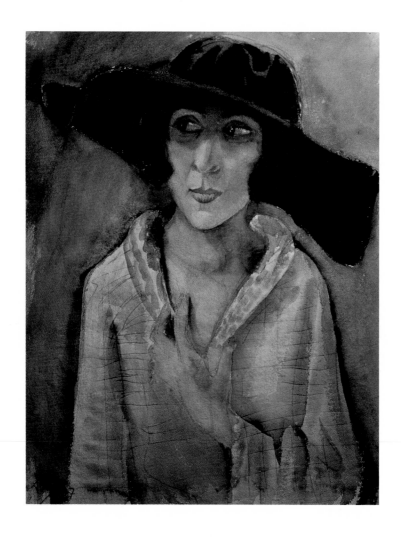

317 *Girl in Pink Blouse (Mädchen in rosa Bluse)*. 1923
Watercolor, gouache, and lead pencil, 21¼ x 20⅛″
(54 x 51 cm.)
Signed and dated l.r.: *Dix 23/347*.
Collection Museum Ludwig, Cologne

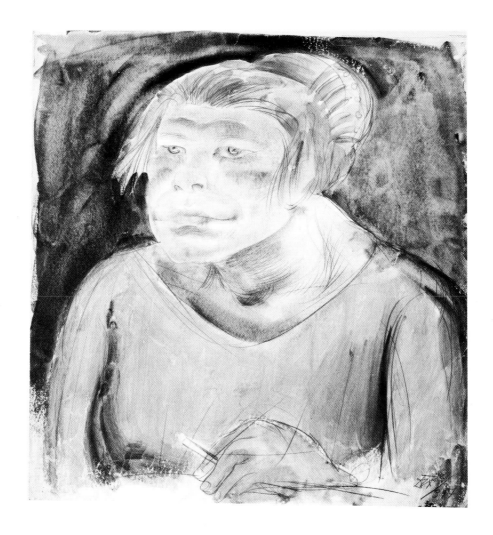

318 *The Sinking of the Titanic (Untergang der Titanic)*. 1912
Oil on canvas, 104½ x 130″ (265.4 x 330.2 cm.)
Signed l.r.: *Beckmann.* Not dated.
Göpel, cat. no. 159
Collection of Morton D. May

319 *Landscape with Balloon (Landschaft mit Luftballon)*.
1917
Oil on canvas, 29¾ x 39⁹⁄₁₆″ (75.5 x 100.5 cm.)
Signed and dated u.r.: *Beckmann 17*.
Göpel, cat. no. 195
Collection Museum Ludwig, Cologne

320 *The Descent from the Cross (Kreuzabnahme)*. 1917
Oil on canvas, 59½ x 50¾" (151.1 x 129 cm.)
Signed and dated u.r.: *Beckmann 17*.
Göpel, cat. no. 192
Collection The Museum of Modern Art, New York,
Curt Valentin Bequest, 1955

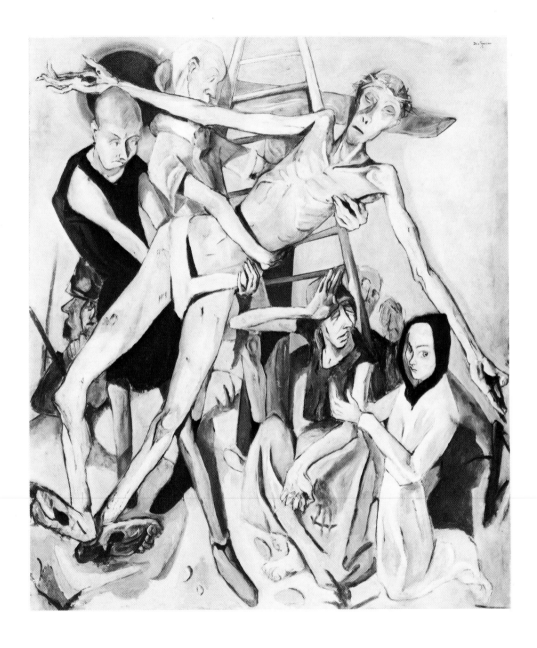

321 *Christ and the Woman Taken in Adultery (Christus und die Sünderin)*. 1917
Oil on canvas, 58¾ x 49⅞″ (149.2 x 126.7 cm.)
Signed and dated u.l.: *Beckmann 17*.
Göpel, cat. no. 197
Collection The St. Louis Art Museum, Bequest of Curt Valentin

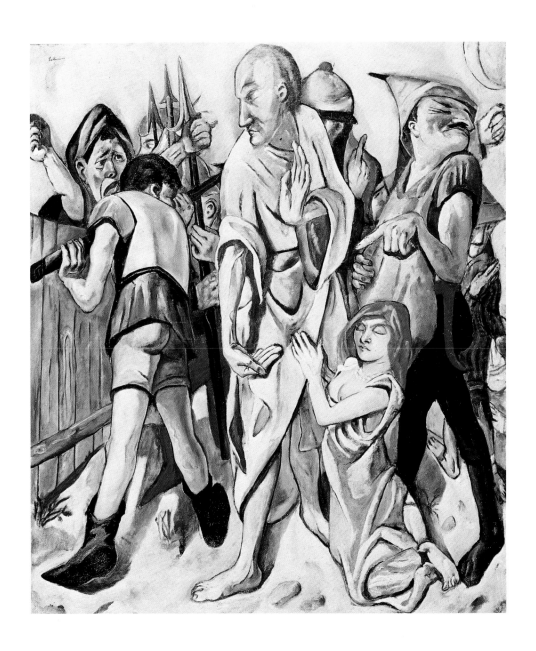

322 *Women's Bath (Frauenbad)*. 1919
 Oil on canvas, 38⅜ x 25⅝″ (97.5 x 65 cm.)
 Signed and dated u.r.: *Beckmann/F. 1919.*
 Göpel, cat. no. 202
 Collection Staatliche Museen Preussischer Kulturbesitz,
 Nationalgalerie, Berlin

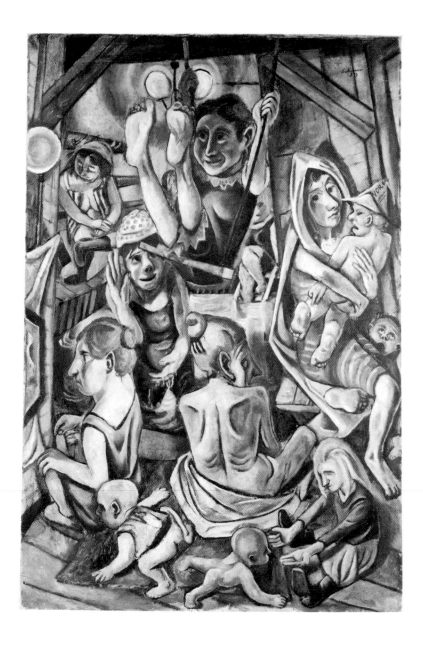

323 *Portrait of Lilly von Schnitzler.* ca. 1928-29
Charcoal, 10⁷⁄₁₆ x 14¼″ (26.5 x 36.2 cm.)
Not signed or dated.
Collection Museum Ludwig, Cologne

†324 *Portrait of Dr. Curt Glaser.* ca. 1929
Black crayon and lead pencil, 19³⁄₁₆ x 14³⁄₁₆″ (48.8 x 36 cm.)
Signed l.r.: *Beckmann.* Not dated.
Collection Museum Ludwig, Cologne

325 *Seated Female Nude (Sitzender Weiblicher Akt).* 1945
Pen and lead pencil, 19¾ x 6⁷⁄₁₆″ (50.2 x 16.4 cm.)
Signed and dated l.r.: *Beckmann A. 45.*
Collection Museum Ludwig, Cologne

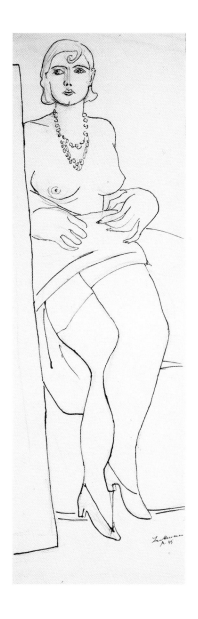

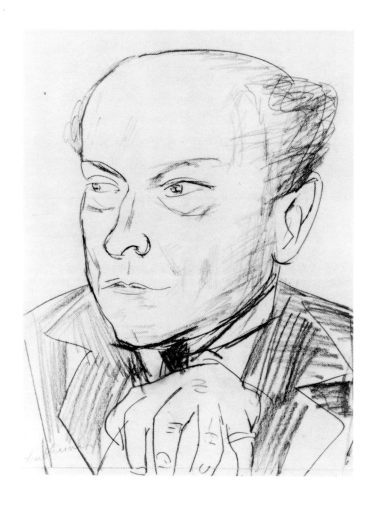

MAX BECKMANN

326 *Portrait of Dr. Gottlieb Friedrich Reber.* n.d.
 Black crayon, 19⅝ x 14¹³⁄₁₆″ (49.8 x 37.6 cm.)
 Not signed or dated.
 Collection Museum Ludwig, Cologne

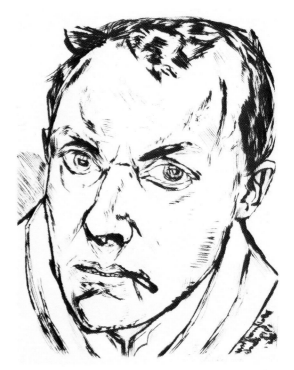

MAX BECKMANN

327 *In the Café (Im Café)*. 1917
 Etching, 6¹⁵⁄₁₆ x 9½″ (17.6 x 23.6 cm.)
 Collection Museum Folkwang, Essen

†328 *Adam and Eve*. 1917
 Etching, 9¹⁄₁₆ x 6¾″ (23.1 x 17.1 cm.)
 Collection Museum Folkwang, Essen

†329 *Main River Landscape (Mainlandschaft)*. 1918
 Etching, 9¾ x 11⅝″ (24.8 x 29.5 cm.)
 Collection Museum Folkwang, Essen

330 *Self-Portrait with Cigarette (Selbstbildnis mit Zigarette)*. 1919
 Etching, 9¼ x 7¾″ (23.5 x 19.7 cm.)
 Collection Museum Folkwang, Essen

Artists' Biographies

PAULA MODERSOHN-BECKER
Born February 8, 1876, in Dresden. Died November 21, 1907, in Worpswede, Niedersachsen.

1892 begins to study painting and drawing in Bremen and in London. 1896–98 continues studies at the painting school of associated Berlin artists. 1898–99 in Worpswede, a North German artists colony, studies with the landscape painter Fritz Mackensen. 1900 makes several trips to Paris, where she studies at the Académie Colarossi and at the École des Beaux-Arts. 1901 marries the painter Otto Modersohn. 1903 and 1905 travels to Paris in order to pursue studies at the Académie Julian. 1907 dies following the birth of her first child.

CHRISTIAN ROHLFS
Born December 22, 1849, in Niendorf bei Leezen, Schleswig-Holstein. Died January 8, 1938, in Hagen, Westfalen.

1870 begins studies at the Kunstakademie in Weimar. Following a long illness and the amputation of a leg, returns to Weimar in 1881 and manages his own studio. 1895 delays a long stay in Berlin. 1901 is appointed to the newly founded Folkwang Museum, Hagen, through the intervention of Henry van de Velde. 1905–6 works in summer months in Soest, Westfalen, where he meets Nolde. 1910–12 goes to Munich and Tyrol and travels through the medieval cities of South and Central Germany. 1922 is appointed to the Technische Hochschule in Aachen and in 1925 at the University of Kiel. From 1927 spends most of his time in Ascona, Switzerland. 1937 his works (412 in number) in German museums are confiscated and declared *entartete* (degenerate) and are barred from the Preussische Akademie der Künste, Berlin.

EMIL NOLDE (née Emil Hansen)
Born August 7, 1867, in Nolde, Tondern. Died April 13, 1956, in Seebüll, Schleswig-Holstein.

From 1884 to 1888 is a pupil at the Sauernmannschen Schnitzschule in Flensburg. 1888 studies at the art school, Karlsruhe, and in 1892 teaches at the Gewerbeschule in St. Gallen, Switzerland. 1898–1900 pursues studies in Munich and at the Académie Julian in Paris. 1901 moves to Berlin and changes his name. 1906 becomes a member of the artists association *Brücke* (Bridge), to which he belongs for one year. 1913–14 participates in an ethnological expedition, visiting Russia, Korea, Japan, China, and the South Seas.

1926 moves to Seebüll. 1931 is named a member of the Preussische Akademie der Künste, Berlin. 1937 work is proscribed; 1938 begins the Unpainted Pictures. 1943 his Berlin studio is destroyed. 1946 is appointed professor; Ada Nolde, the artist's lifelong companion, dies.

ERICH HECKEL
Born July 21, 1883, in Döbeln, Saxony. Died January 27, 1970, in Hemmenhofen, Bodensee (Lake Constance).

By 1904 is studying architecture at the Technische Hochschule in Dresden. 1905 founds the artists association *Brücke* together with Kirchner, Schmidt-Rottluff, and Fritz Bleyl. 1906 meets Nolde and Pechstein. 1907–10 spends summer months painting in Dangast, Oldenburg, and at the Moritzburg lakes near Dresden. 1911 moves to Berlin and becomes founding member of the Berlin Secession. Meets Marc, August Macke, and Feininger. 1912 participates in the Sonderbund exhibition in Cologne. 1915–18 serves in the army medical corps in Belgium; at this time is introduced to the work of Beckmann and James Ensor. 1937 his works (729 in number) in German museums are confiscated and declared *entartete* (degenerate). 1944 his Berlin studio is destroyed; moves to Hemmenhofen. 1949–55 teaches at the Hochschule der Bildenden Künste in Karlsruhe.

ERNST LUDWIG KIRCHNER
Born May 6, 1880, in Aschaffenburg. Died June 15, 1938, in Frauenkirch-Wildboden, near Davos, Switzerland.

1901 begins to study architecture at the Technische Hochschule in Dresden. 1903–4 studies are interrupted and continued at the art school in Munich. 1905 founds the artists association *Brücke* together with Heckel, Schmidt-Rottluff, and Fritz Bleyl; 1906 writes its program. 1911 moves to Berlin and founds the MUIM-Institut (Moderner Unterricht in Malerei: Modern Instruction in Painting). 1912 participates in the Sonderbund exhibition in Cologne with Heckel. 1915–16, following military service, suffers nervous and physical breakdown and spends time in a sanatorium in Königstein, Taunus. 1917 moves to Davos. From 1922 makes tapestries and wool textiles in collaboration with the weaver Lisa Gujer. 1923 moves to Frauenkirch, near Davos. 1931 is appointed member of the Preussische Akademie der Künste in Berlin. 1933 is given a large retrospective exhibition in Bern; simultaneously, exhibitions are prohibited in Germany.

KARL SCHMIDT-ROTTLUFF

Born December 1, 1884, in Rottluff, Chemnitz. Died August 10, 1976, in Berlin.

From 1905 to 1907 studies architecture at the Technische Hochschule in Dresden, where he meets Kirchner. 1905 they found the artists association *Brücke* with Heckel and Fritz Bleyl. 1906 meets Nolde during a sojourn to Alsen. 1907–12 spends summer months working in Dangast, Oldenburg. 1912 participates in the Sonderbund exhibition in Cologne and meets Feininger. Leads study trips to Italy, Paris, Dalmatia, and Ticino. 1931 becomes a member of the Preussische Akademie der Künste, Berlin. 1941 is prohibited from painting as his work is declared *entartete* (degenerate). Following the war, in 1947 becomes a professor at the Hochschule für Bildende Künste, Berlin. In 1957 is a recipient of the decoration "Pour le Mérite."

MAX PECHSTEIN

Born December 31, 1881, in Zwickau. Died June 29, 1955, in Berlin.

Following a two-year art-teaching post, studies at the Kunstgewerbeschule in Dresden in 1900 and in 1902 at the Akademie in that city. 1906 joins the artists association *Brücke*. 1907–8 travels to Italy and Paris as the recipient of the Rome Prize. 1908 moves to Berlin and in 1910 becomes a founding member of the New Secession. Spends the summer months studying in Nidda, Kurische Nehrung, and in Italy. 1914 takes a trip to the Palau archipelago in the South Seas. 1923–33 maintains professorship at the Hochschule für Bildende Künste, Berlin. As a degenerate artist, 1933–45 lives in Leba, Pomerania (on the Baltic). 1945 resumes teaching position at the Hochschule für Bildenden Künste in Berlin.

OTTO MUELLER

Born October 14, 1874, in Liebau, Silesia. Died September 24, 1930, in Breslau.

Following an initial lithographic apprenticeship in the early 1890s, studies at the Dresden Akademie. 1896–97 travels with the Silesian poet Gerhart Hauptmann in Switzerland and to Italy; spends some time at the Munich Akademie. 1908 moves to Berlin and in 1910 joins the *Brücke*. 1911 and 1912 spends the summer months with Kirchner in Bohemia. Following military service, accepts a professorship at the Breslau academy in 1919. In the following years takes trips to Dalmatia, Hungary, Rumania, and Bulgaria.

FRANZ MARC

Born February 8, 1880, in Munich. Killed at Verdun on March 4, 1916.

After initially studying philosophy, becomes a student at the Bayerische Akademie der Bildende Künste in Munich. 1903–7 takes trips through Italy, France, and Greece. Becomes friends with August Macke, Kandinsky, and Jawlensky and is a founding member of the *Neue Künstlervereinigung München (NKVM)* in 1909 and of the *Blaue Reiter* (Blue Rider) in 1911. 1912 travels with Macke to Paris, where he meets Robert Delaunay. 1913 exhibits in the *Erster Deutscher Herbstsalon* in Berlin.

VASILY KANDINSKY

Born December 4, 1866, in Moscow. Died December 13, 1944, in Neuilly-sur-Seine, France.

Following law studies in Moscow, moves to Munich in 1896 and devotes himself to art. 1897 attends the painting school of Anton Ažbè and in 1900 becomes a student of Franz von Stuck at the Munich Akademie. 1901 founds the artists group *Phalanx* and in 1902 joins the Berlin Secession, the Deutscher Künstlerbund, and the Paris salons. 1909 becomes a founder and president of the *NKVM*. 1911, with Marc, founds the *Blaue Reiter* and the following year writes his renowned book *Über das Geistige in der Kunst (On the Spiritual in Art)*. 1914 returns to Moscow. 1918 is appointed to the People's Commissariat of Education and in 1920 to the university, both of Moscow. 1923 is a professor at the Weimar and Dessau Bauhaus. 1933 emigrates to Neuilly-sur-Seine and in 1939 is awarded French citizenship.

ALEXEJ JAWLENSKY

Born March 13, 1864, in Torschok, Russia. Died March 15, 1941, in Wiesbaden.

1882 begins military career in Moscow, shortly changes studies and enrolls at the academy in St. Petersburg, where he is a student of Ilja Rjepin. 1906 moves to Munich with Marianne von Werefkin and continues studies at the painting school of Anton Ažbè. Meets Kandinsky there. 1903–5 takes numerous trips to France and in 1907 works in Matisse's studio. Is a founding member of the *NKVM* and becomes closely connected with the *Blaue Reiter*. During World War I lives in exile in Switzerland and since 1921 in Wiesbaden. 1924, with Kandinsky, Paul Klee, and Feininger, founds the *Blaue Vier* (Blue Four) group. From 1929 suffers from partial paralysis. 1933 exhibitions are forbidden.

OSKAR KOKOSCHKA

Born March 1, 1886, in Pöchlarn, Donau. Died February 22, 1980, in Montreux, Switzerland.

1905–9 attends the Kunstgewerbeschule in Vienna. 1910 goes to Berlin, where he meets Herwarth Walden, the publisher of the Expressionist periodical *Der Sturm*. Works on the publication for a time. 1913 arranges his first one-man show in Berlin with the art dealer Paul Cassirer. The same year exhibits in the *Erster Deutscher Herbstsalon*. 1911–14, association with Alma Mahler. 1913 together take a lengthy trip to Italy. 1919–24 is a professor at the Kunstakademie in Dresden, and after suffering head wounds, moves to Paris. Takes trips in the following years through Europe and Africa. 1934 moves to Prague and from there emigrates to England. From 1953 to 1963 teaches at the School of Visual Arts at the International Summer Academy of Fine Arts in Salzburg.

LYONEL FEININGER

Born July 17, 1871, in New York. Died January 13, 1956, in New York.

Grows up in New York and Sharon, Connecticut. 1887 moves to Germany. Studies at the Hamburger Kunstgewerbeschule, the Kunstakademie in Berlin, and later at the Académie Colarossi in Paris. 1903–6 works as an illustrator and cartoonist for German and American magazines. Inspired by the works of van Gogh and Gauguin, in 1907 devotes himself entirely to painting. 1919 is a founding member of the Weimar Bauhaus, conceived by the architect Walter Gropius. 1924, with Paul Klee, Kandinsky, and Jawlensky, founds the artists group *Blaue Vier* (Blue Four). 1936 emigrates to the United States and teaches at Mills College in Oakland, California. 1937 settles in New York. 1945 teaches at Black Mountain College, North Carolina.

LUDWIG MEIDNER

Born April 18, 1884, in Bernstadt, Silesia. Died May 14, 1966, in Darmstadt.

1903–5 studies at the Königliche Kunstschule in Breslau. 1906 works as a fashion designer in Berlin. Continues studies at the Académie Julian and Académie Cormon in Paris, where he meets Amedeo Modigliani. In the following years works in Berlin. 1912 with Richard Janthur and Steinhardt founds the painting club *Die Pathetiker*, which maintains a close connection with the art dealer and publisher Herwarth Walden. Following the prohibition of exhibitions, in 1935 works as a drawing teacher at a Jewish school in Cologne. 1939 emigrates to England and in 1953 returns to Frankfurt. 1963 moves to Darmstadt, where a year later is the recipient of the *Grosse Verdienstkreuze* of the Federal Republic of Germany. Becomes a member of the academy of art in that city.

JACOB STEINHARDT

Born May 21, 1887, in Zerkow, Posnania. Lives in Jerusalem.

Begins studies at the Kunstgewerbeschule in Berlin. 1907 is a student of Lovis Corinth. 1912 with Meidner and Richard Janthur founds the artists group *Die Pathetiker* in Berlin. The first exhibition of this group takes place at Herwarth Walden's Sturm gallery. 1933 emigrates to Jerusalem. 1939 receives the IBM Prize in New York. 1949 becomes a teacher of graphics at the Bezalel Arts and Crafts School in Jerusalem and from 1953 to 1957 is its director. 1961 receives the gold medal of *Arte Sacra* of the first Biennale of Religious Art in Trieste, Italy.

GEORGE GROSZ

Born July 26, 1893, in Berlin. Died July 6, 1959, in Berlin.

1909 studies at the Dresden Akademie. From 1916 further pursues studies at the Kunstgewerbeschule in Berlin, where his teacher is Emil Orlik. 1918 is a founding member of the Berlin Dada movement. 1922-28 travels to Russia, Paris, Marseilles, and Switzerland. 1932 accepts invitation to be a guest teacher at the Art Students League in New York and moves to the United States. 1941–42 teaches at Columbia University. Following the war takes numerous trips to Europe. 1959 moves back to Berlin.

OTTO DIX

Born December 2, 1891, in Untermhaus, Gera, Russia. Died July 25, 1969, in Singen, on Lake Constance.

1905–9 begins apprenticeship as a scenic painter in Gera. Studies at the Kunstgewerbeschule and later at the Kunstakademie in Dresden. Following military service, continues studies at the Dresden academy. 1919 becomes founding member of the Dresden Secession. 1922–26 continues studies in Düsseldorf and Berlin. With Max Ernst joins the *Junges Rheinland* (Young Rhineland) group. From 1933 teaches at the Dresden academy. As the Third Reich prohibits exhibitions, in 1936 moves to Lake Constance. 1950 teaches at the Kunstakademie in Düsseldorf.

MAX BECKMANN

Born February 12, 1884, in Leipzig. Died December 27, 1950, in New York.

Spends youth in Braunschweig. 1899–1903 studies with Carl Frithjof Smith at the Grossherzogliche Kunstschule in Weimar. Continues studies in Paris, Geneva, Florence, and Jutland, Denmark. 1904 moves to Berlin. 1906 joins the Berlin Secession. Receives the Villa Romana Prize. 1915–33 lives in Frankfurt and since 1925 teaches there. 1933 moves to Berlin and from there emigrates in 1937 to Amsterdam. 1937–38 resides in Paris. 1947–49 teaches at the School of Fine Arts at Washington University in St. Louis. 1949 teaches at the Brooklyn Museum School in New York.

Supplement

Essays in German

I

Einführung

PAUL VOGT

Fragt man nach dem repräsentativen deutschen Beitrag zur europäischen Kunst des 20. Jahrhunderts, so wird an erster Stelle der Expressionismus genannt werden. Man denkt sogleich an Werke von intensiver Ausdruckskraft und bestürzender Unmittelbarkeit, an Farben, die nicht mehr den überlieferten ästhetischen Vorstellungen entsprechen, sondern in gewaltsamen und ungewöhnlichen Klängen Legendäres beschwören, an apokalyptische Visionen und hektische Formattitüde. In der Tat folgte damals die deutsche Kunst auf ganz besondere Weise der allgemeinen europäischen Wegrichtung, die auf eine unmittelbare, weder durch Tradition noch durch Geschichte belastete Auseinandersetzung mit der Wirklichkeit zielte und dieses neue Spannungsverhältnis zwischen dem Ich und der Welt mit möglichster Kraft auszudrücken versuchte.

Mehr als sechs Jahrzehnte sind vergangen, seit der Expressionismus kurz vor dem ersten Weltkrieg in Berlin seinen Höhepunkt erlebte. So gut wie alle Kunstrichtungen nach seinem Ende haben sich in der einen oder anderen Weise mit ihm auseinandergesetzt, ohne dass es bisher zu einer grundsätzlichen Übereinstimmung über Wert und Unwert dieses ausdrucksmächtigen Stils gekommen wäre. Noch immer schwankt seine Beurteilung je nach der Einstellung seiner Freunde und Widersacher; man hat ihn hochgelobt und als "entartet" verdammt, als Ausdruck "deutschen Wesens" gepriesen und als "spätbürgerlichidealistisch" wie als "bolschewistisch" gebrandmarkt. Bis heute herrscht nicht einmal Einigkeit darüber, ob es sich beim Expressionismus überhaupt um einen Stil im strengen kunstgeschichtlichen Sinne oder nur um einen individuell geprägten revolutionären Aufschrei aus einer apokalyptischen Grundstimmung heraus handle, der durch die erregte geistige Situation in Europa um 1900 ausgelöst wurde. Je mehr sich die Wissenschaft mit dieser höchst komplexen Richtung in der bildenden Kunst, in Musik und Literatur beschäftigte, desto deutlicher wurde das Unvermögen, sie künstlerisch oder weltanschaulich auf einen Nenner zu bringen. Denn zu den Wesenseigenschaften des Expressionismus gehört der Widerspruch, die verwirrend erscheinende Vielzahl divergierender Erscheinungsmerkmale, die Gegensätze zwischen Freiheit und Bindung, zwischen Individuum und Masse, Geistigem und Triebhaftem, Instinkt und Intellekt, Idealismus und Anarchie. Indes dürften zwei Tatsachen für eine Analyse von Bedeutung sein.

Zum ersten ist der deutsche Expressionismus tief von der Idee einer universalen und nicht nur auf den ästhetischen Bereich beschränkten Revolution geprägt. Die Überzeugung von der zwingenden Notwendigkeit eines Umsturzes aller Werte und Verhältnisse ist ungeachtet der individuellen Ansichten allen Trägern und Verfechtern gemeinsam. Sie ist die eigentliche Zielutopie expressionistischen Denkens und Handelns; zu ihrer Durchsetzung sind alle Mittel gerechtfertigt. Deren Wahl wird jeweils durch die ideologische Bewusstheit der teilhabenden Künstler oder Gruppen bestimmt.

Zum anderen ist Expressionismus ungeachtet seiner besonders hohen Aktualität zu Beginn unseres Jahrhunderts eine seit Jahrhunderten vertraute spezifische Grundkonstante der deutschen Kunst. Seine Wesensmerkmale sind tief im Formgefühl dieses Landes und einer ihm eigentümlichen Empfindungslage verwurzelt. Man muss daher diese spezielle Sicht, Ordnung und Deutung der Welt als eine nationale Eigenschaft ansehen. Expressivität als Synonym für intensives Ausdruckswollen, für Mitteilungen aus dem "Universum des Innern" steht gleichsam stellvertretend für das Einmalige in der deutschen Kunst und kennzeichnet darin folgerichtig auch deren Position gegenüber dem romanischen Formgefühl.

Gewiss handelt es sich dabei nur um eine, wenn auch sehr bedeutende Komponente jener eigentümlichen Dialektik zwischen Form- und elementarem Ausdruckswollen, die sich wie ein roter Faden durch die Entwicklung der deutschen Kunst zieht. Sie tritt uns in der abstrahierten, von drängender Kraft beseelten Ornamentik der Frühzeit wie in den ausdrucksstarken Gebärden frühmittelalterlicher Handschriften entgegen, wir finden sie in den erschütternden Bildwerken gotischer Mystik, deren Empfindungsintensität alle Formen bis zur Auflösung spannt. Die unruhigen Zeiten der Reformation und der Religionskriege haben die expressiven Tendenzen verstärkt; wir wissen um ihre Rolle in der Zeit der deutschen Romantik. Im Gegensatz zur Kunst der romanischen Länder ging es den deutschen Künstlern nicht darum, ihre bildnerischen Mittel tätig und theoretisch zu kultivieren, das Bild zu einem eigengesetzlichen Organismus von strenger Regelhaftigkeit der Form und des ästhetischen Anspruchs werden zu lassen. Das Kunstwerk sollte die Wirklichkeit weder beschreiben noch ordnen, es sollte sie interpretieren, als Mittler zwischen ihr und dem Menschen dienen. Seine Aufgabe lag darin, "ein unirdisches Sein zu zeigen, das hinter allem wohnt" (Franz Marc), eine metaphysische Seinsvorstellung auszuformen, indem es die Formen des gegenständlichen Seins zu Symbolformen der menschlichen Empfindungs- und Ausdruckswelt umwandelt und erhöht.

Es liegt jedoch im Sinne der eben erwähnten Dialektik, gehört zum geheimen Widerspruch selbst im expressiven Aufschrei, dass man jene Regeln, die man eigentlich als unerträgliche Beengung und Behinderung des unmittelbaren Schöpfungsvorganges empfindet, doch als "neue Ästhetik" sucht; dass der europäische Norden, tief in den geheimnisvollen und spannungsreichen Prozess der Formwerdung verstrickt, gleichwohl in der Harmonie formaler Vollendung ein Ideal sieht. Das erklärt die Jahrhunderte während Blickrichtung der deutschen Künstler zum Süden, nach Italien, die sich erst im späten 19. Jahrhundert mehr und mehr auf Frankreich, ebenfalls ein romanisches Land, verlagert.

Die Kunstgeschichte zeigt eine grosse Anzahl an Beispielen, in denen Künstler versuchten, diesen inneren Zwiespalt durch Übernahme vorgeformter Ordnungsprinzipien zu überwinden. Es liegt nahe, an Albrecht Dürer, einen der grössten deutschen Maler des 16. Jahrhunderts zu denken, in dessen Werk sich diese Auseinandersetzung zwischen den beiden Polen besonders deutlich manifestiert. Sein Tagebuch beweist aber auch, dass er am Ende seines Lebens vor der Aufgabe resignierte, jene absolute Gesetzlichkeit erfassen zu können, die er "die Schönheit" nannte. Er steht darin für viele andere deutsche Künstler bis in unser Jahrhundert.

Allein die grundsätzliche Verschiedenheit der Blick- und Ansatzpunkte verhinderte einen Erfolg solcher Bemühungen. Weder die grossen deutschen Meister des Mittelalters noch die ihnen folgenden wollten im Grunde das Sichtbare derart in reine, abgelöste Form verwandeln, wie das für die romanischen Künstler selbstverständlich gewesen war. Denn der "nordische" oder "germanische" Künstler, wie wir ihn auch immer im Gegensatz zu dem des mittelmeerischen Kulturkreises nennen wollen, sah im Sichtbaren nicht das Material zu geistigem Tun, das in dem Organisationsprinzip des Bildes mündet. Er glaubte nicht an eine Vollkommenheit, die sich in dieser Welt realisieren liesse, wenngleich er deren Vorstellung als geheimes Ideal mit sich trug. Dafür setzte er dem Prinzip der Ratio ein ihm gewichtiger scheinendes entgegen: künstlerische Schöpfung als Widerspiegelung der Spannungen menschlicher Existenz, Wirklichkeit als imaginatives Gegenbild. Die Welt wird als Reflexion des "Ego" transzendent. An die Stelle des direkten Bezugs zum sichtbaren Sein tritt die Vision, in der sich das Ichgefühl exaltiert. Dass solch expressives Handeln in Zeiten geistiger Unruhe schärfer hervortrat, als in beruhigteren, liegt auf der Hand.

Dürers Holzschnitte zur "Apokalypse" (1498), die ekstatische "Kreuzigung" aus dem Isenheimer Altar von Mathias Grünewald (1515) sind prägnante Beispiele für derartige Konfliktsituationen, in denen der Künstler, die ungeheuren Spannungen zwischen dem Ich und der Welt durchleidend, die Lösung nicht in strenger Analytik, sondern in erschütternden Visionen sucht.

Auch bei einem Vergleich solcher Werke mit gleichzeitigen der italienischen Renaissance bestätigt sich erneut, dass die Deutsche Kunst Form primär als Träger von Ausdruck versteht. Ungehemmt setzt sich die bildnerische Phantasie im Norden zugunsten der "inneren Notwendigkeit" über die traditionellen Regeln von Perspektive, Proportion oder Anatomie hinweg. Die noch heute weiterexistierenden Missverständnisse zwischen den Kulturkreisen beruhen auf eben dieser Verschiedenheit der Anschauungen vom Wesen des Kunstwerks: das nordische musste aus romanischer Sicht in seiner scheinbaren Form- und Zügellosigkeit wie Willkür wirken. Man erschrak vor seiner beängstigenden Intensität, die sich keiner überlieferten ästhetischen Regel unterordnete.

Beziehungen zwischen solchen "gotischen" Elementen der deutschen Kunst, wie man die emotionale Funktion von Linie, Farbe und Form gern, wenn auch wissenschaftlich nicht korrekt genannt hat und dem deutschen Expressionismus nach 1900 sind offensichtlich und von der Kunstgeschichtsschreibung bereits früh gezogen worden. Die betroffenen Maler der revolutionären Geburtsgeneration um 1880 haben ihrerseits wiederholt auf Anregungen aus derartigen Quellen verwiesen. So schildert z.B. die Chronik der Künstlergemeinschaft "Brücke" die Beschäftigung mit den Holzstöcken Dürers in Nürnberg, ein Ansatz mit für die bedeutende Rolle des Holzschnittes im Expressionismus. Wir kennen aus vielen Zitaten die Aversion der jungen Künstler gegen alles Klassische und ihr leidenschaftliches Interesse für das "Archaische" und "Primitive"—will sagen Unverbildete. Auch die Visionen des Müncheners Franz Marc, seine "Sehnsucht nach dem unteilbaren Sein," die Überzeugung von dem Eingefügtsein alles Lebendigen in den kosmischen Zusammenhang liegen mit im Allgefühl der deutschen Romantik am Beginn des 19. Jahrhunderts begründet.

Indes sollte man solche Beziehungen weder zu eng betrachten noch als direkte Abhängigkeit definieren. Im Grundsätzlichen verwandt, wahrscheinlich sogar "blutsmässig angelegt," wie Werner Haftmann meint, äussert sich das gemeinsame Erbe im 20. Jahrhundert doch in anderer Weise. Um die Ausgangssituation für die expressionistische Revolution nach 1900 zu verstehen, bedarf es eines kurzen Blicks auf das Ende des 19. Jahrhunderts, aus dem heraus sie sich entwickelte.

Betrachtet man die Zeit um 1900 aus dem Blickwinkel der offiziellen, von den Akademien getragenen Kunst, so war von den nahenden Erschütterungen des neuen Jahrhunderts wenig zu spüren. Gewiss war der Skandal noch frisch im Gedächtnis, den die Ausstellung des Norwegers Edvard Munch 1892 in Berlin hervorgerufen hatte. Sie hatte auf öffentliche Forderung vorzeitig geschlossen werden müssen. Die aus dem Protest gegen dieses Vorgehen geborene "Berliner Secession" unter dem berühmten Max Liebermann trat allerdings mehr für die Freiheit des Künstlers an sich ein, als für die erschreckende und hintergründige Malerei des Norwegers, die ihr fremd blieb. Vincent van Gogh war bereits 1890 aus dem Leben geschieden. Die ersten Ausstellungen seiner Werke, deren Dimensionen bis in seelische Bezirke reichten, schockierten ebenso wie sie beeindruckten. Die europäische Kunstszene musste ihn ebenso zur Kenntnis nehmen wie den Belgier James Ensor, in dessen quälender Bildwelt der Masken und Phantome sich schon jene Entfremdung zwischen dem Menschen und der Welt, der Zweifel an der Glaubwürdigkeit des Sichtbaren abzeichnete, mit dem sich das neue Jahrhundert auseinanderzusetzen hatte. Bei allen drei

Fällen handelte es sich nicht um die Krise einer seelisch gestörten Künstlerpersönlichkeit, wie die damalige Kritik ihre Leser glauben machen wollte, sondern um den Beginn des "Weges nach innen," in die menschliche Ausdruckswelt als Gegenwelt zur sichtbaren Wirklichkeit, wie sie der französische Impressionismus so glanzvoll geschildert hatte.

Wohl waren Gesellschaft und Glaube an Tradition damals noch stark genug, die kritische Situation negieren, eine Realitätsvorstellung aufrecht erhalten zu können, die sich mit den tatsächlichen Gegebenheiten nicht mehr deckte. Doch die Zweifel mehrten sich. Es bedurfte nur eines Anstosses, die Krise zu offenbaren.

Das Nebeneinander vieler Richtungen zwischen Historienmalerei und Naturlyrismus, zwischen Jugendstil und Freilichtmalerei trug ebenso wie die betont landschaftliche Bindung der Kunst in Deutschland wenig zur Klärung der Situation bei. Die rasch fortschreitende Industrialisierung und die ihr verbundene neue Schicht der Wohlstandsbürger förderten eine vom wirtschaftlichen Aufschwung profitierende Kunst als Sinnbild von Bildung und Repräsentation. Der akademisch ausgebildete Künstler hatte sich in die Abhängigkeit gesellschaftlicher Einordnung begeben. Er trat damit als Repräsentant einer Schicht auf, deren Vorstellungen sich nicht in jedem Fall mit den seinen deckten, die er jedoch respektieren musste, um anerkannt zu werden. Nicht zuletzt dadurch wurde der Akademismus in den Augen der jüngeren Generation zu einem Symbol abgewerteter künstlerischer Leistung. Es waren zu jener Zeit nur Einzelne, Sonderlinge und Abtrünnige in den Augen der Öffentlichkeit, die durch ihre abweichende Meinung und Leistung Kontur vor dem gleichförmigen Hintergrund gewannen. Von ihnen ging jene schöpferische Unruhe aus, ohne die die deutschen Akademien am Ende des 19. Jahrhunderts vollends erstarrt wären. Keinem von ihnen gelang ein entscheidender Durchbruch. Doch trugen ihre Ideen soviel Sprengstoff in sich, dass wir ihnen in einer erstarrenden Kunstlandschaft die Funktion von Revolutionären zuerkennen müssen.

Sie fanden sich unter den Anhängern des sog. Naturlyrismus, die abseits der grossen Kunstzentren in der Einsamkeit von Heide und Moor, wie in Dachau im Süden oder in Worpswede im Norden als legitime Nachfahren der deutschen Romantik ihre Empfindungen "im bewundernden Anschauen der Natur" entwickelten. Hier manifestierte sich früh ein starkes Ausdrucksverlangen, das Natur zum Gleichnisträger eines übermächtigen Gefühlserlebens stilisierte. Glühende Sonnenuntergänge, weisse Birken vor verhangenem Himmel, einsame Hütten vor dem Dunkel des Moores vermochten als Gleichnisse eine ganze Skala von Gefühlen auszudrücken. Dazu bedurfte es keiner neuen Sicht der Dinge. Die Malerei dieser kleinen Landschaftsschulen blieb konventionell. Es gehörten lediglich eine um ein weniges übersteigerte Farbe, eine kleine Vereinfachung der Form, eine geringe Umordnung der Dinge dazu, um im Bilde die seelische Antwort des Menschen auf das Naturerleben wachzurufen, ohne den bis dahin üblichen Umweg über Allegorie und Mythologie. Damit war Bedeutungsvolles auch für den späteren Expressionismus geleistet: man hatte das Sprachvermögen der bildnerischen Mittel erprobt, den Ausdruckswert von Farbe berührt, Gegenstand in Emp-

findung umgesetzt. Natur konnte vom Geheimnis zum Schrecknis umschlagen, zum Symbol hintergründiger Angst und schmerzhafter Melancholie. Im Hintergrund wird Edvard Munch sichtbar, Träger eines verwandten Lebensgefühls, das zu dieser Zeit sehr legitim erscheint. Wir werden später sehen, wie die jungen Expressionisten auf solche Anstösse reagierten. Emil Nolde hat immerhin 1899 einige Zeit in Dachau verbracht.

Eine starke Resonanz ging auch von der Freilichtmalerei aus. Sie "deutschen Impressionismus" zu nennen, wie das üblich ist, ist falsch. Zu krass sind die Unterschiede zu Frankreich, zu unterschiedlich auch die Zielsetzung. Waren die Franzosen Realisten, so die Deutschen Idealisten. Trennte der französische Maler Natur und Kunst streng voneinander, weil er auf eine parallele, künstlerisch erhöhte Realität zielte, so wollten sich die Deutschen nicht mit der Faszination des Auges begnügen, sondern das Wesen der Dinge erfassen—auch hier der alte Naturmythos. Das prägte den Charakter der Farben. Hierzulande schätzte man ihren Gefühlswert höher ein als den koloristischen, verwendete sie daher nicht als Licht, sondern durch dynamische, materiebetonende Pinselschrift als Kraft. Kein Wunder, wenn eines der ungestümsten und kraftvollsten Talente dieser Zeit, Lovis Corinth, in seiner Spätzeit über einen visionär gesteigerten Impressionismus an den Expressionismus geriet. Schliesslich wäre als Vorstufe noch der Jugendstil zu nennen, eine Bewegung, die in Deutschland nicht auf die Kunst beschränkt blieb, sondern betont weltanschauliche Züge trug.

Als allgemeine ethische Erneuerungsbewegung schlug er führende Kräfte vieler Bereiche in seinen Bann. Zahlreiche Anregungen wirkten auch von aussen hinein: Munchs expressive Thematik, der monumental-rhythmische Gebärdenstil des Schweizers Ferdinand Hodler, die erregenden Lineaturen des Engländers Aubrey Beardsley samt deren erotischer Substanz, kühne Argumente des belgischen Architekten Henry van de Velde, dazu künstlerische Vorbilder aus östlichen und ostasiatischen Quellen. Das verhinderte eine Einengung auf naturabhängige Ornamentik, auf Kunstgewerbe, Schmuck und Kleinkunst. Man diskutierte in München schon früh die "Macht der reinen Form über das menschliche Gemüt" und die metaphysische Wirksamkeit von Farbe—Überlegungen, die sich damals noch nicht realisieren liessen, doch den Boden für die kommenden Jahrzehnte bereiteten.

"Eine Linie," so lehrte van de Velde "ist eine Kraft; sie entlehnt ihre Kraft der Energie dessen, der sie gezogen hat." Allein diese kühne Vorstellung, dass sie nicht nur formbezeichnende, sondern ebenso abstrakt—gestalterische Funktion besitze, ist eine der kühnsten Erkenntnisse dieser Zeit. Ähnliches gilt für die Farbe. Bereits 1896 formulierte Fritz Endell seine These von der Gefühlswirksamkeit naturunabhängiger Farben. Sie zielte darauf, "ganz reine Flächenhintergründe zu schaffen, in denen eine verlorene Musik von Formen und Farben schwebt." Die Perspektive war ausserordentlich. Sie zielte direkt auf die abstrakte Malerei, die Wassily Kandinsky verwirklichte, befruchtete Symbolismus und Naturlyrismus und wirkte nachhaltig auf den frühen Expressionismus ein.

In diese Situation scheinbarer Ruhe nach aussen und

drängender Unruhe nach innen traten jene jungen Künstler gegen 1905/06 ein, die man wenig später die "Expressionisten" nennen sollte. Die ersten zwei Jahrzehnte unseres Jahrhunderts grenzen zeitlich das Feld der künstlerischen Auseinandersetzungen ein. In ihnen vollzogen sich Aufbruch, Blüte und Ende des Expressionismus, der mehr war als ein Stil im traditionellen Sinne des Wortes, der sich zu einer umfassenden Bewegung, ja zur Lebenshaltung auswuchs. Wir haben zu Anfang darauf hingewiesen, dass seit der Frühzeit der deutschen Kunst expressive Tendenzen als Antwort des Künstlers auf krisenhafte Situationen oder auf starke seelische Spannungen auftraten. Ein Gleiches trifft auch auf die Entwicklung nach 1900 zu: wie in allen vorhergehenden Epochen spiegelt sich auch im Expressionismus die Stellung des Künstlers in seiner Umwelt, sein Verhältnis zur Natur und seine unruhigen Empfindungen: Liebe und Hass, Begeisterung und Skepsis, Schwermut und Leidenschaft, Aggressivität und Selbsthingabe, seine Stellung zu Gott und gegenüber der Welt.

Die deutschen Künstler standen mit ihren Bestrebungen keinesfalls allein, ihr revolutionäres Streben ist bei aller subjektiven Färbung und Ausprägung durchaus Teil der allgemeinen europäischen Bewusstseinsbildung am Beginn unseres Jahrhunderts, die Lebensempfindung und Stilausdruck weitgehend veränderte. Sie spielte sich im wesentlichen in Frankreich und den nordischen Ländern ab, Italien trat mit seinem Beitrag erst später ein. Der Ausgangspunkt war derselbe, lediglich die Reaktionsweise unterschiedlich. Es ging letztlich um die Kritik an der Wirklichkeit, die für Jahrhunderte Massstab und Glaubensgrundlage der europäischen Kunst gewesen war. Schon im Verlaufe des 19. Jahrhunderts hatten sich erste begründete Zweifel an der Wahrheit der sichtbaren Wirklichkeit geäussert, war die Frage aufgetreten, ob nicht die sichtbare Erscheinung weniger wichtig war als der Bezug, der sich zwischen Mensch und Welt herstellen liess. Mit dem Beginn des 20. Jahrhunderts wurde die Frage lauter, der Zweifel stärker: die alten, selbstverständlich scheinenden Übereinstimmungen zerbrachen, an ihre Stelle trat ein Spannungsverhältnis, das der Kunst eine neue Aufgabe zuwies: "nicht mehr das Sichtbare wiederzugeben, sondern sichtbar zu machen" (Paul Klee). Der Blick des Künstlers richtete sich fortan nicht mehr in erster Linie auf den Inhalt, auf das Motiv, die äussere Erscheinung, sondern auf das, was im Bilde als Verwirklichungsfeld in Erscheinung treten soll. Das Bild wird zur Tafel, auf der sich geistige Erfahrung aufzeichnet. Hier konnten die Künstler von van Gogh bis zu den Expressionisten ansetzen: sie vermochten die herkömmlichen Begriffe von Natur nicht mehr als Bezugssysteme zur Wirklichkeit zu akzeptieren, sie vertraten die Meinung, dass die "Mitteilung von innen" das eigentlich Bildwürdige sei, für das eine neue Form und andere Sinnzeichen zu finden waren. In jedem Falle musste sich eine solche Auseinandersetzung mit der Welt auf der Ebene einer intensiven menschlichen Beteiligung, eines gesteigerten Ichgefühls vollziehen. So zielten die Forderungen der jungen Generation folgerichtig auf die bewegenden Kräfte, nicht auf das Abbildhafte. Es galt, zu dem jenseits des kritischen Bewusstseins liegenden Seelisch-Zuständlichen vorzudringen, das Triebhafte als Ausdruck einer neuen

"Natürlichkeit" zu entfesseln. Natur wurde elementar als Ausbruch aus den Zwängen der Gesellschaft, als Verneinung überkommener Werte verstanden. Ungehemmt seinen Trieben zu folgen, die bisherigen ästhetischen Normen zu brechen, war ein lockendes Ziel. Es in Form umzusetzen, bedingte allerdings einen komplizierten Prozess. Man glaubte, ihn aus Quellen ausserhalb der künstlerischen Überlieferung bewältigen zu können: durch freie Formen, starke Farben, durch das Vokabular der Laienkunst oder durch die Blickwendung auf die Werke der Naturvölker, die jenes Mass an kraftvoller Primitivität versprachen, das dem damaligen Europa längst fremd geworden war.

Die Schwierigkeiten der jungen Maler bei der Durchsetzung ihrer revolutionären und sich oft erst im Laufe des Entwicklungsprozesses selbst bildenden Vorstellungen basierten nicht nur auf dem Widerstand der Öffentlichkeit. Sie lagen zum grossen Teil in ihren Absichten und Forderungen selbst begründet. Ihre Theorie, dass jedes Gefühl, wenn es nur stark genug sei, unmittelbar in Kunst münden müsse, führte zum Trugschluss, dass die Stärke der jeweiligen Emotionen direkt die Qualität des Werkes bestimme. Das erklärt die bedeutende Anzahl an Arbeiten, in denen der entfesselte Schrei keine Form gewinnen konnte. Die Malerei vertiefte sich in selbstaufgeworfene Probleme, wobei Ungestüm zum Imperativ, das Unkontrollierte zum Mass, die Rolle des "seelisch zerwühlten Künstlers" (Haftmann) zur Norm erhoben wurde. Der Expressionist konnte sich ungestraft als Provokateur wie als Esoteriker gerieren. Er forderte die Öffentlichkeit auf, in seinen Schrei nach Erlösung miteinzustimmen und brüskierte sie zugleich durch Verachtung als "Masse." Diese Doppelrolle gehört geradezu zu seinem Image als "Wilder" und es liegt für die damalige Zeit kein Widerspruch darin. Das Publikum gewöhnte sich daran, den Künstler nicht mehr als Wächter des geheiligten Kunsttempels anzusehen, sondern ihn als prophetische Kraft zu akzeptieren, die Tore in die Zukunft aufstösst, als eine Potenz, die sich rücksichtslos jenen Freiraum schafft, den der den Zwängen gesellschaftlicher Ordnung ausgelieferte "Normalmensch" für sich nicht in Anspruch zu nehmen wagte. Der Künstler rückte damit der Gesellschaft nicht näher, selbst wenn sie seine Sonderstellung langsam hinnahm. Indem er ihr einen Weg zur möglichen Freiheit und geistigen Unabhängigkeit vorlebte, verbreitete er die alte Kluft. Denn die von ihm propagierte Unabhängigkeit konnte stets nur die Freiheit des Einzelnen, zwangsläufig nicht die der Gesellschaft sein. André Malraux hat ähnliches gemeint, wenn er schreibt: "Seit der Romantik erarbeiten sich Dichter, Maler und Musiker eine gemeinsame Welt, in der wohl alle Dinge miteinander, aber nicht mit der Welt der anderen in Beziehung treten."

Die Rolle der Kunst als konservatives, als Bildungselement war im Expressionismus ausgespielt, ihre neue Funktion als permanent revolutionäre Kraft wurde rasch zum primären Erkennungsmerkmal und später sogar zur Forderung einer nach den Kriegen neu sich formierenden Gesellschaft. Dass sich damit die alten Bewertungsmassstäbe verschoben, ist eine logische Folgerung. Der durch die Expressionisten bewusst forcierte neue Primitivismus war ein Teil ihres Kampfes gegen die überkommenen autoritären, auf bestimmte Bildungsschichten zugeschnittenen

Wertsysteme. Auch die Hochblüte des Holzschnittes zu jener Zeit ist dafür ein beredtes Zeichen. Er ist seit je das demokratischste Ausdrucksmittel der deutschen Künstler gewesen.

Nicht alles lässt sich als Expressionismus bezeichnen, was sich in den anderthalb Jahrzehnten zwischen 1905 und 1920 in Deutschland expressiv gebärdete. Die subjektive Ausdrucksskala war so gross, dass ihre Grenzen sich verwischen; die Akzente wechselten mit den Impulsen, die sie provozierten. So wuchs der Expressionismus nur im Werk einiger führender Kräfte zu wirklicher künstlerischer Bedeutung heran, doch bleibt sein Antlitz janusgesichtig. Echte Dramatik existiert neben tönendem Pathos, tiefe Erregung neben theatralischer Gestik, begründete Deformation neben Zersprengung in Formlosigkeit. Das pathetische Ausdrucksverlangen eines norddeutschen Malers wie Emil Nolde ist dem symbolistischen, romantischen Allgefühl des Müncheners Franz Marc konfrontiert, die undifferenzierten Visionen der Berliner Pathetiker den geistvollen Formulierungen des Russen und Wahldeutschen Wassily Kandinsky.

Die alten landschaftlichen Bindungen der deutschen Kunst blieben auch im Expressionismus erhalten. Eine der ursprünglichsten Wurzeln liegt im Norden Deutschlands. Hier arbeiteten einzelne, von einander unabhängige Künstler wie die Bauernsöhne Nolde und Rohlfs oder Paula Modersohn-Becker. Ihre Kunst kommt aus unverbildetem Instinkt. Sie lebt aus der engen Beziehung zur Heimat, bildet ein expressives Naturgefühl aus und spricht eine bilderreiche Sprache. In ihr walten visionäre Gesichte und das Bewusstsein einer innigen Verbindung zwischen Mensch und Natur. Das Literarische ist ihr ebenso fremd wie das Klassische. Kunst steht in einem direkten Bezug zum Leben, öffnet das Tor zu jenen Kräften, die hinter der äusseren Erscheinung wirken.

Eine zweite Wurzel findet sich in Mitteldeutschland. Hier vollzog sich die Revolution als bewusster Prozess, bei aller Leidenschaftlichkeit letztlich von Intellekt mitbestimmt. Die hier beheimateten Künstler der "Brücke" bezogen die nordische (Ibsen, Strindberg) wie die östliche Literatur (Dostojewsky) als Antriebsquellen in ihr Schaffen ein, setzten sich mit van Gogh und Munch ebenso wie mit den Werken der afrikanischen und fernöstlichen Naturvölker auseinander. Wie die Norddeutschen waren sie begeisterte Graphiker, mehr noch als die Malerei ist sie ihre eigentliche Stärke.

Anders verlief die Entwicklung in Süddeutschland. Hier treffen wir auf die Gegenkomponenten zur nord- und mitteldeutschen Ausdrucksweise, auf die Imagination als Ursprung neuer subjektiver Vorstellungen, Sinnzeichen und Empfindungen, auf Naturpoesie, eine pantheistisch gestimmte Weltsicht, auf mystische Verinnerlichung, in der ein starkes östliches Element mitspricht, vermittelt durch den russischen Einfluss durch Kandinsky und Jawlensky. Dies alles sind expressive Elemente. Sie im Sinne des Nordens expressionistisch zu nennen, scheint unzulässig. Nur hier im Süden konnte jener Begriff des "Geistigen in der Kunst" gefunden werden, der die Grundlage für die Abkehr von der Dingwelt bildet, die Kandinsky 1910 mit seinem ersten abstrakten Aquarell vollzog. Wie der russische, war in München auch der französische Einfluss durch Delaunay

und die Fauves stark. Er beeinflusste das Klima, gab ihm eine Weltläufigkeit und Öffnung gegenüber fremden Impulsen, die wir im stärker introvertierten, ganz auf seine eigenen Probleme bezogenen norddeutschen Expressionismus nicht finden.

Wohl arbeiten beide Richtungen in dem übereinstimmenden Bewusstsein, jenen Punkt finden zu müssen, an dem sich Äusseres und Inneres decken—die gemeinsame Wurzel in der deutschen Romantik. Die Realisierung zum Bild erfolgt jedoch auf verschiedene Weise. Der Norden nutzte die elementaren Gegebenheiten der bildnerischen Mittel, nicht die ästhetischen. Versuchte man dort, die Hüllen des sichtbaren Seins zu zerbrechen, um hinter deren Scheinwirklichkeit den wahren Seinskern zu entdecken, so strebte man hier subtiler nach dem Bild als Gleichnis zu jener "mystisch-innerlichen Konstruktion" des Weltbildes, die Franz Marc entwickelt hatte. Das prägte auch den Charakter der Farben. Der Norden malte farbstark, doch tonärmer, weil es den Künstlern weniger auf den optischen Bildwert als auf die expressive Funktion ankam. Die Maler um den "Blauen Reiter" entwickelten eine sensible Palette voller Valeurs, deren Leuchtkraft auf der Reinheit der Tonlagen beruht, als eine Entsprechung zur Musik, mit der sich Kandinsky eindringlich beschäftigte.

Die Problematik der schwächeren Arbeiten war beiden Richtungen wieder gemeinsam: im Norden eine übersteigerte Bedeutungstiefe oder ein ungezügelter Aufschrei, die Farbe und Form keine Bildwirksamkeit mehr ermöglichten; im Süden ein gefühlsbeladener Ästhetizismus, der an die Grenze des Süsslichen oder Dekorativen geraten konnte.

So bleibt es in Deutschland bei zwei getrennten Wegen der Entwicklung. Was sie bewirkte, zeigte jedoch trotz ihrer relativen Kürze Bestand. Es war mehr, als nur der Durchbruch einer "neuen Generation der Schaffenden wie der Geniessenden" (E. L. Kirchner). Der Expressionismus hat die Blickrichtung auf die Realität nachhaltig verändert. Dass er sich nach 1945 auch international durchsetzen konnte, beruht auf einer Zeitkonstellation, die expressives Empfinden und Handeln noch einmal in das Zentrum künstlerischer Bemühungen rückte. Doch ist die Motivation für eine solche Anerkennung heute anders begründet. Sie beruht mit darauf, dass wir mit einiger Wehmut einer Zeit gedenken, die noch die Kraft zu Revolutionen aufbrachte, in der Überzeugung, dadurch die Zukunft prägen zu können.

II

Zu Aquarell und Farbzeichnung der deutschen Expressionisten

HORST KELLER

Zwischen der aggressiven farbigen Entschiedenheit des Leinwandbildes und der keilschrifthaften Strenge von Holzschnitt und Farbholzschnitt wie auch der wildausfahrenden Gestik der Lithographie und der splitterigen Stachligkeit der Radierung treibt das Aquarell ein leichtes Spiel. Weder hat es das Stileinheitliche der Expressionisten zu verkünden

wie das weithin leuchtende Bild, noch hat es sich an der signalhaften Simplizitas einer bis dahin ganz und gar ungewohnten Sprache der Druckgraphik zu orientieren. Zeichnung und Aquarell geben vielmehr, kühn wie gelassen, und durchaus in der Handschrift des Expressiven, Kunde vom ersten künstlerischen Einfall, von der "prima idea" des Künstlers. Von sonst nichts; sie gehören zuerst zum Atelier.

Aquarell und Zeichnung können also eine Bildidee vorbereiten, stehen aber nicht, wie in anderen Stilepochen, unter diesem oft knechtischen Zwang. Im deutschen Expressionismus ist es vielmehr so,—wie schon bei Edvard Munch—, dass die Druckgraphik, besonders die Radierung, ein zuerst in Bildgestalt fixiertes Thema wiederholt und das dann mit dem Überraschungseffekt der befremdenden Seitenverkehrung. Das Leinwandbild tritt also zuerst allein und für sich auf. Das gilt besonders für die Jahre des Aufbruchs, also nach 1905. Bei Beckmann ist die Bildgenese schon wieder umgekehrt. Das Zeichnen hat seine eigenen Gesetze—ausserhalb eines Programms.

Wasserfarbe auf Papier, das sich saugend oder spröde, büttenhaft oder dünn und lächerlich verkrümmt unter der Last der aufgetragenen Wasserlachen verteilt, wenn der gefüllte Pinsel nicht gerade zimperlich Farben aufträgt, bringt in der grossen Zeit der deutschen Expressionisten dennoch oft genug den geistigen Extrakt der Epoche am reinsten hervor. Es ist reine Schaffenslust, auch gegenseitiges Übertrumpfen an schöpferischen Einfällen. Man sollte dabei in solchem Zusammenhang an die betörende Leichtigkeit und Transparenz des höchst stattlichen, beinahe bildgrossen Blattes "Reiter am Strand" aus dem Jahre 1910 von Wassily Kandinsky denken, das in der Ausstellung vor Augen ist. Es entstand in seiner Münchner Zeit. Wie hier gazellenleichte, geschmeidige, stürmende Pferdewesen mit ihren Farbklecks-Reitern von fabelhaften Wellentupfern und phantastisch geformten Brandungsköpfen umspielt, ja, aufgelöst werden, das ist freie, ungebundene Malerlust. Jäh und schnell folgt sie dem ersinnenden Gehirn. Kein anderes Medium, weder die Druckgraphik noch die Malerei auf absichtlich gewählter grober Leinwand vermöchte das mit gleicher Intensität. Zeichnung ist schnell, flüchtig; Bild und Druckgraphik setzen dem Künstler Widerstand entgegen.

Die früher schon angesprochene aus konservatorischen Gründen den Aquarellen und Farbstiftzeichnungen auferlegte Verborgenheit in Schüben von Graphischen Sammlungen und bei privaten Sammlern hebt sich für die kurze Dauer ihres gloriosen Auftritts in einer Ausstellung umso überwältigender auf. Und es ist noch immer oder immer wieder ein Ereignis, den in ihren Abmessungen oft bildwürdigen—also grossen—Blättern von Kirchner und Heckel, von Kokoschka und Dix, von Marc und Mueller, von Schmidt-Rottluff und eben dem hier im Bereich des Aquarells alle überragenden Nolde gegenüberzustehen.

Dem Gesamtbild dieser Ausstellung ist es dienlich, wenn hier neben dem Einenden und Verbindenden gewisse Stileigenheiten einzelner Künstler als Aquarellisten und Zeichner benannt werden, was auch gerade die vorgewiesenen Blätter nahelegen. Das führt zugleich auf Themen, mit denen Interessensgrenzen angegeben sind, ganz von selbst.

Auch Format und Technik spielen dabei eine Rolle. Und bei den grossen erklärten Aquarellisten wie Nolde und Kokoschka ist in diesem Bereich ihres Schaffens ein besonderes Wort am Platze; denn sie erstellen hier ein selbständiges Werk in der sublimsten Technik seit Dürer: dem Wasserfarbenbild.

Zum einzelnen also. An ursprünglicher Begabung reicht Ernst Ludwig Kirchner, der "besessene" Zeichner weit hervor. Man sagt von ihm, dass er selbst im dunklen Kino kritzelte. Das gilt besonders für die Jahre bis 1914, also sowohl für den geschmeidigeren, rundenden Stil seiner frühesten melodischen Kreidezeichnungen wie für die zweite Phase, also den "stacheligen," mit spitzen Winkeln und absichtlichen Verzerrungen, der zur "Hässlichkeit" auch der leiblichen Erscheinung im Sinne einer Ausdruckskunst vordringt. Wie ist das Verfahren der Künstler knapp zu benennen?

Der leicht schwingende, huschende Pinselstrich, der die Vorzeichnung in Blei nur als allgemeinsten Hinweis bestehen lässt, geht zügig, und die einzelnen Formen beschreibend, über Blatt. Farbe füllt sowohl die Flächen, wo sie sich ergeben, als auch breite Konturen, mit denen sie grosse koloristische Lebhaftigkeit erzeugt. Kirchners Arbeitsweise etwa ist schnell und treffsicher. Er nimmt dabei wenig Rücksicht auf den geniessenden Betrachter. Kokoschka ist ihm darin ähnlich. Kirchner bringt mit fortschreitenden Jahren einen nur ihm zugehörenden maskenhaften Menschentypus von interessanter Anonymität, auch in der Zeichnung, hervor. Das gilt besonders bei seinen Aktdarstellungen. In einer zunehmenden Bizarrerie antwortet die farbige Zeichnung der Formensprache der Bilder ziemlich genau, besonders zwischen den Jahren 1908 und 1912.

Bei Erich Heckel, um weitere Einzelphänomene hervorzuheben, macht das Werk der Aufbruchsjahre eine ähnliche Entwicklung durch, nur hat ihm die geschlossene Farbfläche mehr zu bedeuten. Selbstherrlich übersetzt Heckel Gesehenes in absichtlich schrilles Beieinander von Gelb, Grün und Rot. Freilich mildert sich das Angriffige durch das Mitspielen des weissen Papiers, das er nicht verdeckt. Heckel hat von vornherein ein Organ für Bilderzählungen, für Schilderung der ihn beeindruckenden Szenerien im Gebirge und an der See. Und hier soll seine grossflächige Aquarellkunst denn auch—viel später—in einen milden Hafen einlaufen. Aber das ist lange nach der Zeit, wo "Fränzi," das irritierende und erotisierende Kindermodell, wo auch Südseekunst als Anreger und die jugendliche Hitzigkeit des Wetteiferns der Freunde um die allerkühnste Fassung einer Landschaft oder Atelierszene abgeklungen sind. Der gezeichnete und aquarellierte Reisebericht beschäftigt freilich sie alle, dies schon seit Gauguins Noah-Noah. Die Ferne lockt sie, wo sie doch zuerst nur Südsee-Masken im Völkerkunde-Museum sahen!

Schmidt-Rottluff und Pechstein suchen von Anfang an in der Pinselzeichnung mit Entschiedenheit das Ungebärdige, Wilde des Ausdrucks. Schmidt-Rottluff prellt damit—unter dem Eindruck von Südseekunst und Negerplatik—am weitesten vor, er "vergröbert" absichtlich am entschiedensten in seinen Holzschnitten, während Pechstein sein Südsee-Erlebnis zum Mittelpunkt zeichnerischer Reflektionen macht. Seine Malerei ist andere Wege gegangen,

bleibt dem Wohllaut verpflichtet, was ihn bald von der Gruppe scheidet.

Um noch Verhaltensweisen dem Aquarell gegenüber anzudeuten: Otto Mueller, der sich in ein ungarisches Zigeuner-Arkadien einspinnt und die Welt eigentlich nur belebt sieht von jugendlich-schlanken, in Sumpfgewässern watenden oder am Ufer hockenden, eigentümlich versonnenen Schönen, zeichnet mit groben Farbstiften oder breiten Bahnen von dünner Wasserfarbe auf grossen und zuweilen riesigen Papierbögen. Hier könnte man am ehesten noch davon sprechen, dass seine Figurenkompositionen Bildideen vorbereiten wenn sie es nicht schon selbst verkörpern würden. Bei viel süsser Lieblichkeit und scheuem Über-die-Schulter-Blicken bleibt doch alles herb und züchtig. Die Gestalten von Muellers berückenden "Waldnymphen-Balletts" einzeln zu charakterisieren versagt er sich durchaus: Pagenkopffrisur und typ-markierende Backenknochen eigenen ihnen allen und bringen so etwas wie eine Otto-Mueller-Ikonographie von Badenden zu Tage.

Weitere Einzelphänomene: Während Feininger auch in der aquarellierten Federzeichnung, bei blassem, vergrautem Farbklang, der unermüdliche, erfindungsreiche Lyriker der kubistischen Vision von Domen und Dorfkirchen bleibt, und, wie Klee, kalligraphisch seine Motive am Fusse der Darstellung subtil benennt, haben Otto Dix und George Grosz, später dann auch Beckmann, in ihrem stattlichen Werk an Farbzeichnungen Sozial- und Zeitkritik im Sinn, wie sich das der zweiten Generation von selbst aus der veränderten Nachkriegssituation angeboten hat. George Grosz ist wohl auch genussvoll zeichnend durch den Sumpf der Nachkriegsjahre geschritten, messerscharf anmerkend und enthüllend. Seine Blätter fanden deshalb denn auch immer ein beinahe bedenkliches Publikumsinteresse, das nicht so sehr seiner Kunst wie seinem Stoff zu gelten schien. Die Präzision seiner "Beschreibung" von schlimmem Milieu verführte dazu. Feder und lebhaft aufbrausendes Aquarell sind seine Mittel, die Strasse und das Bordell, Schlemmer und Spiesser auf beklemmend pointierende Weise Revue passieren zu lassen. Poesie allenfalls auf der Hintertreppe.

Die Kritik an Welt und Ungerechtigkeit, an übertünchenendem Puder unde leichtem Plunder reicht tiefer hinab bei Otto Dix. Selbst seine wohl ernstgemeinten Porträts rücken so in die Nähe von Vogelscheuchen. Allerdings ist das ebenso virtuose Aquarellkunst, in der beissende Sachlichkeit die Stelle von euphorischer Atelierstimmung der Älteren einnimmt.

Der junge Beckmann kommt zu grosser Ausdrucksgewalt des reinen Strichs, zuerst noch orientiert an dem malerischen Zeichenstil von Lovis Corinth. Bleistift, Feder und schwarze Kreide genügen ihm oft, grossblickende Erscheinungen mit weitgeöffneten Augen, Köpfe seiner Zeit, knapp konturierend und mit einfachen Schraffen, mit also sich immer mehr verknappenden Mitteln, zu geben. Durch Weisserhöhung wird das bisweilen, also bei der Zeichnung auf getöntem Papier, zur plastischen Form gerundet; gültig werden Gestalten seiner frühen Tage in ferne Zeiten überliefert. Solche Blätter gehören mit ihrem Wohllaut und dem modellierenden Charakter, ebenso wie die Bilder dieser Zeit, wohl zu dem Glanzvollsten, was von dem bis zur Jahrhundertmitte reichenden Werk Beckmanns zu verzeichnen

ist. Das Spätwerk bringt einen nur ihm gehörenden Ausdrucksstil hervor.

Emil Noldes und Oskar Kokoschkas Aquarelle haben Lebens- und Wirkungsraum dieser leichten, durchsichtigen, schwebenden und zu äussersten Farbträumen bereiten Kunst unabsehbar erweitert.

Kokoschkas Menschenbilder, gewirkt aus den "Flickenteppichen" sicher gesetzter Farbflecken und -streifen, sind neben dem riesigen Werk an frühen gezeichneten Porträts, oft auf Umdruckpapier für die Lithographie, mit denen auch in überlegener Weise ein Stück Geistesgeschichte überliefert wird, ein Unikum. Weder Zeitgenossen noch Schüler haben eine solche Dichte wie er, bei soviel formaler Willkür, erreicht. Ganz anders als in der Zeichnung, die damals bald drahthaft sparsam, bald auch schönschreiberisch wirbelnd sein konnte, überträgt er hier den schnell auftrocknenden Farbregionen im Nebeneinander—ohne das zu einer Manier werden zu lassen—die volle Wirkung. Er bewirkt das auf meist beträchtlich grossen Blättern, denen er damit Bildwürde gibt, obwohl das Format zuerst nur seiner Arbeitsweise entspricht, eben wie ein Freskant über weite Flächen zu verfügen.

In dem reichen Oeuvre des Malers und Zeichners Kokoschka nehmen die Aquarelle eine Sonderstellung ein: nie sonst hat er der Farbe, die locker aufgetragen wird, einen solchen Spielraum gegeben, unbehelligt von Kontur und Grenze. Aus dem Klang allein, der nicht immer Harmonie sein muss, wächst die Gestalt, immer etwas balgartig—zusammen; der Pinselschlag erinnert sogar an die Olmalerei.

Und doch wird sie bei solcher scheinbaren Willkür des Pinsels und der flüssigen Wasserfarbe,—anders als bei der mehr formumschreibenden Zeichnung—volle "Persönlichkeit" im Sinne Kokoschkas. Gerade die Farbe macht des Künstlers Schilderung von einem Individuum suggestiv. Sie bringt in die Physiognomie auch der leiblichen Erscheinung, etwas Berserkerhaftes, Ungebärdiges, sie gibt ihr sogar auf nicht zu erklärende Weise immer auch etwas vom Selbstporträt des Künstlers, ob Mann, ob Frau, mit grossem Mundkasten und der langen, schmalen Bahn des Gesichtes. Menschendarstellung hat auch in der schnellen Hinschrift des Aquarells zu jener Zeit bei Kokoschka Vorrang vor anderen Themen, was mit seiner geistigen Neugier und seiner "Welterraffung" zusammenhängt. Beckmann geht das Bildnis skandierender an.

Emil Noldes Aquarelle markieren nun schon seit Jahrzehnten eine Höhenzone des Wohlgefallens. Sie bedeuten eine geschlossene Provinz expressiver Poesie oder auch: der Bereitschaft jener Ausdruckskunst, die Schönheit der Farbe zuzulassen. Ob er reisend seine feinen Japanpapiere mit der entrückten Zauberwelt der Alhambra über Granada mit Farben und wahren Farbengluten durchtränkt, ob er drohend verdunkelte Köpfe von Südsee-Insulanern aquarellierend malt, treffsicher mit schnellem Pinselschlag, auch mit Deckweiss darüber, herunterschreibt, immer anders, oft geradezu mit ethnographischer Treue und Akkribie, oder ob er seine nordfriesische Landschaft, Visionen, Fabel- und Halbwesen aus kostbaren Farbgerinseln zur Gestalt erhebt: sein Können zeugt gerade in diesem Bereich von Urbegabung. Nie hat sich um eines seiner Aquarelle ein Streit der Meinungen, verschiedenartiger Wertschätzung seiner Kunst

erhoben. Die Wirklichkeit der Welt und der Dinge wird durch seine Malerphantasie gerade in den von ihm zu äussersten Steigerungen aufgerufenen oder hervorgelockten Wasserfarbenbildern in die Höhe reiner Kunst erhoben. Sie beschäftigt das Auge auf lange Zeit und immer wieder. Dabei scheint in seinem Farbgewoge, im Himmel und auf der Erde, in kühnen Spiegelungen, Doppelformen, in den sich antwortenden Komplementärfarben, der innere Halt der Komposition gefährdet, und doch verliert keines seiner berückenden Bilder das innere Gefüge, die feste Form.

Das haben seine vielen faselnden, überschwenglichen wie stümpernden Fälscher übersehen und sich am ehesten durch solche Formlosigkeit entlarvt.

Der Anteil der Aquarelle Noldes an dieser Ausstellung ist mit voller Absicht beträchtlich und sogar bestimmend, was ihrem Rang als unvergleichliche Leistung eines einzelnen innerhalb der Gruppe entspricht. Es entwertet dabei nicht den entscheidenden Beitrag dieses nordischen Einzelgängers als Maler und als Schöpfer von Originalgraphik. Es tritt vielmehr als Geschenk zu dem riesigen Werk, dem unter Opfern erstellten Lebenswerk, ähnlich wie bei Kirchner und dem sich im expressiven Schaffen verjüngenden Christian Rohlfs, hinzu.

Weitere Charakteristika expressionistischer Zeichenkunst sind anzudeuten. So die sanft-geschmeidige Zeichnung von Franz Marc, der sich weit genug vom "akademischen Tiermaler" entfernt um seine Symbolformen jenseits der Tier-Anatomie zu erfinden. So Paula Modersohns, der früh verstorbenen, herbe Kohlezeichnungen, mit denen sie eine neue Monumentalität des Menschenbildes vorbereitet. Das Verhältnis zur Zeichnung ist bei allen Künstlern eng, geschwisterlich, vertraut. Aber sie haben allesamt in diesem seit Jahrhunderten zum Atelier gehörenden Bereich der Notiz auf Papier ein neues geschaffen: Zeichnung und Aquarell treten nun in die Welt hinaus, verbergen sich nicht länger als Arbeitsmaterial, das dem Künstler jederzeit zur Hand ist.

Eigentümlichkeiten expressionistsicher Zeichenkunst—oft Kunstwerke im Nebenbei der Arbeit—sind damit beschrieben. Die Themen wurden gestreift, die Freude an neu gesehener Landschaft, auch an der Stadtlandschaft, die "Unterhaltung" mit dem Modell ohne Ende, die wohl eher als ein ewiges Sommeridyll mit Waldausflügen und Badeseen und ebenso mit Atelier-Zauber am Eisenofen zu sehen ist.

Freier Auftritt des Menschen, der Person, ist im Blick. Nicht sein Tun beschäftigt sie eigentlich, sondern das Sein. Müssigkeit ist freilich nicht und nie annekdotisch geschildert, wie Bilderzählung selten angetroffen wird. Sie wird der Druckgraphik anvertraut. Es zeigt sich, dass die entlassenen Dresdner Architekturstudenten von einst und ihre Gleichgesinnte im Norden und Süden auch in der Disziplin der Zeichnung und des farbigen Vortrags auf dem Papier einem heiteren Dasein huldigen und dies auch bekennen. Wieviel Humor und Gelassenheit mancher Porträtierte und manches Modell beim ersten Erblicken ihres Konterfeis bewahrt haben mögen, ist nicht einmal mehr von ferne zu ahnen …

Das bohrend-Hässliche, Krumme, Elende, Jämmerliche gehört nicht zur Darstellungsbreite der grossen Jahre bis

1914. Es stellt sich unter späteren Erschütterungen ein.

Zu Format und Technik der durch spätere stürmische Zeiten geretteten Blätter wurde schon einzelnes angedeutet. Die Blätter haben zumeist stattliches Format, was dennoch nicht auf ein Schielen nach Liebhabern der Zeichnung schliessen lässt. Sie alle suchten Freunde, nicht Käufer ihrer Kunst! Die grossen Formate lassen der zeichnenden Hand vielmehr die Freiheit, der "aus dem Arm" kommenden Bewegung zu folgen, was nicht "Verwahrlosung" der Zeichenkunst, sondern spontane Gestik im Schaffensprozess bedeutet. Und das wird nicht nachträglich so geschehen. Diese, bald mit dem Blei, bald mit der Feder und schwärzlicher Tinte im Zusammenwirken mit Wasserfarbe, dann mit wenigen Farbstiften und endlich dem reinen Aquarell zustand gebrachten, grossen Blätter waren zu ihrer Zeit so unerhört, so verblüffend neu wie einst die Zeichenkunst Dürers. Nur war es einst Silberstift und körnig und dick aufgetragene Wasserfarbe gewesen.

Bei Corinth und einigen anderen hatte sich diese unkonventionelle Zeichenweise vorbereitet. Dieses "Aufjubeln der Farbe," wie man es genannt hat, eingegrenzt von kantigen, eckigen oder kühnwogenden Linien.

Aber diese Stilmittel sind nicht Willkür und Auftrumpfen junger Rebellen, sondern aus einer Ganzheitlichkeit des Denkens und künstlerischen Empfindens hervorgegangen. Die Mal- und Zeichenart van Goghs und der farbaufteilenden Pointilisten hatten sie verstanden und verlassen, und damit auch das Theoretisieren. Es war höhere Eingebung, was den Expressionisten in ihrer grossen Zeit vom ersten Strich an erlaubte, die Welt der Erscheinungen in eine ungeahnte Bildsprache zu fassen.

III

Die Norddeutschen: Paula Modersohn-Becker, Christian Rohlfs, Emil Nolde

MARTIN URBAN

Paula Modersohn-Becker, Emil Nolde, Christian Rohlfs sind die Einzelgänger unter den deutschen Expressionisten. Jeder arbeitete für sich, in grosser Isolierung, als lebten sie an weit entfernten Orten. Andererseits haben sie vieles gemeinsam, Nolde und Rohlfs sind Bauernsöhne aus Schleswig-Holstein, der nördlichsten Provinz des damaligen Deutschen Reiches, auch die Kunst Paula Modersohns ist ohne Verbindung mit der Landschaft und den Menschen im nördlichen Deutschland nicht denkbar. Bisweilen haben sich ihre Wege gekreuzt, so gehörten Rohlfs und Nolde seit 1905 zum Kreis um Karl-Ernst Osthaus in Hagen, beide wohnten zeitweise in der gleichen Stadt, im westfälischen Soest. Aber für ihre Kunst blieb das von geringer Bedeutung, direkte Zusammenhänge und unmittelbar Vergleichbares wird man nicht finden, ihre Bilder sind unverwechselbar, im Gegensatz zu manchen der "Brücke" oder auch der französischen Fauves in bestimmten Stilepochen ihrer Entwicklung. Das Verbindende wird erst später sichtbar, nach-

dem die Leistung des einzelnen als Teil einer umfassenden geistigen Bewegung erkennbar wird, die wir den deutschen Expressionismus nennen.

Paula Modersohn-Becker (1876-1907)

Sie ist jünger als Rohlfs und Nolde, 1876 geboren, zählt sie eher zur Generation der "Brücke"-Maler, die den Jahrgängen um 1880 angehören. Als Künstlerin hat sie jedoch mit dem Expressionismus der "Brücke" wenig gemeinsam, auch nicht indirekt; sie kannte Bilder von Munch und van Gogh, denen die jungen Dresdner entscheidende Anregungen verdanken, aber auf die Ausbildung ihrer Kunst hatten sie keinen Einfluss. Als sie 1907 starb, standen die "eigentlichen" Expressionisten erst am Anfang ihrer künstlerischen Entwicklung, die ungewöhnlich schnell ihren Höhepunkt erreichte und schon 1910 mit der Sprengung der Berliner Sezession auch nach aussen sichtbar das Kunstleben in Deutschland revolutionierte. Paula Modersohn hat an dieser Entwicklung nicht mehr teilnehmenkönnen. Als man sie ausserhalb ihres engeren Kreises entdeckte—was verhältnismässig spät geschah—, wurde sie als "Vorläufer" des Expressionismus eingeordnet; doch jene Einschränkung, die darin mitklingt, wird der absoluten Eigenständigkeit und dem künstlerischen Rang ihres Werkes nicht gerecht.

Die in Dresden als Paula Becker geborene Tochter eines Ingenieurs wuchs in Bremen im Kreise einer grossen, angesehenen Familie auf. Mit 15 Jahren erhält sie bei einem Bremer Maler ersten Zeichenunterricht, als sie für ein Jahr zu Verwandten nach England kommt, wird sie Schülerin der Londoner School of Arts. Doch die Eltern wünschen, dass sie Lehrerin wird, und bis zum Abschluss-Examen 1895 auf dem Seminar in Bremen muss sie fast völlig auf jede künstlerische Betätigung verzichten. Anschliessend darf sie für ein Jahr die Malerinnen-Schule in Berlin besuchen, doch gilt ihr Interesse weniger dem akademischen Unterricht als dem Studium der alten Meister in den Museen. 1897 geht Paula Becker nach Worpswede bei Bremen in die von Fritz Mackensen gegründete Malerkolonie im Teufelsmoor. Worpswede wird ihre Heimat, aber so viel sie der Landschaft, den Menschen dort und den Worpsweder Malerfreunden zu danken hat, so sehr wächst sie als Künstlerin darüber hinaus. Sie muss schon früh die Einengung gespürt haben, welche das Zusammenleben einer Gruppe von Malern in der Einsamkeit mit sich bringt, und sie setzte sich zur Wehr. Bald ist sie in Norwegen, Berlin oder Wien, 1900 zum ersten Mal in Paris, in den folgenden Jahren führt sie eine Art Wanderleben zwischen dem Moordorf Worpswede und Paris.

Worpswede bildete am Rande des schwer überschaubaren und sehr uneinheitlichen Feldes der deutschen Malerei um die Jahrhundertwende ein eigenes Zentrum. Hier hatte sich eine Gruppe befreundeter Maler gefunden, die fern vom Akademismus und Pseudonaturalismus der Kunstschule inmitten einer unberührten Landschaft den Gleichklang zwischen der Welt ihrer Gefühle und der natürlichen Aussenwelt suchten. "Meine Empfindung kann sich allein im bewundernden Anschauen der Natur weiterbilden," sagte Mackensen, der eigentliche Gründer und führende Kopf der Künstlergruppe, den Paula Becker 1897 zu ihrem Lehrer

wählte. Aus ihren Briefen und Tagebüchern erfahren wir, wie innig sie die Worpsweder Landschaft geliebt hat, den weiten Himmel, das dunkle Moor, Birkenstämme an blanken Wassergräben, Moorhütten und die vom Leben in dieser Welt geprägten Menschen. Dennoch hat sie im Gegensatz zu den eigentlichen Worpswedern nur wenige reine Landschaftsbildes gemalt.

Rainer Maria Rilke hat 1903 ein Buch über Worpswede geschrieben, eine poetische Monographie der Landschaft und ihrer Maler ("auf den schwarzen Wassern des Kanals wartet beladen das Boot, und dann fahren sie ernst wie mit Särgen . . ."). Es überrascht, dass Paula Modersohn-Becker in diesem Buch nicht vorkommt. Ob der empfindsame Dichter dieser jungen Frau, die er als Gesprächspartnerin schätzte, die mit seiner Frau, der Bildhauerin Clara Westhoff, befreundet war und nach deren Tod, 1907, er sein berühmtes "Requiem für eine Freundin" schrieb, die Anerkennung als Malerin versagen wollte? Oder hat er vielleicht erkannt, dass ihre Kunst mit dem Naturlyrismus der Worpsweder, zu denen ja auch der seit 1901 mit Paula Becker verheiratete Otto Modersohn zählt, dass die Kunst der Paula Modersohn-Becker mit der gefühlsbeladenen Stimmungsmalerei, die er so treffend besang, nicht in Einklang zu bringen war?

Paula Modersohn war es, die Rilke mit der Kunst von Cézanne vertraut gemacht hat seinen "Briefen über Cézanne," 1907 anlässlich der Gedächtnisausstellung in Paris geschrieben, gehen intensive Gespräche mit der Malerin voraus; einer ihrer letzten Wünsche war, diese Ausstellung zu sehen. Vier Wochen vor ihrem Tod schrieb sie an ihre Mutter: "Ich wollte wohl gern auf eine Woche nach Paris reisen. Da sind 56 Cézannes ausgestellt!"

1900, bei ihrem ersten Aufenthalt in Paris, hatte sie bei Vollard zusammen mit Clara Westhoff zum ersten Mal Bilder von Cézanne gesehen. Er war ihr—nach dem Zeugnis von Clara Westhoff—"wie ein grosser Bruder . . . eine unerwartete Bestätigung ihres eigenen künstlerischen Suchens." Diese Begegnung hatte ihr die Augen geöffnet für die grosse, einfache Form. Nach der Rückkehr kritisiert sie die Art von Mackensen als "nicht gross genug, zu genrehaft." Schon ihre frühen Zeichnungen haben sich von denen ihres Lehrers—der als einziger Worpsweder vor allem Figurenbilder malte—durch grössere Härte in der Charakterisierung, durch Knappheit der Gesten und Verzicht auf das Anekdotische unterschieden. "Es brennt in mir das Verlagen, in Einfachheit gross zu werden" notiert sie im Tagebuch (April 1903). Ihre Kunst entfernt sich mehr und mehr von den Worpswedern.

1906 trennt sie sich von Otto Modersohn, erst nach einem Jahr kehrt sie aus Paris zurück. Neben Cézanne, der nach ihrem eigenen Bekenntnis "wie ein Gewitter und ein grosses Ereignis" auf sie gewirkt hat (21.10.1907 an Clara Rilke), hat die Begegnung mit den Bildern von Gauguin, den Nabis und im Louvre die frühe Antike und die ägyptische Kunst ihr die Kraft und die Freiheit gegeben, sich selbst zu finden, indem sie das Bild als bewusst gestaltetes, selbständiges Formgefüge begriff. "Ich glaube, man müsste beim Bildermalen gar nicht so an die Natur denken, wenigstens nicht bei der Konzeption des Bildes. Die Farbenskizze ganz so machen, wie man einst etwas in der Natur empfun-

den hat. Aber meine persönliche Empfindung ist die Hauptsache. Wenn ich die erst festgelegt habe, klar in Form und Farbe, dann muss ich von der Natur das hineinbringen, wodurch mein Bild natürlich wirkt, dass ein Laie gar nicht anders glaubt, als ich habe mein Bild vor der Natur gemalt" (Tagebuchblätter 1.Okt.1902). Die von der eigenen Empfindung, der Kraft des Gefühls durchdrungene Form der Dinge—das bedeutet Abkehr vom Zufälligen der äusseren Erscheinung, Absage auch an das anekdotische Beiwerk, die innere Wirklichkeit erkennen, das Menschliche in den Dingen in ihrer einfachsten, lautersten Form darstellen.

Ihre eigene warmherzige Menschlichkeit ist unverwechselbarer Teil der Bilder. Die Menschen in Worpswede, Bäuerinnen und Kinder, das wunderbare, streng dunkle Bildnis von Werner Sombart, Frau Hoetger, Rainer Maria Rilke und viele Stilleben mit Früchten, Blumen und den Sachen des Alltags, Küchengerät, Spielzeug, bunt arrangiert, in feste Konturen gefasst, ob weitflächig oder dicht gedrängt, unter bewusstem Verzicht auf Perspektive sind sie in einer strengen Ordnung lapidar in den Bildraum gestellt. Die Dinge gewinnen in ihren Bildern eine Monumentalität, die nie künstlich ist, sondern prall voll Natur. Die kräftigen, dichten, meist warmen, manchmal fast dunklen vollen Farben haben eine sinnliche Konsistenz— was ihre Bilder nun sehr von Cézanne unterscheidet. Schon 1900 hatte sie aus Paris geschrieben, sie möchte "alle Farben tiefer haben, satter und [ich] werde ganz ärgerlich bei dieser Helligkeit" (29.2.1900 an Otto Modersohn). Moorbauern, Armenhäuslerinnen, nackte Kinder und Mütter sind für Paula Modersohn nicht Objekte des Mitleids, denn Klage und Sozialkritik sind ihr fremd; die Menschen haben wie die Dinge etwas Vertrautes und behalten zugleich den Ernst und die Würde der Distanz. Das gilt auch für die zahlreichen Selbstbildnisse, die sie von Anfang an und bis in die letzten Wochen vor ihrem Tod gemalt hat. Viele sind von grosser Kühnheit, sehr selbstsicher und überlegen, so die späten Selbstbildnisse als Akt oder Halbakt ("Selbstbildnis am 6. Hochzeitstag" 1906). Andere sind ganz auf den Kopf und das Gesicht konzentriert, sie haben etwas Ikonenhaftes und sind tatsächlich von spätantiken Mumienbildnissen angeregt; mit der kühnen Vereinfachung der Form wird das persönlich Nahe und Eigenständige des Porträts ins gleichnishaft Allgemeine entrückt.

Paula Modersohn hat ein unverwechselbares Werk hinterlassen, das eine bewundernswerte, innere Geschlossenheit aufweist und trotz ihres frühen Todes als wahrhaft vollendet gelten darf.

Christian Rohlfs (1849-1938)

Christian Rohlfs ist 1849—also 27 Jahre vor Paula Modersohn—geboren, er wurde fast 90 Jahre alt. Seine Schaffenszeit umfasst etwa sieben Jahrzehnte; er war mit den gegensätzlichsten künstlerischen Ereignissen konfrontiert, von denen sein Werk auf sehr eigenartige Weise mitgeprägt ist. Der "frühe" Rohlfs ist ein bedeutender Maler des 19. Jahrhunderts, er gehört zu den führenden Kräften der deutschen Freilichtmalerei. Jedoch mit dem Ausbruch des neuen Jahrhunderts—biographisch fällt die Zäsur mit seinem endgültigen Abschied von Weimar zusammen—finden wir den bald 60-jährigen überraschend bei den durchweg 30 Jahre jüngeren Expressionisten, deren Weggefährte er noch drei Jahrzehnte bleibt. Man hat ob der Begeisterung über den "Expressionisten" Rohlfs den Freilichtmaler fast vergessen, zu Unrecht, zumal es zwischen beiden mehr Verbindendes gibt, als eine oberflächliche Betrachtung erkennen lässt.

Rohlfs wurde in einer Bauernkate im holsteinischen Dorf Leezen geboren und sollte eigentlich den Hof seines Vaters übernehmen. Zur Malerei ist er dann durch Zufall gekommen. Nach einem Unfall, der später zur Amputation eines Beines führte, hatte der 15-jährige während seines langen Krankenlagers auf Anregung des Arztes angefangen zu zeichnen. Die Zeichnungen bekam der Dichter Theodor Storm zu sehen, er erkannte die Begabung, förderte den Jungen und sorgte dafür, dass er zu dem Maler Pietsch nach Berlin kam und 1870 auf die Akademie in Weimar.

An der vom Grossherzog gegründeten Schule wurde vornehmlich die aus der Goethezeit überkommene klassizistische Tradition gepflegt; Figurenbilder im Sinne der Bildungs- und Historienmalerei waren die vornehmsten Themen, die ein angehende akademische Maler beherrschen musste. Rohlfs Studienzeit, durch Krankheit unterbrochen, dauerte bis etwa 1880.

Als besondere Auszeichnung erhielt Rohlfs 1881 ein "Freiatelier" der Akademie. In diesen Jahren beginnt sein eigentliches Werk. Nicht im Figurenbild vollzog sich der Durchbruch zum selbständigen Künstler—die akademische Ausbildung scheint vergessen, Rohlfs beschränkte sich in den zwei Jahrzehnten vor der Jahrhundertwende fast ausschliesslich auf das Thema des Landschaftsbildes. Die Motive fand er in der näheren Umgebung von Weimar oder in Weimar selbst, den "Kalksteinbruch," den "Wilden Graben," die "Schlossbrücke in Weimar." Einige hat er wiederholt gemalt, was an die französischen Impressionisten denken lässt, die "Heuhaufen" von Monet oder seine zwanzig Bilder der "Kathedrale von Rouen." Es ist auch kein Zweifel, dass der französische Impressionismus seine Malerei beeinflusst hat, 1890 sah er in Weimar Bilder von Monet, 1891 von Sisley und Pissarro; er wird sie sorgfältig studiert haben, seine Palette ist seitdem heller, die Einbeziehung des farbigen Lichtes hat seine grosse koloristische Begabung erst freigelegt. Aber die Einwirkung bleibt in Grenzen, das eigentliche Prinzip des Impressionismus, die Durchdringung von Licht und Farbe bis zur Verwischung der Grenzen, zur Auflösung der Gegenstandformen, hat Rohlfs nie übernommen. Übrigens ebensowenig wie die anderen sogenannten deutschen Impressionisten, unter denen er einen eigenen Rang behauptet. Ein Maler, der den Dingen in der Natur durch Farbe und Licht eine eminente Leuchtkraft verleiht, der die Farbe manchmal sehr locker, getupft aufträgt, mit einem vitalen Temperament, das die Kritiker veranlasst, seine Malerei "patzig" zu nennen, das heisst frech, ungehörig. Dabei ist nicht die Wiedergabe des atmosphärischen Lichtes sein Ziel, die Gegenstände behalten ihr Gewicht und bleiben massgebend für die formale Gestalt des Bildes. (So ist Rohlfs näher am Realismus eines Courbet als am eigentlichen Impressionismus.) Seine Malerei ist ganz unpathetisch und ebenso weit von Repräsentation oder Idealismus entfernt wie vom gefühlsbeladenen Naturlyris-

mus, der zur gleichen Zeit in Dachau und Worpswede gepflegt wird.

Bald nach der Jahrhundertwende gab Rohlfs scheinbar abrupt alles Erreichte auf. Die Begegnung mit Karl-Ernst Osthaus, dem Begründer des Folkwang-Museums in Hagen, und Henry van de Velde, dem Architekten des Museums und Berater von Osthaus, hatte den Anstoss gegeben. Rohlfs folgt 1901 dem Ruf nach Hagen. Wenngleich er bis 1904 sein Atelier in Weimar behält und aktiv an der neuen Entwicklung teilnimmt, die nunmehr auch die dortige Kunstschule erfasst hat. In der Sammlung Osthaus sah Rohlfs Bilder von Seurat, Signac und Rysselberghe, ihre Leuchtkraft, die Reinheit der Farbe müssen ihn fasziniert haben, er übernahm das Dogma des Pointilismus, Farbzerlegung und Auflösung der Fläche in ein System von Punkten. Wenig später beginnt seine Auseinandersetzung mit Munch und van Gogh. Der 55-jährige macht eine stürmische Entwicklung durch. Der freie Umgang mit den Mitteln, die direkte Aussagekraft von Farbe und Form, die Frage nach der Autonomie des Bildes, das sind nunmehr zu bewältigende Probleme. Rohlfs hat sich dieser Auseinandersetzung gestellt im Gegensatz zu den etablierten anderen deutschen Freilichtmalern, die auf ihrer Position beharrten oder gar das Aufkommen der neuen Kunst bekämpften, wie Liebermann und Corinth, womit die ehemals revolutionären Secessionisten in den Augen der Jungen zu Reaktionären wurden. Auf der Sonderbundausstellung 1910 in Düsseldorf war der 61-jährige Rohlfs im Kreise der jungen Maler als einer der ihren dabei, neben Kirchner, Nauen, Nolde, Pechstein, Kandinsky, Schmidt-Rottluff.

Der "Birkenwald" von 1907 ist eins der ersten Bilder, in denen ihm die Synthese aus den neu gewonnenen Einsichten voll gelungen ist. Die ungemischten kräftigen Farben sind in Tupfern, Bändern und Streifen pastos aufgetragen, ineinander verwoben bilden sie ein dichtes Geflecht, das die Bildfläche in ein Feld rhythmischer Bewegung verwandelt. Die Struktur des Bildes ist frei von emotionaler Gestik, vielmehr sachlich, jedoch von Wärme und Heiterkeit erfüllt. Waldbilder zählten zu den Lieblingsmotiven des frühen Rohlfs, um so bemerkenswerter ist die gelungene Anverwandlung in die neue Form des Bildes. In Zukunft verliert das Landschaftsbild immer mehr an Bedeutung, es wird abgelöst vom Thema der Figurenkomposition und des Architekturbildes.

Ein oft wiederkehrendes Thema sind die "Türme von Soest." Nach einem ersten Besuch im Jahre 1904 hat Rohlfs die mittelalterliche Stadt immer wieder besucht, 1906 traf er dort mit Nolde zusammen, der über die Begegnung schreibt, dass "wohl niemals zwischen zwei Malern so wenig über Kunstprobleme gesprochen" wurde, Nolde "stand ratlos vor den grossen Kirchen. . . . ich fand mich nicht zurecht." Für Rohlfs dagegen wurde Soest mit den mächtigen Kirchtürmen über den roten Ziegeldächern der Wohnhäuser zum Sinnbild der "Alten Stadt." Nach einer Reihe von Aquarellen, die seit etwa 1905 einen besonderen Rang in seinem Werk bekommen, entstehen ab 1906 zahlreiche Oelbilder, die das Bild der Stadt mit ihrem ausgeprägten mittelalterlichen Charakter anfangs vergleichsweise getreu, bisweilen fast trocken, bald aber mit grösserer Zusammenfassung der Details in immer geschlossener werdenden grossen Kompositionen festhalten. Die geliebte Stadt, das "herrliche Nest" wird dem Maler so vertraut, dass er sie noch Jahre später aus der Erinnerung malt. Die Türme rücken zusammen, in der Mitte der mächtige schwere von St. Patroclus, Wahrzeichen der Stadt, flankiert von den Türmen St. Pauli und St. Petri, dahinter die Turmspitzen der gotischen Wiesenkirche. Die Komposition wird dichter, fest ineinandergefügt, die Bildgestalt vermittelt den Eindruck von uneinnehmbarer Festigkeit. Die Farben, die zunächst noch in einer Art gesteigerten Impressionismus aufgetragen wurden, breiten sich bald flächenhaft aus, oft überwiegen die braunen, erdhaften Töne; in späteren Bildern sind sie zu grosser Leuchtkraft gesteigert; in abstrakt geometrischen, kristallinen Formfeldern bekommen sie eine diaphane Wirkung, wie von rückwärts durchleuchtet.

Die Gegenstände können dem Formenkanon des Bildes so sehr untergeordnet sein, dass sie ihrer Individualität völlig entkleidet gleichnishaften Charakter erhalten. Soest wird die "Alte Stadt" schlechthin.

Schliesslich ist der Gegenstand nur noch wegen seiner farbigen und formbildenden Qualität interessant. Die Verselbständigung der Bildarchitektur kann bis in die Nähe der Abstraktion vorgetrieben werden. Während in Bildern wie "Das rote Dach" und "Rote Dächer unter Bäumen" die Beziehung zur realen Gegenstandswelt gerade noch bewahrt bleibt, besteht das 1912 entstandene Bild mit dem Titel "Blauer Berg" allein aus blauen Farbformen, breiten Bahnen, die mit dem Spachtel aufgetragen zu bergartigen Formationen aufgetürmt sind. Eine Variation über das Thema Blau, sie könnte auch—weniger sinnbezogen—der blaue Turm, die blaue Stadt, ein blauer Wald sein.

Nach der Abkehr vom Landschaftsbild gewinnt die Figurenkomposition an Bedeutung. Zunächst entsteht eine Reihe von Akten, die jedoch eher den Charakter von Studien haben; es folgen Bilder mit bedeutungsvollen Inhalten, Themen aus der Welt der Phantasie, visionäre Erfindungen und biblische Motive. Die Erschütterung durch den Weltkrieg schlägt sich schliesslich in Themen nieder, welche diesem Werk bisher fremd waren: "Gehetzter," "Gethsemane," "Der Krieg." Die dunklen Seiten des Daseins, die Abgründe von Zerstörung und Gewalt waren nie Inhalt seiner Kunst gewesen, sie gehörten zu einer Gegenwelt, die seinem inneren Wesen zutiefst widersprach. So überwiegen denn auch versöhnliche, menschliche Themen: "Der verlorene Sohn bei den Dirnen" und "Die Rückkehr des verlorenen Sohnes," "Gottes Geist über den Wassern," "Engel, der das Licht in die Gräber trägt."

Vereinfachte, grosse Formen sind die eigentlichen Träger des Ausdrucks, Gesten der Figuren werden zu Gebärden der Form, sie beherrschen das Bildfeld in holzschnitthafter Vereinfachung und Grösse. Die Form ist betont zeichnerisch als lineares Gerüst in schwarzen Konturen angelegt. Farbe tritt zurück, sie beschränkt sich auf die reiche und differenzierte Tönung der Flächen, während die sinnliche Wirkung zurückgenommen ist, beruht der Anteil der Farbe in Inhalt des Bildes auf ihren immateriellen, geistigen Wert.

Neben den ernsten religiösen Darstellungen gibt es Bilder mit heiterem Inhalt, es sind temperamentvoll gemalte, bewegungsreiche, dynamische Kompositionen: die

verwirrenden Kopfstände der "Akrobaten," Unruhe und Turbulenz des "Strassenbildes," der schwebende Rhythmus des "Tänzerpaares," oder burleske Szenen wie "Clowngespräch," "Der Onkel." Die Farben als wesentliche Träger des Ausdrucks und formgestaltende Kraft gewinnen an Bedeutung, sie erhalten Glanz und Kostbarkeit.

Die Kunst des Christian Rohlfs ist dem Leben zugewandt—vielleicht kann man es als ein Erbe seiner Weimarer Zeit verstehen—, sie ist sinnenfroh, heiter. Disharmonien und Dramatik liegen ihm fern, man kann ihn den Lyriker unter den Expressionisten nennen. Keiner hat wie Rohlfs, ausser vielleicht Feininger, Farbe so in schwebendes Licht verwandelt. In seinen letzten Jahren zieht es ihn in den Süden, so oft er kann lebt er im freundlichen Ascona. Ihm blieb nicht erspart, die Demütigungen und Verhöhnung seiner Kunst durch die Nationalsozialisten zu erleben. 1938 ist Rohlfs im Alter von 88 Jahren gestorben.

Emil Nolde (1867-1956)

Nolde ist der Prototyp des norddeutschen Expressionisten, eigenwilliger als die anderen lebte er abseits in selbstgewollter Einsamkeit. Noch der 80-jährige notiert: "wie bin ich froh als Künstler unter Künstlern fast allein zu sein und der ganze Künstlerschwarm ist anderswo" (13.3.1947).

Dennoch verläuft sein Weg als Maler nicht isoliert, sondern parallel und oft in enger Verbindung mit den anderen. Er war 1906/07 an den ersten gemeinsamen Ausstellungen der "Brücke" beteiligt, teilte mit ihnen die Ablehnungen und ersten Erfolge. Sein öffentlicher Streit mit Max Liebermann im Jahr 1910 führte zur Sprengung der "Berliner Secession," der mächtigsten aller deutschen Künstlervereinigungen; das bedeutete die Durchsetzung "gegenüber den wohlangesessenen älteren Kräften," wie es die "Brücke"-Maler in ihrem Programm formuliert hatten. Nolde war zum Wortführer der jungen Generation geworden, fast erschreckt stellte er es fest—und zog sich zurück. Von der Künstlergruppe "Brücke," die ihn 1906 in Huldigung an seine "Farbenstürme" zum Mitglied berufen hatte, trennte er sich schon nach einem Jahr. Er wollte allein sein, fern von der Unruhe und Betriebsamkeit der Künstlergruppierungen.

Emil Nolde hiess eigentlich Hansen, er ist 1867 als Sohn eines Bauern im Dorf Nolde im deutsch-dänischen Grenzland geboren und hat sich mit allen Kräften gegen viele Widerstände aus seiner ländlichen Umgegend gelöst. Auf eine Lehrzeit als Möbelschnitzer in Flensburg folgten vier Jahre Fabrikarbeit in München und Berlin, von 1892-1897 war er Zeichenlehrer an der Gewerbeschule St. Gallen in der Schweiz. Erst der 30-jährige konnte eine private Malschule in München besuchen, von dort ging er nach Dachau zu Hölzel, der damals eine tonige Malerei im Sinne des deutschen Naturlyrismus vertrat. Doch Schulen und Akademien gaben ihm wenig, er fühlte sich seinen Lehrern gegenüber "wie ein Heide." Er griff nur auf, was seinem eigenen Empfinden verwandt war, dabei bedeuteten ihm zeitgenössische und alte Kunst gleichviel, Ägypter, Assyrer, die Masken der Südsee und Afrikanisches, Tizian, Rembrandt, Goya, später Munch und Gauguin. 1899 geht er für neun Monate nach Paris, an die Akademie Julian. Die

Impressionisten beeindrucken ihn wenig, mit zwei Ausnahmen: Degas und Manet "der grosse bedeutende Maler lichter Schönheit." Als er im Sommer 1900 in seine jütische Heimat zurückkehrt, bringt er "nur ein paar Akte, Schularbeiten" mit und die Kopie eines Tizian-Bildes im Louvre; er hat mit sicherem Instinkt Tizian gewählt, den Vater der modernen Koloristik, den schon Rubens, Delacroix und schliesslich Cézanne und van Gogh als ihren eigentlichen Anreger verehrt haben.

In den folgenden Jahren ist er bald in Kopenhagen, bald in Berlin; im Fischerdorf Lildstrand an der Nordküste Jütlands entstehen merkwürdige Bleistiftzeichnungen, frei erfundene Phantasien. Er schreibt dazu 1902 an seinen Freund Hans Fehr, sie "schweben mir nun vor in schwimmenden Farben, schöner als ich sie wohl werde malen können . . . , ich sehne mich nach dem Tage, wo ich Farbenharmonien, meine Harmonien gefunden habe."

Eine erste Erfüllung sind die Blumen- und Gartenbilder von 1906/07. Er entdeckt die evokative Kraft der Farbe, sie wird zum tragenden Medium seiner Kunst. Nolde hatte ein ungewöhnliches, fast physisches Verhältnis zu den Farben: "mir war als ob sie meine Hände liebten." An anderer Stelle notiert er: "Gelb kann Glück malen und auch Schmerz . . . Jede Farbe birgt in sich ihre Seele, mich beglückend oder abstossend und anregend." Immer wieder sann er darüber nach: "Das Material, die Farben, waren mir wie Freundschaft und Liebe, das beides sich ausleben will in allerschönster Form." Er wollte, dass die Farbe in ihrer psychischen und physischen Kraft das Inhaltliche des Bildes nicht nur trägt, sondern geradezu hervorruft. "Die Farben sind meine Noten, mit denen ich zu- und gegeneinander Klänge und Akkorde bilde." In den Notizen des Malers findet sich oft dieser Vergleich mit der Musik.

Alles kann jetzt zum Bild werden, Träume und Ängste, Zweifel und Glück. Er malt in unbekümmerter Subjektivität, ohne äusseren Auftrag; so sind auch seine religiösen Bilder zu verstehen, die kaum ihresgleichen in der modernen Malerei haben. Sie müssen als persönliche Deutungen gesehen werden, in denen sein viel versuchter Glauben, Ergriffenheit und Zweifel Ausdruck fanden. "Falls ich am Bibelbuchstaben und am erstarten Dogma gebunden wäre, ich habe den Glauben, dass ich dann diese tief empfundenen Bilder Abendmahl und Pfingsten so stark nicht hätte malen können. Ich musste künstlerisch frei sein—nicht Gott vor mir haben, wie einen stahlharten assyrischen Herrscher, sondern Gott in mir, heiss und heilig wie die Liebe Christi." "Abendmahl," "Pfingsten" und als drittes "Verspottung" entstanden 1909; ein Jahr später "Christus und die Kinder," "Der Tanz um das Goldene Kalb" und 1911/12 das grosse neunteilige Werk "Das Leben Christi"; im Kriegsjahr 1915 die "Grablegung," "Die Zinsmünze," "Simeon begegnet Maria im Tempel." Als Gegengewicht, gleichsam auf der Flucht aus geistiger Anspannung und Ergriffenheit, malte Nolde oft in umittelbarer zeitlicher Nähe Bilder mit einfachen Themen: spielende, tanzende Kinder, "Landschaft mit jungen Pferden" oder dyonisisch erotische Bilder: "Kerzentänzerinnen," "Krieger und Weib," "Fürst und Geliebte."

Nolde hatte eine Neigung zu antithetischen Konzeptionen, in seiner Malerei wie in seinen Handlungen und Gedanken;

das konnte zu überraschenden Widersprüchen führen. So hat er zeitlebens die Technik als Zerstörerin der natürlichen Ordnung verurteilt. Er wetterte gegen die Ingenieure, welche die geliebte heimatliche Landschaft ohne Sinn für deren Schönheit durch den Bau von Deichen und Schöpfwerken verschandelten. Aber der gleiche Nolde ist von der Dynamik der technischen Arbeitswelt fasziniert, sobald er sie als Maler entdeckt, so im Hafen von Hamburg 1910. Er wohnt in einer billigen Pension über einer Matrosenkneipe, fährt in den Pinassen mit den Hafenarbeitern mit, das Panorama des Hafens, das lärmende Treiben, der pulsierende Rhythmus versetzen ihn in Begeisterung. Innerhalb von drei Wochen entstehen mehrere Oelbilder, die berühmte Serie der Hamburg-Radierungen und eine Folge grosser Tuschpinselzeichnungen. Sie sind in ihrer Dynamik und monumentalen Archaik ein Höhepunkt im Werk des Malers.

Ein anderes Beispiel sind die Berlin-Bilder. In seinen Briefen und Büchern hat er die Grosstadt Berlin als Stätte der Verkommenheit und des Verderbs geschmäht: "nach Parfüm stinkt's, sie haben Wasser im Gehirn und leben als Bazillenfrass und schamlos wie die Hunde" schreibt er 1902 an einen Freund, in seinen Büchern steht's ähnlich. Wie hat er die Hure Babylon, Berlin—wo er alle Winter verlebte—beschimpft! Doch der Maler vergisst das, er ist fasziniert vom Glanz und sinnlichen Reiz, von Licht und Schatten des nächtlichen Treibens, mit offenen Sinnen nimmt er Schönheit und Glück, Spuk und Laster, die Verderbtheit und die Menschlichkeit dieser Welt in sich auf. "Herr und Dame im roten Saal," "Am Weintisch," "Publikum im Kabarett," "Vom Ball" sind die Titel einiger Gemälde. Sie entstanden im Winter 1910/11, hinzu kommen viele Aquarelle und Zeichnungen vom Theater, Tingel-Tangel und Strassencafé. Die Berlin-Bilder stellen einen geschlossenen Komplex in Noldes Werk dar. Aber sie sind nicht isoliert, auch wenn er sie in dieser Form nicht wieder malt, die hier manifestierten Einblicke und Erfahrungen bleiben Bestandteil seiner Kunst, sie können in ganz anderen Bildern wiederkehren, bis hin zu den "Ungemalten Bildern" aus der Zeit des Malverbotes.

Auf die Frage nach einer Rangordnung der Themen nannte Nolde als erste die figürlichen Bilder, aber er nahm die Antwort wieder zurück, denn nicht das Thema oder Motiv entscheide über den Rang des Bildes. Allerdings sei das Wagnis beim Malen der freien Phantasien und auch der biblischen Bilder ungleich grösser als etwa bei den Blumen- und Gartenbildern, die eher in Zeiten der Entspannung entstanden seien und vielleicht deshalb viele Freunde gefunden hätten, jedenfalls mehr als die anderen Bilder, aber das machte ihn eher skeptisch.

Als Nolde 1913 zur Teilnahme an einer Expedition in die Südsee eingeladen wurde, gab er andere Pläne auf, ihn lockte das Abenteuer fremder Küsten. Die Reise dauerte ein Jahr, sie führte über Moskau, Sibirien, Korea, Japan, China nach Neuguinea. Hier entstehen neben zahlreichen Studien-Zeichnungen viele Aquarelle und 20 Gemälde. Er malt die "Tropensonne," ein dramatisches, farbstarkes Bild, auf dem Kontrast der Komplimentärfarben Rot und Grün aufgebaut und dem ornamentalen Rhythmus der weissen Brandungswellen. Mehr als die Landschaft zogen ihn die

Menschen an. Er sucht den unverfälschten Ausdruck der anfänglichen Stufen des Menschseins, aber er sieht Verlorenheit und Angst und das unausweichliche Schicksal, dass ihr mit der Natur verbundenes Leben in den alten sozialen Strukturen und Verbänden der Stämme durch die rohen Praktiken der Kolonialherren bereits zum Tode verurteilt ist. Das wirft über seine Bilder aus der Südsee einen Schatten von Melancholie.

Nach der Rückkehr zu Beginn des Krieges zieht Nolde in ein altes Bauernhaus an der Westküste: Utenwarf. Es liegt nicht weit vom Dorf Nolde am schilfbewachsenen Ufer der Wiedau, einem breiten Fluss, der in die Nordsee strömt. Hier und später im nahen Seebüll sind seitdem fast alle seine Bilder entstanden.

Wer diese Landschaft kennt, findet sie in Noldes Bildern wieder. Seine Farben gibt es hier wirklich, das scharfe Grün der weiten Wiesenflächen, das Gelb der Rapsfelder, das tiefe Blau der Seen, Flüsse und Sielzüge, und über dem flachen Land das Licht des weiten Himmels, der besonders im Herbst, in den langen Morgen- und Abenddämmerungen, mit den wandernden Wolken in einer Fülle von Farben leuchtet, deren Skala vom blassen Grün bis Dunkel-Violett und Blau, von Gelb, Braun, Orange bis zu glühendem Rot reicht; das Licht verwandelt alles in ein unwirkliches Farbenmeer. Diese Landschaft, zu der das nahe Meer gehört, bedeutet für die Kunst Noldes das gleiche, was die Provence bei Aix-en-Provence, Tholenet und Château-Noir für Cézanne war. "Die Natur kann dem Künstler, wenn er sie lenkt, eine wunderbare Helferin sein," notiert der alte Nolde (9.10.44).

Zwischen Utenwarf und Seebüll fand Nolde die Landschaft, welche die Erfüllung einer Sehnsucht versprach, die zu den Grunderlebnissen des deutschen Expressionismus gehört, das Sehnen nach der Verschmelzung von Ich und Kosmos, das Streben nach den "Urzuständen" des menschlichen Lebens, als Aussen und Innen noch nicht getrennt waren. Aus der gleichen Sehnsucht war Nolde in die Südsee gefahren, er suchte die "Urstufen" des Menschen, die "Urnatur," denn "die Urmenschen leben in der Natur, sind Eins mit ihr und ein Teil vom ganzen All." Die Maler wie die Dichter des Expressionismus liebten das Präfix "ur." 1913, im Jahr der Südseereise, schrieb Gottfried Benn die "Gesänge," welche mit dem Ausruf beginnen: "O dass wir unsere Ururahnen wären!" Die "Bilder des grossen Urtraums" (Benn) sind die letzte uns gebliebene Erfahrbarkeit des Glücks. Dies mochte Nolde meinen, als er auf einem kleinen Zettel, denen er in der Zeit der Verfemung seine Gedanken anvertraute, notierte: "Bilder können so schön sein, dass sie profanen Augen nicht gezeigt werden können" (5.6.42).

Nach dem 1. Weltkrieg kam das Land mit Utenwarf und dem Dorf Nolde an Dänemark, Nolde wurde dänischer Staatsbürger. Als die Dänen im Gebiet der Wiedau neue Deichbauten und Entwässerungsprojekte vorbereiteten, zog Nolde wenige Kilometer südwärts über die nahe Grenze, wo er auf einer alten hohen Warft nach seinen eigenen Entwürfen das Haus Seebüll baute. Es erhebt sich wie ein Kastell abwehrend, eigenwillig, in der flachen Landschaft, weithin sichtbar auf seiner Warft. Inmitten der bäuerlichen Umgebung behauptet es sich durch sein Anderssein, ein

Symbol des Stolzes und der Einsamkeit. Hier lebte der Maler zurückgezogen in seiner eigenen Welt, nur für einen kleinen Kreis von Freunden erreichbar.

Später wurde das abseits gelegene Haus zum Zufluchtsort, in dem der Maler Schutz fand vor den Angriffen der Nationalsozialisten. Dabei hatte Nolde die "Bewegung" anfangs begrüsst und war 1933 Mitglied der N.S.-Partei geworden. Sehr bald wurde klar, wie sehr er sich geirrt hatte: seine Ausstellungen wurden geschlossen, alle Bilder in den deutschen Museen (insgesamt 1052 Arbeiten) beschlagnahmt, ins Ausland verkauft oder verbrannt; er erhielt Malverbot. Dennoch hat Nolde in diesen dunklen Jahren in Seebüll einen Bilderkreis geschaffen, der wie eine Zusammenfassung und Krönung seines Werkes ist; es sind viele hundert kleine Aquarelle, die er seine "Ungemalten Bilder" nannte. 1956 ist Nolde im Alter von 89 Jahren in Seebüll gestorben. Er wurde in einer Gruft beigesetzt, die er während des Krieges für sich und seine Frau am Rande des Blumengartens in Seebüll gebaut hatte.

IV

Die Künstlergruppe "Brücke"

WOLF-DIETER DUBE

Es ist ein seltsames Phänomen: vier der bedeutendsten Maler, die die deutsche Kunst unseres Jahrhunderts bestimmt haben, leben immer noch als Gruppe stärker im Bewusstsein der Kunstwelt denn als einzelne Persönlichkeiten. Wird einer der Namen Ernst Ludwig Kirchner, Erich Heckel, Karl Schmidt-Rottluff oder Otto Mueller genannt, so stellt sich überwiegend zunächst die Assoziation "Künstlergruppe Brücke" ein. Das Bild der Gruppe schiebt sich vor die Vorstellung vom Individuum und fixiert den Blick auf eine nur kurze Zeitspanne im Leben und Werk dieser Künstler.

1913 hatten sich die vier noch verbliebenen Mitglieder der "Brücke" getrennt. Sicher war das eine Notwendigkeit gewesen, und jeder hatte versucht, je nach Temperament, diesen schmerzlichen Bruch mehr oder weniger radikal zu vollziehen. Gelungen ist das keinem. Heckel beschwor noch Jahrzehnte später in Bildnissen der Freunde das Ideal seiner Jugend, Schmidt-Rottluff stiftete ein halbes Jahrhundert danach das "Brücke"-Museum in Berlin, und selbst Kirchner, der 1919 in einem Brief an Gustav Schiefler, den beständigsten Förderer seiner Kunst, geschrieben hatte: "Da die Brücke für meine künstlerische Entwicklung nie in Frage kam, ist ihre Erwähnung in einem Aufsatz über meine Arbeit überflüssig," konnte sich nicht von dem grossen Erlebnis der Freundschaft lösen. 1926 begann er ein Bild mit dem Titel "Eine Künstlergruppe" zu malen, das sich heute im Museum Ludwig in Köln befindet. Da sitzt Otto Mueller vorn links ganz in sich gekehrt auf einem Hocker, still an seiner Pfeife ziehend. Hinter ihm steht links Kirchner, auf die Chronik der Künstlergruppe "Brücke"

weisend, die Anlass für die Auflösung der Gruppe gewesen war. Er blickt angespannt auf Schmidt-Rottluff, am rechten Bildrand stehend, der den Blick aushält, ohne jedoch zu antworten. Zwischen ihnen Heckel, frontal gegeben, der je nach Notwendigkeit sich vermittelnd zur einen oder anderen Seite wenden kann. Diese Spannung zwischen den Figuren, ihr Verhältnis zueinander, wie Kirchner es aus dem Abstand von 15 Jahren darstellt, bestand vom Tage der Gründung der Künstlergruppe "Brücke" an.

Künstlergemeinschaften gab es am Anfang unseres Jahrhunderts viele. Da waren jene, die als reine Ausstellungsgruppen entstanden, etwa die ganze Bewegung der Sezessionen, die wiederum in Neue und Freie Sezessionen auseinanderfielen. Da waren die Gruppen, die durch eine Ästhetik zusammengehalten wurden, wie etwa die Nabis. Und da gab es Gemeinschaften, die aus freundschaftlichen Beziehungen entstanden waren, wie die Fauves. Gerade wegen gewisser Gemeinsamkeiten kann der Vergleich mit den Fauves die Besonderheit der Künstlergruppe "Brücke" deutlich machen. Denn im Jahre 1905, als "Brücke" gegründet wurde, trat die Malergruppe um Matisse im Salon d'Automne hervor, was ihr bekanntlich den Namen les fauves eintrug. Allein Matisse war bereits 36 Jahre alt und nicht nur im Atelier Moreau ausgebildet, sondern auch schon ein erfahrener Maler. Anders in Dresden. Hier waren es vier Architekturstudenten, der Älteste 25 Jahre, die sich zu einer Gruppe zusammenschlossen. Keiner von ihnen konnte auf eine nennenswerte malerische Erfahrung oder Ausbildung verweisen, geschweige denn darauf, irgendwo künstlerisch an die Öffentlichkeit getreten zu sein. Am Anfang stand nicht ein künstlerischer Entwicklungsprozess, der notwendig zum Zusammenschluss führte. Am Beginn stand der Glaube an die eigene, unbewiesene Kraft. Es war der revolutionäre, zukunftsfrohe Impetus, der damals die Jugend Europas verband, der zur Triebfeder wurde. Das Ufer, an dem man stand, musste verlassen werden. Mit welchen Mitteln jedoch der Brückenschlag zur anderen Seite bewerkstelligt werden sollte, das wusste niemand zu sagen. Für die Gründer von "Brücke" galt die Überzeugung des gleichaltrigen Franz Kafka: "Es gibt nur ein Ziel. Das, was wir Weg nennen, ist Zögern." Daher enthält das 1906 von Kirchner verfasste und in Holz geschnittene Programm der "Brücke" auch keine ästhetische Maxime. "Mit dem Glauben an Entwicklung an eine neue Generation der Schaffenden wie der Geniessenden, rufen wir alle Jugend zusammen und als Jugend, die die Zukunft trägt, wollen wir uns Arm— und Lebensfreiheit verschaffen gegenüber den wohlangesessenen älteren Kräften. Jeder gehört zu uns, der unmittelbar und unverfälscht das wiedergibt, was ihm zum Schaffen drängt."

Die Basisgruppe bildeten Ernst Ludwig Kirchner, Fritz Bleyl, Erich Heckel und Karl Schmidt-Rottluff. Kirchner, 1880 in Aschaffenburg als Sohn eines Papierchemikers geboren, hatte seit 1890 in Chemnitz in Sachsen die Schule besucht. Seit 1901 studierte er in Dresden an der Technischen Hochschule Architektur und legte 1905 sein Examen ab. Schon in den letzten Jahren in Chemnitz hatte Kirchner privaten Zeichenunterricht erhalten, und später erinnerte er sich dankbar seines englischen Aquarellehrers. Die Wahl des Architekturstudiums erfolgte wohl mehr mit

Rücksicht auf die Familie, als aus eigenem Entschluss des 21-jährigen, in dem fest "der Traum der Malerei" sass. 1903/04 besuchte er in München die Kunstschule von Wilhelm von Debschitz und Hermann Obrist, wo er Komposition und Aktzeichnen studierte. 1901 war er in Dresden Fritz Bleyl begegnet, gleich ihm 1880 geboren und Student der Architektur wie er. Gemeinsam unternahmen sie zeichnerische und malerische Versuche. Bleyl blieb bis 1909 Mitglied von "Brücke," bis er gezwungen war, sich ganz seinem Beruf als Architekt zu widmen.

1901 waren sich in Chemnitz als Schüler der 1883 in Döbeln (Sachsen) geborene Erich Heckel und der ein Jahr jüngere Chemnitzer Karl Schmidt-Rottluff begegnet. Sie hatten sich in einem Literaturzirkel getroffen. Neben der Neigung zur Literatur entdeckten sie schnell die gemeinsame Liebe zur Malerei und begannen miteinander zu zeichnen und zu malen. Für Heckel bedeutete Literatur und Malerei zunächst gleich viel, so dass er lange unentschieden war, ob er Dichter oder Maler werden sollte. 1904 ging Heckel nach Dresden, um dort Architektur zu studieren. Bald schon lernte er durch seinen älteren Bruder Kirchner und Bleyl kennen. 1905 gab er das Studium nach drei Semestern jedoch wieder auf, um sich ganz der Malerei zu widmen, wenngleich er zunächst auch noch des Gelderwerbs wegen als Zeichner in einem Architekturbüro arbeitete. 1905 kam endlich auch Karl Schmidt-Rottluff nach Dresden, um ebenfalls Architektur zu studieren, was indessen nur zwei Semester währte.

Entsprechend dem im "Brücke"-Programm ausgesprochenen Ziel einer Sammlung aller im Wollen Gleichstrebenden, konnte und sollte sich die Gruppe nicht auf die vier durch persönliche Freundschaft verbundenen Maler beschränken. Als 1906 Emil Nolde in der Galerie Arnold in Dresden ausstellte, erging alsbald die Aufforderung an den wesentlich älteren, der Gruppe beizutreten. Schmidt-Rottluff verfasste den Brief: "Dass ich gleich mit der Sprache herausrücke—die hiesige Künstlergruppe Brücke würde es sich zur hohen Ehre anrechnen, Sie als Mitglied begrüssen zu können. Freilich—Sie werden ebensowenig von der Brücke wissen, als wir vor Ihrer Ausstellung bei Arnold von Ihnen wussten. Nun, eine von den Bestrebungen der Brücke ist, alle revolutionären und gärenden Elemente an sich zu ziehen—das besagt der Name Brücke. Die Gruppe besorgt ausserdem jährlich mehrere Ausstellungen, die sie in Deutschland tournieren lässt, so dass damit der einzelne der Geschäfte enthoben wird. Ein weiteres Ziel ist die Schaffung eines eigenen Ausstellungsraumes—vorläufig ideal, denn es fehlt noch das Geld.—Nun, geehrter Herr Nolde, denken Sie wie und was Sie wollen, wir haben Ihnen hiermit den Zoll für Ihre Farbenstürme entrichten wollen. Ergebenst und huldigend die K. G. Brücke." Für eineinhalb Jahre wurde Nolde Mitglied.

Im Sommer 1906 trafen sich Max Pechstein und Erich Heckel. Pechstein, 1881 in Zwickau in Sachsen geboren, hat zunächst eine Lehre als Dekorationsmaler absolviert und war 1900 in die Kunstgewerbeschule in Dresden eingetreten. Von 1902 bis 1906 vollendete er seine Ausbildung als Meisterschüler an der Dresdner Akademie, die ihn mit dem Sächsischen Staatspreis, dem "Rompreis," auszeichnete. Dieses Studium gab Pechstein sicher zunächst einen

gewissen Vorsprung, auch sein weniger aggressives Temperament verschaffte ihm Vorteil, so dass er später als erster Anerkennung fand.

1906 trat auch der Schweizer Cuno Amiet und 1907 der Finne Axel Gallén-Kallela für einige Zeit der "Brücke" bei. Die Kontakte zu ihnen, die etwa gleich alt wie Nolde waren, entstanden über Ausstellungen und ihre Mitwirkung beschränkte sich ebenfalls auf die Beteiligung an den "Brücke"-Ausstellungen.

1908 stiess vorübergehend der Hamburger Franz Nölken, geboren 1884, zur "Brücke," wandte sich aber bald nach Paris, um bei Matisse zu studieren. Als 1910 die Einsendungen von Nolde, Pechstein, Otto Mueller und anderen zur Ausstellung der "Berliner Sezession" abgelehnt wurden, gründeten sie die "Neue Sezession," in deren Vorstand Pechstein berufen wurde, und stellten zusammen mit den "Brücke"-Malern aus. Heckel erinnerte sich später: "Die erste Begegnung mit Otto Muellers Bildern geschah in Berlin, in der Ausstellung der 'Zurückgewiesenen der Berliner Sezession' im Frühjahr 1910, die in der Galerie Macht stattfand, mit ihm selbst noch am gleichen Tag in seinem Atelier in der Mommsenstrasse. Für jeden von uns war sie bedeutsam und im fruchtbaren Moment, und es war selbstverständlich, dass er von nun an zur Gemeinschaft der 'Brücke' gehörte." Otto Mueller war sechs Jahre älter als Kirchner. 1874 in Liebau in Schlesien geboren, absolvierte er seit 1891 eine Lithographenlehre und besuchte ab 1894 die Akademie in Dresden. Gemeinsame Reisen mit seinem Vetter, dem Dichter Gerhart Hauptmann, führten ihn nach Italien und in die Schweiz. 1898/99 besuchte er die Akademie in München, kehrte dann nach Dresden zurück und übersiedelte 1908, im selben Jahr wie Pechstein, nach Berlin. Schliesslich trat 1911 noch der Prager Bohumil Kubišta der "Brücke" bei, ohne dass es jedoch zu einem intensiven Kontakt gekommen wäre.

Wenn auch die eigentliche künstlerische Aktivität die "Brücke" zu dem werden liess, was wir in der historischen Rückschau erkennen, im wesentlichen auf die Mitglieder beschränkt war, die sich in der ständigen gemeinsamen Arbeit steigerten, so ist doch der Versuch bemerkenswert, ausländische Künstler in die Gruppe mit einzubeziehen. So wurde 1908 auch Kees van Dongen aufgefordert, bei "Brücke" auszustellen. Die Sammlung progressiver Kräfte wurde in jedem Fall über den künstlerischen Weg des Einzelnen gestellt.

Wenn man heute das Programm der "Brücke," diesen knappen Aufruf liest, so kann man sich kaum dem Urteil der bisherigen Kunstkritik anschliessen, diese Erklärung sei reichlich allgemein gehalten und besage nicht viel. Wie die "Brücke" selbst sich als strenge Kampfgemeinschaft von anderen Künstlervereinigungen unterschied, so unterschied sich ihr Aufruf wesentlich von deren Manifesten. Hier, in Dresden 1906, wurde erstmals der Betrachter, der Konsument, gleichberechtigt neben den Künstler in die Überlegung einbezogen. Der Glaube richtete sich in gleicher Weise an die "neue Generation der Schaffenden wie der Geniessenden." Es kam also nicht nur darauf an, auf seiten der Künstler Zellen zu bilden, sondern zugleich durch Zellenbildung auf seiten des Publikums dessen Bewusstsein zu verändern. "Brücke" forderte daher zur sogenannten passi-

ven Mitgliedschaft auf. Gegen einen Jahresbeitrag von 12,— Mark erhielten die "passiven Mitglieder," die zum Teil eine sehr beachtliche Aktivität zur Förderung des Verständnisses neuer Kunst entfalteten, jährlich einen Tätigkeitsbericht und eine Graphikmappe, die später so berühmten und gesuchten "Brücke-Mappen." 68 Mitglieder wurden auf diese Weise geworben. Damit war auch die Idee, durch Vervielfältigung des Kunstwerkes ein breiteres Publikum zu erreichen, als Möglichkeit im Kreis der "Brücke" gesehen worden. Allerdings benutzen die Einzelnen sehr verschieden diesen Weg. Erich Heckel war solchen Ideen am weitesten offen, daher versah er auch das Amt des Geschäftsführers der Gruppe. Für ihn bedeutete die Druckgraphik immer ein Mittel, in die Breite zu wirken, so dass von zahlreichen seiner Holzschnitte sehr hohe Auflagen gedruckt wurden. Bei Kirchner dagegen, der seine Blätter mit wenigen Ausnahmen selbst abzog, zeigt jeder Druck einen individuellen Charakter. An einer grossen Verbreitung war er weniger interessiert, ähnlich wie Schmidt-Rottluff, der von ihm nicht signierte Drucke nie anerkannte. Dass auf diese Weise vorwiegend—und darin hat sich die Situation bis heute kaum verändert—nur solche Menschen erreicht wurden, die bereits interessiert oder bekehrt waren, spricht nicht gegen die Richtigkeit des Ansatzes.

Aus dem gemeinsamen Zeichnen und Malen der jungen Studenten entwickelte sich ganz zwangsläufig die Notwendigkeit zu immer intensiverer Arbeit. Die Gründung einer Künstlergruppe bedeutete daher für sie keine Veränderung, sondern war lediglich die äussere Dokumentation der bereits praktizierten Lebensform. Kirchner notierte 1923 in sein Tagebuch: "Es war ein glücklicher Zufall, dass sich die wirklichen Talente trafen, deren Charakter und Begabung auch in menschlicher Beziehung ihnen gar keine andere Wahl liess als den Beruf des Künstlers, deren für den regulären Menschen zum mindesten seltsame Lebensführung, Wohnung und Arbeit kein bewusstes Epater les Bourgeois war, sondern das ganz naive reine Müssen, Kunst und Leben in Harmonie zu bringen. Und gerade dieses ist es, was mehr als alles andere einen ungeheuren Einfluss gehabt hat auf die Formen heutiger Kunst. Allerdings meist unverstanden und total verzerrt, denn dort bildete (der Wille) die Form und gab ihr Sinn, während hier die fremde Form auf Gewohnheit aufgepfropft wird, wie der Kuh der Cylinder.

Der Weg der Entwicklung in diesen Dingen des äusseren Lebens, von der ersten applizierten Decke im ersten Dresdner Atelierzimmer bis zum vollendeten harmonischen Raum in den Berliner Ateliers der einzelnen, ist eine ununterbrochene logische Steigerung, die Hand in Hand ging mit der malerischen Entwicklung der Bilder und Grafik und Plastik. Die erste Schale, die geschnitzt wurde, weil man keine einem gefallende zu kaufen bekam, brachte die plastische Form in die flächige Form des Bildes und so wurde die persönliche Form durch die verschiedenen Techniken durchgeknetet bis zum letzten Strich. Die Liebe, die der Maler dem Mädchen entgegenbrachte, die sein Gefährte und Helfer war, ging über auf die geschnitzte Figur, veredelte sich (über) die Umgebung (in) das Bild und vermittelte wiederum die besondere Stuhl- oder Tischform aus der Lebensgewohnheit des menschlichen Vorbildes. Das war der Weg des Kunstschaffens am einfachen Beispiel. Das ist die Kunstanschauung der 'Brücke.'

Diese restlose Hingabe leuchtete im Auge Erich Heckels als er zum ersten Mal zu mir Aktzeichnen kam und die Treppe emporstieg laut aus Zarathustra deklamierend, und (einige) Monate (später) sah ich dasselbe Leuchten in den Augen S-R's, als dieser zu uns kam, Befreiung suchte so wie ich in freier Arbeit, und das erste für die Maler war das freie Zeichnen nach dem freien Menschen in freier Natürlichkeit. Es begann aus Gelegenheitsrücksicht bei Kirchner. Es wurde gezeichnet und gemalt. 100e von Blättern am Tage, dazwischen Rede und Spiel, die Maler wurden mit zu Modellen und umgekehrt. Alle Begegnungen des täglichen Lebens wurden so dem Gedächtnis einverleibt. Das Atelier wurde eine Heimstatt den Menschen die gezeichnet wurden: Sie lernten von den Malern, die Maler von ihnen. Unmittelbar und reichhaltig nahmen die Bilder das Leben auf."

Kunst und Leben in sinnliche Harmonie zu bringen, war das Ziel dieser jungen Bürgersöhne. Das schien ihnen ein Weg zu sein, aus der Beliebigkeit und Unverbindlichkeit der Kunst ihrer Väter herauszufinden. Aus einer impressionistischen Kunstübung, die die bürgerliche Gesellschaft, die bürgerliche Herrschaft repräsentierte: "Impressionismus, das ist der Abfall des Menschen vom Geiste, Impressionist ist der zum Grammophon der äusseren Welt erniedrigte Mensch," schrieb Hermann Bahr 1920. Es ging in der Auseinandersetzung aber nicht um formal-künstlerische Probleme. Franz Marc wies im Almanach "Der Blaue Reiter" 1912 auf diesen Punkt: "Es ist unmöglich, die letzten Werke dieser Wilden (gemeint sind die in München und Berlin arbeitenden Künstler des 'Blauen Reiter' und der Künstlergruppe 'Brücke') aus einer formalen Entwicklung und Umdeutung des Impressionismus heraus erklären zu wollen. Die schönsten prismatischen Farben und der berühmte Kubismus sind als Ziel dieser Wilden bedeutungslos geworden. Ihr Denken hat ein anderes Ziel: durch ihre Arbeit, ihrer Zeit Symbole zu schaffen, die auf die Altäre der kommenden geistigen Religionen gehören und hinter denen der technische Erzeuger verschwindet."

Der Antagonismus von bürgerlicher Gesellschaft und kritischem Geist der Jugend prägte die Kunst des Expressionismus. Die Expressionisten und unter ihnen die Mitglieder der Künstlergruppe "Brücke" begriffen die bürgerliche Gesellschaft als eine Wirtschaftsgesellschaft, die vom kapitalistischen Grossbürgertum bestimmt ist, das sich mit dem Adel die Macht teilt. Als die stärksten Triebkräfte dieser Gesellschaft wurden platter Materialismus und schamloser Egoismus erkannt. Materialismus und Egoismus tragen das geschlossene ökonomische System, das Otto Flake in dem Roman "Die Stadt des Hirns" beschreibt: "Heilig war daran wohl die Frohn, der Zwang, die Last, das Muss, das also, was nicht freiwillig war und den Menschen abhielt, zu sich zu finden. Die Arbeit selbst, das System, das mit eisernen Armen in seine Mühlen zog, der Wunsch nach Geld, Verdienst und Macht, der Ehrgeiz, die Befriedigung, das war Lüge, Sklaverei, Ausnutzung der egoistischen Instinkte, Lieblosigkeit aller gegen alle." Das ist das Gegenprinzip zu Zukunft und Ekstase, dem die Jugend verpflichtet sein musste. Um sich Arm- und Lebensfreiheit zu verschaffen,

liessen sich die jungen Maler in einem Arbeiterviertel in Dresden nieder. Der Umgang mit den dort lebenden, scheinbar unverbildeten Menschen sollte nicht nur äusserlich den Bruch mit dem eigenen Herkommen dokumentieren. Vielmehr erhofften sich Kirchner und seine Freunde, einer ursprünglichen Empfindung näher zu sein. Sie hofften, an Ursprünge zu gelangen, aus denen ein neuer Mensch erwachsen könnte, den Nietzsche ihnen als Ziel gewiesen hat. Als glühende Verehrer Friedrich Nietzsches fanden sie ihren Glauben, ihre Sehnsucht und Zuversicht im "Zarathustra" bestätigt, aus dessen vierter Vorrede wohl der Name ihrer Gemeinschaft genommen wurde. Dort heisst es:

Der Mensch ist ein Seil, geknüpft zwischen Tier und Übermensch—ein Seil über einem Abgrunde.

Ein gefährliches Hinüber, ein gefährliches Auf-dem-Wege, ein gefährliches Zurückbleiben, ein gefährliches Schaudern und Stehenbleiben. Was gross ist am Menschen, das ist, dass er eine Brücke und kein Zweck ist: was geliebt werden kann am Menschen, das ist, dass er ein Übergang und ein Untergang ist.

Ich liebe Die, welche nicht zu leben wissen, es sei denn als Untergehende, denn es sind die Hinübergehenden.

Ich liebe die grossen Verachtenden, weil es die grossen Verehrenden sind und Pfeile der Sehnsucht nach dem anderen Ufer.

Ich liebe Die, welche nicht erst hinter den Sternen einen Grund suchen, unterzugehen und Opfer zu sein, sondern die sich der Erde opfern, dass die Erde einst des Übermenschen werde.

Von daher wird auch verständlich, dass das Vorbild van Goghs ausserordentlich stark auf Kirchner, Heckel und Schmidt-Rottluff wirken musste. War doch van Goghs Ausgangspunkt, wie auch ihrer, nicht künstlerisches Kalkül, sondern existenzielle Notwendigkeit. Die Malerei war für van Gogh die einzige Möglichkeit, seine ekstatische Liebe zu den Menschen und zu den Dingen auszudrücken. Ihnen setzte er sich unmittelbar aus. Er verfügte sich einfühlend in die Dinge hinein, um den Abglanz der äusseren Welt zu durchdringen und eine andere, in gespanntester Erregung erfahrene Wirklichkeit mitteilen zu können. Diese Mitteilung geschieht durch den gesteigerten Klang der lodernden Farben, durch eine dynamischzüngelnde Pinselschrift, in deren spontanen Strichen sich der psychische Zustand des Künstlers direkt wiederspiegelt. Der Zwang, sich ungeschützt an die Welt ausliefern zu müssen, um ihre Wahrheit erfahren zu können, verzehrte in wenigen Jahren die Kräfte des Künstlers. Sein Weg, Kunst als Antwort auf existenzielle Not zu schaffen und sein Leben hinzugeben, als die Spannung nicht mehr zu ertragen war, wirkte als vorbildliches und beispielhaft tragisches Schicksal, das sich schliesslich auch an Kirchner erfüllen sollte.

In Dresden in der Berliner Strasse, hatte Heckel einen Metzgerladen als Atelier gemietet. Hier wurde mit besessenem Fleiss und höchster Intensität gearbeitet. Den Ausgangspunkt bildeten der Neoimpressionismus und van Gogh, dessen Werke 1905 und 1906 in Dresden gezeigt worden waren. Von Anfang an wurde der Holzschnitt geübt, der als Mittel der Formklärung grosse Bedeutung erhielt. Denn der Holzschnitt verlangt die strenge und knappe Formung des Bildgedankens wie keine andere Technik. Kirchner hat die Bedeutung der Graphik so beschrieben: "Der Wille, der den Künstler zur graphischen Arbeit treibt, ist vielleicht zu einem Teil das Bestreben, die einmalige lose Form der Zeichnung fest und endgültig auszuprägen. Die technischen Manipulationen machen andererseits im Künstler Kräfte frei, die bei der viel leichteren Handhabung des Zeichnens und Malens nicht zur Geltung kommen. Der mechanische Prozess des Druckens fasst die einzelnen Arbeitsphasen zu einer Einheit zusammen, die Formungsarbeit kann ohne Gefahr solange ausgedehnt werden als man will. Es hat einen grossen Reiz, in wochen-, ja monatelanger Arbeit immer und immer wieder überarbeitend, das Letzte an Ausdruck und Formvollendung zu erreichen, ohne dass die Platte an Frische verliert. Der geheimnisvolle Reiz, der im Mittelalter die Erfindung des Druckens umfloss, wird auch heute noch von jedem verspürt, der sich ernsthaft und bis in die Details des Handwerks mit Graphik beschäftigt. Es gibt keine grössere Freude als die, die Druckwalze das erste Mal über den eben fertig geschnittenen Holzstock fahren zu sehen, oder die lithographische Platte mit Salpetersäure und Gummiarabikum zu ätzen und zu beobachten, ob die erstrebte Wirkung einsetzt, oder an den Zustandsdrucken das Ausreifen der endgültigen Fassung eines Blattes zu prüfen. Wie interessant ist es, graphische Blätter bis in die kleinsten Details abzutasten, Blatt um Blatt, ohne dass man die Stunden rinnen fühlt. Nirgends lernt man einen Künstler besser kennen als in seiner Graphik."

Die Themen dieser ersten Zeit sind aus der alltäglichen Umgebung genommen: Landschaften, Strassenansichten, Porträts und Akte. Im Holzschnitt ist dabei das Vorbild Vallotons und des Jugendstils durchaus deutlich. Die Gleichrangigkeit der Bewertung von Malerei und Graphik zeigt sich darin, dass im Herbst 1906 in Dresden die beiden ersten "Brücke"-Ausstellungen veranstaltet wurden, die eine mit Malerei, die andere mit Holzschnitten.

Durch Emil Nolde, der nach seinem Beitritt zur "Brücke" im Winter 1906/07 für einige Zeit in Dresden lebte, lernten die jungen Maler dessen Technik der Radierung kennen. Deren neuartige Besonderheit lag darin, dass die einzelnen Partien der Platte mehr oder weniger beim Ätzen abgedeckt waren, so dass sich nuancenreiche, flächige Helldunkelwirkungen erzielen liessen. Nolde seinerseits übernahm für sich die Holzschnitt-Technik der "Brücke." 1907 wurde die Lithographie aufgenommen, in dem Augenblick, als die formale Entwicklung malerische, bildhafte Lösungen verlangte.

Die gemeinsame Arbeit der Freunde wurde dadurch gefördert, dass sie sich in der Regel in den Sommermonaten trennten, um dann die einzeln gewonnenen Erfahrungen unter gegenseitiger Kontrolle zu verarbeiten. Den Herbst 1906 hatte Schmidt-Rottluff in Alsen bei Nolde verbracht, während Kirchner und Pechstein in Goppeln bei Dresden arbeiteten. 1907 reiste Pechstein nach Italien und Paris, Heckel und Schmidt-Rottluff malten, wie auch in den folgenden Jahren, zusammen in Dangast (Oldenburg) an der Nordsee. 1908 übersiedelte Pechstein nach Berlin, und Kirchner weilte zum ersten Male auf der Ostsee-Insel Fehmarn. 1909 ging Heckel nach Italien, anschliessend mit Kirchner zum Aktstudium an die Moritzburger Seen bei

Dresden. Pechstein entdeckte an der Ostsee Nidden in Ostpreussen. Den Sommer 1910 verbrachten Heckel, Kirchner und Pechstein an den Moritzburger Seen. Heckel und Pechstein gingen anschliessend zu Schmidt-Rottluff nach Dangast. 1911 reiste Schmidt-Rottluff von Dangast aus nach Norwegen, Heckel malte in Prerow an der Ostsee und anschliessend mit Kirchner in Moritzburg. Pechstein hielt sich in Italien und in Nidden auf, während Kirchner und Mueller nach Böhmen reisten. Und 1912 schliesslich war Schmidt-Rottluff in Dangast, Kirchner auf Fehmarn, Heckel auf Rügen und anschliessend bei Kirchner auf Fehmarn.

An den Sommer 1910 erinnerte sich Pechstein: "Als wir in Berlin beisammen waren, vereinbarte ich mit Heckel und Kirchner, dass wir zu dritt an den Seen um Moritzburg nahe Dresden arbeiten wollten. Die Landschaft kannten wir schon längst, und wir wussten, dass dort die Möglichkeit bestand, unbehelligt in freier Natur Akt zu malen. Als ich in Dresden ankam und in dem alten Laden in der Friedrichstadt abstieg, erörterten wir die Verwirklichung unseres Planes. Wir mussten zwei oder drei Menschen finden, die keine Berufsmodelle waren und uns daher Bewegungen ohne Atelierdressur verbürgten. Ich erinnerte mich an meinen alten Freund, den Hauswart in der Akademie—ich weiss nun wieder, dass er Rasch hiess—, und er hatte sogleich nicht bloss einen guten Rat, sondern auch jemanden an der Hand und wurde so unser Nothelfer. Er wies uns an die Frau eines verstorbenen Artisten und ihre beiden Töchter. Ich legte ihr unser ernstes künstlerisches Wollen dar. Sie besuchte uns in unserem Laden in der Friedrichstadt, und da sie dort ein ihr vertrautes Milieu vorfand, war sie damit einverstanden, dass ihre Töchter sich mit uns nach Moritzburg aufmachten.

Wir hatten Glück auch mit dem Wetter: kein verregneter Tag. Zwischendurch fand manchmal in Moritzburg ein Pferdemarkt statt. Ich habe das Gedränge um die glänzenden Tierleiber in einem Bild und in zahlreichen Studien festgehalten. Sonst zogen wir Malersleute frühmorgens mit unseren Geräten schwer bepackt los, hinter uns die Modelle mit Taschen voller Fressalien und Getränke. Wir lebten in absoluter Harmonie, arbeiteten und badeten. Fehlte als Gegenpol ein männliches Modell, so sprang einer von uns dreien in die Bresche. Hin und wieder erschien die Mutter, um als ängstliches Huhn sich zu überzeugen, dass ihren auf dem Teich des Lebens schwimmenden Entenküken nichts Böses widerfahren sei. Beschwichtigten Gemüts und von Achtung vor unserer Arbeit durchdrungen, kehrte sie immer nach Dresden zurück. Bei jedem von uns entstanden viele Skizzen, Zeichnungen und Bilder."

In zahllosen Skizzen wurden die Eindrücke festgehalten, rasch auf den Zeichenblock geschrieben oder mit der "kalten Nadel" in die Metallplatte gerissen. Hier hatte auch das Aquarell seinen wichtigen Platz, das bald mit grosser Meisterschaft beherrscht wurde. Auf die Spontaneität des Ausdrucks kam es an, der aus einer natürlichen, wie zufälligen Haltung zu ziehen war. Daher hatte man sich von Anfang an beim Aktzeichnen geübt, die Modelle in schnell wechselnden Stellungen zu erfassen. Durch die anschliessende Umsetzung in Malerei oder Holzschnitt im Atelier blieben Mass und künstlerische Ordnung jedoch immer erhalten.

Thematisch stehen im Mittelpunkt des Schaffens der ersten Jahre der Künstlergruppe "Brücke" der nackte Mensch und die Landschaft. Dabei dient die intensive Auseinandersetzung mit dem Akt, vor allem mit dem Akt in schneller Bewegung, zur Formfindung. Die Landschaft dagegen ist das Motiv, das Empfindungen und Gefühle evoziert. Das heisst, die vom Motiv ausgelöste Empfindung setzt sich in Farbe um. Der Gefühlswert der Farbe bildet den Ausgangspunkt für die Malerei. Erst werden farbige Flächen gesetzt, aus denen Gegenstandsformen allmählich im Laufe der Arbeit herausgestaltet werden. Es entsteht der farbige Flächenstil, der von allen Mitgliedern der Künstlergruppe "Brücke" ab 1910 geübt wird. Akt und Landschaft fügen sich zu einem Motiv zusammen. Nackte Menschen in der freien Natur werden zum Ausdruck ursprünglichen und zuständlichen Seins, bedeutet eine Möglichkeit der Überwindung gesellschaftlicher Zwänge. Der Mensch wird als Teil der Natur empfunden, ordnet sich ein, ist ihr zugehörig. Dies auch im Sinne der Befreiung des Eros, der Befreiung des Körperlichen aus der Enge der verlogenen bürgerlichen Moralbegriffe. Dafür einige Beispiele: 1910 an den Moritzburger Seen bei Dresden entstand Kirchners Bild "Spielende nackte Menschen unter Baum." Aus spontan aufgetragenen Farben entsteht eine vor allem von Grün bestimmte dekorative Flächenharmonie, deren intensive Färbung und wie skizzenhafte Pinselführung eine vibrierende und expressive Unmittelbarkeit mitteilt. Die dramatische Form des grossen Baumes wird von der Bewegung der Figuren aufgenommen. Diese sind farbig in den Ausdruck des Bildes integriert, einerseits die Farbigkeit des Bildes wiederholend, andererseits sie komplementär steigernd. Diese existenzielle Einheit im Natürlichen komprimiert sich schliesslich bei Schmidt-Rottluff 1913 zu wenigen wesenhaften Abkürzungen und Bedeutungszeichen, wie in dem Gemälde "Sommer." Zwei weibliche Figuren stehen innerhalb einer Landschaft, die mit sparsamsten Mitteln, einigen Gebüschzacken und Dünenkurven zeichenhaft angelegt ist. Zwischen diese Linien sind grosse Farbflächen eingeschoben. Mensch und Natur verschmelzen in leuchtendem Rot. Die monumentale Strenge dieser Kunst zielt auf das Sinnbild, will nicht über das Gefühl Seelenzustände sichtbar machen, sondern Grundwahrheiten darstellen. Dieses Streben gilt für Kirchner genauso wie für Heckel, der ebenfalls 1913 das Gemälde "Gläserner Tag" gemalt hat. Auch hier wird die Ordnung der Dinge und ihre gleichwertige Spannung untereinander gesucht. Die bewusst eckige, wie ungelenke Struktur, die in grossen Holzschnitten ihren Ursprung hat, ermöglicht eine eigentümliche Darstellung des Lichtes. Spiegelungen, Brechungen und Reflexe werden in kristallinische Formen verwandelt. Himmel, Erde, Wasser und Mensch sind mit Hilfe der sichtbaren Atmosphäre zu einer Einheit verschmolzen.

Neben diesem Thema wird häufig das Erlebnis vom Zirkus und Varieté als Ausdruck gesteigerten Lebens gestaltet. Diese Steigerung wird wie die Natürlichkeit als Möglichkeit zur Überwindung verkrusteter bürgerlicher Verhaltensweisen empfunden, sind Wege zum "neuen Menschen." Um dies ganz deutlich zu machen, trat das Individuelle hinter dem Allgemeinen zurück. Die Bildtitel vermeiden selbst dort, etwa bei Porträts, wo das Persönliche zu benennen ist, diesen Hinweis und bezeichnen das Zuständliche.

In Ausstellungen, die zum Teil durch Deutschland und

die Schweiz wanderten, wurden die Ergebnisse vorgelegt. Die Beteiligung an Ausstellungen der Neuen Sezession in Berlin brachte vielfältige Kontakte, darunter auch zur Neuen Künstlervereinigung München um Kandinsky. Die grössere, konzentrierte Wirksamkeit der neuen Kunst und die besseren wirtschaftlichen Möglichkeiten in Berlin liessen 1911 die Mitglieder der "Brücke" nach dort übersiedeln.

Wenn auch "Brücke" weiterhin als Gruppe auftrat, so hatte die sechsjährige gemeinsame Arbeit die künstlerischen Persönlichkeiten so ausgeprägt, dass jeder von ihnen immer mehr seinen eigenen Weg zu gehen begann. Wie sicher man jetzt seiner künstlerischen Mittel war, dokumentiert sich auch darin, dass Kirchner und Pechstein das MUIM-Institut (Moderner Unterricht im Malen) gründeten, eine Schule, die jedoch keinen Erfolg hatte. Die sichtbarste Bestätigung des Erreichten bildete schliesslich 1912 die Sonderbund-Ausstellung in Köln, wo die zeitgenössische deutsche und französische Kunst nebeneinander gezeigt wurde. Heckel und Kirchner hatten den Auftrag erhalten, auf der Ausstellung eine Kapelle auszumalen—ein aufsehenerregendes Ereignis.

Als die Gruppe beschloss, aus der Neuen Sezession auszutreten, Pechstein sich diesem Beschluss aber nicht fügen wollte, wurde er aus der Gruppe ausgeschlossen. Der Plan, durch die Herausgabe der Chronik der Künstlergruppe "Brücke," das Gemeinsame noch einmal zu betonen, führte nicht zum Erfolg. Kirchners Text wurde wegen seiner subjektiven Interpretation von den Freunden abgelehnt. Was als gemeinsames Bekenntnis gedacht war, gab 1913 den Anlass zum endgültigen Bruch. Die eigentlichen Ursachen lagen jedoch tiefer. So sehr sich die Künstler mühten, so sehr sie sich den zukunftsfrohen Impetus zu erhalten versuchten, so mussten sie doch erkennen, dass sie wenig gegen die Leiden der Welt vermochten. Sie sahen wohl, dass man sich einerseits wie in Paris auf das Problem der formalen Erfassung der Welt mit Hilfe des Kubismus konzentrierte. Sie sahen, wie andererseits in München die ursprüngliche Forderung des "Blauen Reiter" nach einer Synthese aus Erlebnissen der äusseren Welt mit den Erlebnissen der inneren Welt des Künstlers abgewandelt wurde in die schliesslich subjektive Darstellung individueller Empfindungen und Gefühle. Sie sahen, wie die Futuristen bereits in ihrem ersten Manifest 1909 in der Gewalt das Heil suchten, wo Marineti erklärte: "Wir wollen den Krieg preisen—diese einzige Hygiene der Welt—den Militarismus, den Patriotismus, die zerstörende Geste der Anarchisten, die schönen Gedanken, die töten und die Verachtung des Weibes."

Auf dieses veränderte Bewusstsein konnten die Maler der "Brücke" nicht mehr als Gruppe antworten. Jetzt erwies sich, wie verschieden die unterschiedlichen Temperamente reagieren mussten. Denn ob Leiden sozial bedingt ist, ob sie ihre Ursache im gesellschaftlichen System haben, oder ob sie persönlichem Schicksal oder Krankheit entspringen, in jedem Fall werden sie vom einzelnen Menschen erlitten. Und der Einzelne muss reagieren. Besonders bei Erich Heckel wird nun deutlich, dass er nichts ohne persönliche Anteilnahme tun kann. Bei ihm haben die Motive am deutlichsten persönlichen Bezug. Ab 1912 häufen sich bei Heckel Themen wie leidende Frau, die Tote, Kranke, sterbender Piérot, "Irre beim Essen" und so fort. Selbst die

Welt der Artisten gewinnt nun den Aspekt der tragischen Erscheinung des Menschen. Schwermut tritt an die Stelle der erlösenden Heiterkeit. Hier wird viel von dem vorweg genommen, was Heckel nach Ausbruch des Ersten Weltkrieges gestalten wird. Er übernimmt 1915 den Dienst eines Krankenpflegers in Flandern. Zu den vertrauten Motiven treten nun die Bilder der Verwundeten, der Genesenden und Sterbenden.

Auch Karl Schmidt-Rottluff, der das Figurenbild bis dahin nur selten geübt hatte, wendet sich nun unter dem Eindruck des drohenden Unheils einem neuen Thema zu: bekleidete Frauen am Meer. Voll stummen Ernstes und voll Trauer sind die wortlosen Unterhaltungen von zwei Frauen wie in dem Holzschnitt "Trauernde am Strand" von 1914. Diese Gestalten mit übergrossen Köpfen und kleinen ausdrucksvoll verkrampften Händen bewegen sich wie in einem Traumland. Jetzt zeigen die Figuren Schmidt-Rottluffs zum ersten Male seelische Bedrängnis und menschliche Nähe, die nicht von der sie umgebenden Natur aufgenommen werden. Im Gegenteil, die nun differenzierter gegebene Landschaft betont die ungelöste Spannung. Die Farben, vorherrschend Ocker, rötliches Braun und dunkles Grün, unterstreichen den melancholischen Charakter dieser Bilder. Die zuständliche Einheit von Natur und Mensch ist zerbrochen, der Mensch der Natur entfremdet. Folgerichtig entstehen bis zur Einberufung zum Kriegsdienst 1915 Einzelfiguren, Porträts oder das ganze Bildfeld füllende Akte. Die Notwendigkeit, Psychisches allein durch die Ausdruckskraft von Linie und Farbe zu geben, liess ihn auf die früher in Dresden entdeckten Skulpturen Afrikas und der Südsee zurückgreifen, deren formale Raffung einerseits und plastische Isolierung andererseits er direkt übernimmt.

Am heftigsten aber reagiert Ernst Ludwig Kirchner. Er findet sein neues Thema in der Hektik und Unnatur der modernen Grossstadt. Er gestaltet als einziger das hilflose Getrieben-Sein, die Verlassenheit des entfremdeten Menschen, der er selbst ist. 1913/14 entstehen die berühmten Berliner Strassenszenen. Die die nächtlichen Strassen belebenden Kokotten werden ihm zum Sinnbild des Ausgeliefert-Seins, zum Sinnbild einer haltlos schwankenden Existenz. In dem grossen Gemälde "Potsdamer Platz Berlin," entstanden 1914, betont Kirchner die Isolierung, die Lieblosigkeit aller gegen alle, indem er die beherrschenden Figuren der beiden Frauen auf eine Verkehrsinsel stellt. Der nervös-gefächerte Pinselstrich teilt die Unruhe, die Gefährdung des Künstlers mit. Die psychische Bedrängnis steigert sich zur zerstörerischen Krise, als Kirchner zum Militärdienst einberufen wird. Bereits nach einem halben Jahr wieder entlassen, bleibt ihm die panische Angst, durch das Tragen der Uniform das eigene Ich verloren zu haben. Aus diesem Gefühl entsteht 1915 der Holzschnittzyklus "Peter Schlemihls wundersame Geschichte" nach Adalbert von Chamisso. In die Form dieser fantastischen Erzählung der Romantik kleidet Kirchner das ihn erschütternde Erlebnis des Militärdienstes. Die wundersame Geschichte des Peter Schlemihl, der seinen Schatten verkauft, darüber mit seiner Seele in Konflikt gerät und vergeblich versucht, seinen Schatten zurückzugewinnen, ist für Kirchner ein Gleichnis seiner Existenz, die Lebensgeschichte eines Verfolgungswahnsinnigen, wie er selbst sagt. 1918/19, also

nach der Übersiedlung in die Schweiz, schneidet Kirchner in sieben Blättern die Holzschnittfolge "Absalom." Es ist die Illustration der im 2. Buch Samuel berichteten Geschichte von Absalom, dem Sohne König Davids. Absalom empört sich gegen seinen Vater, vertreibt ihn und errichtet eine eigene kurze Herrschaft, bis er in der Schlacht König David unterliegt und erschlagen wird. Im Grund illustriert Kirchner damit den Kampf, Hoffnung und Niederlage seiner Generation.

So arbeitete jeder auf sich allein gestellt weiter. Dabei blieb für jeden das gemeinsam gelebte Ideal unbedingter Ehrlichkeit, Konsequenz und Verantwortlichkeit im Künstlerischen und Menschlichen verbindlich. Der Ausbruch des Weltkrieges und seine Folgen, die jeden in anderer Weise trafen, hatten grausam den Glauben an die neue Generation, an den neuen, besseren Menschen zerschlagen. Kirchner erlitt 1915 noch in der Ausbildung zum Kriegsdienst einen völligen seelischen und körperlichen Zusammenbruch. Freunde brachten ihn in die Schweiz, in die Nähe von Davos. Hier, in der grossen Einsamkeit der Berge, fand er eine neue Möglichkeit des einfachen Lebens. Aus dem sensiblen Schilderer der Grossstadt wurde der bedeutendste Alpenmaler unseres Jahrhunderts. Heckel, der den Krieg als Sanitätssoldat in Flandern erlebte, vermochte nur unter Anspannung seiner ganzen geistigen Disziplin der übermächtigen Empfindungen Herr zu werden und zu einer geläuterten künstlerischen Existenz zu finden. Schmidt-Rottluff diente drei Jahre in Russland. Auch er brauchte alle Kraft, um das Übermass der Erschütterung zu bewältigen. Das Bewusstsein von Todesnähe und unbegreiflich wiedergeschenktem Leben führte ihn über eine Folge religiöser Holzschnitte zu einer Harmonie, zu einem umfassenden Bild der Welt. Nur Otto Mueller, der an der Westfront kämpfen musste, lebte wie immer in einer eigenen Welt. Er ging wie unberührt aus dem grossen Krieg hervor, um sein begrenztes, aber doch so reiches Thema zur meisterhaften Formung zu steigern.

Das Phänomen, von dem am Anfang die Rede war, erklärt sich nicht aus der künstlerischen Bedeutung dieser Maler allein. Es ist vielmehr die Faszination, die von der Erfahrung ausgeht, dass es einer Gruppe junger Menschen gelang, mit unbedingtem Wollen und Glauben die Welt zu bewegen.

V

Der Blaue Reiter

PAUL VOGT

Der Name "Der Blaue Reiter" besitzt in der deutschen Kunst des 20. Jahrhunderts einen besonderen Klang. Genau genommen bezeichnet er lediglich ein Jahrbuch, das als Chronik der künstlerischen Ereignisse um 1911 gedacht war, von den befreundeten, in München ansässigen Malern Franz Marc und Wassily Kandinsky konzipiert wurde und 1912 im Verlage Piper im Druck erschien. Wenn uns dieser Almanach heute auch als ein künstlerisches Zeitdokument von hohem Rang gilt, so hat sich sein Name doch zugleich auf eine ideelle Gemeinschaft von Künstlern aus mehreren

Ländern übertragen, die im Gewirk unseres unruhigen Jahrhunderts tiefe Spuren hinterlassen haben.

Die Kunstgeschichte zählt den "Blauen Reiter" zum deutschen Expressionismus, sicher nicht unberechtigt, weil es ohne ihn kaum zu einer genauen Definition dieses auf die Innenwelt des Menschen gerichteten, visionären und ausdrucksmächtigen Stils kommen kann. Man wird jedoch der Rolle der Künstler in ihrem geistigen Umfeld nicht gerecht, bemisst man deren Vorstellungen an jenen, die den nord- und mitteldeutschen Expressionismus trugen, der seit etwa 1910 sein Aktionszentrum in Berlin gefunden hatte. Die Maler selbst haben die Verschiedenartigkeit der jeweiligen Positionen so deutlich empfunden, dass es zwar beiderseits zur Beteiligung an den Ausstellungen der damaligen Avantgarde in München, Berlin und Köln, nicht jedoch zu engeren persönlichen Kontakten oder zu einem ähnlichen Ideenaustausch gekommen ist, wie er zwischen den Künstlern in München und Paris existiert hat.

Um die Stellung und das künstlerische Gewicht des "Blauen Reiter" nicht nur innerhalb der deutschen, sondern auch der europäischen Kunstszene bestimmen zu können, ist ein kurzer Rückblick auf jene Voraussetzungen geboten, die für die damals einzigartige internationale Konstellation zwischen Ost und West ursächlich waren, die den Charakter des "Blauen Reiter" bedingt.

Das latente Spannungsverhältnis zwischen Künstler und Welt, das sich in der Krisensituation um 1900 im Aufbruch einer revolutionären jungen Künstlergeneration manifestiert, setzte der Kunst neue Ziele. Je schärfer sich der Blick auf die Wirklichkeit richtete, umso fremder wurde sie. Der französische Impressionismus hatte als letzte, auch ästhetisch glanzvolle Demonstration des europäischen Realismus noch die tiefe Übereinstimmung mit der gegenständlichen Welt gezeigt. Schon der Neoimpressionismus jedoch äusserte erste Zweifel an der Glaubwürdigkeit der nur-sinnlichen Wahrnehmungen. Der methodische Geist eines Seurat und Cézanne, die symbolistischen Bestrebungen der "Groupe Synthétiste" um Gauguin in Frankreich, die brennende Leidenschaft des Holländers van Gogh, die psychologische Hintergründigkeit des Belgiers Ensor oder des Norwegers Munch, sie suchten jeder auf seine Weise das bildnerische Äquivalent für die neuen Bezüge, die sich zwischen Mensch und Ding anbahnten. Die Kunst wollte sich nicht mehr darauf beschränken, Sichtbares wiederzugeben, sie drängte danach, sichtbar zu machen. Doch in der Verfolgung dieses gemeinsamen Zieles trennten sich die Wege. Cézannes Mahnung "Kunst ist eine Harmonie parallel zur Natur" wies der französischen Kunst ihre Richtung. Natur wurde nicht mehr reproduziert, sondern durch das selbständige Sprachvermögen von Farbe, Linie und Form repräsentiert. Das Bild wurde zum Erzeugnis des forschenden und erkennenden Geistes und damit autonom.

Anders im Norden Europas. Hier dominierte der Wunsch nach bildnerischer Mitteilung aus der Innen- und Ausdruckswelt des Menschen. Die sichtbare Wirklichkeit wurde durch die Vision des Künstlers ersetzt und damit nach dem Grade menschlicher Beteiligung durchlässig. Ein exaltiertes Ichgefühl, zerreissende psychologische Spannungen akzeptierten die gegebenen Formen nur als Symbol- und Mitteilungszeichen, die von der Krisis, dem tragischen Lebensgefühl,

einer fast pathologischen Antinomie Mensch-Welt künden sollten: Expressionismus.

Wir können ihn als eine letztlich gemeinsame geistige Grundlage, nicht jedoch als allgemein verbindlichen Stil betrachten. Norden und Süden bildeten eigene Wege aus. München bot als eine der traditionellen deutschen Kunstmetropolen um 1900 besonders glückliche Voraussetzungen für die kommende Kunstrevolution. Der Jugendstil—nach der 1896 in München erschienen Zeitschrift "Jugend" benannt, hatte bereits am Ende des 19. Jahrhunderts eine Reihe jener Voraussetzungen geschaffen, auf denen das Neue aufbauen konnte. Früh schon wurden die Möglichkeiten der Linie im Hinblick auf das Ziel der absoluten, naturunabhängigen Form diskutiert. 1896 formulierte Fritz Endell seine Thesen von der Gefühlswirksamkeit gegenstandsunabhängiger Farben—Ideen, die direkt auf die abstrakte Malerei verwiesen, die Kandinsky verwirklichen sollte. Auch er war bereits 1896 von Moskau nach München übergesiedelt.

1908 hatte der junge Privatdozent Wilhelm Worringer in seiner Arbeit "Abstraktion und Einfühlung" geschrieben, dass Kunst auch vom Abstraktionsdrang ausgehen könne und nicht an die Erscheinungen der Dingwelt gebunden sei, Voraussetzung für seine damals kühne Formulierung (in der wir parallele Gedanken von Cézanne erkennen), "dass das Kunstwerk als selbständiger Organismus gleichwertig neben der Natur und in seinem tiefsten innersten Wesen ohne Zusammenhang mit ihr stehe." Solche Anregungen fielen in München ebenso auf fruchtbaren Boden wie die stimulierenden Erkenntnisse der Wissenschaft, auf die sich die dortigen Maler wiederholt bezogen haben. Franz Marc wagte unter dem Eindruck des Einsteinschen Raum-Zeit-Kontinuums und der Planckschen Atomtheorie die Prognose: "Die kommende Kunst wird die Formwerdung unserer wissenschaftlichen Überzeugung sein." Nicht die existentielle Lage des Individuums war hier zu diskutieren, mit der sich der Norden auseinandersetzte, sondern die kosmische Seinsbezogenheit des Menschen, die "mystisch-innerliche Konstruktion des Weltbildes" als "das grosse Problem der heutigen Generation" (Franz Marc). Der bestimmende Einfluss der in München ansässigen russischen Künstlerkolonie kam hinzu. Er zielte auf pantheistische Weltsicht, mystische Verinnerlichung, auf Imagination als Quell subjektiver Einsichten in die Zusammenhänge des Seins. Für sie waren neue formale Sinnzeichen und farbmusikalische Harmonien auszubilden. Solche Überlegungen bedingten den Begriff des "Geistigen in der Kunst" (Kandinsky), der damals nur in München entstehen konnte, Vorstufe für die nahende Abkehr von der Dingwelt, an der die nord- und mitteldeutschen Expressionisten bis zuletzt festgehalten haben. Erwähnen wir in diesem Zusammenhang auch den französischen Einfluss, der durch persönliche Kontakte zwischen den Künstlern beider Länder in München enger war als anderswo. Die aus dem französischen Fauvismus und Kubismus stammenden Anregungen, die es auch im Norden gab, ohne dort allerdings die Stilrichtung zu beeinflussen, boten in der süddeutschen Kunstszene die Grundlage für jene fruchtbare geistige Auseinandersetzung, aus der der "Blaue Reiter" sein unverwechselbares Gesicht gewinnen sollte.

Blicken wir nun auf solche Künstlerpersönlichkeiten, die die Tendenzen ihrer Zeit nicht nur theoretisch formulieren, sondern durch ihre Arbeiten bestätigen konnten, so treffen wir auf den Russen Wassily Kandinsky und den Deutschen Franz Marc, die Initiatoren des "Blauen Reiter."

Kandinsky stand am Beginn der Entwicklung. Er hatte 1901 in München die Künstlergruppe und Malschule "Phalanx" gegründet, die bis 1904 bestand. In engstem Kontakt zur französischen Entwicklung—seit 1902 reiste er regelmässig nach Paris, sein Frühwerk zeigt die Spannweite der Entwicklung vom Jugendstil russischer Prägung über den französischen Spätimpressionismus bis zum Fauvismus—hatte er seine Gründung zugleich als Kristallisationspunkt für die europäische Avantgarde gedacht und veranstaltete in Verfolgung dieses Zieles eine Reihe bemerkenswerter Ausstellungen. Den ersten massgeblichen Akzent setzte jedoch erst die 1909 gegründete "Neue Künstlervereinigung," als deren Vorsitzender wiederum Kandinsky fungierte. Unter den Mitgliedern finden sich klangvolle Namen: Alexej Jawlensky, Russe wie Kandinsky, Adolf Erbslöh, Gabriele Münter (Kandinsky-Schülerin seit 1902) und Alfred Kubin, dazu der deutsche Neoimpressionist Paul Baum, Karl Hofer, Wladimir von Bechtejeff und Moissey Kogan. Ihr Zirkular präsentierte kühne Gedankengänge:

"Wir gehen von dem Gedanken aus, dass der Künstler ausser den Eindrücken, die er von der äusseren Welt, der Natur erhält, fortwährend in einer inneren Welt Erlebnisse sammelt und das Suchen nach künstlerischen Formen, die von allem Nebensächlichen befreit sein müssen, um nur das Notwendige stark zum Ausdruck zu bringen—kurz das Streben nach künstlerischer Synthese, die scheint uns eine Lösung, die gegenwärtig immer mehr Künstler geistig vereinigt."

Solche Formulierungen verraten den unruhigen Geist von Kandinsky, der damals wohl als einziger die möglichen künstlerischen Konsequenzen ungefähr abzuschätzen vermochte. Sie stiessen natürlich auf den Widerstand jener Mitglieder der "Neuen Künstlervereinigung," die als Maler des eigentlichen Münchener Milieus zwischen Symbolismus, Jugendstil und Naturlyrismus sich dem Gedanken der Abstraktion verweigerten. Unterstützung erhielt Kandinsky allein von Franz Marc, einem noch unbekannten Maler, der instinktiv die überlegene schöpferische Potenz erkannte. Selber mit Vorstellungen beschäftigt, die er in der Malerei noch nicht nachvollziehen konnte, begriff er die Folgerungen, die Kandinskys Ideen andeuteten und die seine Kunst befruchten konnten.

Der mit ihm befreundete Rheinländer August Macke, mit dem er in brieflichem Gedankenaustausch stand, verfolgte die aufkommende Entwicklung mit einiger Skepsis. Selber nicht expressiv gestimmt, blieb auch seine heitere, farbfreudige, am Erlebnis der Kunst von Matisse und Delaunay geschulte Malerei als Metapher einer reinen und geordneten Schönheit der Welt trotz des persönlichen Engagements von den Impulsen aus München unberührt. Scharfsichtig erkannte er das Problem der Situation. Sein Hinweis in einem Brief von 1910 "Die Ausdrucksmittel sind zu gross für das, was sie sagen wollen" bezeichnet genau jene Kluft zwischen Theorie und Praxis, die sich noch nicht schliessen liess.

1911 kam es zum Bruch zwischen den Neuerern und Traditionalisten in der "Neuen Künstlervereinigung." Kandinsky und die ihm nahestehenden Maler Franz Marc und Gabriele Münter traten aus. Ihnen folgten wenig später Alexej Jawlensky und Marianne von Werefkin, die versucht hatten, die Gegensätze noch einmal auszugleichen.

1910 hatte Kandinsky bereits seine erste abstrakte Komposition geschaffen, ein Aquarell. Es dokumentiert noch experimentelle Vorstellungen, die der Künstler erst in den folgenden Jahren zu fundieren vermochte. Die Lösung war damit jedoch vorbereitet, das Ziel lag offen und nicht nur in München. 1911 vollendete Larionoff in Moskau seine erste abstrakte Arbeit, 1912 folgten in Paris Delaunay und Kupka. In seinem Freundeskreis blieb Kandinsky mit seinem kühnen Schritt vorerst allein. Anders als bei der Künstlergemeinschaft "Brücke," der Keimzelle des mitteldeutschen Expressionismus, bei der die Gemeinsamkeit der Anfangsjahre Werke von frappierender Verwandtschaft zeitigte, die die Urheberschaft der einzelnen Künstler nicht immer sofort erkennen lässt, gingen die Maler um Kandinsky ihre eigenen Wege, die zu keiner Zeit mehr als eine geistige Übereinstimmung verraten. Franz Marc hat erst in seinen letzten Lebensjahren die Schwelle zur Abstraktion überschritten. Jawlensky oder der später hinzugekommene Paul Klee fühlten sich anfangs noch, wenn auch aus verschiedenen Gründen weiter dem sichtbaren Sein verpflichtet.

1911, inmitten der Schwierigkeiten mit der "Neuen Künstlervereinigung" hatten Franz Marc und Wassily Kandinsky mit der Arbeit an jener Schrift begonnen, die später den Titel "Der Blaue Reiter" erhalten sollte. Es hat also niemals eine Vereinigung oder Künstlergruppe dieses Namens gegeben, wie Kandinsky später noch einmal nachdrücklich betont hat. Streng genommen bestand der "Blaue Reiter" nur aus seinen beiden Redaktionsmitgliedern Marc und Kandinsky. Alle anderen ausdrücklich zur Mitarbeit eingeladenen Künstler hielten mehr oder weniger engen Kontakt zu den Freunden, nahmen an ihren Ausstellungen und Diskussionen teil oder beteiligten sich an der geplanten Veröffentlichung. Zu ihnen gehört der unermüdlich um Unterstützung bemühte August Macke, gehörten Paul Klee und Alfred Kubin, Gabriele Münter und Marianne von Werefkin wie Alexej Jawlensky, Namen, die uns grösstenteils bereits aus der "Neuen Künstlervereinigung" geläufig sind. Auch den berühmten Komponisten Arnold Schönberg müssen wir dazu rechnen. Sein erstes Auftreten in München 1911 hat Franz Marc so beeindruckt, dass er davon sogleich an Macke berichtete. "Kannst Du Dir eine Musik denken, in der die Tonalität (also das Einhalten irgend einer Tonart) völlig aufgehoben ist? Ich musste stets an Kandinskys grosse Kompositionen denken, der auch keine Spur von Tonart zulässt . . . und auch an Kandinskys 'springende Flecken' bei Anhören dieser Musik, die jeden angeschlagenen Ton für sich stehen lässt (eine Art weisser Leinwand zwischen den Farbflecken!) . . ." Wir werden Schönberg als Autor wie als Maler im Almanach und auf der ersten gemeinsamen Ausstellung finden.

"Der Blaue Reiter" erschien im selben Jahr 1912, in dem Kandinsky auch seine grundlegende Schrift "Über das Geistige in der Kunst" veröffentlichte, an der er seit 1910

gearbeitet hatte. Beide Bücher spiegeln programmatisch die geistige Lage des entscheidenden Aufbruchsjahres 1911, kurz vor dem allgemeinen Durchbruch zur Abstraktion, der sich seit 1912 allenthalben in Europa vollzog. Auf den ersten Blick scheint die Vielfalt der Texte und Abbildungen eher verwirrend. Maler, Wissenschaftler, Musiker, Dichter und Bildhauer sind als Autoren beteiligt, Kunst der Gegenwart steht neben den Werken der klassischen Antike, neben Kinderzeichnungen oder den Werken der Primitiven. Kahnweiler hatte Fotos nach Gemälden von Picasso gesandt, Matisse verweigerte zwar einen Aufsatz, gestattete jedoch jegliche Reproduktion nach seinen Werken. Ordnet man Texte und Abbildungen ihrem Sinne nach, so empfindet man bald die einheitliche geistige Grundlage, die auf der Idee des "Gesamtkunstwerks" basiert. Dieser Blickwinkel eint Musik und bildende Kunst, schlägt den Bogen von der bayrischen Hinterglasmalerei zur russischen Volkskunst, setzt Kinderkunst in den Kontext zu den Masken und Skulpturen aus Afrika und der Südsee, verbindet die klassischen Werke Ostasiens, Griechenlands und Ägyptens mit denen des deutschen Mittelalters.

Das lebendige Fluidum, das dieser ungewöhnliche Band noch auf den heutigen Betrachter ausströmt, verrät etwas von dem intensiven Wunsch seiner Initiatoren, geistige Signale einer Zeit zu setzen, die in den Augen der jungen Generation an einem Symptom krankte, das Marc als die "allgemeine Interesselosigkeit der Menschen für neue geistige Güter" bezeichnete. Welch Sendungsbewusstsein liegt in seinen Worten: "Wir werden aber nicht müde werden, es zu sagen, und noch weniger müde, die neuen Ideen auszusprechen und die neuen Bilder zu zeigen, bis der Tag kommt, wo wir unseren Ideen auf der Landstrasse begegnen."

Neue Ideen: das war die von Kandinsky im "Blauen Reiter" verfochtene Überzeugung von den zwei Polen, der "grossen Abstraktion" und der "grossen Realistik," die schliesslich in ein gemeinsames Ziel münden. Sie stützte sich auf die Überzeugung, dass "die Form . . . der äussere Ausdruck des inneren Inhalts" sei—der Blick des Malers hatte sich von der Aussenwelt abgewendet, der Dialog mit der Dingwelt war zugunsten der Auseinandersetzung mit der Innenwelt aufgegeben worden und sie durchzuführen bedurfte es nicht mehr der traditionell ausgeformten Symbole des Gegenständlichen. Nicht mehr die Form an sich besass Bedeutung, sondern "ihr innerer Klang, ihr Leben" (Kandinsky). In solcher Interpretation treten nun allerdings bei aller Nähe zu Frankreich auch die tieferen Unterschiede zutage: hier lateinische ratio, dort ein nordisch-östliches, intuitives Gefühl.

Die Vorstellung von der zwingenden inneren Notwendigkeit, die sich unabhängig von Abstraktion oder Realistik als Argument für das Kunstwerk ergibt, klingt als Grundthema in allen Beiträgen an. Verständlicherweise hatten sich die beiden Redakteure mit jeweils mehreren Beiträgen engagiert. Von Marc stammen die Artikel: "Geistige Güter," ein Beitrag zur Situation "Die Wilden Deutschlands" (in dem er zum ersten Male, wenn auch nur am Rande, die "Brücke"-Expressionisten erwähnte), sowie "Zwei Bilder," von Kandinsky die wichtige Abhandlung "Über die Formfrage," die für das Verständnis seiner Malerei unentbehrlich

ist. Die Spannweite seiner Bemühungen geht aus seinem Text "Über Bühnenkomposition" hervor, der seinem im "Blauen Reiter" veröffentlichtem Bühnenwerk "Der Gelbe Klang" vorangestellt ist. Arnold Schönberg äusserte sich über "Das Verhältnis zum Text," während der in Moskau geborene und später in die USA übergesiedelte Komponist und Maler Thomas von Hartmann "Über die Anarchie in der Musik" schrieb. Nennen wir noch Erwin von Busse mit seinem Artikel "Die Kompositionsmittel bei Robert Delaunay," den Beitrag David Burljuks "Die Wilden Russlands," "Die Masken" von August Macke und die Untersuchungen von Leonid Sanejew zum "Prometheus" von Skrjabin, den Aufsatz "Kennzeichen der Erneuerung in der Malerei" des Franzosen Roger Allard, Zitate von Delacroix und Rosanow, so ist damit der Umfang einer für die damalige Zeit ungewöhnlichen Veröffentlichung umrissen. Dass musikalische Probleme im Almanach einen so breiten Raum einnahmen, kam nicht von ungefähr. Die Beziehungen zwischen Musik und bildender Kunst, die farbharmonikale Anlage der Gemälde von Kandinsky wie die Analogie tonaler Schwingungen zu farbigen Akkorden beschäftigten gleichermassen Maler wie Musiker. Im "Prometheus" hatte Skrjabin versucht, die Musik mit farbiger Beleuchtung in Übereinstimmung zu bringen und den Tönen bestimmte visuelle Klänge zuzuordnen, Vorstufen des späteren Farblichtklaviers. In diesen Zusammenhang gehört auch Kandinskys kühnes Bühnenopus "Der Gelbe Klang" als Versuch des Zusammenwirkens von Farbe, Pantomime und Musik aus mystisch-romantischer Grundstimmung. Von hier aus sind denn auch die Überlegungen im Kreise des Blauen Reiters zu würdigen, sich mit den musikalischen Eigenschaften des bildnerischen Vokabulars zu befassen, eine Harmonielehre der Farben und Formen zu entwickeln, die ähnlich anwendbar sein sollte wie das in der Musik möglich war. Eine derartige Ablösung des Dinglichen beeinträchtigte ihren Empfindungscharakter nicht—auf ihn mochten weder Deutsche noch Russen zu verzichten—befreite sie aber vom Ballast des Inhaltlichen und Allegorischen. Das Expressive, das sich hier bemerkbar macht, besitzt also eine ganz andere Tonart als der Expressionismus der Nordens. Blicken wir aus München zum sog. "Brücke-Expressionismus" hinüber, so tritt die Verschiedenheit der Anschauungen sogleich zutage. Während der Norden und der Süden in der deutschen Romantik ihre Grundlangen hat, bildeten beide eigene verschiedene Wege aus. Im Norden versuchte man ein bildnerisches Mittel wie die expressive Funktion der starken Farben zu entdecken. Der Süden war beunruhigt über die mystisch—innere Bedeutung hinter äussern Dingen. Die sensitive Palette fand ein Gegenstück in dem reinen Ton der Musik. Keine Richtungen arbeiteten voll erfolgreich. Zuweilen im Norden eine übertriebene Bedeutungstiefe, und im Süden das Dekorative an die Grenze geraten konnte.

Dass zwischen Nord und Süd eine letzte Reserviertheit geblieben ist, scheint uns daher verständlich. Franz Marc hat die Künstler der "Brücke" zwar in Berlin besucht und war von der Stärke ihrer Äusserungen wie von ihrem Impetus fasziniert, zu einem tieferen Verständnis der gegenseitigen Positionen ist es jedoch nicht gekommen. Kandinsky lehnte die Arbeiten der "Brücke" rundweg ab. Ihr direktes

Engagement, die spontanen und impulsiven Reaktionen, die formsprengende Intensität ihres Selbstausdrucks schienen ihm zu wenig gefiltert, zu ungeistig, um darin einen entscheidenden Beitrag zur Entwicklung der zeitgenössischen Kunst sehen zu können, wie er sie sich vorstellte. So weigerte er sich, in den Almanach, der zahlreiche Abbildungen von Matisse, Delaunay, Cézanne oder Le Fauconnier enthält, Reproduktionen von Werken der Expressionisten aufzunehmen. "Ausstellen muss man solche Sachen. Sie aber im Dokument unserer heutigen Kunst (und das soll unser Buch werden) zu verewigen, als einigermassen entscheidende, dirigierende Kraft—ist in meinen Augen nicht richtig. So wäre ich jedenfalls gegen grosse Reproduktionen . . . die kleine Reproduktion heisst: auch das wird gemacht, die grosse: das wird gemacht."

Kandinskys Standpunkt setzte sich durch. Die Expressionisten nahmen zwar an der Graphik-Ausstellung des Blauen Reiters teil, doch wurde der ursprünglich vorgesehene Text von Max Pechstein nicht in die Veröffentlichung aufgenommen. Nolde, Pechstein, Mueller, Heckel und Kirchner sind dort nur durch Abbildungen graphischer Blätter präsent.

Beide Publikationen, "Das Geistige in der Kunst" wie "Der Blaue Reiter" bedeuten Marksteine in der Geschichte der deutschen Moderne. Sie hatten den Künstlern auf seine Freiheit von der traditionellen Bindung an den Gegenstand aufmerksam gemacht, ihm demonstriert, dass er sich in Übereinstimmung mit dem Zeitgeist befand, wenn seine Imagination Bilder jenseits der sichtbaren Wirklichkeit fand. Alles forderte ihn auf, die Vorstellung von einer erweiterten Schöpfung, von deren ideellen und materiellen Strukturen im Bilde anschaulich zu machen.

Übersehen wir an diesem Punkte der Betrachtung noch einmal den Weg der Entwicklung, wie er sich im "Blauen Reiter" so eindeutig abzeichnet, so kristallisieren sich jene beiden Positionen der europäischen Szene heraus, deren Synthese in München versucht worden ist. Es waren dies das Expressive und das Kubistische, besser noch das Orphistische, die von den deutschen und russischen Malern als trag- und entwicklungsfähige Ausgangspunkte für die kommende Malerei begriffen wurden.

Das Expressive: das waren ebenso der deutsche Expressionismus zwischen Elementarem und Kosmisch-Romantischem, wie der französische Fauvismus, der durch leidenschaftliches Angehen der sichtbaren Realität Wirklichkeit in bildnerische Gegenwirklichkeit erhöhen wollte. Matisse wie Kandinsky können beide mit ihrem Werk als Zeugen dienen: der Franzose, indem er die Dualität zwischen dem Ich und der Welt durch die geistige Ordnungsformel des Bildes zu überzeugender Einheit verband, der Russe, der die Grenze der sichtbaren Realität negierte, um mit neugefundenen Mitteilungszeichen im Bilde jenen Punkt zu ertasten, an dem sich das Zuständliche im Menschen mit der universaleren kosmischen Ordnung berührt.

Dem ungefilterten expressiven Mitteilungsdrang konnten solche Funde nicht zur bildnerischen Verwirklichung anvertraut werden. Das sehr deutsche, in der Romantik verwurzelte Allgefühl eines Franz Marc wie die farbharmonikale Synthese eines Kandinsky fanden durch die gleichzeitige französische Malerei Bestätigung und zugleich die notwen-

digen Hinweise zur tätigen und theoretischen Kultivierung der farbigen und formalen Mittel. Die Ästhetik des "Blauen Reiter," angesiedelt zwischen Expressivem und Konstruktivem, hatte sich zunehmend vom Motiv als Bildgegenstand abgekehrt und dafür auf das Bild als selbständigen Organismus und formale Einheit gerichtet. Von diesen Überlegungen aus ist der starke Einfluss der orphistischen Malerei eines Delaunay auf die Künstler um den "Blauen Reiter" leicht zu verstehen. Seine Entdeckung, dass Farbe im selben Sinne wie Form aus sich heraus Bewegung und Rhythmus evozieren kann, sein "sens giratoire" der Farben, führte ihn konsequent zur abstrakten Malerei aus reiner Farbe, die gegenständlich nichts mehr, inhaltlich und ausdrucksmässig viel bedeutet. Sie steht für jenen übergeordneten Rhythmus, der Sein und Welt bestimmt, sucht jenen Klang, der die Harmonie des Ganzen auszudrücken und zu umschliessen vermag. Eine solche Vorstellung von Malerei als reiner Orchestrierung von Farbe und Licht musste sich mit den spekulativen Vorstellungen der Müchener Maler zu einer überzeugenden Synthese verbinden lassen.

Die von der Redaktion des "Blauen Reiter" veranstalteten Ausstellungen sollten dazu dienen, die theoretischen Grundlagen durch das Kunstwerk zu bestätigen. Zwei Ausstellungen 1911 and 1912 fixieren beispielhaft die jeweilige Zeitsituation. Am 18.11.1911 stellte der Freundeskreis um den späteren "Blauen Reiter" zum ersten Male in der Galerie Thannhauser aus. Die Schau war als Demonstration gedacht und wurde deshalb zu jener Zeit eröffnet, an dem auch die "Neue Künstlervereinigung," von der man sich gerade im Streit getrennt hatte, in den anderen Räumen der Galerie Arbeiten ihrer Mitglieder zeigte.

Selbstverständlich waren Kandinsky, Marc, Macke und Münter vertreten. Es beteiligten sich der Rheinländer Campendonk, die russischen Brüder Burljuk, Albert Block, der frühverstorbene Eugen von Kahler, Jean Bloe Niestle, Arnold Schönberg und zwei bedeutende Franzosen: Henri Rousseau und Robert Delaunay. Ohne Zweifel spüren wir in dieser Zusammenstellung die Hand von Kandinsky. Vor allem in den beiden eingeladenen Franzosen verkörperten sich für ihn die zwei immer wieder zitierten Gegensatzpaare in der Kunst: Das "grosse Abstrakte" und das "grosse Reale," auf die er in seinen Abhandlungen immer wieder verwiesen hat. Die Ausstellung wanderte anschliessend durch Deutschland. Sie war 1912 in Köln zu sehen und wirkte dort auf die rheinische Szene ein, die ohnehin durch Macke und Campendonk enge Bindungen an München besass. In Berlin eröffnete Herwarth Walden mit ihr seine "Sturm"-Galerie, wobei er seinen künstlerischen Weitblick bewies, indem er Arbeiten von Paul Klee, Alexej Jawlensky und Alfred Kubin hinzufügte, die in München gefehlt hatten. Bremen, Hagen und Frankfurt schlossen sich an.

Die zweite Ausstellung 1912 war nicht so sehr als eine spontane Reaktion gedacht, sondern sorgfältig geplant und vorbereitet. Sie beschränkte sich unter dem Titel "Schwarzweiss" auf graphische Arbeiten, liess aber neben Drucken auch Zeichnungen und Aquarelle zu.

"Marc und ich nahmen alles, was uns richtig schien, was wir frei wählten, ohne uns um irgendwelche Meinungen und Wünsche zu kümmern." Beteiligt waren wieder Künstler vieler Nationen: aus Deutschland neben denen der

"Brücke" (ohne Schmidt-Rottluff) und des "Blauen Reiter" selbst der Worpsweder Tappert, der Westfale Morgner, diesmal auch Alfred Kubin und Paul Klee, letzterer mit 17 Arbeiten aus den Jahren 1911 und 1912. Der französische Beitrag war wie erwartet umfangreich. Man sah Arbeiten von Georges Braque, Robert Delaunay, Roger de la Fresnaye, André Derain, Pablo Picasso und Maurice Vlaminck und fand damit die Situation zwischen Fauvismus und Kubismus angedeutet. Die Schweiz war durch Hans Arp, Moritz Melzer, Wilhelm Gimmy und Oskar Lüthy vertreten. Russland hatte seine Avantgarde entsandt: Natalia Gontscharowa, Michail Larionoff und Kasimir Malewitsch.

Eine derart weit gespannte Übersicht wie diese ist später nicht mehr zustande gekommen. Die Maler um den "Blauen Reiter" nahmen noch an der berühmten Sonderbund-Ausstellung 1912 in Köln teil, die Europas junge Künstlergeneration in einer grossen Übersicht vereinte; im selben Jahr stellte Herwarth Walden in Berlin jene Werke von Kandinsky, Jawlensky, Werefkin, Block, Münter und Marc aus, die nicht im Sonderbund zu sehen gewesen waren. 1913 veranstaltete die Sturm-Galerie in Berlin den "Ersten Deutschen Herbstsalon" (in Anlehnung an den berühmten "Salon d'Automne" in Paris), auf der die Münchener Maler noch einmal mit den internationalen parallelen Tendenzen zusammen gezeigt wurden. Walden zeigte sie 1914 als Wanderausstellung in den skandinavischen Ländern. Dann brach der Krieg aus und beendete auch in München das gemeinsame Streben.

Gemessen an der Zeit, die der Dresdener Künstlergruppe "Brücke" gegeben war, bildet der "Blaue Reiter" nur eine kurze Episode. Seine Bedeutung für die europäische Szene war darum nicht geringer, seine Auswirkungen in die Zukunft übertrafen die des mittel- und norddeutschen Expressionismus. Die Künstler hatten sich als Wegbereiter einer neuen Epoche geistiger Kultur gefühlt, unter der Devise, "dass die Erneuerung nicht formal sein darf, sondern eine Neugeburt im Denken ist." Dass die Kunst dabei der Mittelpunkt war, wenn auch nicht das ausschliessliche Ziel, dass man sie als Teil eines übergeordneten Seinszusammenhanges erkannte zwischen dem Diesseitigen der Natur und den Jenseitigen, der Innen- und Ausdruckswelt des Menschen, an deren Durchdringungspunkt der Künstler seinen Platz hatte, dass ihm die Aufgabe zufiel, "der Zeit Symbole zu schaffen, die auf die Altäre der kommenden geistigen Revolution gehören," kennzeichnet das Besondere ihrer Visionen. Ein Weg war vorgezeichnet, der erst von den folgenden Generationen in seiner ganzen Tragfähigkeit erkannt worden ist.

VI

Grossstadt-Expressionismus
Berlin und der deutsche Expressionismus

EBERHARD ROTERS

In Berlin ist der deutsche Expressionismus nicht entstanden. In Berlin wird aber das Wort Expressionismus zum erstenmal unter die Leute gebracht, um sich von hieraus, als ein

von Anfang an höchst ungenauer Stilbegriff, der zunächst fast alle im Pathos von Form und Farbe von der damaligen ästhetischen Norm abweichende Kunst meint, rasch durchzusetzen und auszubreiten.[1]

Geburtsort des Expressionismus sind die deutschen Provinzen, ihre Hauptstädte wie Dresden und München, und ihre landschaftlichen Zentren und Epizentren wie beispielsweise Worpswede, die Moritzburger Seen, die westfälische Landschaft um Soest und Hagen, sowie die Kleinstädte Sintelsdorf und Murnau am Staffelsee in Bayern oder die Küstenlandschaften von Dangast und der Insel Fehmarn, denn dem deutschen Expressionismus wohnt, verbunden mit der Suche nach Ursprünglichkeit der Lebens- und Schaffensweise, von Beginn an die Neigung zur Flucht aus der Stadt und zum "Zurück zur Natur" inne. Der Einzug der Expressionisten und ihrer Werke in die Metropole markiert daher schon eine zur anfänglichen Tendenz gegenläufige Bewegung, die einen spektakulären Höhepunkt und Abschluss der ersten, für die Stilbildung wichtigen Phase geradezu voraussetzt, da nunmehr das Wagnis der Besitzergreifung des grossstädtischen Kunsturteils darauf gegründet wird, und da die Künstler jetzt dem Bedürfnis folgen, die Zeugnisse ihrer künstlerischen Revolution dem sachverständigen Grosstadtpublikum vorzustellen, dem anspruchsvollsten, skeptischsten, widerborstigsten, wetterwendischsten aber auch am meisten aufgeschlossenen und darum wichtigsten Kunstpublikum überhaupt. Das Zusammentreffen des Expressionismus mit der Grosstadt Berlin löst einen gesellschaftlichen Vorgang aus, der einer aufbrausenden chemischen Reaktion gleicht. Im Austausch jeweils eigener Qualitäten findet eine doppelte Verwandlung statt, an deren Ende sowohl der Stil des Expressionismus wie die grossstädtische Gesellschaft Berlins ihre Substanz jeweils deutlich erkennbar verändert haben.

Die Art und Weise, nach der diese Entwicklung abläuft, hängt selbstverständlich auch mit den politischen Ereignissen zusammen, die der Epoche ihre geschichtliche Gestalt gegeben haben. Der Lebensweg des Berliner Grosstadtexpressionismus dauert etwa ein Jahrzehnt; er setzt präzis im Jahre 1910 ein und endet 1920 im Ungefähren. In seinem politischen Verlauf entspricht das Jahrzehnt einer Fieberkurve, deren Klimax die Jahre des Ersten Weltkrieges bilden.

Der Weg des Berliner Expressionismus, währenddessen sich der Stil infolge seiner Auseinandersetzung mit der gleichzeitigen politischen Entwicklung in Deutschland und in Berlin signifikant verändert, gliedert sich daher von heute aus gesehen in drei Phasen: die Vorkriegszeit der Jahre 1910 bis 1914, die Kriegszeit der Jahre 1914 bis 1918 und die Nachkriegszeit der Jahre 1918 bis 1920 und darüber hinaus. In allen drei Phasen ist Berlin eine Hauptstadt gesellschaftlicher Widersprüche.

Bis zum Jahre 1914 ist Berlin die Hauptstadt des deutschen Reiches, eines Kaiserreiches, das, ein Anachronismus im europäischen Staatenbereich, 1871 gegründet worden war, zu einem Zeitpunkt, in dem andere europäische Nationen eben zu der Erkenntnis gelangt sind, dass es überholt sei, ihre Hegemonialansprüche in die verbrauchte Idee des Kaisertums zu kleiden. Im ersten Jahrzehnt unseres Jahrhunderts verbinden sich in Gestalt des letzten Hohenzollern-

kaisers Wilhelm II, seiner Hofhaltung und seines Kabinetts moderne imperalistische Machtpolitik und lauthals vorgetragene kaiserliche Opernromantik auf höchst lächerliche Weise. Berlin ist in jenen Jahren aber nicht nur die Hauptstadt eines technisch fortschrittlich, weltanschaulich aber restaurativen Reiches, dessen Oberhaupt im Versuch der Vereinbarung des Unvereinbaren schauspielerische Höchstleistungen an ungewollter Komik vollbringt, Berlin ist zugleich auch die Hauptstadt eines liberalen deutschen Bürgertums, das seine Impulse besonders auch von seiten des emanzipierten jüdisch-deutschen Bürgertums empfängt, und das sich zur Politik des Kaiserhauses im offen ausgesprochenen Gegensatz weiss. Berlin ist deshalb auch die Hauptstadt der intellektuellen Avantgarde, in deren Kreisen radikale Ideen zur politischen Revolution ebenso diskutiert werden wie solche zur ästhetischen Revolution. In jenen Kreisen formiert sich schon lange vor Ausbruch des Krieges der Widerstand gegen die Machtpolitik des Kaiserreiches. Die Bezeichnung "Vorkriegsjahre"—nicht letzte Friedensjahre—für diesen Zeitabschnitt ist absichtlich gewählt, denn sie entspricht dem untergangsprophetisch gestimmten Lebens- und Weltgefühl, das in der Bildsprache der Gemälde und Gedichte hervorgekehrt wird.

In den Kriegsjahren 1914 bis 1918 ist Berlin Hauptstadt eines untergehenden Reiches. Berlin ist Hauptstadt eines imperialen Angriffskrieges, zugleich ist die Stadt Hauptstadt der Not und der Entbehrungen, und sie ist die Haupstadt einer Nation, in deren zutiefst erschütterten Gesellschaftsstruktur der politische Umsturz bereits vorbereitet wird.

In den Nachkriegsjahren seit 1918 ist Berlin die Hauptstadt der ersten deutschen Republik, zugleich ist Berlin die Hauptstadt einer nicht vollendeten Revolution und andererseits Wunschziel der restaurativen und reaktionären Kräfte. Im Spannungsfeld einander widerstrebender Energien, zwischen Rechtsradikalen und linksradikalen Richtungen, zwischen Spartakus und Kappputsch wird Berlin damit nach 1918 zur europäischen Hauptstadt des offen zutage tretenden und offen ausgefochtenen gesellschaftlichen Widerspruchs. Das Erlebnis einer bis an den Zerreisspunkt geführten Spannung innerhalb des Gesellschaftsgefüges wirkt sich selbstverständlich auf die Intentionen der Kunst aus. Die Künstler finden sich dazu aufgefordert, mit ihren Werken im politischen Kampf selbst Stellung zu beziehen, und sie nehmen die Forderung an. Das Lebensgefühl und die Epochenstimmung der Städter im Jahrzehnt von 1910 bis 1920 werden durch die Kunstwerke eindeutig angezeigt, durch die Werke der bildenden Kunst ebenso wie durch die der Literatur. Der Bogen reicht von der apokalyptischen Vision vor dem Kriege bis zur direkt in die politischen Tagesereignisse eingreifenden künstlerischen Stellungnahme in den Nachkriegsjahren. Im Jahre 1920 ist im Rowohlt-Verlag Berlin die von Kurt Pinthus herausgegebene erste bedeutende Antologie expressionistischer Dichtung erschienen. Sie trägt den Titel "Menschheitsdämmerung."[2] Die ersten zehn Gedichte am Beginn des Buches tragen folgende Titel: Jakob van Hoddis, "Weltende"; Georg Heym, "Umbra Vitae"; Wilhelm Klemm, "Meine Zeit"; Johannes R. Becher, "Verfall"; Georg Heym, "Der Gott der Stadt"; Johannes R. Becher, "Berlin"; Alfred Wolfenstein, "Städter"; Jakob van

Hoddis, "Die Stadt"; Alfred Wolfenstein, "Bestienhaus"; Alfred Lichtenstein, "Die Dämmerung." Weltende—Umbra Vitae—meine Zeit—Verfall—der Gott der Stadt—Berlin—die Stadt—der Städter—Bestienhaus—die Dämmerung—allein schon in den Titeln erscheint das Lebens- und Weltgefühl des Expressionismus verdichtet. Das Buch ist mit Schriftstellerporträts aus der Hand bedeutender Künstler des Expressionismus illustriert, vor allem mit Federzeichnungen von Oskar Kokoschka und Ludwig Meidner.

In Berlin ist der deutsche Expressionismus städtisch geworden, in Berlin hat sich der Expressionismus der bildenden Kunst mit dem literarischen Expressionismus verbündet, in Berlin hat der Expressionismus politischen Inhalt und politische Form gewonnen;—in Berlin hat der Expressionismus seine Unschuld verloren.

Das Gedicht "Weltende" von Jakob van Hoddis, das die "Menschheitsdämmerung" von Kurt Pinthus einleitet, hat folgenden Wortlaut.

Dem Bürger fliegt vom spitzen Kopf der Hut.
In allen Lüften hallt es wie Geschrei.
Dachdecker stürzen ab und gehn entzwei,
und an den Küsten—liest man—steigt die Flut.

Der Sturm ist da, die wilden Meere hupfen
An Land, um dicke Dämme zu zerdrücken.
Die meisten Menschen haben einen Schnupfen.
Die Eisenbahnen fallen von den Brücken.

Pathos mischt sich mit Mokanz, apokalyptische Vision mit Sarkasmus, Verzweiflung mischt sich mit Heiterkeit, im Tonfall expressionistischer Beschwörung klingt anarchistischer Witz an. Der Weltuntergang wird auf die leichte Schulter genommen. Dada macht sich bemerkbar. Das Gedicht ist 1911 entstanden.

Vorkriegsjahre

Eine Reihe von Ereignissen zeigt in den Jahren 1910 und 1911 den Einzug des Expressionismus in Berlin an. 1910 gründen junge Berliner Künstler die "Neue Sezession." Das erste Heft der von Herwarth Walden gegründeten Zeitschrift "Der Sturm" erscheint. Im Frühjahr kommt Ernst Ludwig Kirchner aus Dresden zum erstenmal für längere Zeit nach Berlin. Er wohnt im Atelier seines Freundes Max Pechstein und malt die ersten Berliner Stadtansichten. Auch Oskar Kokoschka kommt 1910 zum erstenmal nach Berlin. Adolf Loos hat ihn 1909 an Herwarth Walden empfohlen und diesen vor Gründung des "Sturm" gefragt, ob er nicht eine geeignete Galerie für den Künstler wisse.[3] Das ist der Beginn einer engen Freundschaft zwischen den beiden Exzentrikern, Kokoschka hält sich von da an bis zum Ausbruch das Weltkriegs mehrmals monatelang in Berlin auf. Im Februar 1911 erscheint die erste Nummer der von Franz Pfemfert gegründeten Zeitschrift "Die Aktion." Im Oktober zieht Ernst Ludwig Kirchner nach Berlin um, seine Dresdner Brücke-Kameraden Karl Schmidt-Rotluff und Erich Heckel tun es ihm gleich. Kirchner richtet sein Atelier über dem Max Pechsteins in Berlin-Wilmersdorf ein und gründet gemeinsam mit Pechstein das MUIM-Institut.

Max Pechstein war bereits 1908 nach Berlin übergesiedelt. Seine Begabung für die grossflächig zusammengefasste

dekorative Form befähigt ihn dazu, das Pathos der expressionistischen Gestaltungsweise mit leichter Hand vorzutragen. Seine Version des Brücke-Stils gefällt daher dem Berliner Kunstpublikum schon zu einer Zeit, als dieses sich mit den Werken anderer Expressionisten noch schwertut. Pechstein, rührig, gewandt, vital, energisch und kämpferisch, weiss sich innerhalb der Berliner Kunst-Society zu bewegen. 1909 stellt er zum erstenmal in der "Berliner Secession" aus. Das Bemerkenswerte daran ist, dass die Jury die Werke eines unkonventionellen jungen Neuankömmlings zur Ausstellung zugelassen hat.

In der "Berliner Secession," einer 1898 unter Vorsitz von Max Liebermann gegründeten Künstlervereinigung, in der sich um 1900 die gegen den Akademiebetrieb revoltierenden Künstler des Berliner Realismus, des Jugendstils, des Impressionismus und der Freilichtmalerei zusammenfanden, haben sich mit dem Älterwerden der Mitglieder allmählich Spannungen aufgestaut, die um 1910 zum offenen Ausbruch kommen. Ein bärbeissiger "Protest deutscher Künstler" wirft dem Führer der Secession Max Liebermann sowie seinem Freund, dem Direktor der Berliner Nationalgalerie, Hugo von Tschudi vor, sie zögen den deutschen Künstlern französische Impressionisten vor. Die daraus folgenden Streitereien führen zu einer Demission Tschudis sowie zu einer Spaltung der Secessionsmitglieder in Progressive und Konservative. Die Secession läuft Gefahr, den Impetus, der zu ihrer Gründung geführt hat, vergessend, zu einem etablierten Altherrenverein zu werden, der den stilistischen Eigenwillen der nachfolgenden Generation junger Künstler nicht mehr zu begreifen imstande ist. Noch auf der 16. Ausstellung im Dezember 1908, den zeichnenden Künstlern gewidmet, sind jüngere Künstler wie Max Beckmann, Lyonel Feininger, Wassily Kandinsky, Paul Klee, Emil Nolde und die Künstler der Dresdener "Brücke" vertreten. Auf der 18. Ausstellung im Jahre 1909 ist den jungen Künstlern weit weniger Teilnahme eingeräumt. Von den "Brücke"-Künstlern ist nur Pechstein dabei. Anlässlich der 20. Ausstellung im Jahre 1910 kommt es zum Eklat. Die Beiträge aller jüngeren Künstler, darunter auch Pechstein, werden zurückgewiesen. Unter Führung Max Pechsteins und Georg Tapperts schliessen sich die Zurückgewiesenen daraufhin zur "Neuen Sezession" zusammen. Die erste Ausstellung findet im Mai/Juli 1910 im Kunstsalon Maximilian Macht unter dem Titel "Kunstausstellung Zurückgewiesener der Secession Berlin" statt. Plakat und Katalogumschlag zeigen das von Max Pechstein entworfene Bild einer knienden Bogenschützin. Die zweite Ausstellung ist der Graphik gewidmet; der Teilnehmerkreis hat sich erheblich erweitert. Die dritte Ausstellung vom Februar bis zum April 1911 macht deutlich, dass sich in der "Neuen Sezession" die jungen deutschen Expressionisten zusammengefunden haben. Dennoch wird kein programmatisch betonter Zusammenschluss angestrebt. Die Jungen wollen offen bleiben. Die vierte Ausstellung im November 1911 bringt der Vereinigung ihren grössten Erfolg. Wilhelm Morgner aus Soest und Bohumil Kubišta aus Prag kommen hinzu. Die "Neue Künstlervereinigung München" beteiligt sich mit Werken von Alexej von Jawlensky, Wassily Kandinsky, Alexander Kanoldt, Franz Marc, Marianne von Werefkin und anderen. Von grösster Bedeutung für die

"Neue Sezession" ist aber die durch Pechstein herbeigeführte Beteiligung der Dresdener "Brücke." Die "Brücke"-Künstler beschliessen 1912, nicht mehr gemeinsam mit Max Liebermann und der "Berliner Secession" auszustellen. Eine Zuwiderhandlung soll mit dem Ausschluss aus der Gruppe beantwortet werden. Da Pechstein sich nicht an diesen Beschluss hält und noch im gleichen Jahr drei Werke bei der "Berliner Secession" einreicht, ist damit nicht nur die Auflösung der "Brücke" besiegelt, sondern auch der Zerfall der "Neuen Sezession" eingeleitet.

Die gruppenbildende und gruppenauflösende Dynamik des Temperaments von Max Pechstein hat sich in jenen künstlerisch und kunstpolitisch bewegten Jahren mehrfach bewiesen. Er findet neue Freundschaften im Kreis der Berliner Expressionisten. Dazu gehören vor allem die ebenso wie er kunstpolitisch engagierten und aktiven Persönlichkeiten der Maler Georg Tappert, Moriz Melzer und Heinrich Richter—Berlin. Von den drei Künstlern steht Tappert stilistisch der "Brücke" am nächsten. In Berlin geboren, übersiedelt Tappert 1906 nach Worpswede und gründet dort eine Kunstschule. Sein bekanntester Schüler ist Wilhelm Morgner. 1910 nach Berlin zurückgekehrt, entwickelt Tappert in seinen Gemälden und graphischen Blättern einen deftigen Grossstadt-Expressionismus von unverhüllter Sinnlichkeit. Seine derben fülligen Akte zeigen Frauengestalten in voller Blüte ihrer Fleischlichkeit, mit Verve gemalt und temperamentvoll konturiert,—Akte im Atelier, Frauen mit grossen Radhüten im Café und auf der Strasse. Tapperts eigener Beitrag zum Expressionismus ist, im Schatten der "Brücke"-Malerei, lange Zeit übersehen worden und verdient eine eingehendere Würdigung als bisher. Moriz Melzer, ein in sich versponnener Eigenbrötler, beginnt mit einem religiös betonten expressionistischen Figuralstil, von dem aus er alsbald zu einer kubofuturistisch formulierten Bildsprache findet. Heinrich Richter erfindet unter dem Einfluss des Futurismus um 1913 seinen "Kreiselstil," den er sein Leben lang beibehält. Sein Hauptwerk ist das Gemälde "Unsere liebe Frau von der Tauentzienstrasse," 1913, das motivisch den Strassenbildern von Kirchner verwandt ist.

Der wandelnde Einfluss Berlins auf den deutschen Expressionismus, der zur Entstehung des spezifischen Grossstadt-Expressionismus führt, wird aber nirgends so offensichtlich wie im Werk Ernst Ludwig Kirchners. Indem die Künstler der "Brücke" nach Berlin übersiedeln, setzen sie das Formen- und Farbenpathos ihres mitteldeutschen Expressionismus, das sie auf der Suche nach Ursprünglichkeit des Lebens und Schaffens in den Jahren unmittelbar davor noch dem Leben in der freien Natur beim Nacktbaden an den Moritzburger Seen gewidmet hatten, der Begegnung mit der neuen Weltstadterfahrung aus. Ernst Ludwig Kirchner, der nervöseste und für motorischen Rhythmus empfänglichste aus dem Kreis der "Brücke"-Künstler, zeigt in seinen Arbeiten die intensivste stilistische Anverwandlung des Grossstadtempfindens. Der neurasthenische Genuss jener Motorik überträgt sich ihm bis in die Fingerspitzen, und der tänzerische Gestus seiner Handschrift steigert sich zum hektischen Stakkato der spitz ausfahrenden Pinselstriche, deren rhythmisch schwingende Aneinanderreihungen in den grossen Berliner Strassenbildern von 1913/14 die Darstellungsmo-

tive zum Oszillieren bringen, in Kunstseide und Straussenfedern durch die Strassen rauschende Strich-Damen, die die Kaskaden ihrer schnellen Verehrer hinter sich herziehen, gestaffelte Reihen von Männern in dunklen Anzügen und spitzen Hüten, erotisch-neurotisches Strassenballett. Kirchners "Potsdamer Platz" von 1914 ist das bedeutendste Werk des Berliner Grossstadt-Expressionismus überhaupt. Auf der Rundform einer Verkehrsinsel, die einer rotierenden Scheibe gleicht, entfaltet sich die Komposition vom stöckeligen Pas de Deux zu Füssen der beiden Kokotten aus auf die Spitze gestellt in einer trichterförmigen Öffnung nach oben derart, dass der Eindruck entsteht, die ganze Szene beginne, von den Ausstrahlungen der Kreiselbewegung in Umlauf gesetzt, hektisch zu tanzen. Die funkensprühenden Entladungen solch farbiger Strichgewitter entfalten ihre Wirkung auch in den Gemälden zweier anderer Expressionisten, die um 1910 von der flackernden Nervosität der Grossstadt inspiriert werden. Emil Nolde, der Norddeutsche, dessen Gesamtwerk motivisch durch den Hang zur Mystik, stilistisch durch verfliessende und wolkig ineinander überfliessende Farbflecken gekennzeichnet ist, malt in den Jahren 1911 und 1912 einige Bilder mit der Darstellung von Paaren an Caféhaustischen, Damen und Herren im Tête à Tête, deren Gestalten ihre farbig irisierende Eleganz im fahlen Schein eines azetylengasgelben Grossstadtsonnen-Fluidums entfalten. Oskar Kokoschka bringt die überzüchtete Nervosität des Grossstädters aus Wien mit, wo er seine ersten Porträts gemalt hat, intuitive Psychogramme der Dargestellten von brillanter Eindringlichkeit wie etwa das Bildnis des Architekten Adolf Loos von 1909. In Berlin malt er 1910 das Profilporträt seines temperamentsverwandten Förderers, des Kaffeetrinkers, Kettenrauchers und Naturverächters Herwarth Walden. Dem Bild ist das manische Bewegungstempo des Dargestellten eingeschrieben. Eine in allen Nervenfasern vibrierende Intellektuellengestalt zieht selbstversunken am Betrachter vorbei, einem Phantom gleich, dessen Gedankendurchsichtigkeit aus dem Zittern des elektrischen Lichts geboren scheint. Die Federzeichnungen von Oskar Kokoschka bilden den ersten graphischen Schmuck auf den Titelseiten des "Sturm," Porträts der Wiener und Berliner Künstlerkollegen Karl Kraus, Paul Scheerbart, Rudolf Blümner sowie aus der Poesie von Federstrichakkumulationen hervorwachsende Szenen mit Titeln wie "Der Erstebeste darf der schönen Lilith das Haar küssen."[4]

Bildene Künstler und Literaten begegnen einander in Berlin, sie diskutieren miteinander, sie arbeiten gemeinsam, und es beginnt der Verschmelzungsprozess zwischen bildender Kunst, Literatur und Politik, zwischen Phantasie und Intellekt, aus dem das spezifische Klima des bildkünstlerisch-literarischen Berliner Expressionismus hervorgeht.

Zur Beschleunigung dieses Integrationsvorgangs tragen die zahlreichen hier erscheinenden avantgardistischen Wochenzeitschriften für Literatur, Kunst, Kultur und Politik bei, im besonderen zwei musisch-intellektuelle Blätter, die beide wöchentlich im Zeitungsformat erscheinen, "Der Sturm" und "Die Aktion."

Herwarth Walden, seiner Ausbildung nach Musiker und Komponist, seit 1901 für wenige Jahre mit der Dichterin Else Lasker-Schüler, seit 1912 mit der Schwedin Nell Roslund verheiratet, ist einer der bedeutendsten Talent-Auf-

spürer seiner Zelt. Seiner Vermittlungstätigkeit ist es in erster Linie zu verdanken, dass Berlin in den zehner und zwanziger Jahren zu einem Integrationszentrum der modernen Kunst wird. "Der Sturm" ist eine radikal kulturkritische Zeitschrift, in der die literarische und bildkünstlerische Avantgarde der Zeit zu Wort kommt. Neben den Textbeiträgen,—kritischen Essays und Gedichten—, erscheint auf den Titelseiten, aber auch im Innern des Blattes vom Stock oder vom Stein gedruckte Originalgraphik junger Künstler, Holzschnitte der "Brücke"-Künstler, Kokoschkas Lithographien, graphische Arbeiten der Künstler des "Blauen Reiters," der französischen Kubisten und vieler anderer. In Verbindung mit den Titel-Lettern geht daraus das unverwechselbare Erscheinungsbild des "Sturm" hervor.

Im März 1912 eröffnet Herwarth Walden die Galerie des "Sturm," die durch eine Reihe von Ausstellungen, die wie Paukenschläge aufeinanderfolgen, rasch berühmt und berüchtigt wird. Auf die Eröffnungsausstellung "Der Blaue Reiter, Oskar Kokoschka, Expressionisten" folgen im April die Ausstellung der italienischen Futuristen und im Juni/Juli die Ausstellung der Refusierten der bis dahin als avantgardistisch geltenden Kölner Sonderbundausstellung. Im August zeigt eine Ausstellung "Französische Expressionisten" u.a. Werke von Braque und Derain. Das wichtigste Ereignis der Vorkriegszeit ist der "Erste Deutsche Herbstsalon," der im September 1913 eröffnet wird und drei Monate dauert. Auf der Ausstellung werden ca. 400 Werke von 73 Künstlern gezeigt. Daran beteiligt sind u.a. die Deutschen Heinrich Campendonk, Alfred Kubin, August Macke, Franz Marc, Gabriele Münter, der Schweizer Paul Klee, der Österreicher Oskar Kokoschka, der Deutsch-Amerikaner Lyonel Feininger, die Franzosen Robert Delaunay, Sonja Delaunay, Albert Gleizes und Fernand Léger, die Italiener Umberto Boccioni, Luigi Russolo und Gino Severini und die Russen Alexander Archipenko, David Burljuk, Marc Chagall, Natalia Gontscharowa, Alexej Jawlensky, Wassily Kandinsky, Michail Larionov und Marianne von Werefkin. Dies Ereignis, publizistisch und finanziell ein Desaster, fasst zum erstenmal die Spitzenleistungen der europäischen Avantgarde instinktsicher zusammen. Sein Ruhm wird durch eine kleine Schar von Künstlern und Kunstfreunden vorbereitet, die den neuen Entwicklungen gegenüber aufgeschlossen sind. In der gewitterschwül flimmernden Atmosphäre jener letzten Monate der heilen Gesellschaft Europas, in deren Lichtreflexen die Farben des Lebensglanzes noch einmal intensiv aufleuchten, wird das Wetterleuchten des nahenden Untergangs von den Künstlern hellsichtig wahrgenommen. Im November 1912 stellen im "Sturm" die "Pathetiker" aus, eine Gruppe von drei Malern: Ludwig Meidner, Richard Janthur und Jakob Steinhardt. Meidner ist der führende Künstler der Gruppe. Seine Bilder sind im Gestus eines atemlos ekstatischen Expressionismus mit breiten pastosen Pinselstrichen auf die Leinwand geschrieben. Unter dem Druck aus dem Innern hervorkochender Emotionen scheinen die Bilder der Stadtlandschaften auseinanderzubersten. Die Komposition explodiert aus ihrer Mitte. Das Grauen des Krieges und die Gewalt der Revolution erscheinen in diesen Bildern vorweggenommen. Häuser brennen und Ruinen qualmen. An den Rändern riesiger Krater liegen nackt die verkrümmten

Leichen Gefallener. "Revolution" heisst ein Bild von 1913, das der Nationalgalerie Berlin gehört. Ein Fahnenträger mit verbundenem Kopf stürmt, den Mund zum Schrei aufgerissen, aus dem Explosionsgewirr eines Barrikadenkampfes hervor,—Weltuntergang. Die lyrische Entsprechung dazu ist das Berliner Georg Heym Gedicht "Der Krieg" aus dem Jahre 1911.

Aufgestanden ist er, welcher lange schlief,
aufgestanden unten aus Gewölben tief.
In der Dämmrung steht er, gross und unbekannt,
und den Mond zerdrückt er in der schwarzen Hand. . . .

Nicht nur die "Pathetiker," auch die "Neopathetiker" melden sich in jenen Jahren zu Wort. Im Dezember 1911 findet in Berlin eine Soirée des "Neopathetischen Cabarets" statt. Eine zweite folgt 1912. Veranstalter sind Erich Loewenson und Kurt Hiller, Hauptbeteiligte sind Carl Einstein und Salomon Friedländer, beide prominente Mitarbeiter des "Sturm" und der "Aktion." Ihre scharf geschliffenen zeitsatirischen Beiträge sind Meisterstücke des Berliner expressionistischen Essays. In ihren das Selbstverständnis des Bürgertums und damit auch das eigene Selbstverständnis radikal in Frage stellenden Kommentaren, Parabeln und Dichtungen zeigt der Expressionismus schon selbstzerstörerische Züge, sein Pathos ist von gläserner Ironie durchsetzt. 1912 veröffentlicht Carl Einstein seinen "Bebuquin,"[5] einen präsurrealistischen Roman, dessen traum-analytische Eigenart der Zeichnung eines gespenstischen Gesellschaftsbildes bis heute ausserhalb eines kleinen Kennerkreises so gut wie unbekannt geblieben ist, und der seiner Entdeckung noch harrt. Salomon Friedländer, der Philosoph, der seine satirischen Schriften unter dem Psyeudonym "Mynona" veröffentlicht, arbeitet damals schon an seiner durch die Auseinandersetzung mit Nietzsche beeinflussten philosophischen Abhandlung "Schöpferische Indifferenz,"[6] die aber erst 1918 erscheint. Zu den Wesensmerkmalen des Expressionismus gehören Pathos, Ekstase, Dynamik, Motorik, Erotik, Steigerung des Lebensgefühls, nicht aber Ironie.

Ironische und sarkastische Töne in den Schriften von Mynona und Einstein sind erste Anzeichen für die produktive Zerstörung des Expressionismus aus dem Kern seiner eigenen Substanz. Dieser Prozess beginnt unmittelbar vor Ausbruch des Weltkrieges bezeichnenderweise in der Literatur und nicht in der bildenden Kunst. Damit werden die Züge eines musisch-intellektuellen Anarchismus sichtbar, der, bis dahin latent, durch den Krieg zwar nicht ausgelöst aber beschleunigt bald darauf in sein virulentes Stadium treten wird. In den Schriften von Einstein und Mynona kündigt sich Dada an.

Kriegsjahre

Die internationale Dada-Bewegung beginnt 1916 mit den Soiréen des Cabaret Voltaire in Zürich, Ort und Zeitpunkt dieser Initialzündung sind derart bekannt, dass über deren Fixierung oft die Voraussetzungen übersehen werden, die dazu geführt haben. Die Dada-Bewegung hat nicht nur eine Geschichte sondern auch eine Vorgeschichte. Die Lunte, die 1916 die Bombe zur Explosion brachte, wurde schon

einige Jahre vorher, in den letzten Weltfriedensjahren ge-
zündet. Die meisten Dadaisten haben einander nicht erst
in Zürich und später kennengelernt, sie kannten sich schon
vorher—aus Berlin. Der Berliner Grossstadt-Expression-
ismus schafft das Klima, in dem Dada mit seinem Anarch-
ismus and seinem angriffslustigen Pazifismus ausgebrütet
wird. Die künftigen Dadaisten treten in beiden Zeitschriften
bereits in den Vorkriegsjahren mit Textbeiträgen auf. Im
"Sturm" veröffentlichen Einstein und Mynona ihre Texte.
Ausserdem erscheinen Beiträge von Apollinaire, Aragon,
Breton, Eluard und Tzara. In der "Aktion" schreiben u.a.
Hugo Ball, Emmy Hennings, Otto Gross, Franz Jung und
Walter Serner.

"Der Sturm" und "Die Aktion" sehen einander auf den
ersten Eindruck hin sehr ähnlich. Beide haben Zeitungs-
format, beide verbinden die Veröffentlichung expressionist-
ischer Lyrik und Prosa mit dem Abdruck von Original-
graphik, beide Zeitschriften bringen dazu scharf und ge-
schliffen formulierte Beiträge, die, politisch gesehen, zum
weitaus grössten Teil einen links-liberalen Standpunkt ver-
treten. Für beide Zeitschriften arbeiten vielfach die gleichen
Autoren und gelegentlich auch die gleichen bildenden
Künstler. Der wesentliche Gegensatz ist nicht auf den ersten
Blick zu erkennen. Er beruht auf dem unterschiedlichen
Tenor der Herausgeber in ihren Meinungsäusserungen über
das Verhältnis zwischen Kunst und Politik. Walden erklärt:
"Die Revolution ist keine Kunst, sondern die Kunst ist
Revolution." Pfemfert dahingegen erblickt in der Kunst ein
Instrument revolutionärer Politik. Franz Pfemfert, der sich
in seinem brennenden Interesse für Politik bereits Anfang
des Jahrhunderts anarchokommunistischen Kreisen zuge-
wandt hat, verkündet in der "Aktion" einen von humanen
Idealen getragenen Pazifismus, den er in aggressiv stili-
sierten Aufsätzen vorträgt. 1912 schreibt er: "Er scheint
unheilbar, Europas Wahnsinn. Was gibt uns das Recht, von
dem Fortschritt einer Menschheit zu faseln, die ihre erbärm-
lichsten Instinkte mit Enthusiasmus zur Schau trägt? Die
so verbrecherisch ist, das Morden auf Kommando als Pflicht
der 'nationalen Ehre' auszuschreien. Die als Mut bejauchzt,
was fanatische Unwissenheit ist? Was gibt uns das Recht,
einem Zeitalter Kultur zuzugestehen, das vor Gespenstern
aus grauer Vorzeit auf den Knien liegt? Europas Wahnsinn
ist unheilbar. Was sollen all die Phrasen unserer pla-
tonischen Friedensfreude? Nicht eine Kugel bleibt im Lauf
der Gewehre, weil einige harmlose Schwärmer auf der
Friedenswarte stehen. Da werden Friedenspreise verliehen
und Friedenskonferenzen veranstaltet, aber dem Wahnsinn
mit ernsten Heilmitteln zu Leibe zu gehen—dazu bleibt
keine Zeit übrig." Im August 1914 beginnt der Erste
Weltkrieg.

Im Frühjahr 1915 wird der Rekrut Ernst Ludwig Kirch-
ner von seiner Feldartillerie-Einheit in Halle beurlaubt,
da er sich den Anforderungen des Dienstes nicht gewachsen
zeigt. Die Diagnose lautet "wegen Lungenaffektation und
Schwäche." In Wirklichkeit handelt es sich um eine tief-
greifende körperliche und seelische Krise, die zu einem
Sanatoriumsaufenthalt in Königstein im Taunus führt. Die
Versuche zur künstlerischen Bewältigung des Traumas geben
sich zu erkennen in Werken wie dem Gemälde "Selbst-

bildnis als Soldat" von 1915. Der Künstler stellt sich selbst
in der Maskerade der Uniform dar; das Antlitz ist eine
Maske der Vereinsamung, aus dem rechten Ärmel ragt ein
blutender Armstumpf, die tätige Hand des Malers erscheint
abgehackt. Im gleichen Jahr entsteht die Holzschnittfolge
zu Adalbert von Chamissos Erzählung "Peter Schlemihl,"
der Parabel von einem Mann, der seinen Schatten verkauft
und damit seine Identität verloren hat.

Im Jahre 1915 lernt der Sanitätsfreiwillige Erich Heckel
aus Berlin in Ostende den Sanitätsfreiwilligen Max Beck-
mann aus Berlin kennen. Beide begegnen einander in ihrer
Verehrung für die Werke des alten Visionärs James Ensor,
der in Ostende lebt. Im Herbst 1915 wird Beckmann wegen
eines Nervenzusammenbruchs aus dem Militär entlassen.
Er zieht nach Frankfurt. Das erschütternde "Selbstbildnis
mit rotem Schal" aus dem Jahre 1917 verrät physiogno-
misch wie stilistisch die scharf gezogenen Spuren der see-
lischen Erschütterung, die das Kriegserlebnis dem Wesen
des Künstlers eingekerbt hat.

Im Mai 1915 wird der Kriegsfreiwillige George Grosz
aus Berlin als "dienstunbrauchbar" entlassen. Er kehrt nach
Berlin zurück, wird 1916 erneut eingezogen und sofort in
eine Nervenheilanstalt gesteckt, daraufhin wieder entlassen,
am 4. Januar 1917 nochmals eingezogen, am 5. Januar ins
Lazarett Guben und Ende Februar 1917 in die Nerven-
heilanstalt Görden bei Brandenburg eingeliefert. Ende
April wird er endgültig aus dem Heer entlassen. In Berlin
lernt George Grosz den Kriegsfreiwilligen Franz Jung ken-
nen, der desertiert und zeitweilig in einer Irrenanstalt
interniert gewesen ist. Grosz zeichnet in dieser Zeit bissig
nervöse Kritzelblätter mit Soldaten, die dem Grauen der
Schlachtfelder hilflos ausgeliefert sind. In einem Brief an
seinen Schwager Otto Schmalhausen schreibt er 1917 aus
Görden: "Meine Nerven gingen entzwei, ehe ich dieses
Mal Front, verweste Leichen und stechenden Draht sah;
vorerst hat man mich unschädlich gemacht, interniert, zur
speziellen Begutachtung meiner noch in Frage kommenden
Dienstfähigkeit. Die Nerven, jede kleinste Faser, Abscheu,
Widerwillen!"[7] Im Jahre 1916 wird der MG-Schütze und
Strosstruppführer Otto Dix aus Dresden an der Westfront
zum fanatischen Kriegsgegner.

Diese Episoden bedürfen keines weiteren Kommentars
um zu begründen, warum die deutsche Kunst aus dem
Krieg, den sie vorausgeahnt hatte, verändert hervorging. Die
schon in den letzten Vorkriegsjahren gefundenen stilistischen
Mittel des Berliner Grossstadt-Expressionismus dienen jetzt
als Grundlage zur Hervorkehrung einer stilistischen Ver-
änderung. Die Kunst, die, vom Expressionismus kommend,
jetzt entsteht, ist antimilitaristisch, äusserst aggressiv in
ihrer Formulierungsweise und politisch engagiert. Sie ver-
sucht, mittels künstlerischer Stellungnahme, direkt in das
politische Tagesgeschehen einzugreifen. Dazu gehört, dass
die Mittel der bissigen Ironie und der sarkastischen Satire,
die, dem Expressionismus ursprünglich fremd, im gross-
städtischen Vorkriegsexpressionismus zuerst am Rande auf-
tretend, nunmehr zu hauptsächlichen Ausdrucksmomenten
werden. Darin bereitet sich die Kunst des Nachkriegs vor.
Hinzu kommt, dass sich jetzt in den Kriegsjahren eine neue
Generation bemerkbar macht, deren Angehörige zehn bis

zwanzig Jahre jünger als die Expressionisten der ersten Welle sind.

Nachkriegsjahre

Schon in den letzten Kriegsjahren hat Franz Pfemfert den jungen Conrad Felixmüller aus Dresden kennengelernt. Der beliefert ihn wöchentlich mit Titelholzschnitten für "Die Aktion" mit bildlichen Stellungnahmen zu politischen Tagesproblemen, deren Thematik der Verleger dem Künstler von Berlin nach Dresden telephoniert hat. Die bewährte Zusammenarbeit wird nach dem Krieg fortgesetzt. Der expressionistische Holzschnitt wird damit zum erstenmal als politisches Agitationsmittel gezielt eingesetzt. Das Beispiel macht Schule. Der Schwarzweisskontrast des Holzschnitts, der zu einer plakativen Stilisierung der Formensprache zwingt, eignet sich hervorragend für eine Verwendung als künstlerisch gestaltetes Flugblatt in einer den Blockbüchern und Einblattholzschnitten des fünfzehnten und sechzehnten Jahrhunderts vollkommen entsprechenden Art und Weise. So wird der Holzschnitt zum grundlegenden Medium eines politisch engagierten Nachkriegs-Expressionismus in der Weimarer Republik, der von zahlreichen Künstlern ausgeübt wird. Dazu gehören z.B. Lea und Hans Grundig, Sella Hasse, Alfred Frank und Carl Meffert. Vorbild für diese Künstler ist vor allem das Holzschnittwerk von Käthe Kollwitz. Felixmüller gründet nach dem Krieg die "Dresdener Sezession 1919," von der die nachkriegsexpressionistische Zeitschrift "Menschen" herausgegeben wird. Felixmüllers Hauptwerk in jener Zeit ist das Gemälde "Der Tod des Dichters Walter Rheiner" aus dem Jahre 1925. Rheiner, mit dem Felixmüller eng befreundet war, hat sich durch einen Sprung aus dem Fenster das Leben genommen. Das Gemälde zeigt in einer aus Spitzen-. Kanten- und Ecken-Konstellationen dramatisch bewegt zusammengeschachtelten Komposition den Sprung des Selbstmörders, der dem Sog der Tiefe folgt, in den lichterfüllten Abgrund der Stadtnacht. Das ist das letzte bedeutende Grossstadtgemälde des deutschen Expressionismus,—eine Apotheose ex Negativŏ.

So, wie schon vor dem Kriege die Expressionisten der Dresdener "Brücke" nach Berlin gekommen sind, so bilden sich auch nach dem Kriege enge Verbindungen zwischen Dresden und Berlin heraus. Nicht nur Felixmüller kommt aus Dresden, auch Dix kommt aus Dresden, Grosz hat in Dresden ebenso wie Dix bei Richard Müller studiert. Die Dresdener zeigen in ihrer Malerei eine auffällige Neigung zu einer angriffslustigen farbig und formal überspitzten Gegenständlichkeit. Diese Eigenart der Dresdener Malerei wirkt sich auf die Nachkriegskunst in Berlin fermentierend aus. Sowohl Otto Dix wie George Grosz gewinnen den sozialkritischen Realismus, der ihr klassisches Werk der zwanziger Jahre kennzeichnet, aus den spitzigen und sperrigen, stachligen Formen einer Art zähneknirschenden Rest-Expressionismus, der in den frühen Gemälden beider Künstler vom Futurismus beeinflusst ist. Auch Max Beckmann in Frankfurt findet aus den Impulsen eines traumatisch gebrochenen Expressionismus zur grossen Form seines individuellen Stils. 1917 malt er seine "Kreuzabnahme," und im März 1919 vollendet er das Bild, das in der geballten Wucht seiner auf sich selbst wie auf die Welt gerichteten Aggressivität ein in seiner Symbolik die Stimmung der Zeit umgreifendes Hauptwerk der Epoche ist, die "Nacht." Eine Mörderbande ist aus der finsteren Nacht durchs Fenster ins Haus gestiegen. In der Dachkammer wird ein Mann von einem Schinder stranguliert, ein anderer knackt ihm die Arme aus. Seine Frau ist an den Handgelenken gefesselt; man hat ihr die nackten Beine gespreizt. Eine brennende Kerze schwankt, die andere ist erloschen. Ein Grammophon mit grossem, schwarz klaffendem Trichter ist zu Boden gefallen. Die Formen der Menschen und Dinge im engen Raum bedrängen und bedrücken einander auf quälende Weise. In seiner geistigen Haltung schlägt das Gemälde Brücken zur deutschen Malerei des 15. Jahrhunderts, weniger zu Matthias Grünewald, mehr zu Hans Multscher.

In Berlin formieren sich die Richtungen und Verbände nach Ende des Krieges neu. Die Berliner Dadaisten, zu denen ausser George Grosz und Otto Dix, John Heartfield, Raoul Hausmann, Johannes Baader, Walter Mehring, Richard Huelsenbeck und andere gehören, inszenieren ihre spektakulären Auftritte der direkten künstlerischen Aktion. Dada, das, wie wir sahen, seine Ursprünge im Grossstadt-Expressionismus durchaus nachweisen kann, hat nunmehr aber selbst nichts mehr mit dem Expressionismus zu tun, sondern verkörpert etwas ganz anderes, Neues. Die Nachwirkungen des Expressionismus finden sich in den Gründungen anderer Berliner Gruppen. Ende 1918 bildet sich in Berlin der "Arbeitsrat für Kunst," der "Einfluss und Mitarbeit bei allen Aufgaben der Baukunst" fordert. Die Ideen, die Walter Gropius dann zur Gründung des "Bauhauses" führen, werden hier schon formuliert. Feininger entwirft dafür sein Holzschnittsignet "Die Kathedrale des Sozialismus." Tonangebend in den Debatten ist der junge Architekt Bruno Taut, der im Herbst 1919 die ihm befreundeten Kollegen zu einem Briefwechsel auffordert. Unter dem Namen "Gläserne Kette" dauert diese Freundeskorrespondenz fünf Jahre an. In Texten, Zeichnungen und Aquarellskizzen wird die Utopie einer expressionistischen Architektur entworfen, die dann, von wenigen Ausnahmen abgesehen, an den praktischen und politischen Anforderungen der Wirklichkeit scheitert,—leider! Auch diese Bewegung hat ihren Berliner Propheten, den phantastischen Dichter Paul Scheerbart, der 1914 das Buch "Glasarchitektur" veröffentlicht hat.[8] Der "Arbeitsrat für Kunst" geht schliesslich in einer anderen Vereinigung auf, die sich im Dezember 1918 konstituiert hat, die "Novembergruppe." Diese Berliner Künstlervereinigung entwickelt sich in den zwanziger Jahren aus anfänglich kulturrevolutionären Impulsen zu einer bunt gemischten Ausstellungsgemeinschaft deutscher Künstler mit Gästen aus anderen europäischen Ländern. Der expressionistische Ursprung ist den Werken vieler Künstler, die der Gruppe zugehören, durchaus noch anzumerken, indes amalgamieren nun die gegenseitigen Beeinflussungen von Formerfindungen, die durch die Künstler der unterschiedlichen Richtungen—die Futuristen, die Kubisten, die Konstruktivisten und die Abstrakten—eingebracht werden, zu einem Stilgemisch, aus dessen Synthese ein für die Kunst, im besonderen die mitteleuropäische, die deutsche ebenso wie die z.B. ungarische und tschechische Kunst der zwanziger Jahre

charakteristischer Stilsynkretismus hervorgeht, dessen geschichtliche Eigenart trotz aller neuerdings stattfindenden Beschäftigung mit der Kunst der Zwanziger Jahre bisher noch nicht recht gewürdigt worden ist.

Anmerkungen

1. Vergl. Donald E. Gordon, "On the Origin of the Word 'Expressionismus,'" *Journal of the Warburg and Courtauld Institutes*, Bd. XXIX, 1966

2. Kurt Pinthus, *Menschheitsdämmerung. Synphonie jüngster Dichtung.* Berlin 1920. Neuausgabe, Reinbeck b. Hamburg, 1959

3. Original im Sturm-Archiv, Staatsbibliothek der Stiftung Preussischer Kulturbesitz, Textwiedergabe im Katalog: *Der Sturm. Herwarth Walden und die Europäische Avantgarde.* Nationalgalerie Berlin, 1961

4. *Der Sturm*, 1. Jhg., 1910, Nr. 32

5. Carl Einstein, *Bebuquin oder die Dilletanten des Wunders*, Berlin, Verlag "Die Aktion," Dezember 1912. Neuauflage Frankfurt 1974

6. Salomo[n] Friedländer, *Schöpferische Indifferenz*, München 1918

7. *George Grosz, Leben und Werk.* Herausg. von Uwe M. Schneede, Stuttgart 1975, S. 34

8. Paul Scheerbart, *Glasarchitektur.* Berlin, Verlag "Der Sturm," 1914. Neuauflage München 1971

Photographic Credits

WORKS IN THE EXHIBITION

Color

Courtesy The Art Institute of Chicago: cat. no. 301

Courtesy Brücke-Museum, Berlin: cat. no. 185

Courtesy Brücke-Museum, Berlin; photo by Henning Rogge, Berlin: cat. no. 218

Courtesy Fogg Art Museum, Harvard University, Cambridge, Massachusetts: cat. no. 33

Dieter Grundmann, Gelsenkirchen-Erle: cat. no. 97

Kunst-Dias Blauel, Munich: cat. nos. 27, 92

Courtesy Ludwig-Roselius-Sammlung der Böttcherstrasse, Bremen: cat. no. 1

Robert E. Mates: cat. nos. 231, 242, 257, 268

Courtesy Museum Folkwang, Essen: cat. nos. 12, 144, 146, frontispiece

Courtesy The Museum of Modern Art, New York: cat. nos. 135, 184

Courtesy Neue Galerie der Stadt Linz/Wolfgang-Gurlitt Museum: cat. nos. 274, 282

Courtesy Nolde-Stiftung Seebüll: cat. nos. 42, 51, 59, 61

Courtesy Nolde-Stiftung Seebüll; photo by Ralph Kleinhempel, Hamburg: cat. no. 30i

Courtesy Rheinisches Bildarchiv, Museen der Stadt Köln: cat. nos. 14, 49, 62, 101, 150, 189, 223, 262, 287, 292, 311, 316

Courtesy The St. Louis Art Museum: cat. nos. 138, 208, 288, 321

Courtesy Staatliche Museen Preussischer Kulturbesitz, Nationalgalerie, Berlin: cat. no. 181

Courtesy Staatsgalerie Stuttgart: cat. nos. 233, 277

Courtesy Städtische Galerie im Lenbachhaus, Munich: cat. nos. 235, 252

Courtesy Tate Gallery, London: cat. no. 306

Courtesy Thyssen-Bornemisza Collection, Lugano: cat. nos. 90, 130

Black and White

Jörg P. Anders, Berlin: cat. nos. 179, 217, 304, 322

Courtesy The Art Institute of Chicago: cat. no. 283

Courtesy Gertrud Bingel, Munich: cat. no. 271

Courtesy The Detroit Institute of Arts: cat. no. 142

Courtesy Fogg Art Museum, Harvard University, Cambridge, Massachusetts: cat. nos. 93, 96, 133, 143

Courtesy Foto Studio van Santvoort, Wuppertal: cat. nos. 4, 220

Courtesy Germanisches Nationalmuseum, Nürnberg: cat. no. 140

Courtesy Hamburger Kunsthalle: cat. no. 270

Courtesy Galerie Klihm, Munich: cat. nos. 312, 313

Courtesy Kunstsammlung Nordrhein-Westfalen, Düsseldorf: cat. no. 307

Lachsse, Bonn: cat. no. 187

Courtesy Landesbildstelle Rheinland, Düsseldorf: cat. nos. 236, 251, 289

Courtesy Landesmuseum Oldenburg: cat. nos. 3, 178

Courtesy Leopold-Hoesch-Museum, Düren, cat. no. 269

Robert E. Mates: cat. nos. 98, 243, 244, 263–65, 281

Robert E. Mates and Mary Donlon: cat. nos. 234, 237, 239, 240, 255, 260, 261

Courtesy The Minneapolis Institute of Arts: cat. no. 132

Courtesy Museum am Ostwall, Dortmund: cat. no. 278

Courtesy Museum Folkwang, Essen: cat. nos. 2, 8, 9, 11, 15, 17, 19, 22, 24, 26, 64, 65, 67, 69, 72, 74, 76, 77, 80, 82, 85, 88, 95, 103, 105, 107, 109, 113, 114, 117, 118, 120, 121, 125, 126, 141, 145, 146, 149, 151, 153, 158, 162–64, 166, 172, 173, 175, 191–93, 195, 197, 199, 200, 203, 204, 213, 215, 216, 219, 225–27, 246, 248, 249, 266, 284, 285, 295, 297, 298, 327, 330

Courtesy Museum Ludwig, Cologne: cat. nos. 46, 100, 102, 148, 212, 224, 241, 267, 273, 276, 286, 291, 293, 310, 315, 319, 323, 326

Courtesy The Museum of Modern Art, New York: cat. nos. 28, 32, 127, 258, 259, 275, 309, 320

Courtesy Nolde-Stiftung Seebüll: cat. nos. 29, 34, 36, 40, 43, 57, 176

Courtesy Nolde-Stiftung Seebüll; photo by Ralph Kleinhempel, Hamburg: cat. nos. 30a–h, 31, 35, 39, 47, 56

Courtesy Pfalzgalerie Kaiserslautern: cat. no. 128

Courtesy Rheinisches Bildarchiv, Museen der Stadt Köln: cat. nos. 6, 13, 41, 50, 222, 302, 317, 325

Henning Rogge, Berlin: cat. nos. 136, 180

Courtesy Saarland-Museum Saarbrücken: cat. no. 300

Courtesy Serge Sabarsky Gallery, New York: cat. nos. 94, 290

Courtesy The St. Louis Art Museum: cat. nos. 129, 139, 182, 207, 299, 314, 318

John D. Schiff, New York: cat. no. 280

Courtesy Staatliche Kunstsammlungen Kassel: cat. no. 134

Courtesy Staatsgalerie moderner Kunst, Munich: cat. nos. 131, 188, 210, 221, 238, 279

Courtesy Staatsgalerie Stuttgart: cat. no. 205

Courtesy Stadelsches Kunstinstitut und Städtische Galerie, Frankfurt; photo by Ursula Edelmann, Frankfurt: cat. no. 186

Courtesy Städtische Galerie im Lenbachhaus, Munich: cat. nos. 253, 254, 256, 272

Courtesy Städtische Museen Recklinghausen; photo by Weimann: cat. no. 10

Courtesy Städtisches Karl Ernst Osthaus Museum, Hagen; photo by Kühle Studio, Hagen: cat. no. 99

Courtesy Thyssen-Bornemisza Collection, Lugano: cat. nos. 137, 177, 209, 308

Courtesy Thyssen-Bornemisza Collection, Lugano; photo by Brunel, Lugano: cat. no. 89

Courtesy University Art Museum, University of California, Berkeley: cat. no. 230

Courtesy Walker Art Center, Minneapolis: cat. no. 232

Courtesy Wilhelm-Lehmbruck-Museum der Stadt Duisburg: cat. no. 91

Courtesy Richard S. Zeisler Collection, New York: cat. no. 250

SUPPLEMENTARY ILLUSTRATIONS

Courtesy Allen Memorial Art Gallery, Oberlin College, Oberlin, Ohio: fig. 8

Mary Donlon: fig. 6

Copyright Dr. Wolfgang and Ingeborg Henze, Campione d'Italia: figs. 4, 5

Courtesy Dr. med. Wolfgang Kruse, Sozio-Medizinische Beratungen, Berlin: fig. 11

Courtesy Kunstmuseum Hannover mit Sammlung Sprengel: fig. 2

Courtesy Museum Ludwig, Cologne: fig. 1

Courtesy of The Robert Gore Rifkind Foundation, Beverly Hills: figs. 10, 12

Courtesy Staatliche Museen Preussischer Kulturbesitz, Nationalgalerie, Berlin: fig. 7

Courtesy Staatsgalerie moderner Kunst, Munich: fig. 3

Courtesy Staatsgalerie Stuttgart: fig. 9

EXHIBITION 80/6

12,000 copies of this catalogue, designed by Malcolm Grear Designers, typeset by Dumar Typesetting, Inc., have been printed by Eastern Press in October 1980 for the Trustees of The Solomon R. Guggenheim Foundation on the occasion of the exhibition *Expressionism—a German Intuition, 1905-1920.*